DUBLIN
THE VIEW FROM ABOVE

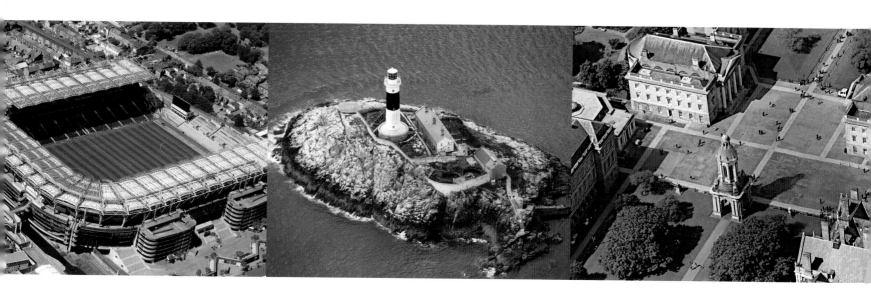

DENNIS HORGAN
FOREWORD BY PAT KENNY

The Collins Press

FOR DEIRDRE, WITH LOVE

First published in 2015 by
The Collins Press
West Link Park
Doughcloyne
Wilton
Cork

© Dennis Horgan 2015

Dennis Horgan has asserted his moral right to be identified as
the author of this work in accordance with the Irish Copyright
and Related Rights Act 2000.

A CIP record for this book is available from the British Library.

Hardback ISBN: 978-1-84889-256-9

Design and typesetting by Inspire.ie

Typeset in Futura

Printed in Italy by Printer Trento

I hope you enjoy the images in this book,
all of which are available
to purchase on my website,
www.dennishorgan.ie.

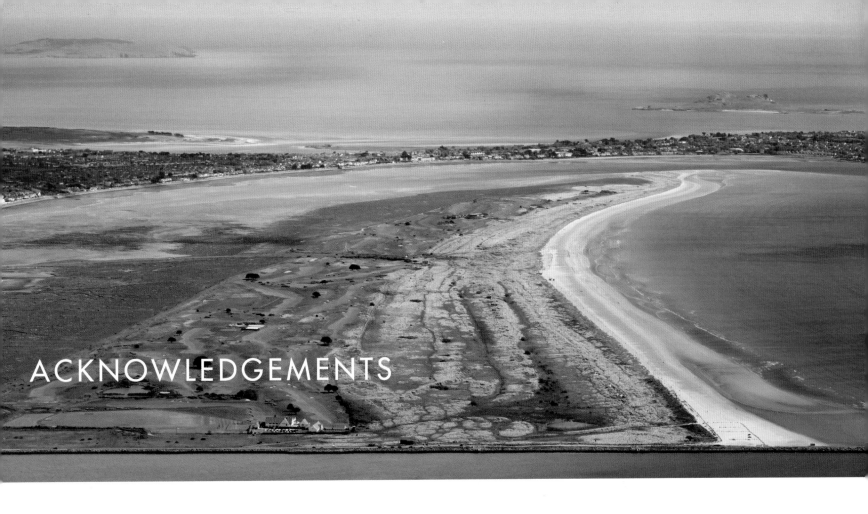

ACKNOWLEDGEMENTS

The author acknowledges with sincere thanks the kind support of

TOPAZ ENERGY GROUP LTD
HOOKE & MacDONALD

Text:	Marcus Connaughton
Research:	Peter Rafter, FRIAI Architect
Flight planning:	Capt. Angelo Cunningham
Pilots:	Alan O'Loughlin & Mark O'Neill, National Flight Centre

Thanks also to: Con Crowley and Michael Hogan Jnr for their assistance during the various flights over Dublin; Michael Sheehan for editing skills; Capt. Kieran O'Connor, National Flight Centre Weston Airport; Pat Kenny; Leslie Buckley.

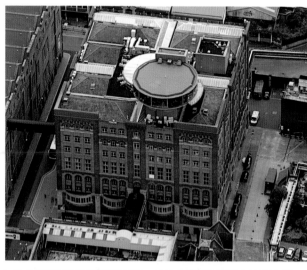
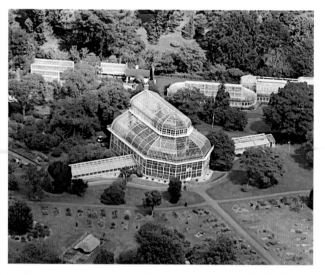
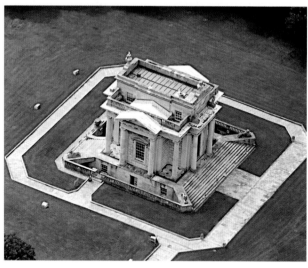
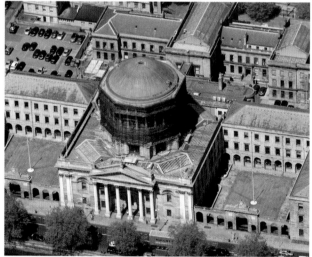

FOREWORD

As a true blue Dubliner whose roots in the city go back many generations, I have an affection for my home place which is almost genetic in its inevitability. It is only when a stranger comes to visit that I begin to explore for them, and with them, the places and things – and people – that have kept me here, in spite of the allure and seduction of other places.

The Dublin of my childhood was one of green grass, red brick, limestone and granite. Steel and glass constructions were only beginning to encroach on what was once the second city of the empire. My landscape stretched from the Phoenix Park and Dublin Zoo, all the way past the colonial precision of the McKee Barracks into the faded elegance of Mountjoy Square, close to my school. The smell that dominated our lives was that of the massive Guinness brewery close to our home, except when the cattle were herded up the slope of Infirmary Road where we lived, from the railway station en route to the cattle market and the abattoir on the North Circular Road. The smell on Wednesdays was very different.

My young life was spent exploring, running in the Fifteen Acres, climbing the hill up to the Magazine Fort, lazily watching chukkas of polo in the polo grounds, or cricket or football. Looking back, it was idyllic.

All around us were architectural jewels, but we took them for granted. We passed the majestic Four Courts without looking upwards. We went into the historic GPO simply to buy stamps. We rarely looked down: the river, meandering from Chapelizod in the west all the way to the industrial dockland, was only sometimes interesting. When we watched the Guinness barges at high tide lower their hinged smokestacks to squeeze under the Liffey's many bridges, we hoped for a collision. Once a year we speculated on which diseases the swimmers might catch in the throes of the annual Liffey swim. The Botanic Gardens in Glasnevin, with the glorious symmetry of the Palm House, was where we might be dragged by a well-meaning uncle or aunt for a tedious Sunday afternoon. Our annual holidays didn't take us very far, just to Rush in north County Dublin where a city of vegetable-growing glasshouses was still decades in the future, and the nightly winking of the lighthouse on Rockabill added its own mystery and magic. This was the extent of our world.

Now I see Dublin through a different prism. I thought that I had developed a good, although critical, appreciation of the ancient and old, as well as the new and modern aspects of our capital city. But this volume of photographs, taken from above by Dennis Horgan, has been a revelation. Buildings we take for granted, like St Peter's Church in Phibsborough, wedged in as it is at street level, is a masterpiece when viewed from the sky. We can see the miniature perfection of the Casino in Marino, the awful reality that once was St Ita's in Portrane: now sanitised by distance and time, we can appreciate its beauty. And who knew there were rooftop swimming pools in the Dublin docks?

The view of Dublin from above is wonderful. It gives us an understanding of how the city works, makes sense of streets and squares, exposes hidden beauties. Modern buildings sit sometimes uncomfortably beside the old imperial heart of the city, but somehow this reassures us that this generation is also making its mark and we are not a city set in aspic. I love my city, and this book has made me love it even more. I hope that as you read these words, and delight in these pictures, you can begin to share the love. Thank you, Dennis.

Pat Kenny

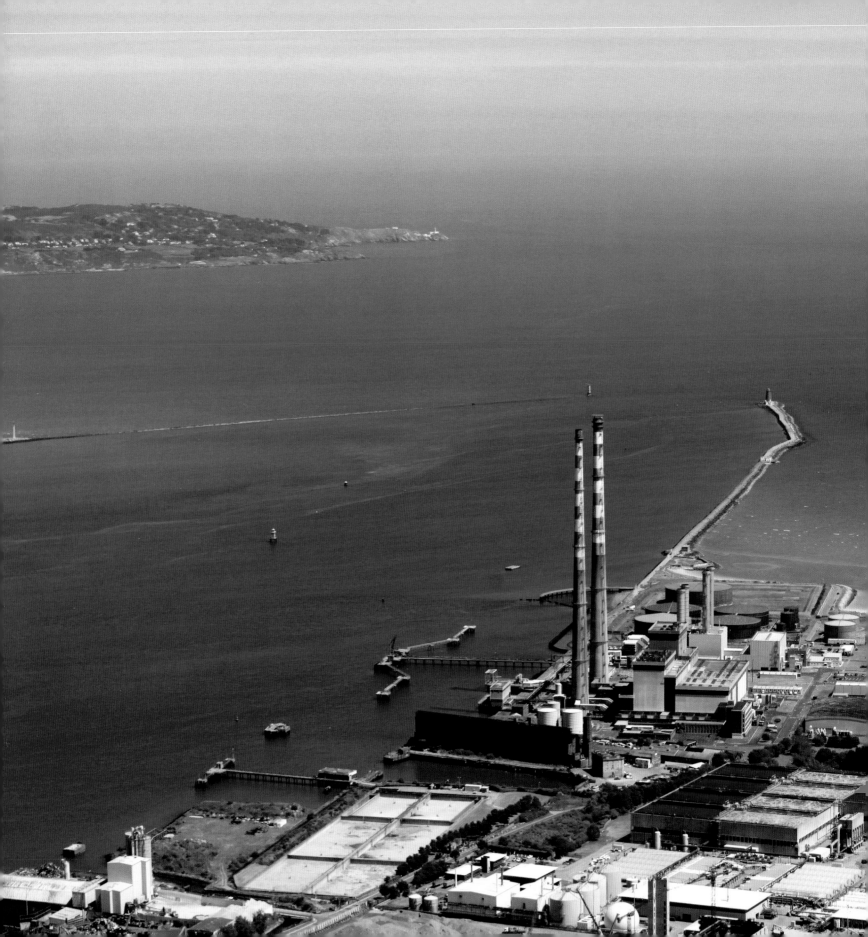

INTRODUCTION

'You're cleared to operate over the city, at seventeen hundred feet' said the air traffic controller at Dublin Airport. With that, the pilot banked the aircraft over Dublin Bay and we headed towards the city.

The skies over the city were ours for a short time and I intended to make the most of it. That was when I got my first 'up close and personal' aerial view of Dublin. Stretching below as far as the eye could see, was the panorama of Ireland's capital city with its wonderful collection of old and new buildings, parkland, river, countryside and coast. Seen from the edge of an open aircraft door, the city below looks breathtaking. I feel privileged that I am getting a view that most people rarely see. As passenger jets whisk us to great heights within minutes of take-off, there is little opportunity to study the landscape below.

I am fortunate to be doing something that I enjoy immensely. I love leaving the land and observing it from a totally different perspective. The images in this book were compiled over a period of a year in all seasons and weather conditions. I flew in both helicopter and fixed-wing aircraft, usually with a door removed to get clearer shots and unobstructed camera angles. Aerial photography is always a challenge as one is constantly at the mercy of the weather and truly clear days are few and far between. The fact that there is a large volume of flights to and from Dublin to Europe and beyond means that certain parts of Dublin are difficult to overfly. I spent many hours waiting on the ground for the weather to change and when it did I was gifted with fine days of which I took full advantage. Some of the images in this volume were planned; others were sights that surprisingly presented themselves during my various sorties over the county. There were some places I would have like to have included, but air traffic control restrictions/weather conditions at the time prevented me from doing so.

I have to acknowledge the skill and professionalism of the pilots from National Flight Centre at Weston Airport who flew me on my many sorties over Dublin. Photo flying is difficult, but these consummate professionals made it look easy and it was a pleasure to work with them. Dublin Air Traffic Control were always courteous and facilitated me wherever possible with clearances through their busy airspace.

Dublin has changed dramatically since I first visited it all those years ago as a young boy on a school tour. It is now a vibrant, modern city with an eclectic mix of old and new buildings and a population of over one million people. It is a capital city of which all of Ireland can be justly proud.

I hope you enjoy this book as much as I have enjoyed creating it. Dublin is a beautiful place to cover on foot. However, it is, in my opinion, all the more fascinating from the air.

Dennis Horgan

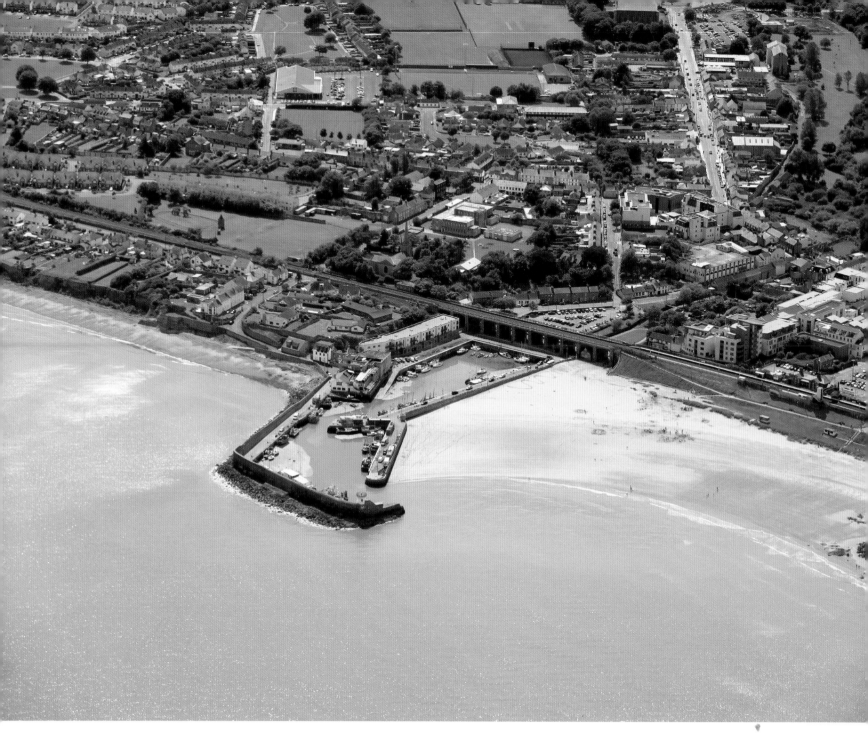

Balbriggan, an expanding seaside town to the north of the capital in Fingal.
The name in Irish, *Baile Bricín,* means 'the town of the small trout'.

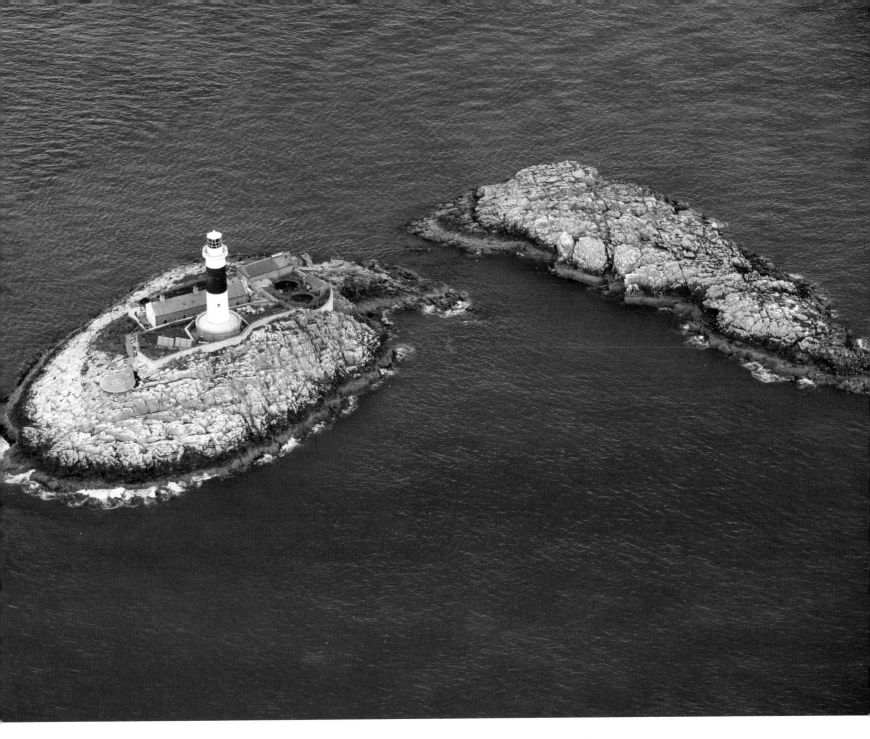

Rockabill is a small group of islands situated about 6 km off Skerries in north Dublin. The lighthouse was built in 1860 and went automatic in 1989.

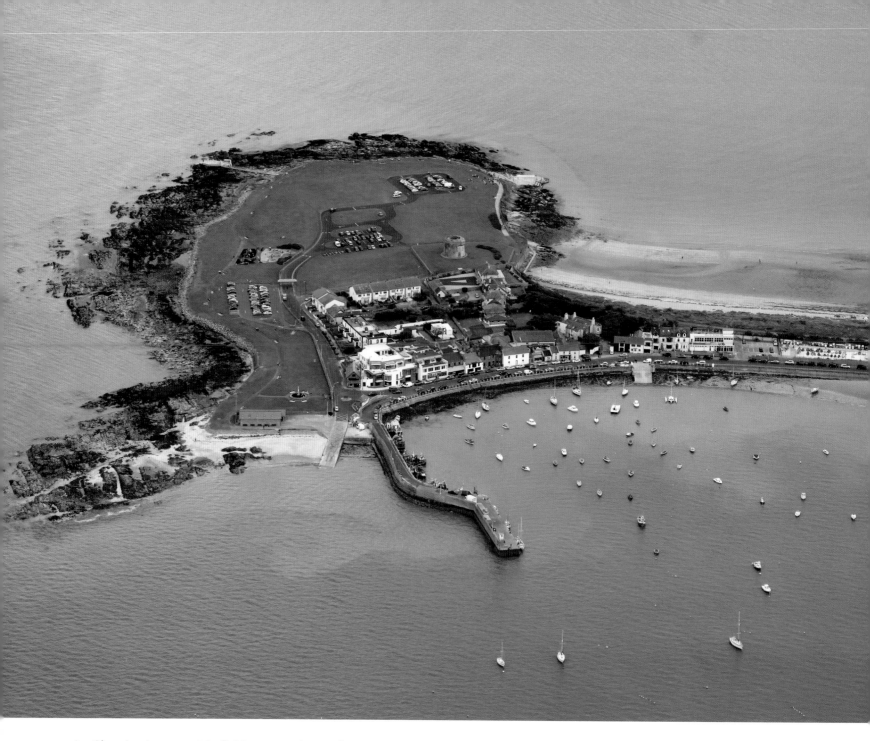

▲ Skerries is a seaside fishing town in north County Dublin with a long, sandy beach.
In recent years it has become a large residential area due to its proximity to Dublin city.

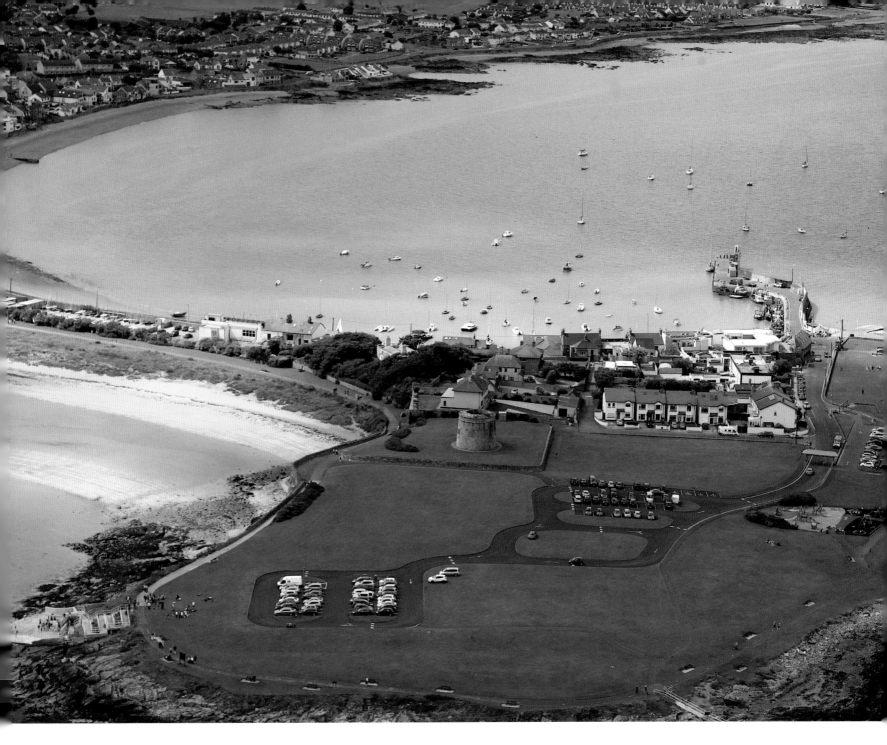

Skerries Harbour, looking west.

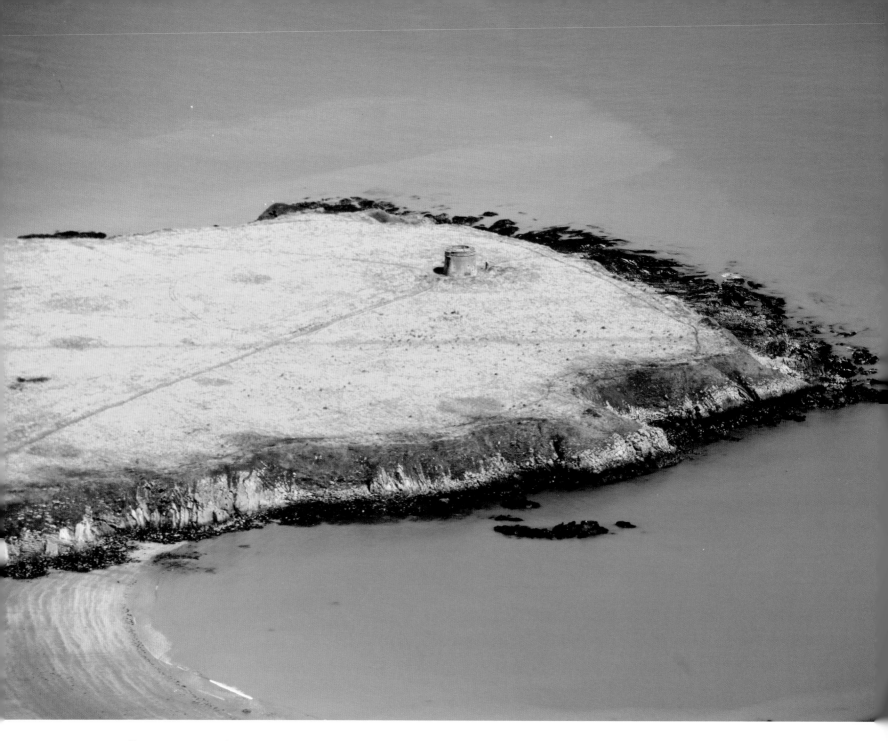

▲ Martello tower near Skerries, one of the nineteenth-century defensive forts built around Ireland's coast.

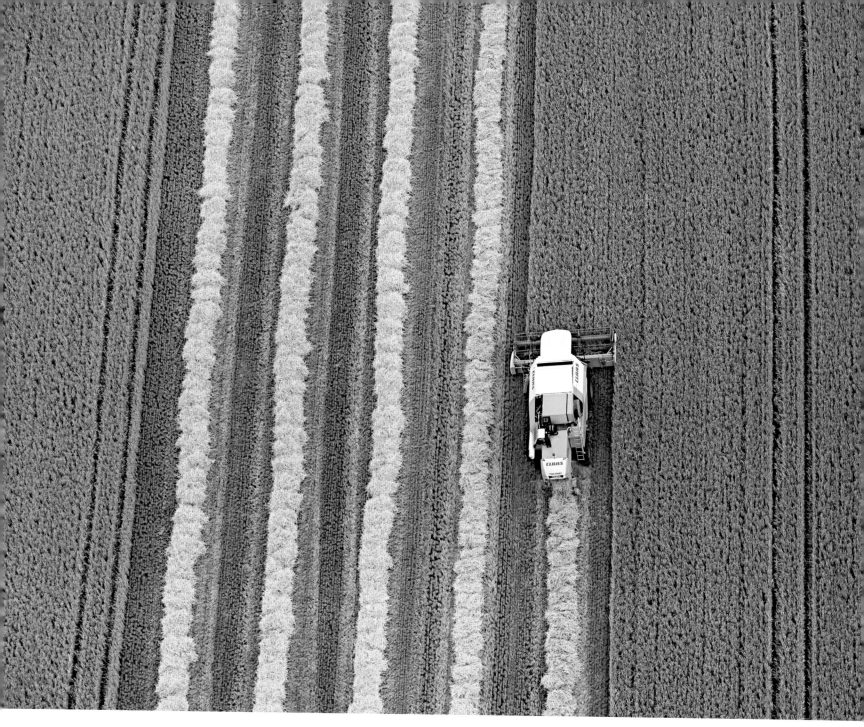

A combine harvester works a barley field in north Dublin. The lines and patterns created during this process look spectacular from above.

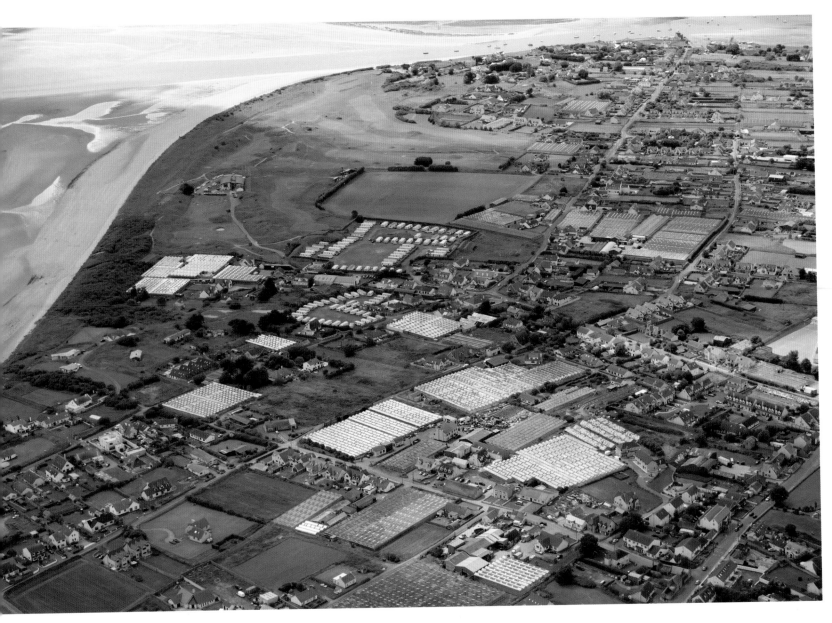

Rush is a village located north of Dublin city and is a centre of the market-garden industry. With broad beaches north and south of the harbour, it is a popular spot for visitors.

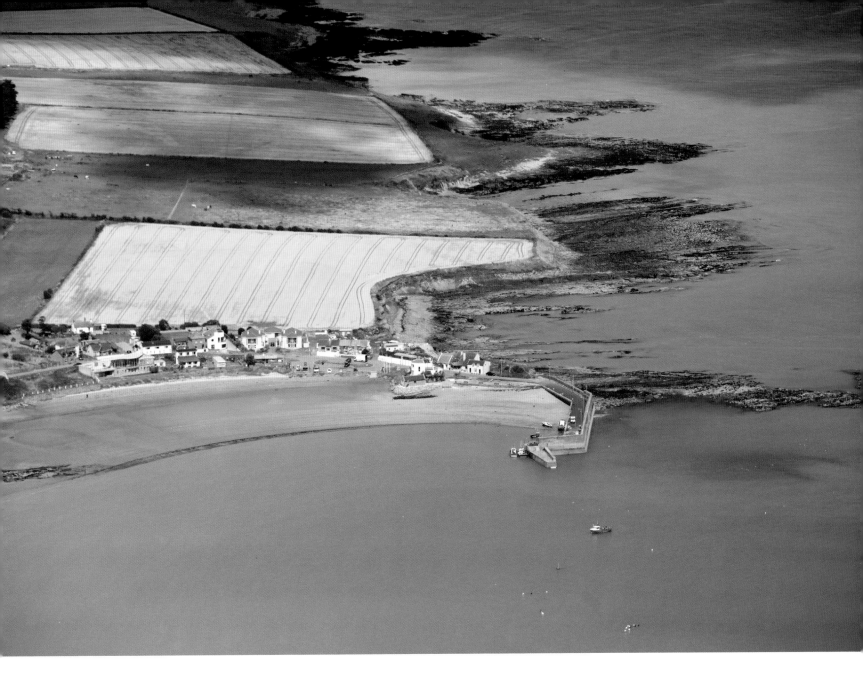

The picturesque seaside village of Loughshinny, situated between Skerries and Rush in north County Dublin.

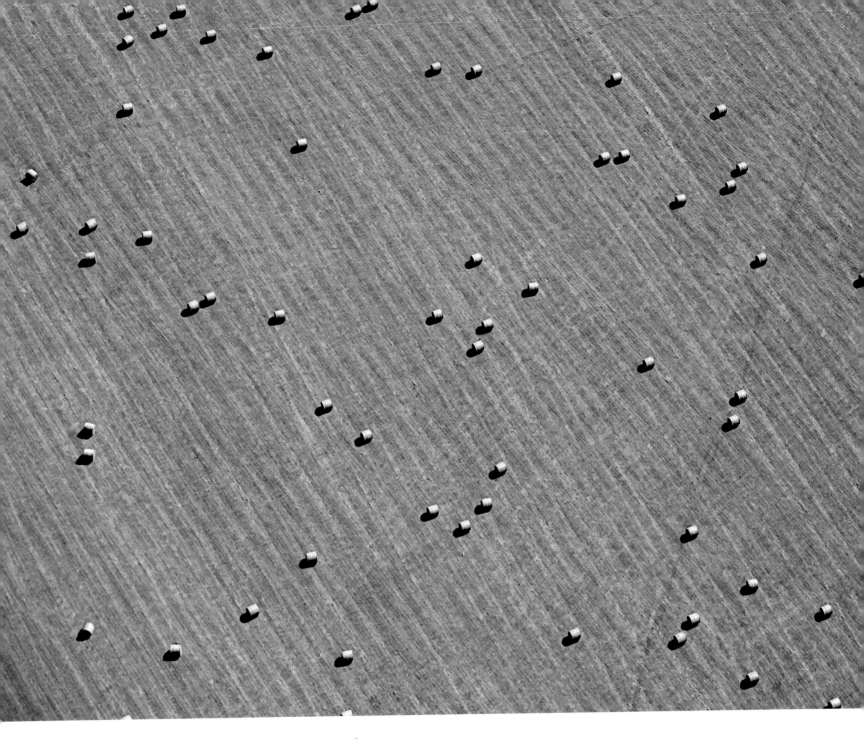

▲ Bales of straw, adding their own pattern to the
landscape, await collection and storage.

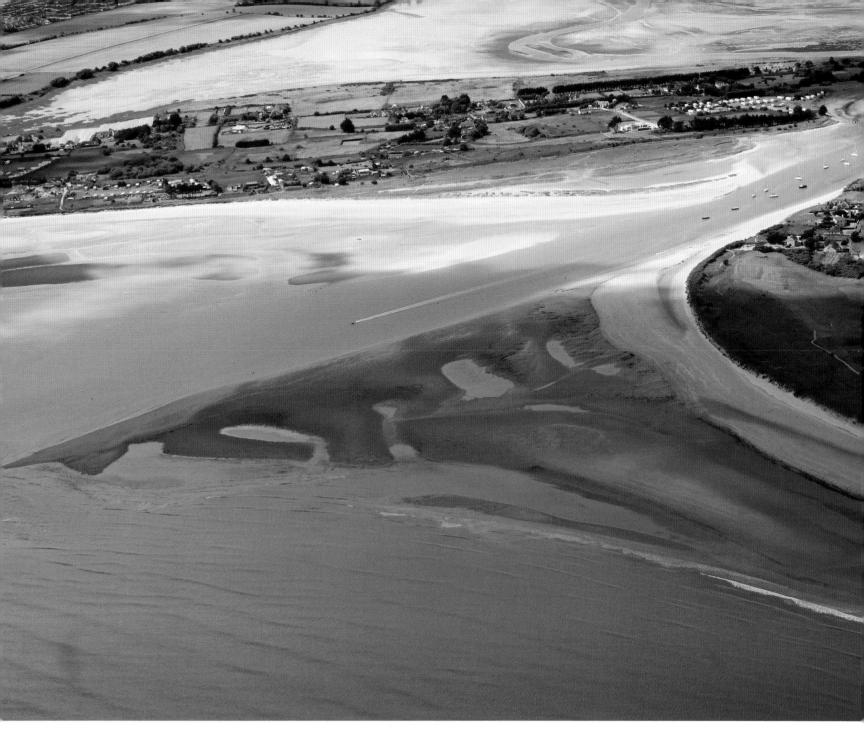

Rogerstown Estuary is situated north of the Portrane peninsula and south of Rush.

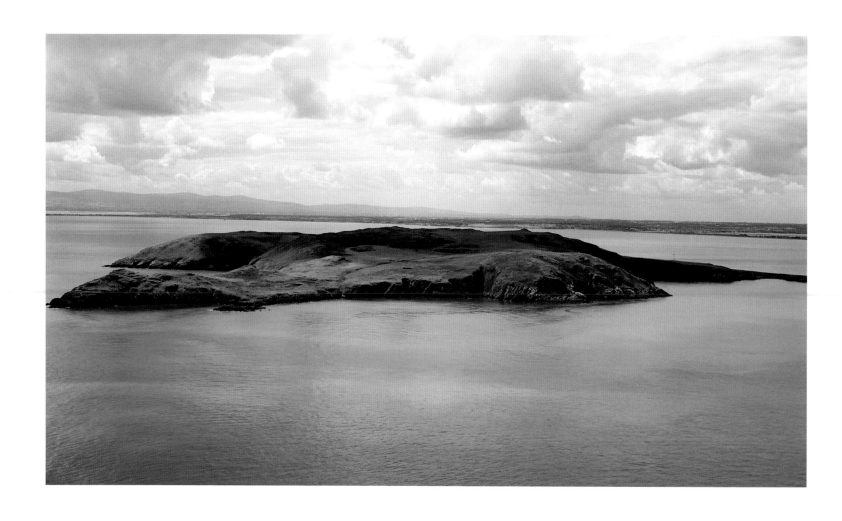

▲ Lambay, the largest of Dublin's coastal islands, has a long history and was once occupied by the Vikings. The island, now privately owned, is an internationally important seabird colony and an area of conservation.

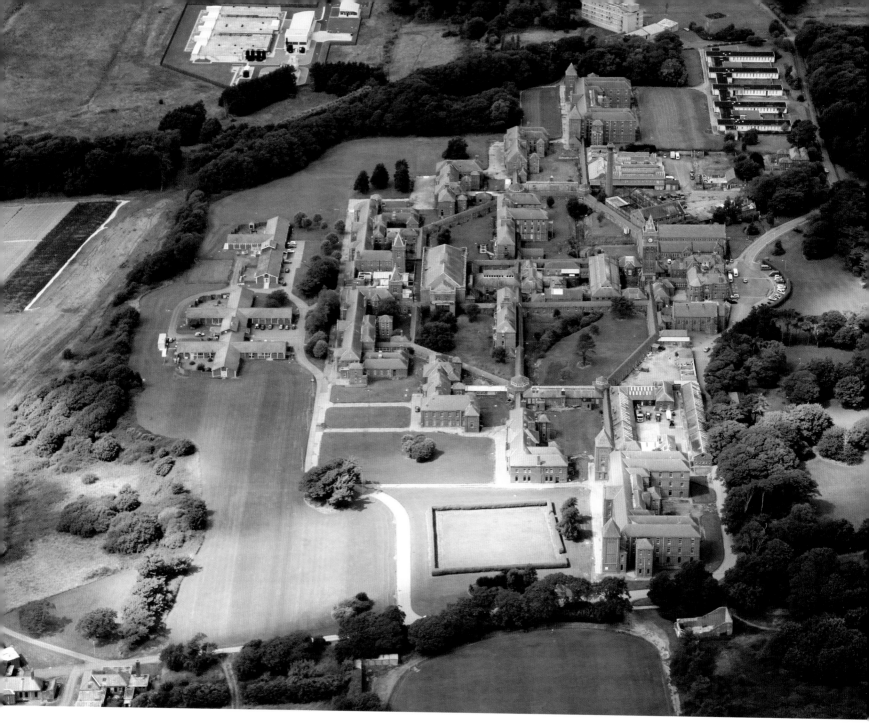

▲ St Ita's Hospital was originally built as an asylum at the end of
the nineteenth century. It is now a long-stay facility for those with
intellectual disabilities.

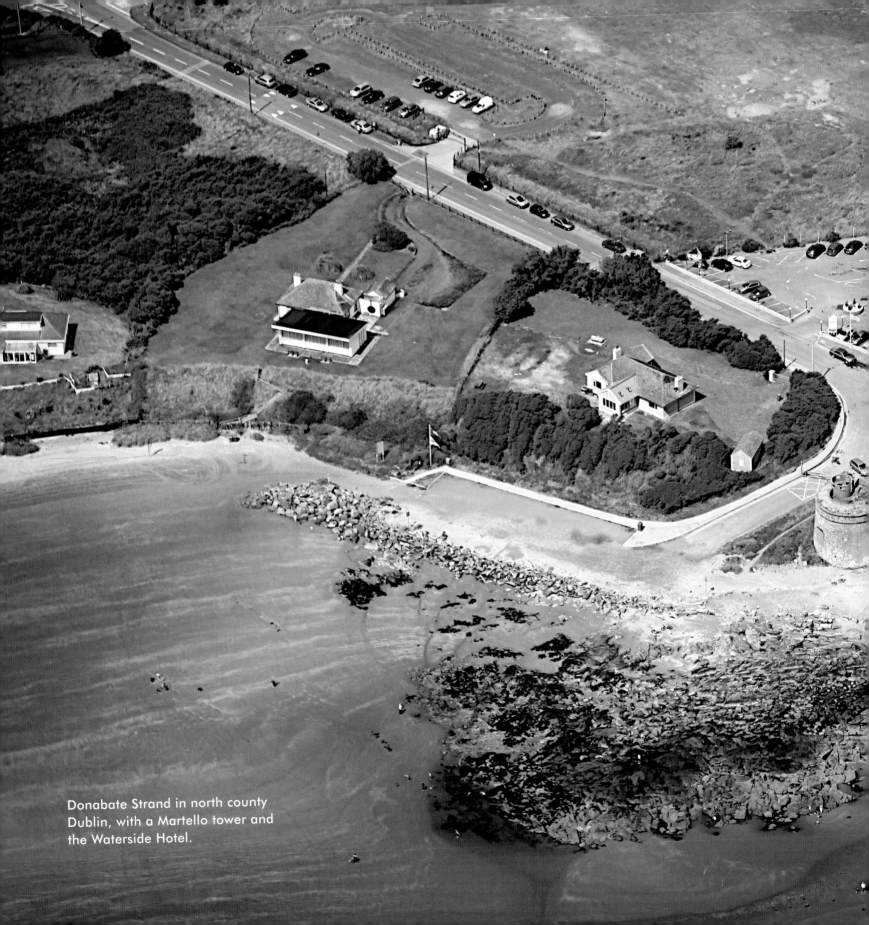

Donabate Strand in north county Dublin, with a Martello tower and the Waterside Hotel.

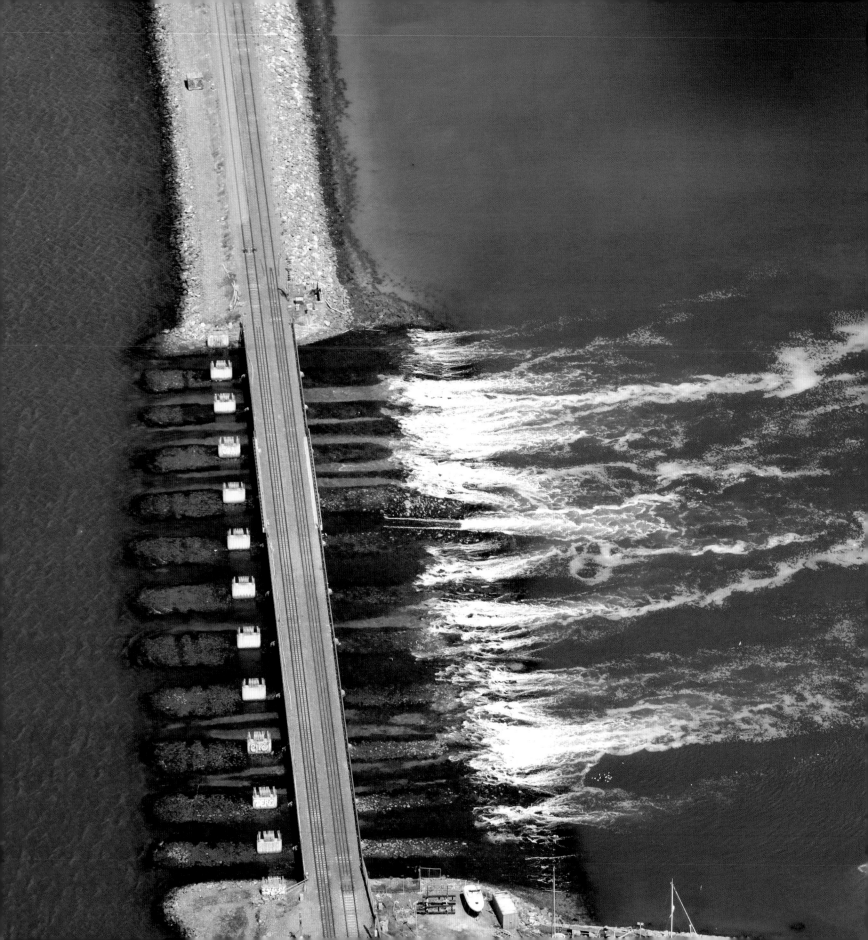

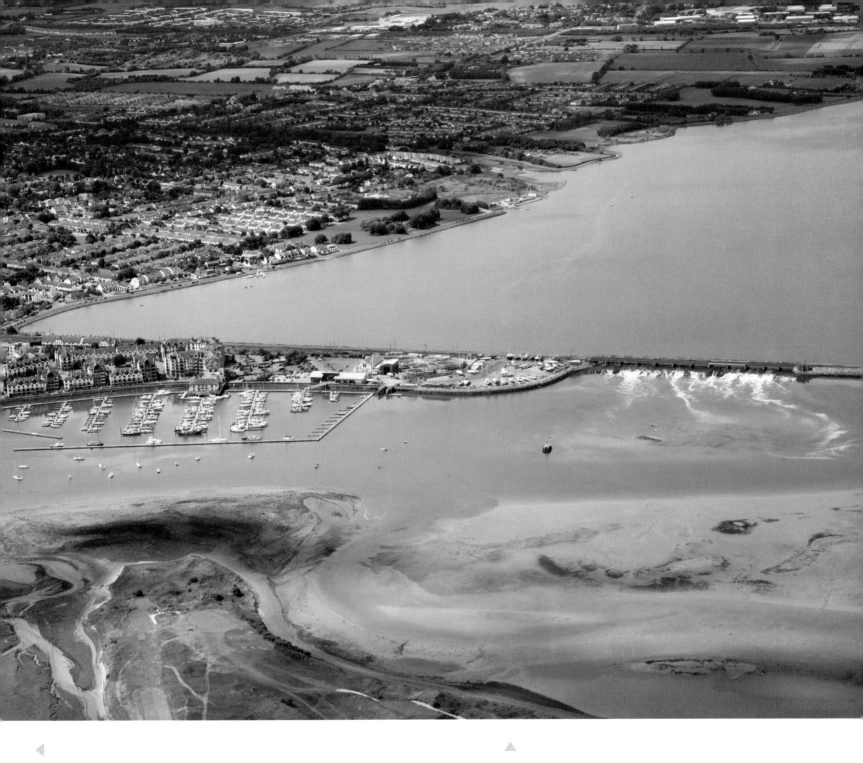

The Malahide Viaduct bridge crosses the Broadmeadow Estuary north of the town. It carries the track of the Dublin/Belfast railway and is also used by commuter trains.

Malahide is a coastal suburban town north of Dublin city. It has grown rapidly over the years and is now an extensive suburb with a large resident population.

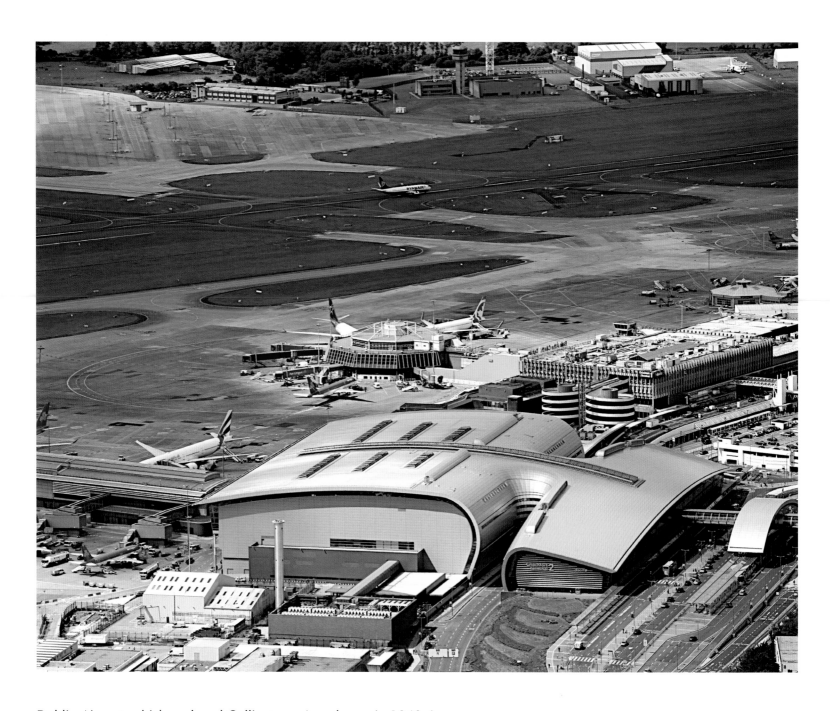

Dublin Airport, which replaced Collinstown Aerodrome in 1940, is now an international aviation transport hub and home to Aer Lingus and Ryanair. The latest addition to the airport, Terminal 2 (T2), opened in 2010. The airport is used by all the leading international carriers.

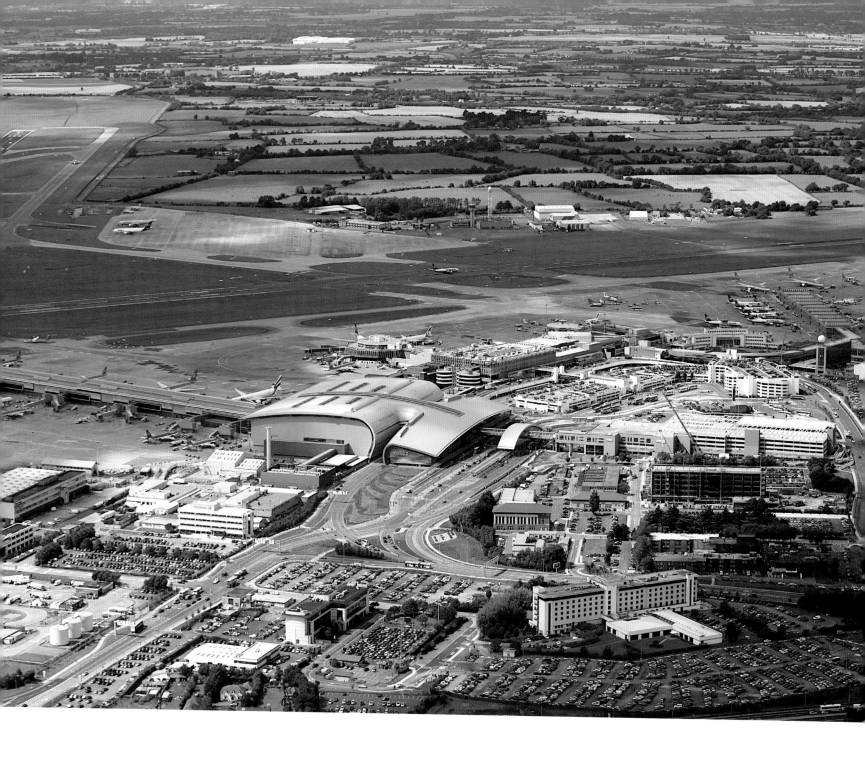

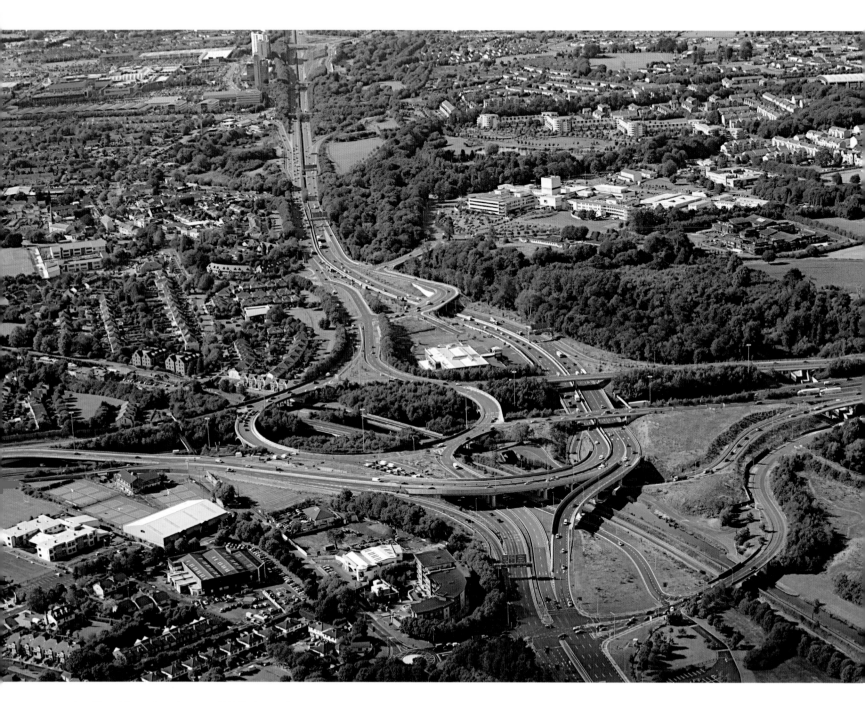

▲ The Blanchardstown/M50 Interchange.

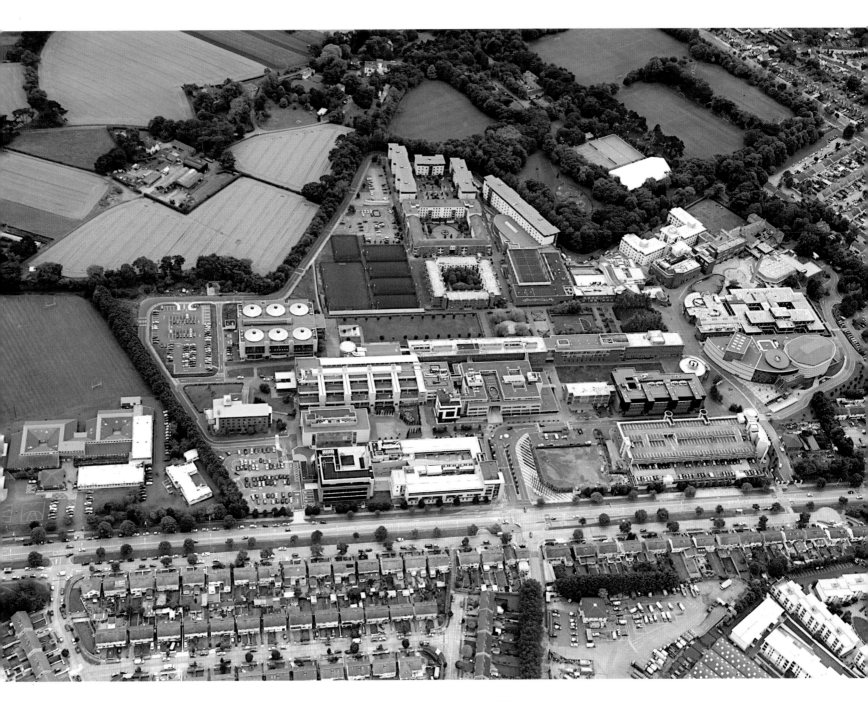

▲ Dublin City University, Glasnevin, was elevated to university status in 1989.
It has an extensive campus on the north side of the city.

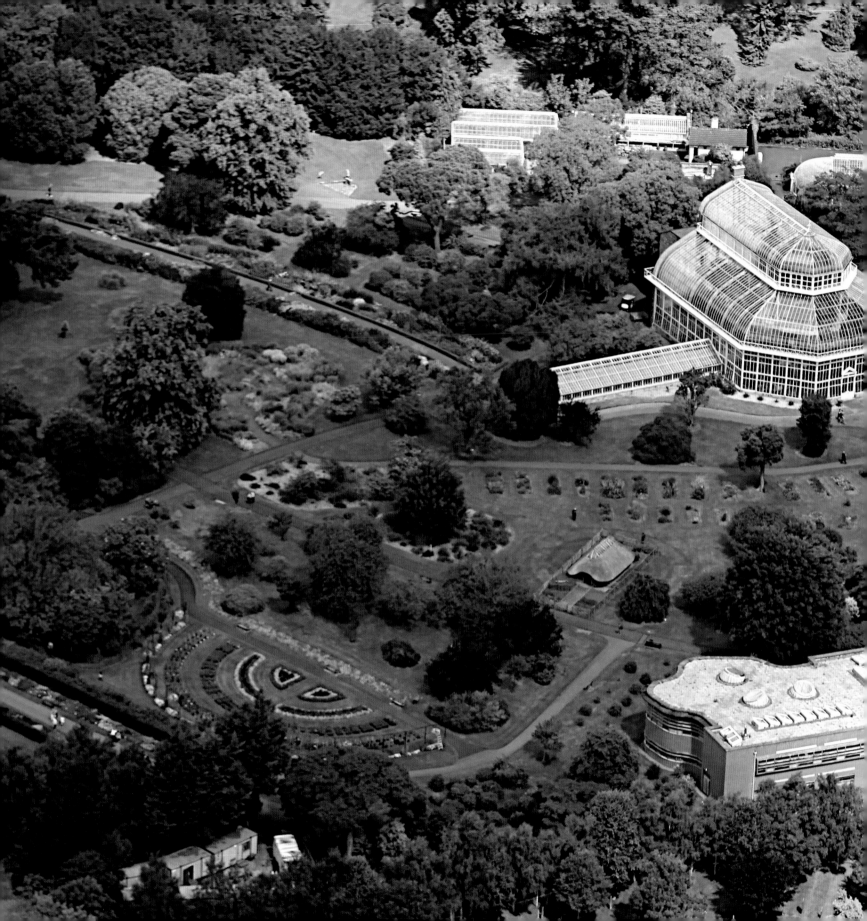

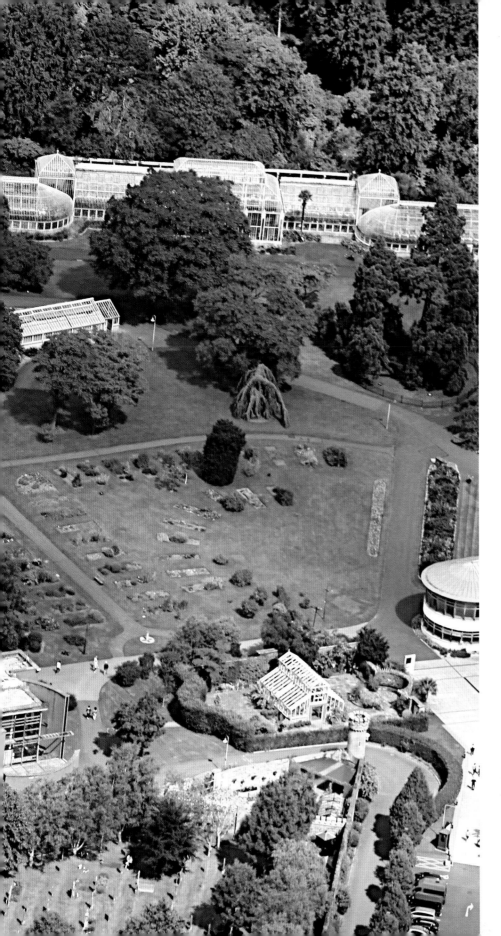

The National Botanic Gardens in Glasnevin, with the restored Palm House.

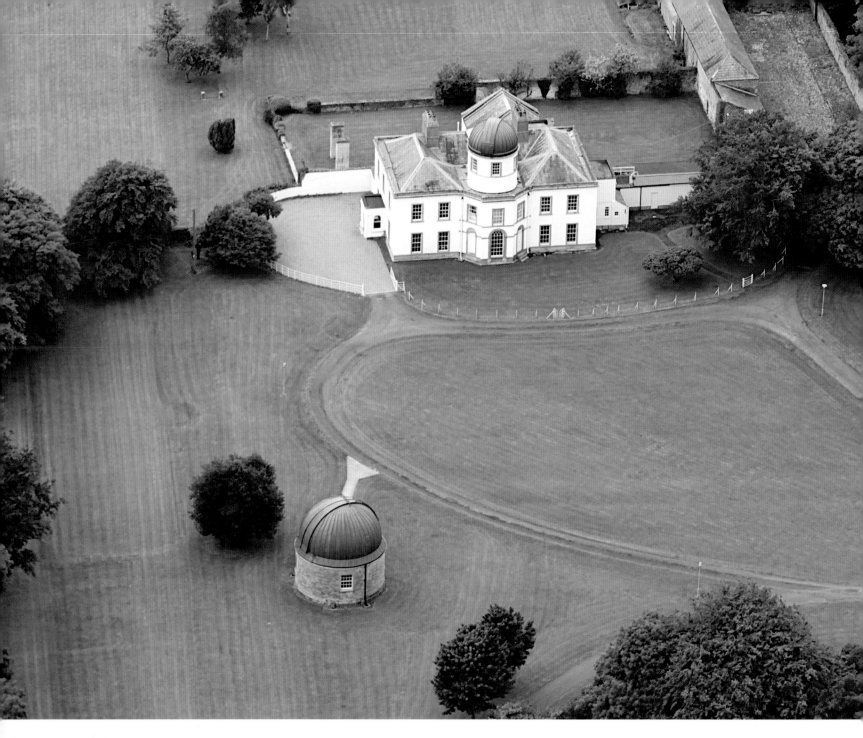

◄ Dunsink Observatory opened in 1785 and was specifically constructed for astronomical research. 'Dunsink time' is mentioned in *Ulysses* by James Joyce on several occasions.

Glasnevin Cemetery opened in 1832 as a non-denominational graveyard and is the largest cemetery in the country. Daniel O'Connell, 'The Liberator', is interred here. ►

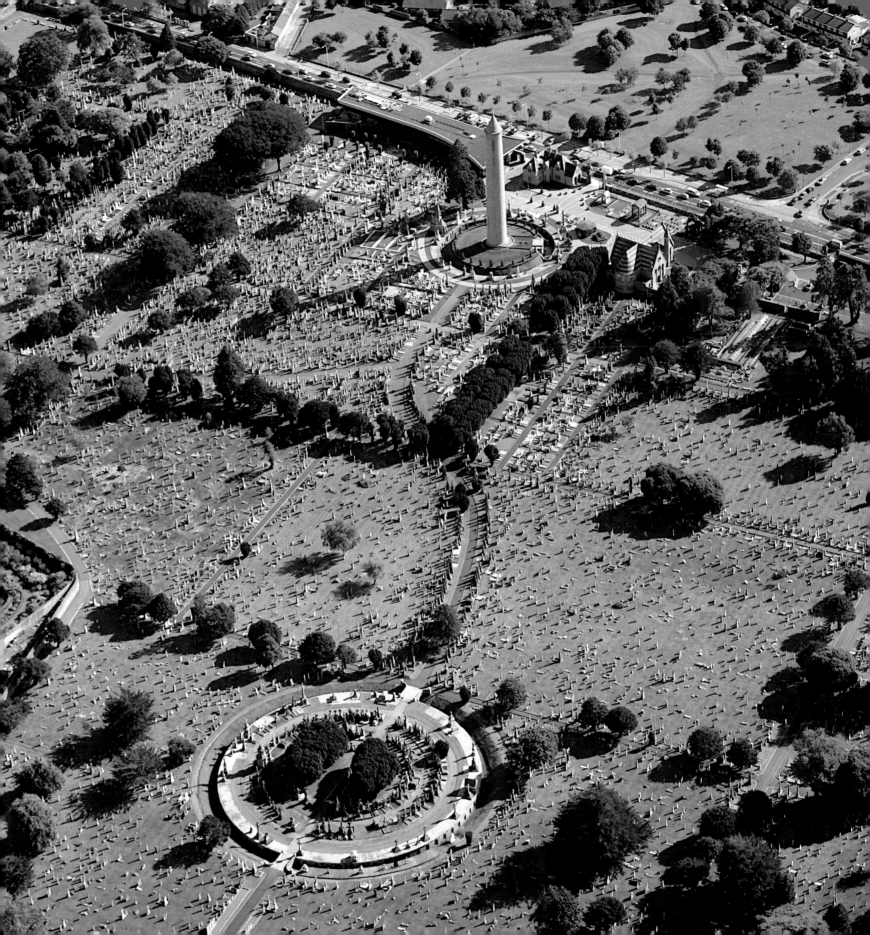

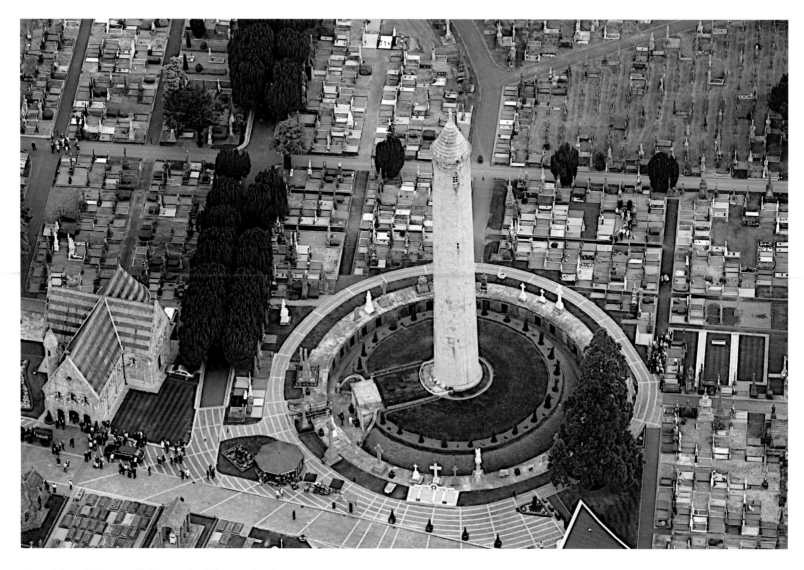

The O'Connell Tower in Glasnevin Cemetery.
At a height of 52 metres/171 feet, it is the
tallest round tower in Ireland.

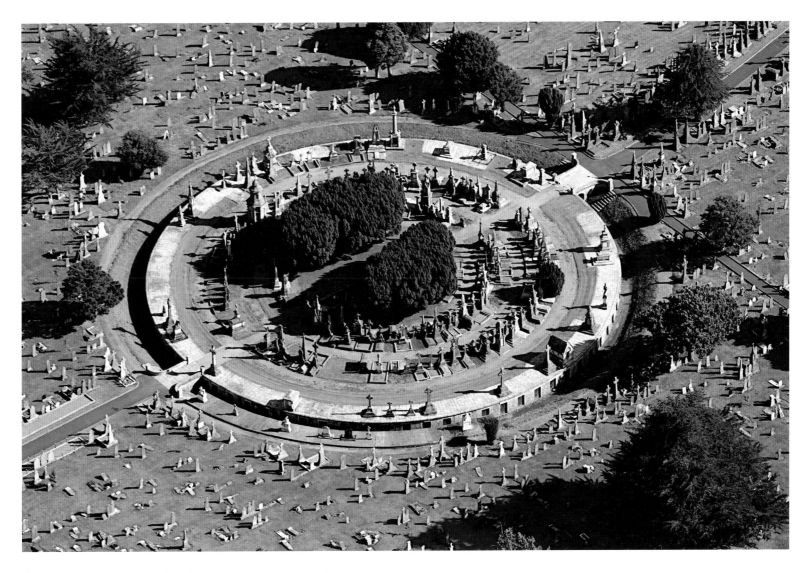

The O'Connell Circle, Glasnevin Cemetery, where
Daniel O'Connell, 'The Liberator', is interred.

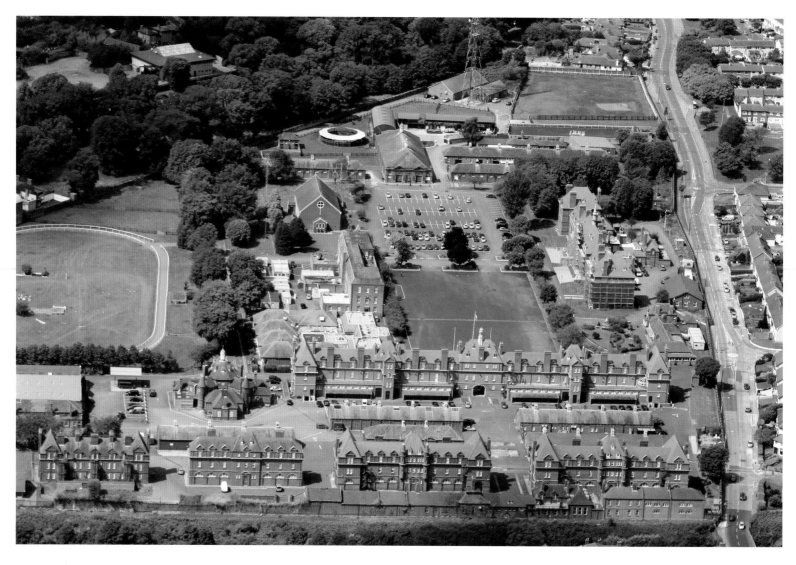

▲ McKee Barracks was built in 1888 and is now a base of the Irish Defence Forces.
It is also the home of the Army Equitation School.

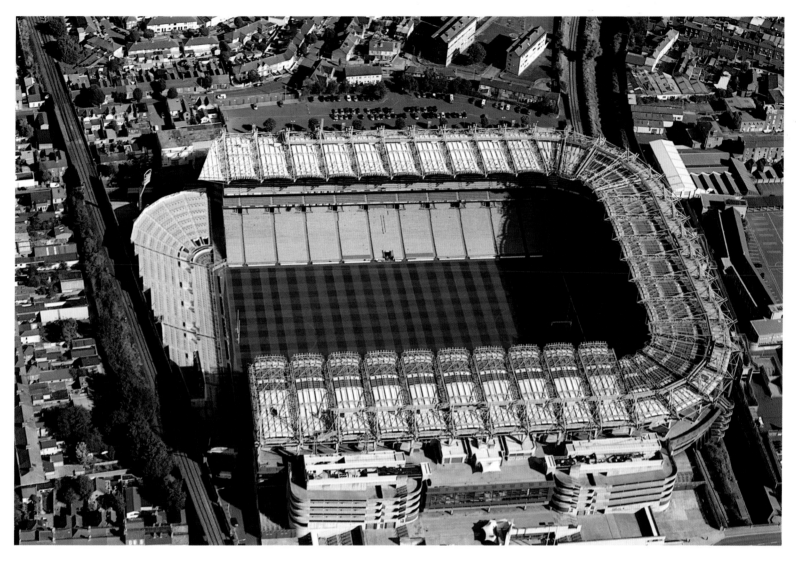

Croke Park is the headquarters of the Gaelic Athletic Association/ Cumann Lúthchleas Gael. With a capacity of 82,300, it is the third largest stadium in Europe.

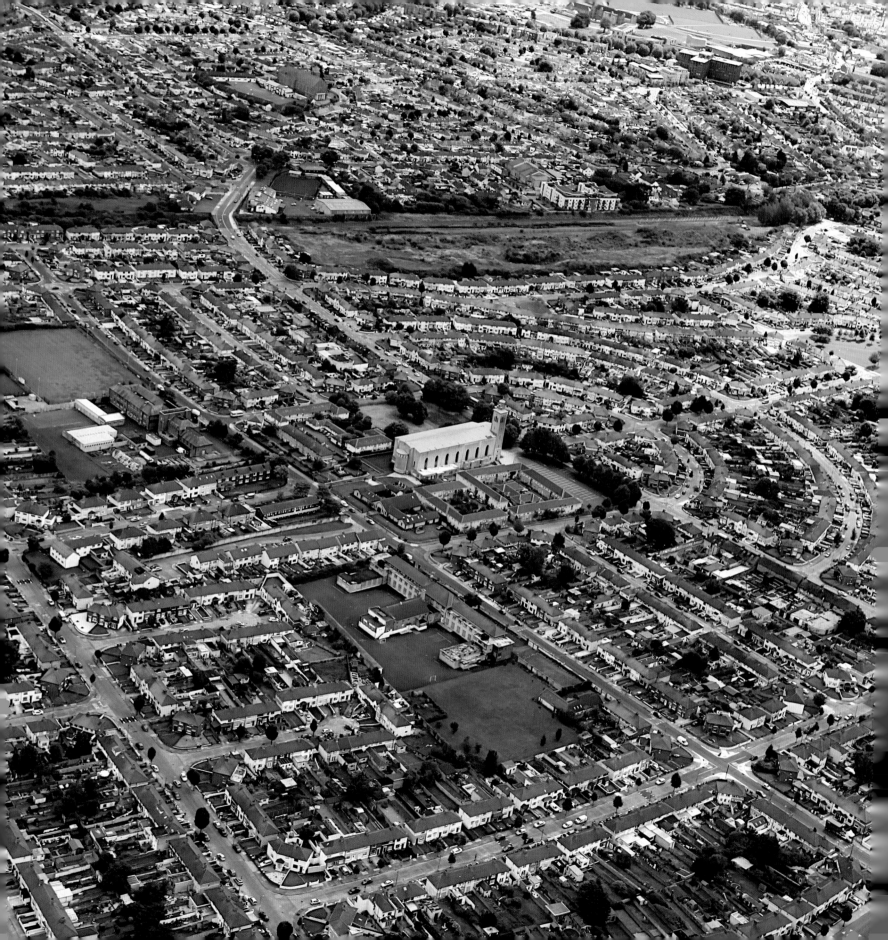

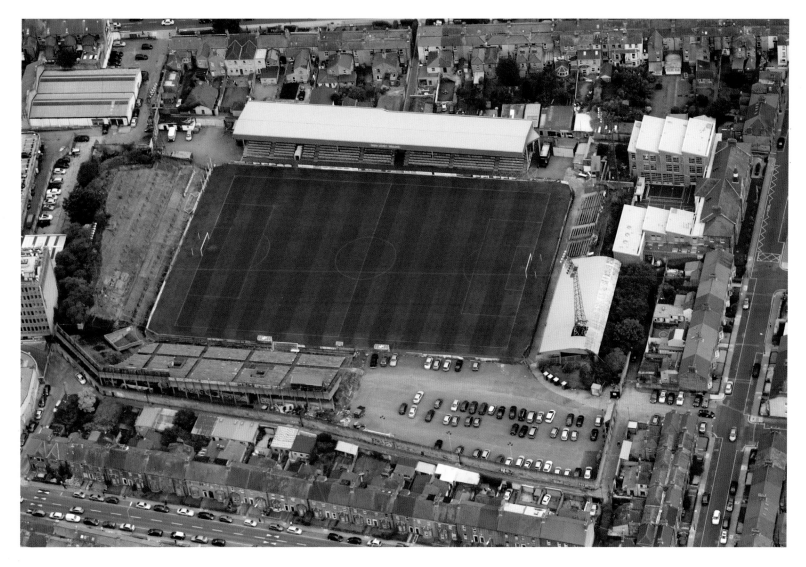

▲ Dalymount Park is the Phibsborough home of Bohemians FC, the oldest football club in Ireland, who have played soccer there since the early twentieth century.

◄ Cabra, one of west Dublin's earliest suburban housing developments, was begun in the 1920s.

Grangegorman Hospital is a former asylum with a mixture of Georgian and Victorian buildings built in the 1800s. It is now being developed as the new campus for the Dublin Institute of Technology.

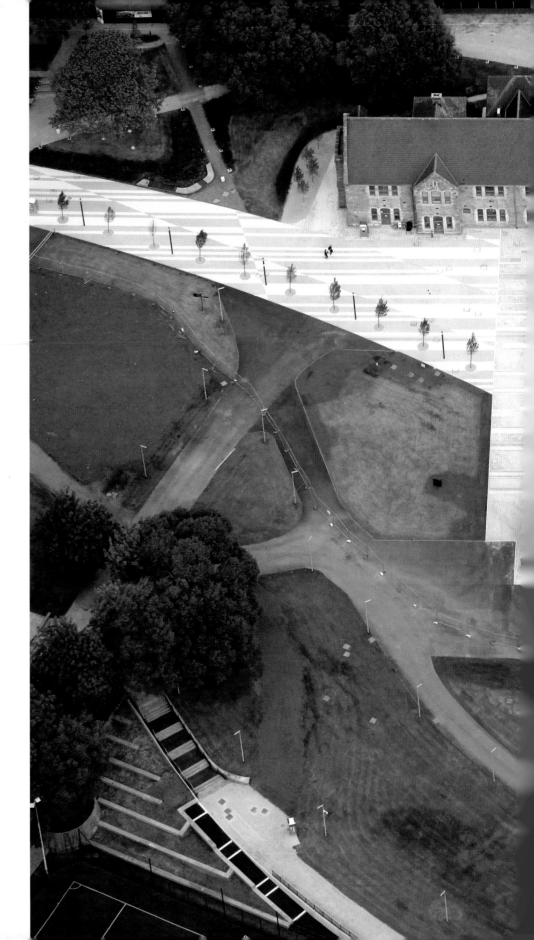

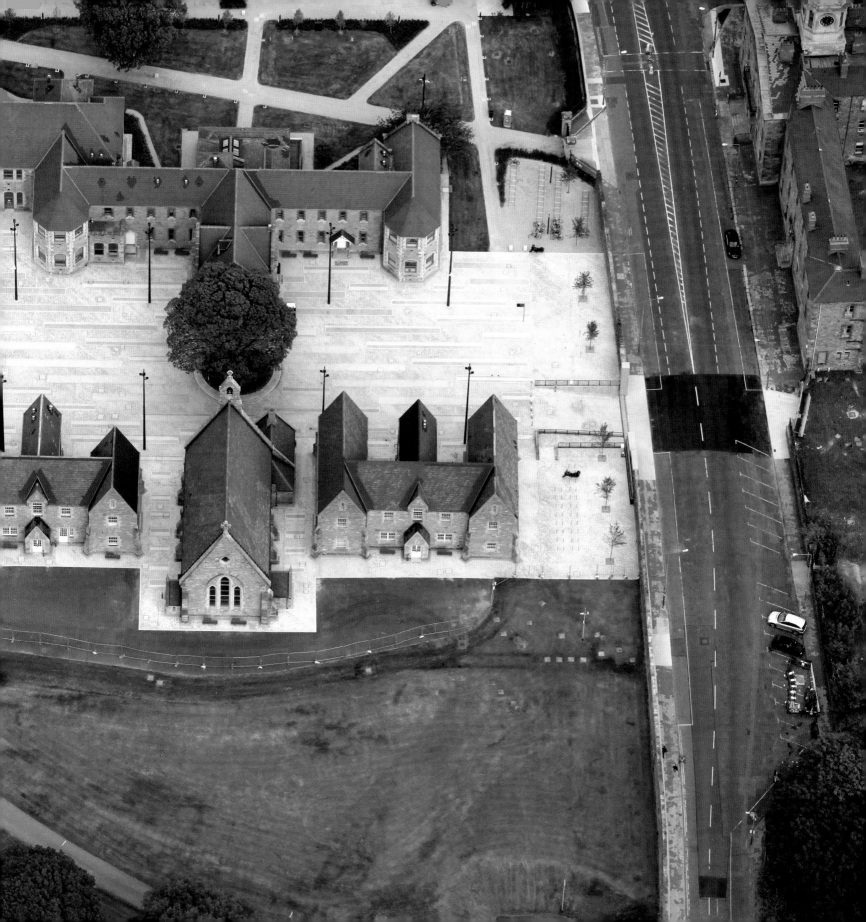

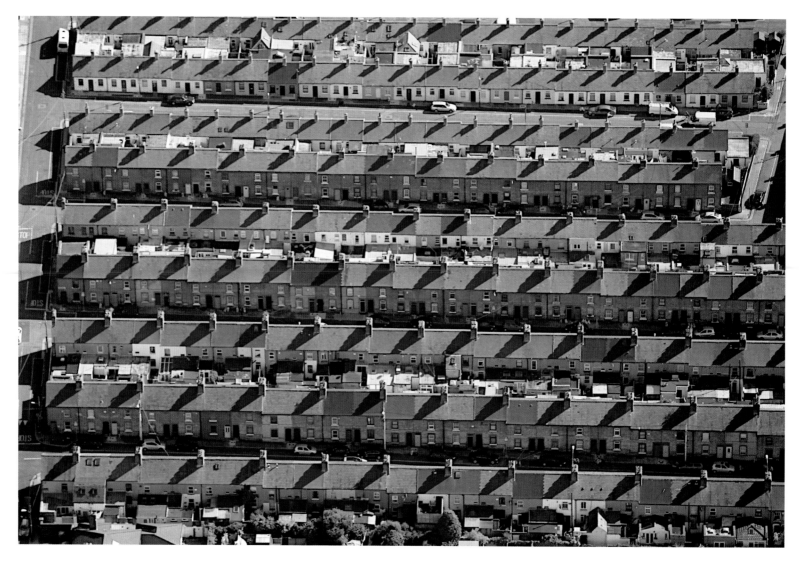

▲ These uniform lines of terraced houses in Arbour Hill create symmetrical street layouts.

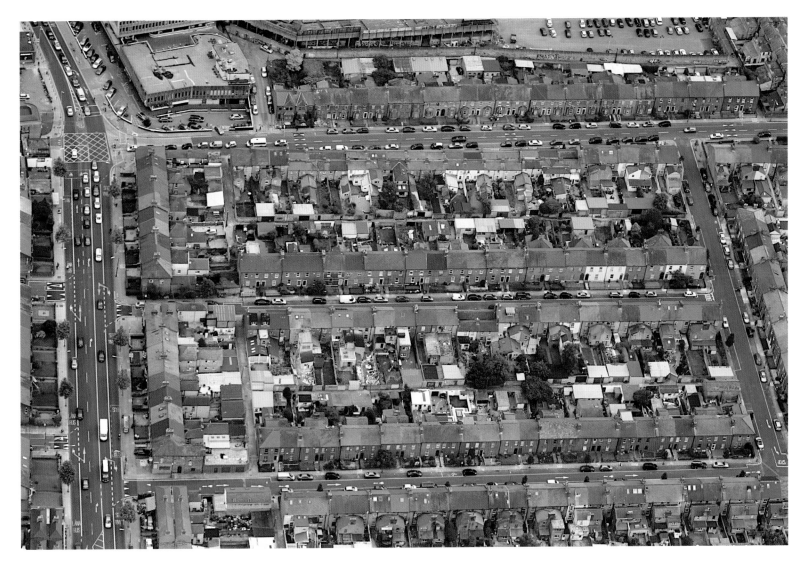

This group of houses off Phibsborough Road has four of its streets named after the provinces of Ireland: Munster, Leinster, Connaught and Ulster.

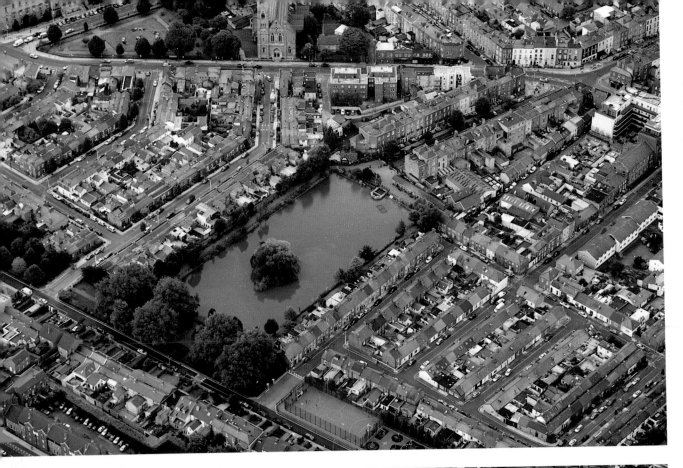

Blessington Street Basin, Phibsborough, was built to provide a clean water supply to the north side of Dublin. It was opened in 1810 and officially named the Royal George Reservoir. It is now a public park.

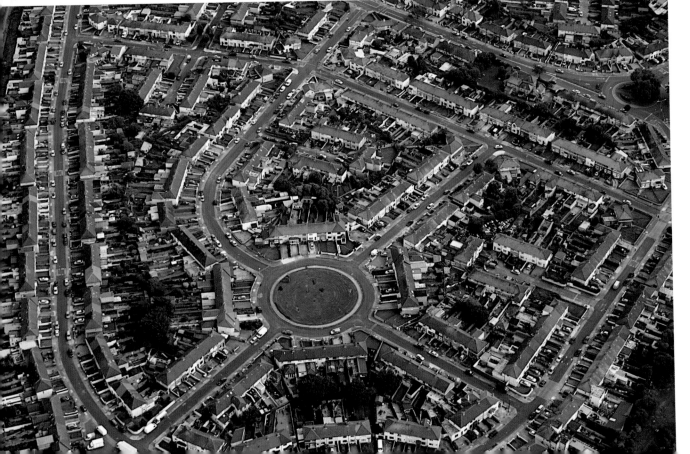

With a circular green at their centre these suburban streets in Cabra have a maze-like appearance from this perspective.

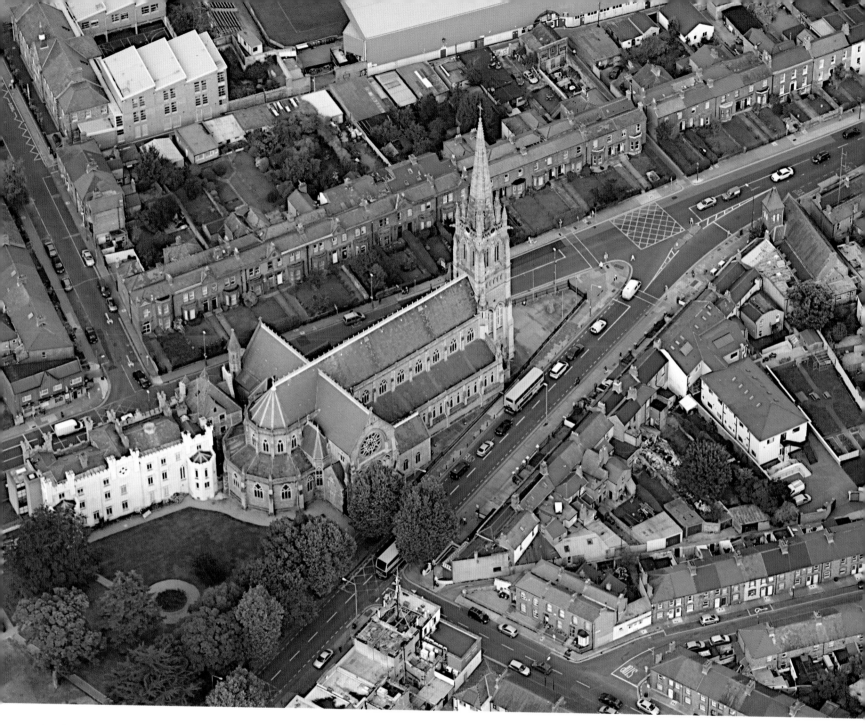

▲ St Peter's Church in Phibsborough was built in the late 1800s. It is noted for its windows, which were created by renowned Dublin stained-glass artist Harry Clarke.

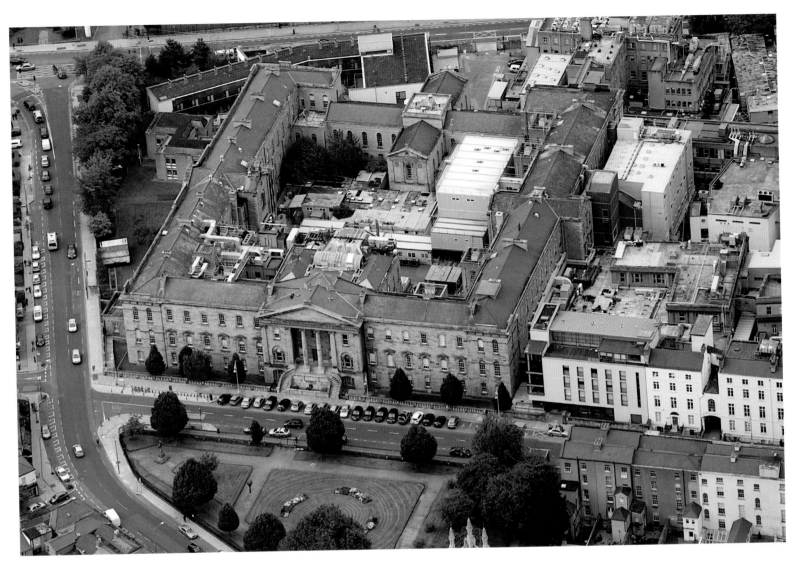

The Mater is a major teaching hospital in Phibsborough. It was founded by the Sisters of Mercy order in 1861.

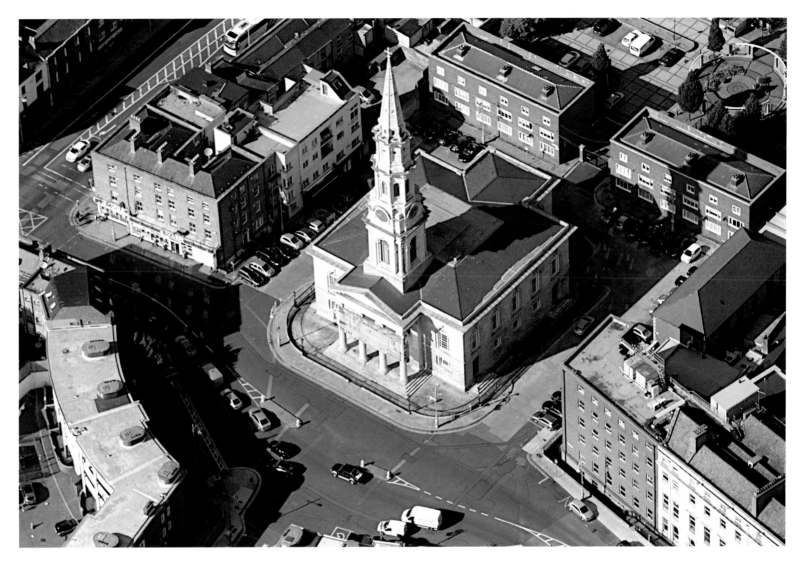

▲ St George's Church in Temple Street with its elegant spire is a well-known landmark in the inner city. It closed as a church many years ago and was acquired for office use in 2004.

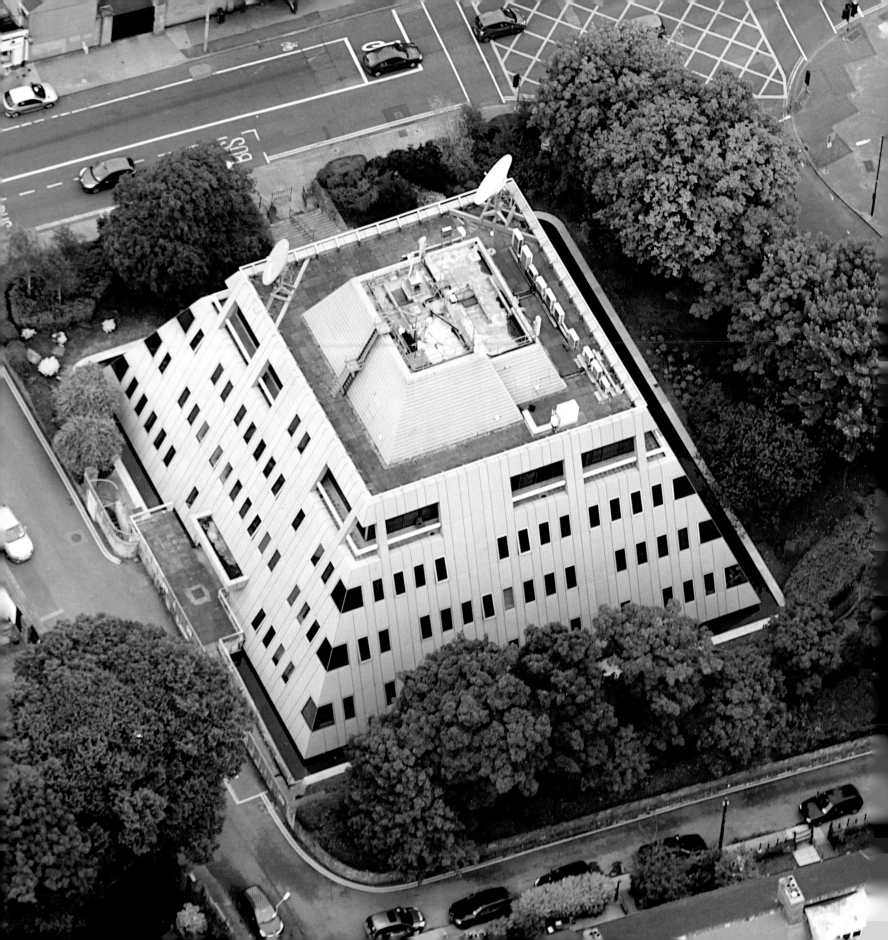

The Met Éireann building in Glasnevin is the headquarters of the national meteorological service. Its unusual pyramid shape and many windows give it the best possible view of the sky.

Extending to 707 hectares, the Phoenix Park is one of the largest enclosed recreational spaces in any European capital city. It was established in 1662 and is noted for its herds of deer.

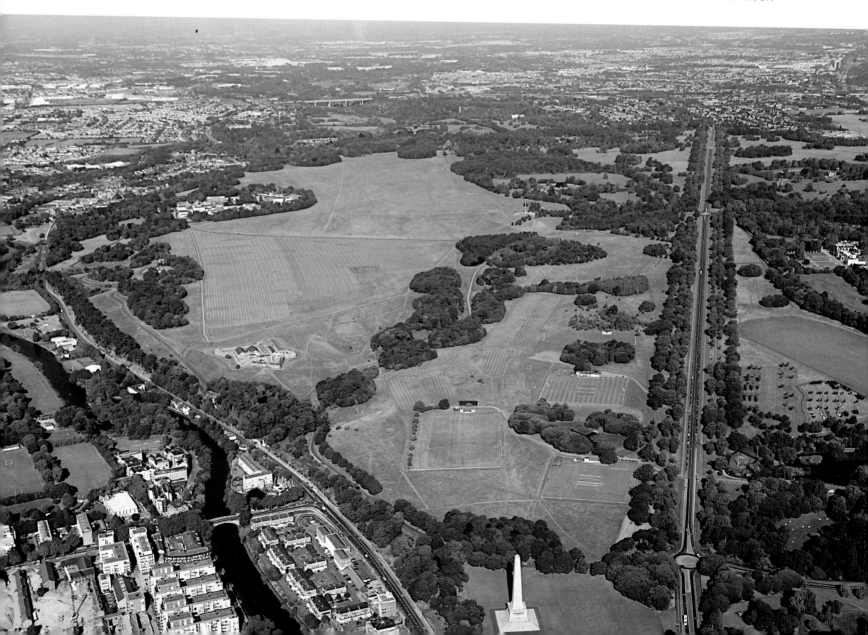

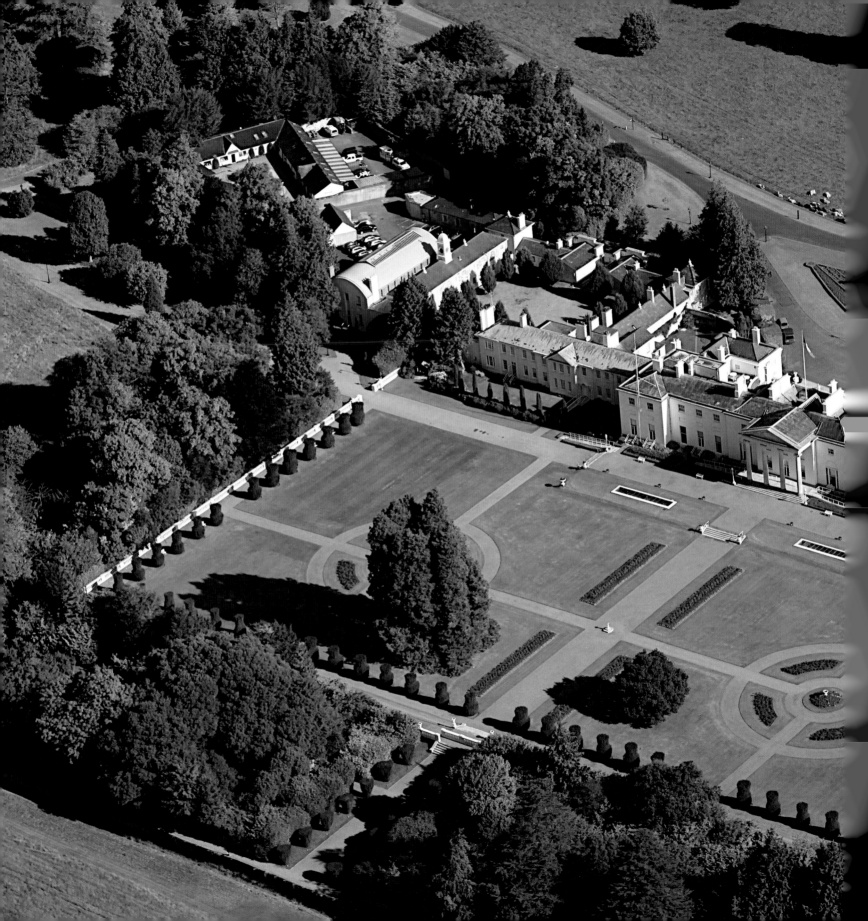

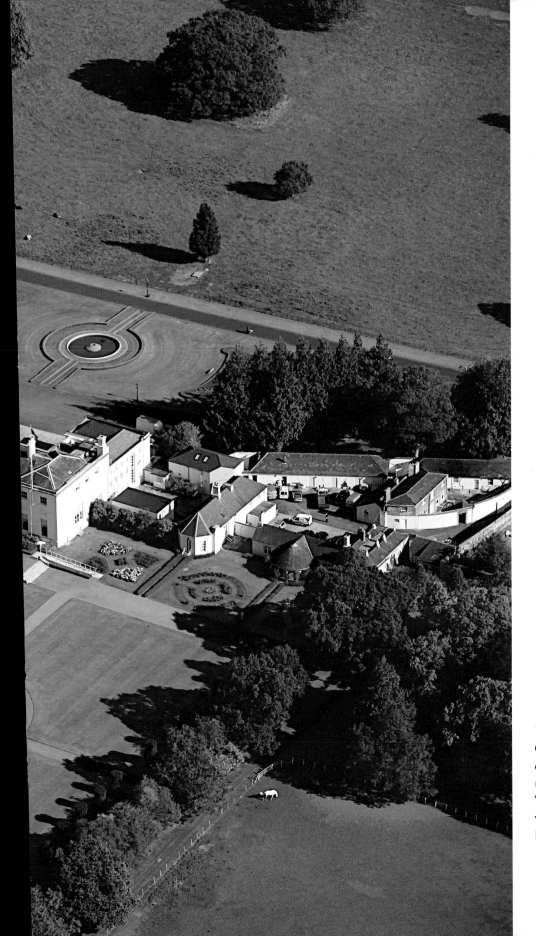

Completed in 1751, Áras an Uachtaráin is the official residence of the President of Ireland (Uachtarán na hÉireann) and formerly the Viceregal Lodge. The building has welcomed world leaders, including John F. Kennedy, Barack Obama and Queen Elizabeth II.

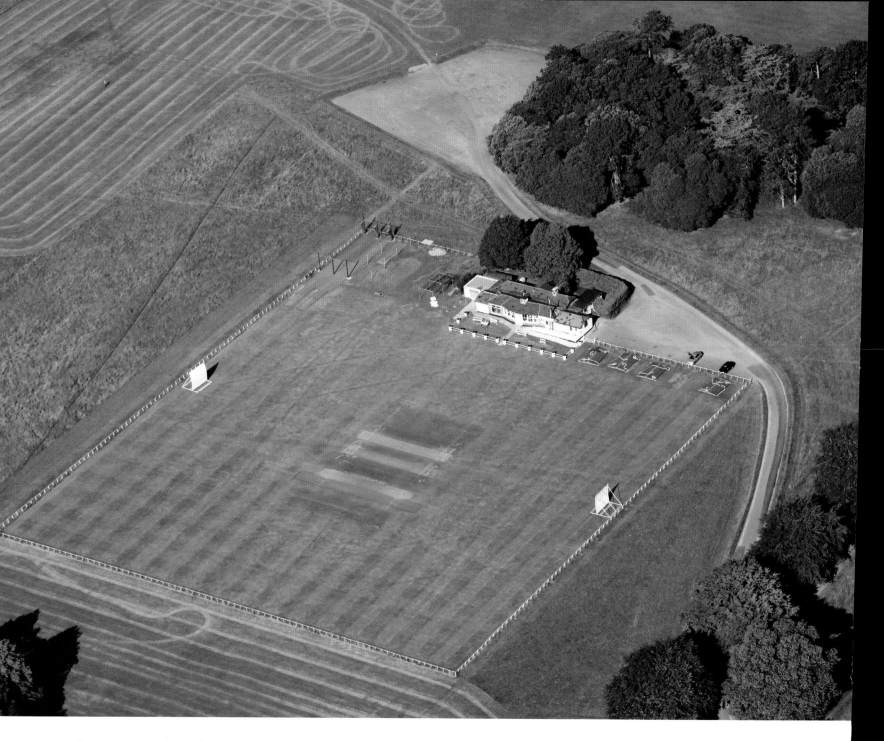

Cricket Grounds in the Phoenix Park. The Phoenix Cricket Club was established in 1830 and is one of the oldest cricket clubs on the island.

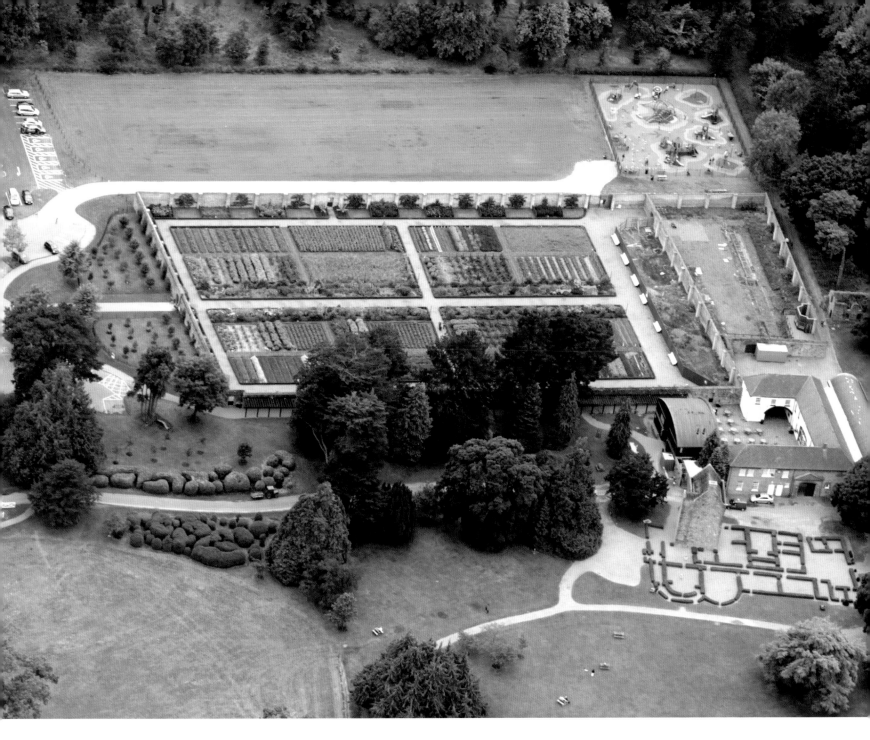

▲ The beautifully maintained gardens of Ashtown Castle, a fully
restored fortified tower house in the grounds of the Phoenix Park.

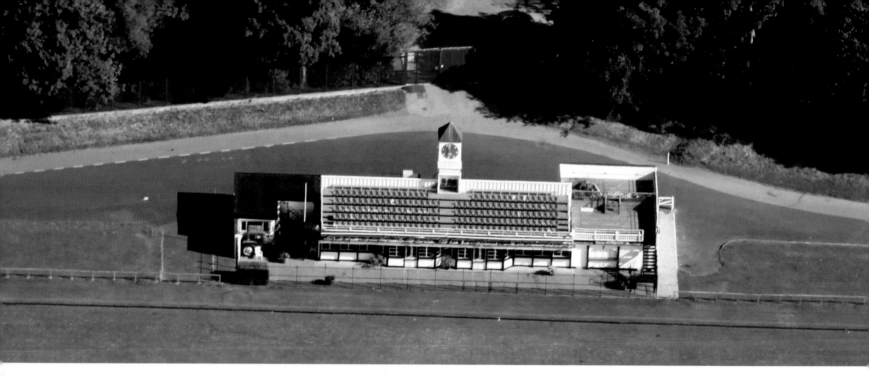

This Victorian-style polo pavilion is built on the 'Nine Acres' in Phoenix Park and is the focal point of games played on most weekends.

The polo grounds in Phoenix Park were established in the mid-1800s.

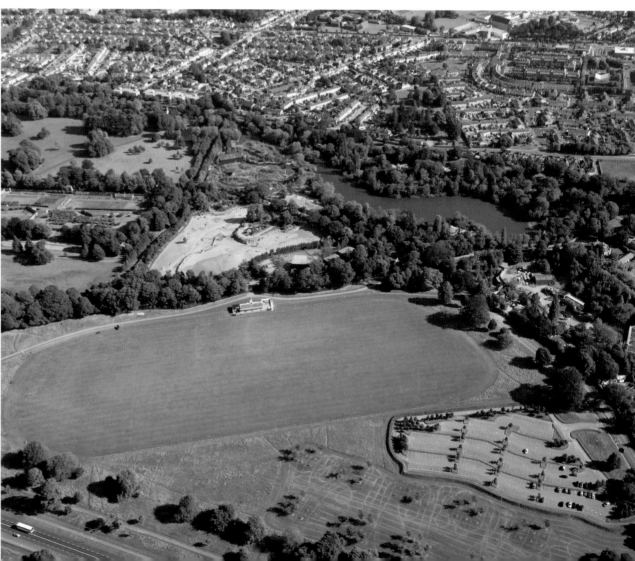

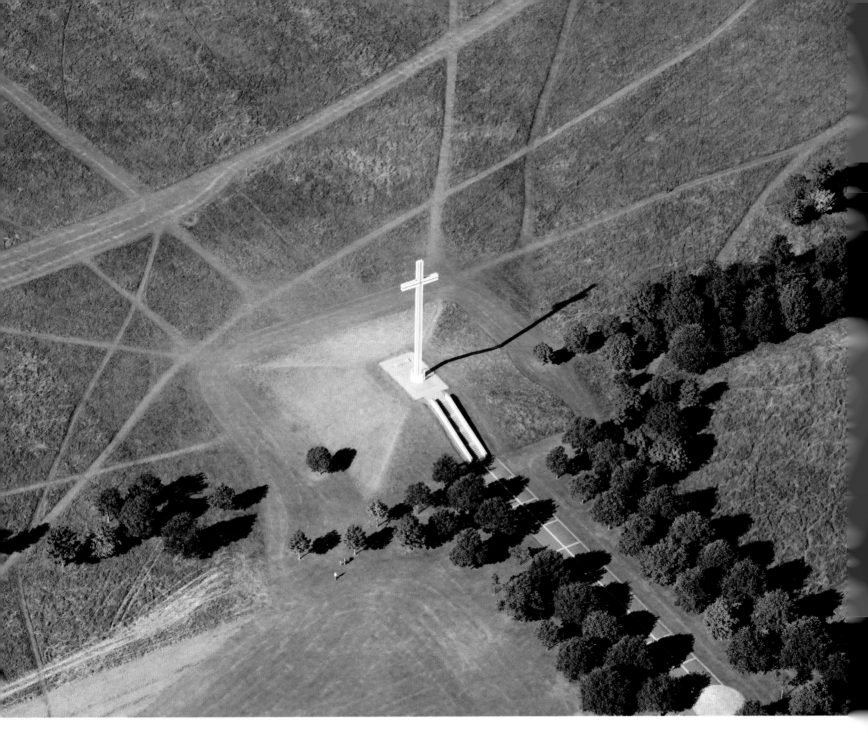

The Papal Cross in Phoenix Park was erected for the visit of Pope John
Paul II to Ireland in 1979.

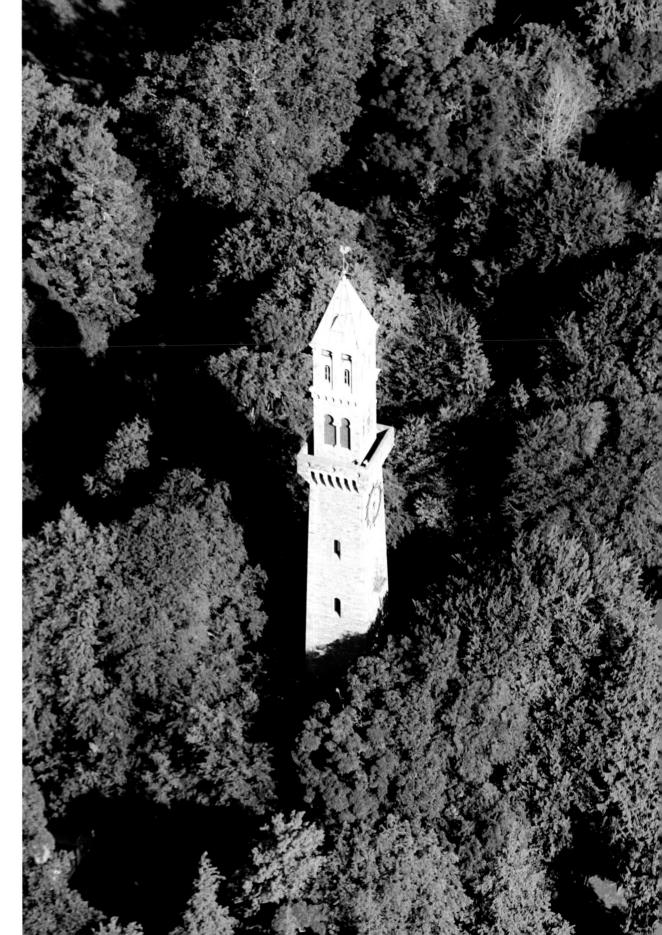

Guinness Clock Tower
at Farmleigh House,
originally designed as
a water tower for the
Guinness family.

54

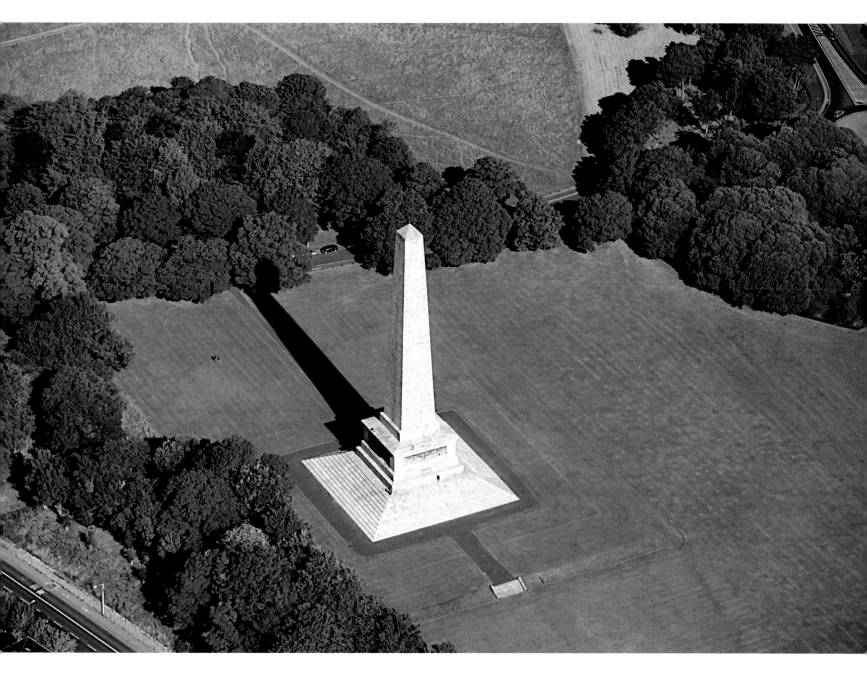

The Wellington Testimonial in Phoenix Park, at 62 metres/203 feet high, is the tallest obelisk in Europe. It was begun in 1817 but not completed until 1861.

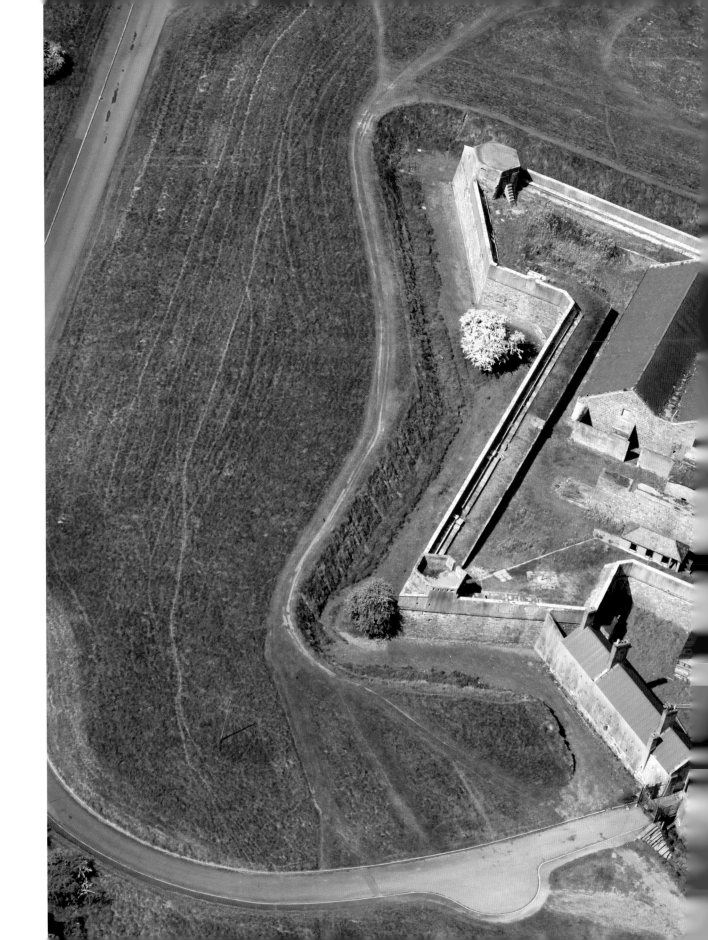

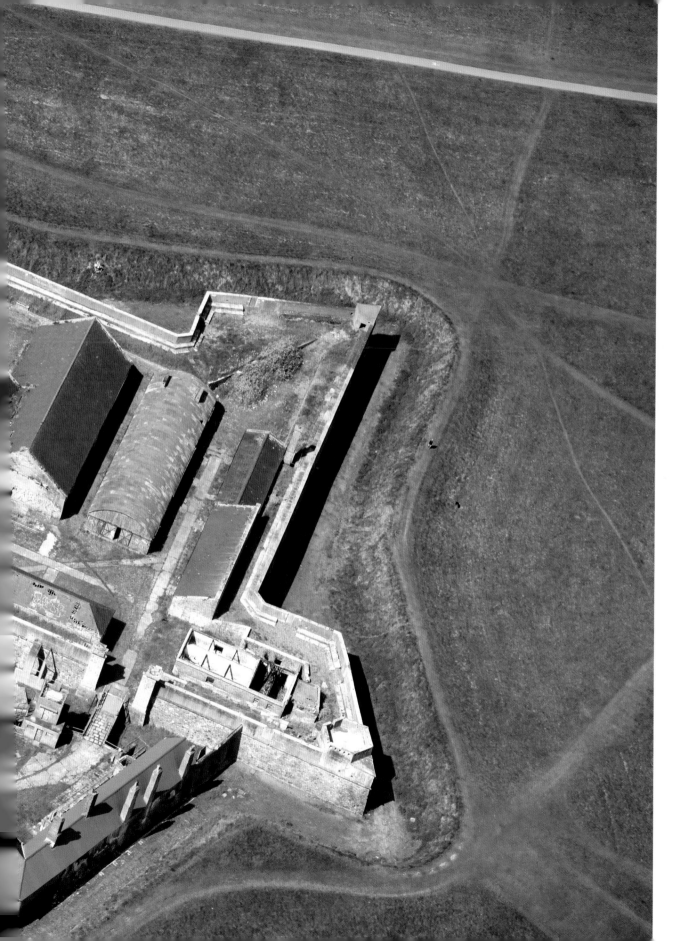

The Dublin Magazine Fort in Phoenix Park was built in the mid-1730s and used by the British Army to store stocks of guns and ammunition. The magazine was captured by the Irish Volunteers during the 1916 Rising.

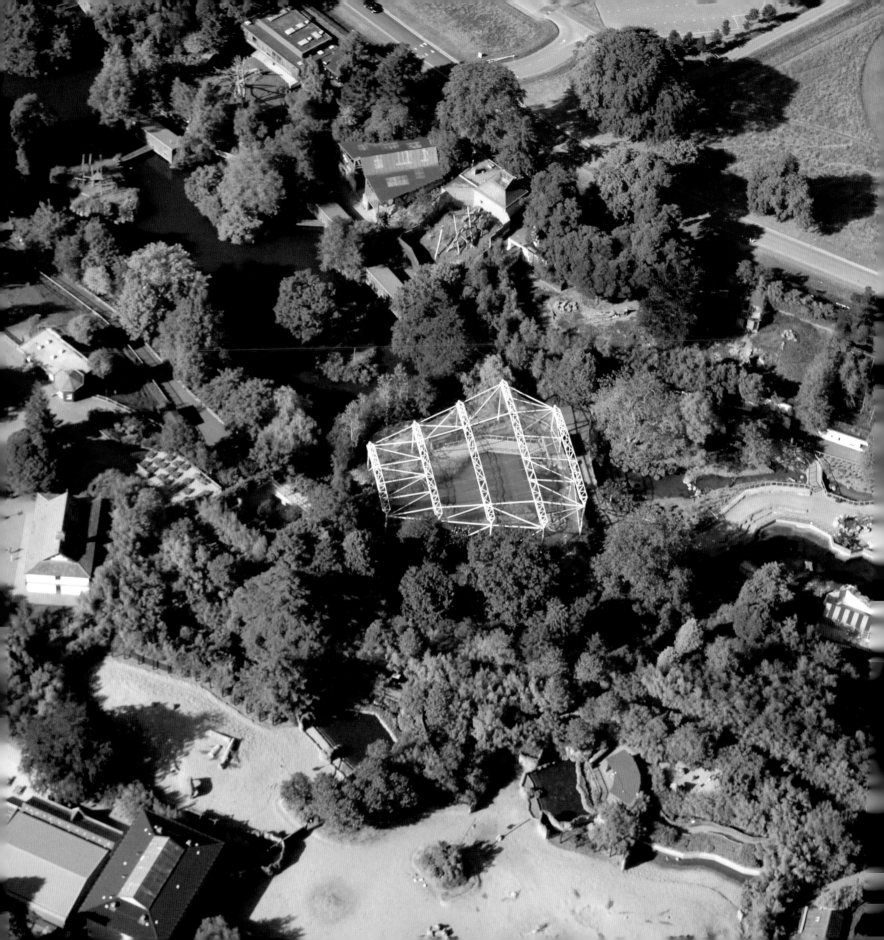

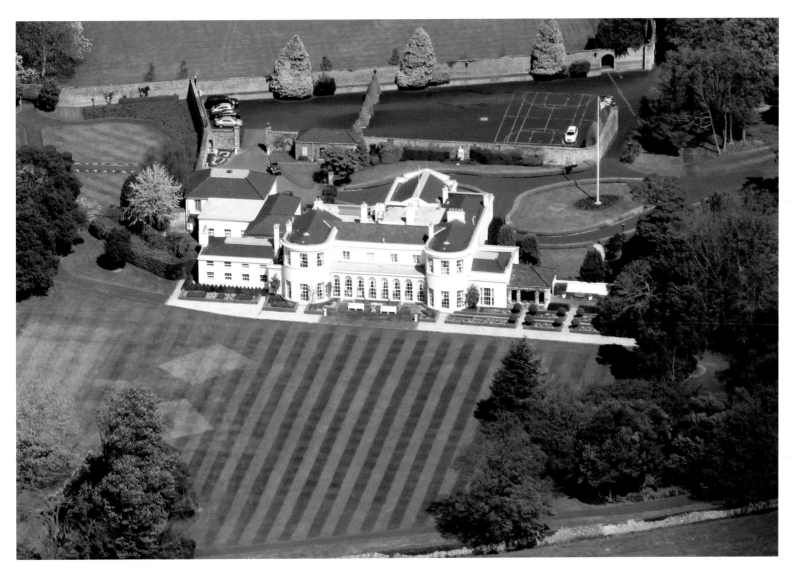

Deerfield, Phoenix Park. Constructed in the Georgian style by Sir John Blaquiere, then Surveyor General, the former Chief Secretary's Lodge has, since 1927, been the residence of the US ambassador to Ireland.

Dublin Zoological Gardens in the grounds of the Phoenix Park opened to the public in 1831 and is one of Dublin's most popular tourist attractions.

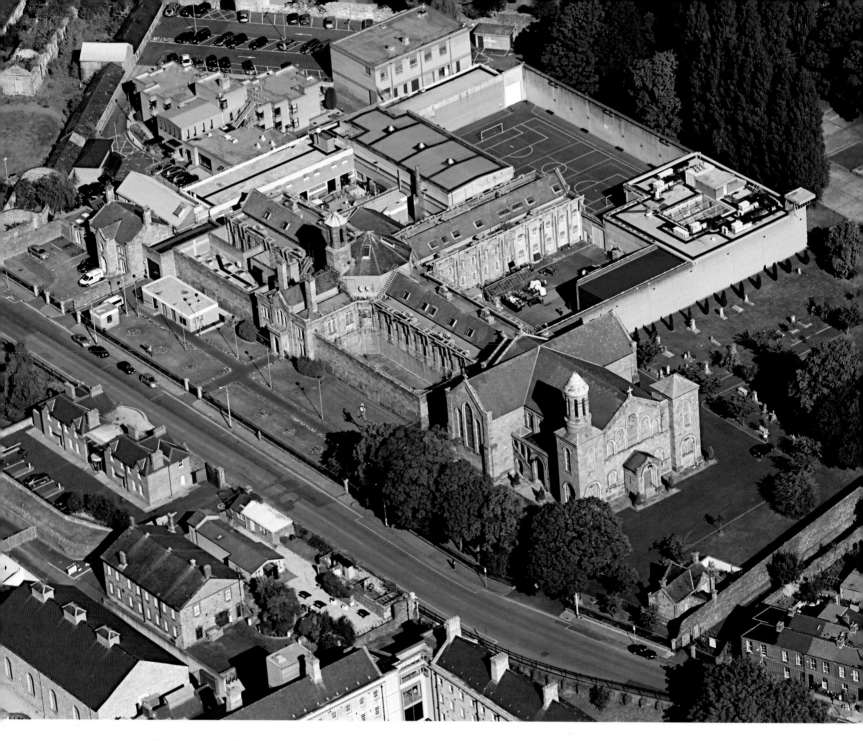

Arbour Hill Prison and the adjoining Church of the Sacred Heart, near the National Museum of Ireland, and Arbour Hill Cemetery where the bodies of patriots James Connolly and Patrick Pearse are interred.

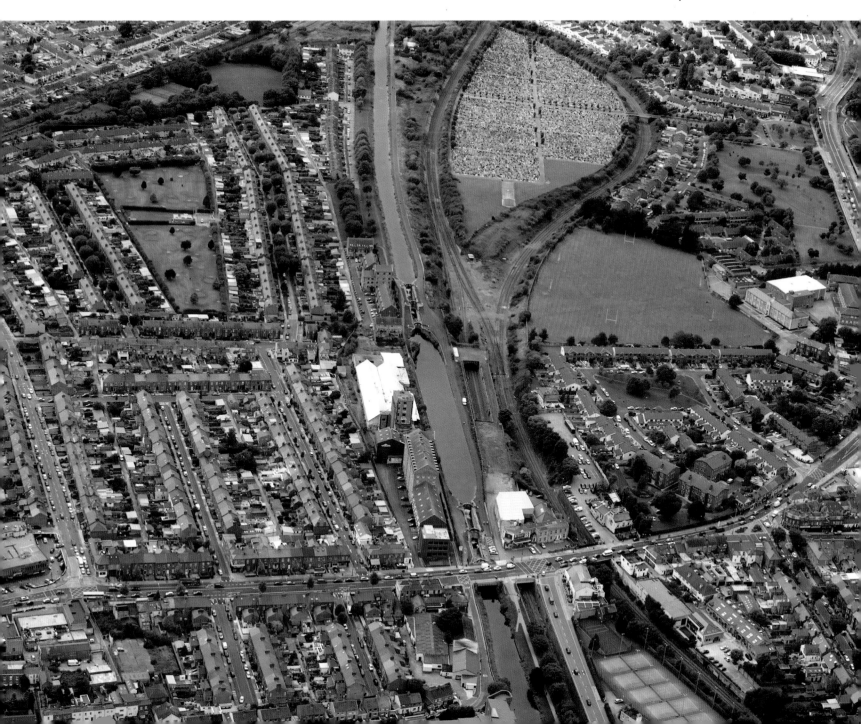

The Royal Canal Basin at Phibsborough. In bygone years the canal was used for freight and passenger transportation and was vital to the commercial life of the city.

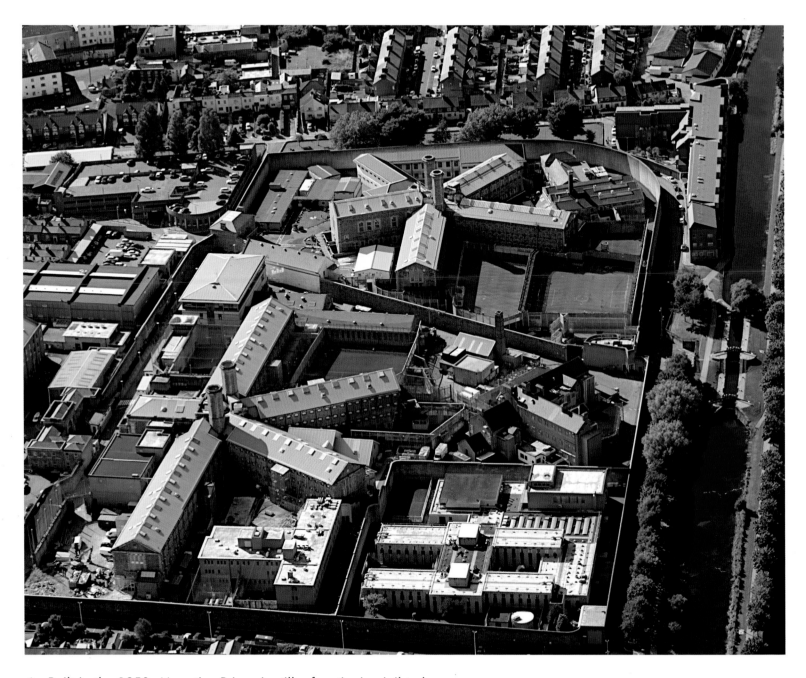

Built in the 1850s Mountjoy Prison is still a functioning jail today. The prison has a long history and some of the leaders involved in the Irish War of Independence and Civil War were held here.

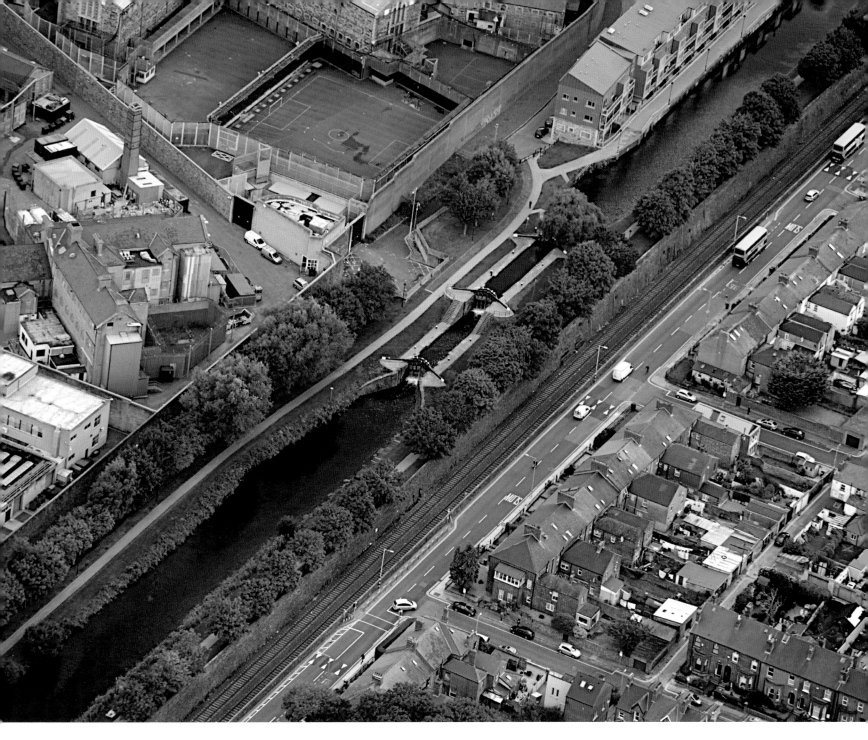

▲ This view shows the Royal Canal as it flows past the northern side of Mountjoy Jail.

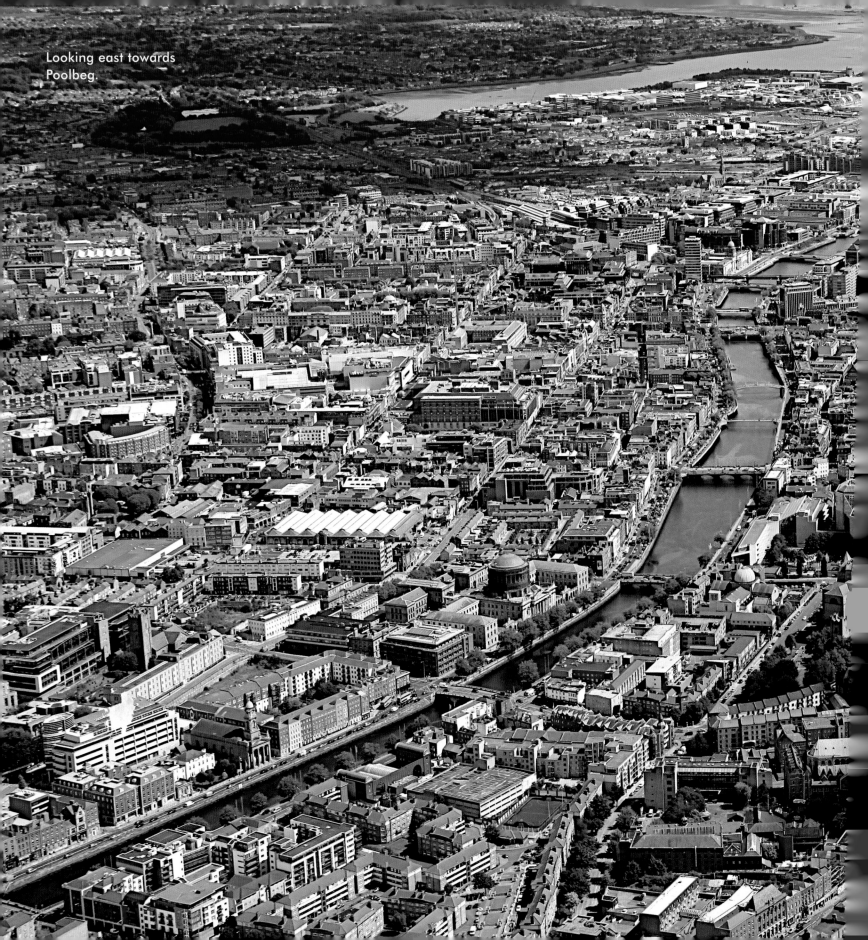

Looking east towards Poolbeg.

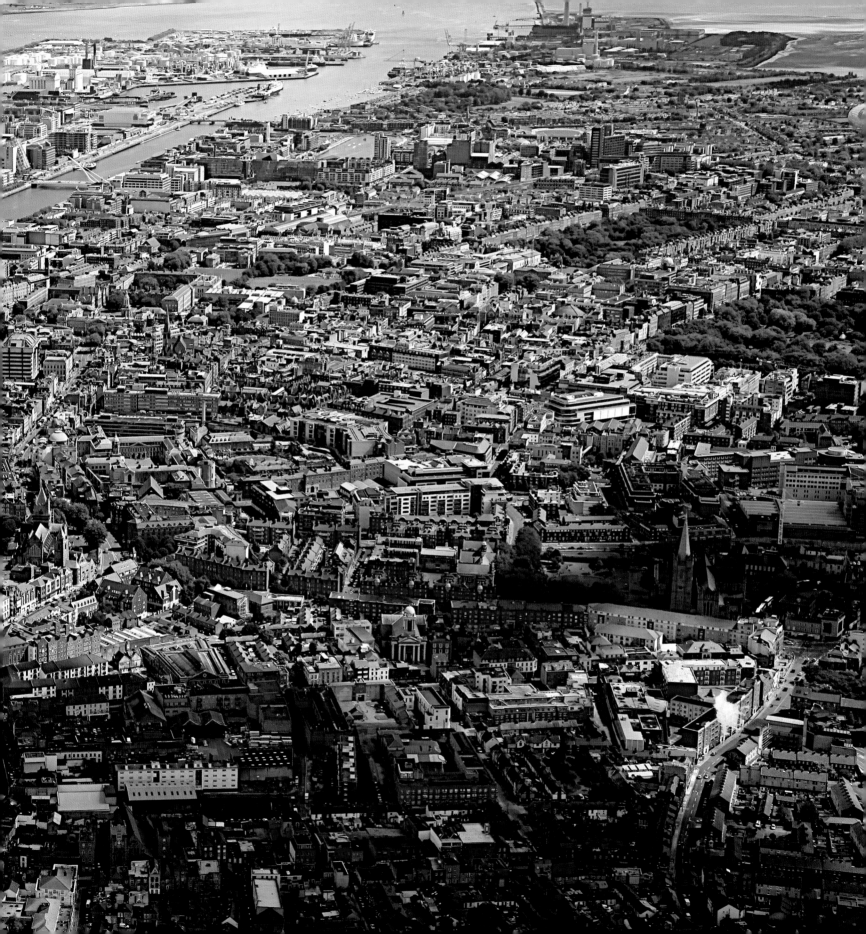

A mixture of old and new suburban housing at
Fairview Green.

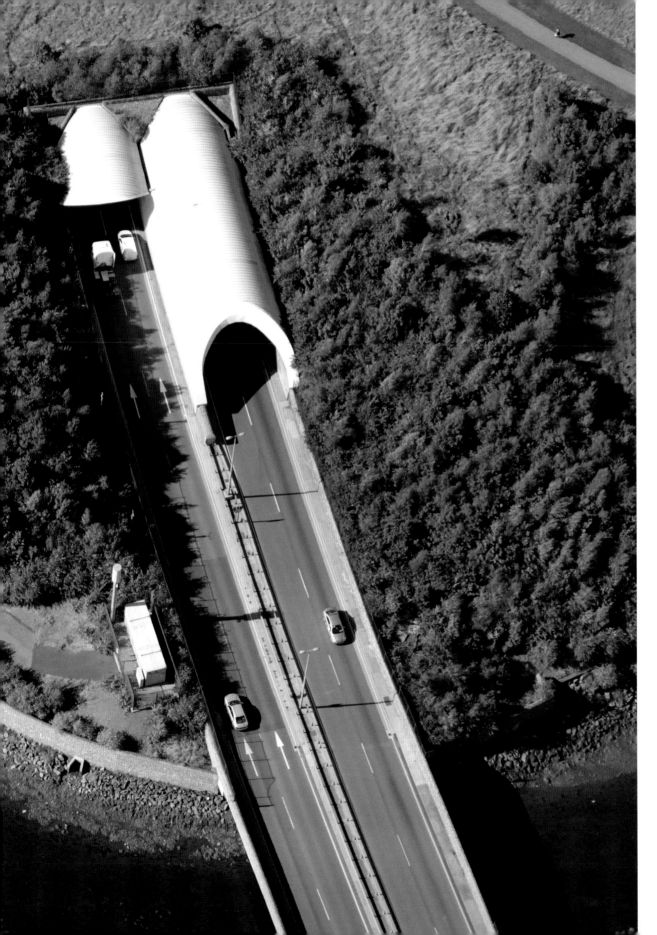

The Dublin Port
Tunnel is part of the
M50 motorway. The
4.5 km tunnel was
opened to traffic in
2006.

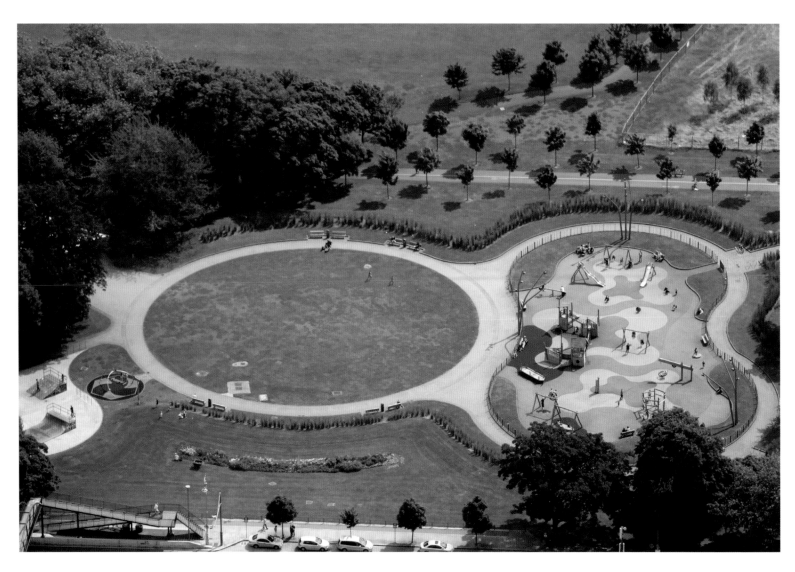

▲ Playgrounds make great aerial photographic subjects.
This one in Fairview Park with its intricate design and
bright colours is no exception.

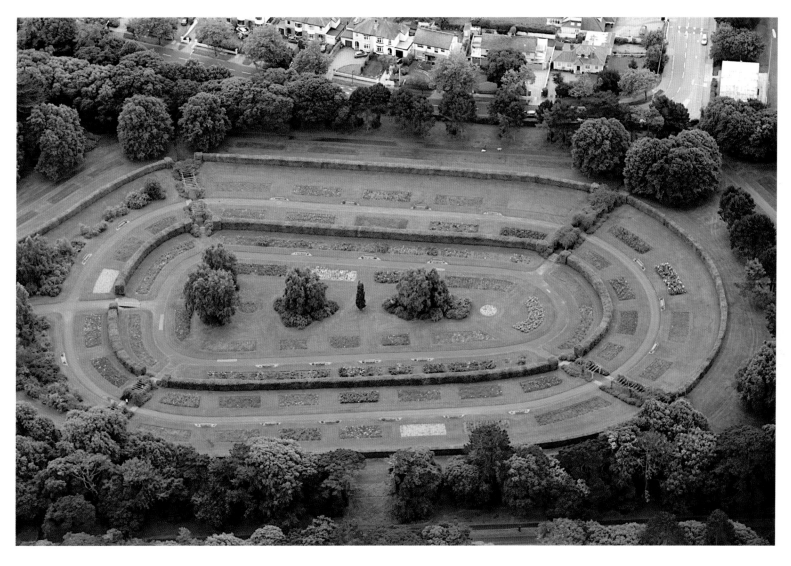

Saint Anne's Park is situated between Raheny and Clontarf. This image shows the wonderfully detailed layout of one of the gardens.

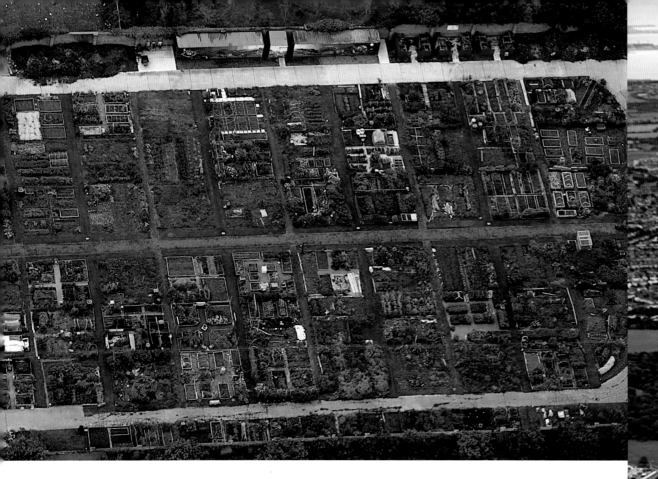

▲ Allotments in St Anne's Park, Raheny. There has been a resurgence in cultivating plots in recent years.

▶ An eastwards view of Bull Island, which is home to two fine golf links, a nature reserve and interpretive centre with Lambay Island (left) and Ireland's Eye (right) on the horizon.

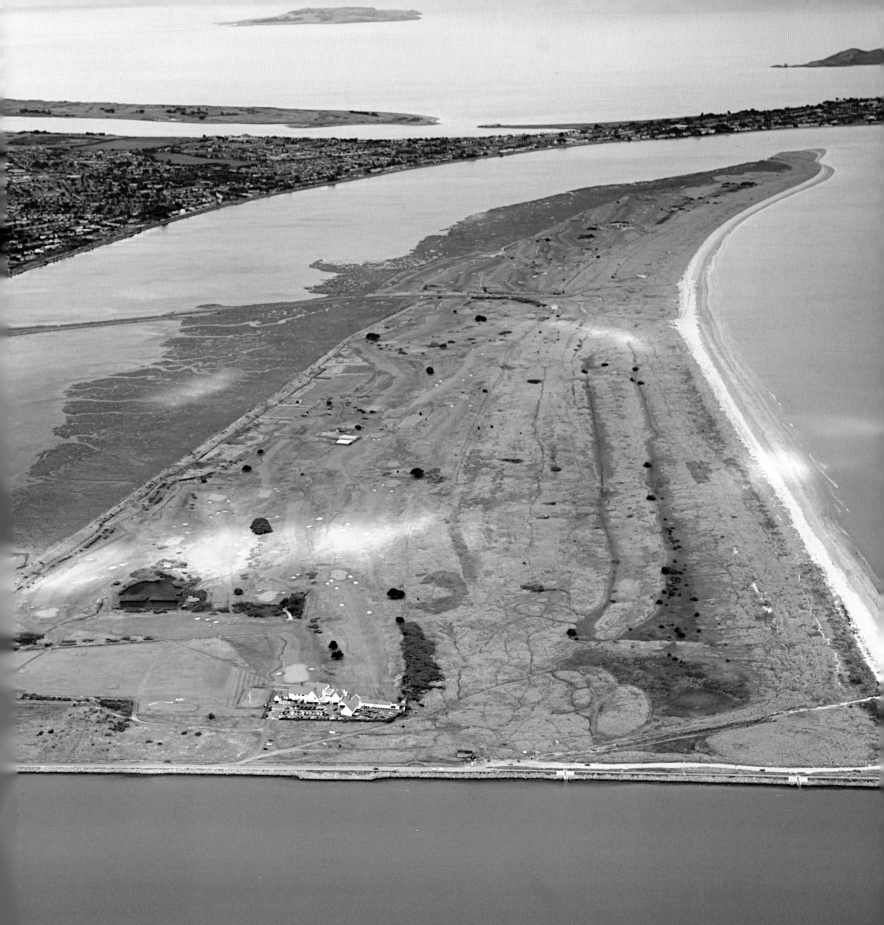

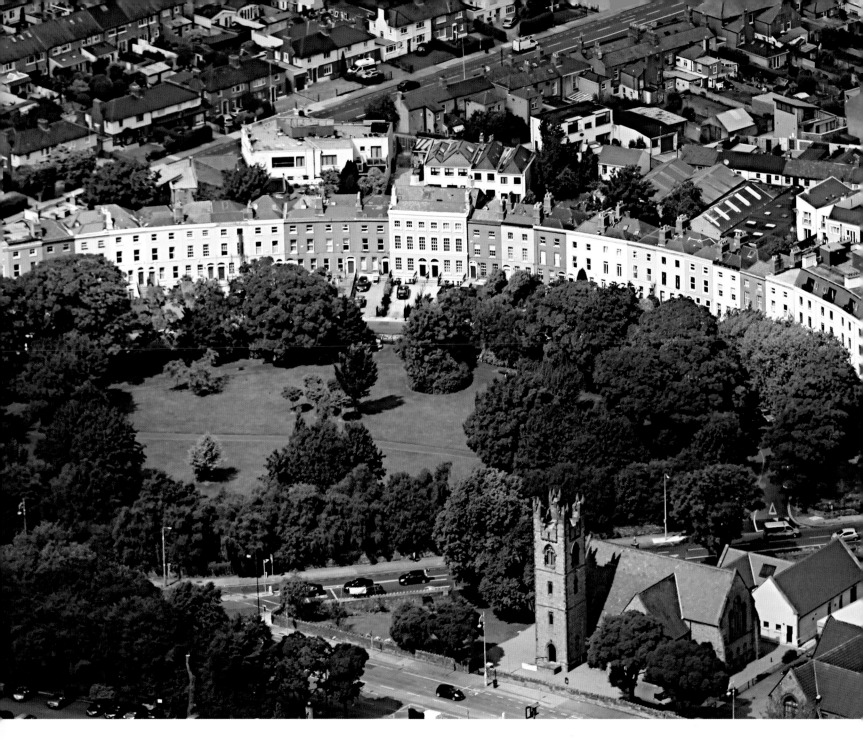

▲ Marino Crescent is a terrace of fine Georgian houses built in 1792. Its most famous resident was author Bram Stoker, the creator of *Dracula*, who was born here in 1847.

The Casino at Marino is considered to be one of the finest neoclassical buildings in Europe. Originally built for James Caulfield, First Earl of Charlemont, as a pleasure house, it was completed in 1775. It is now in State ownership.

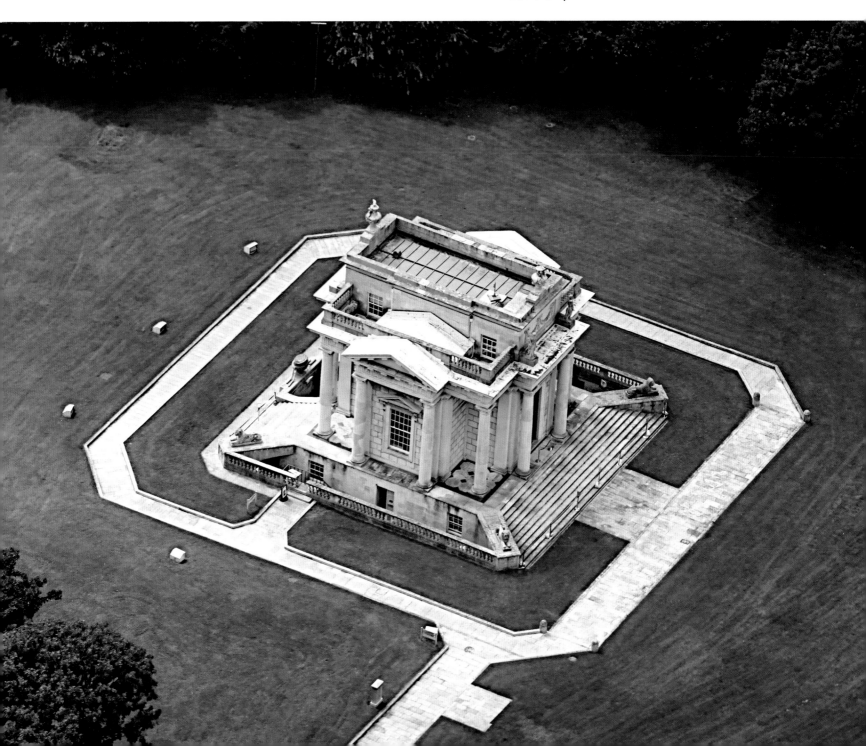

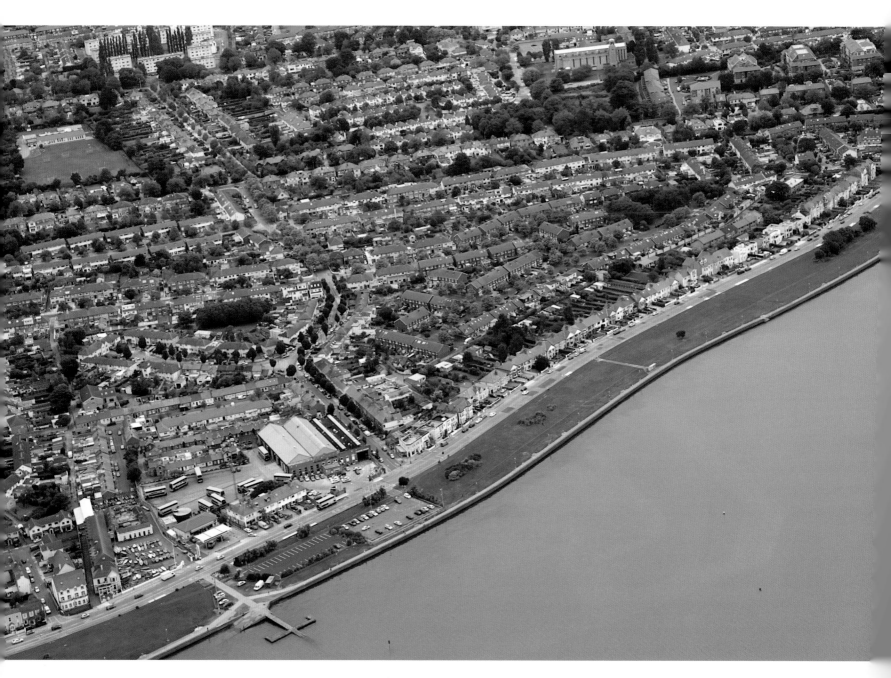

▲ The coastal town of Clontarf adjoins Fairview and Marino. It is most famous for the Battle of Clontarf in 1014 when Brian Boru, High King of Ireland, defeated the Vikings.

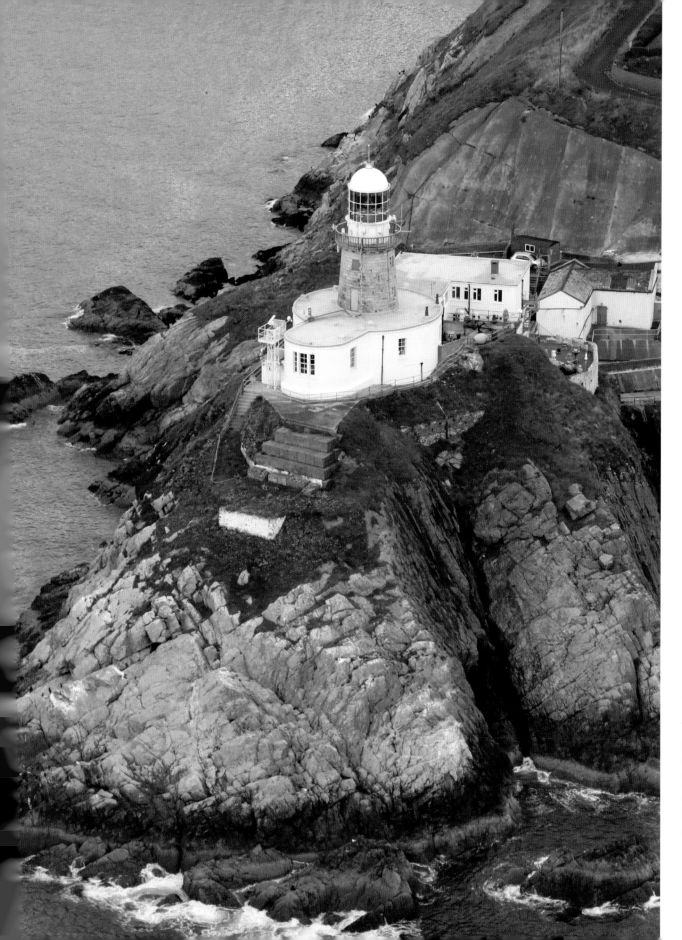

The Baily Lighthouse on Howth Head. Originally a cottage-type lighthouse, a style unique to Ireland, it was established in 1667.

75

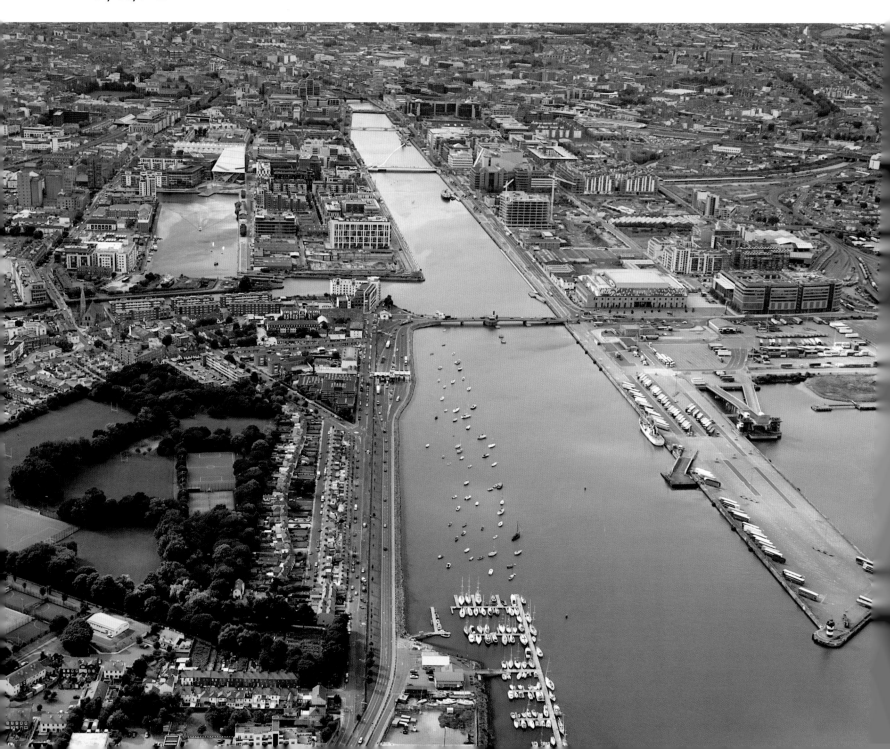

This view looks west from Ringsend yacht marina towards the East Link Bridge and the city beyond.

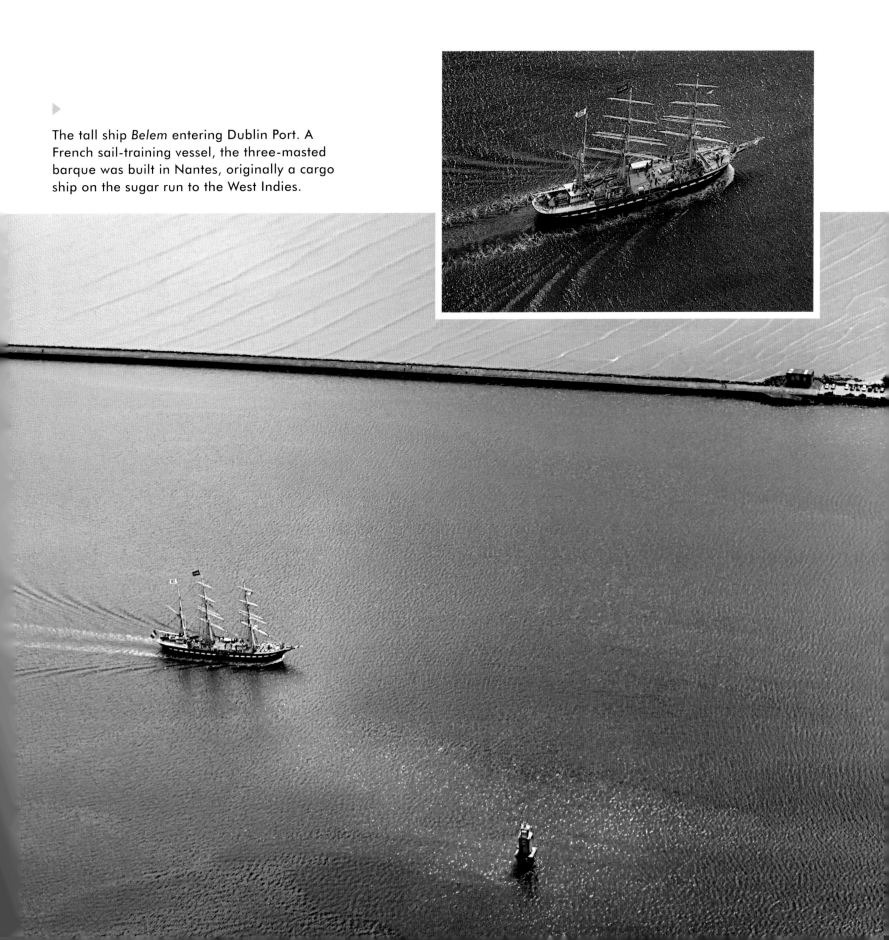

The tall ship *Belem* entering Dublin Port. A French sail-training vessel, the three-masted barque was built in Nantes, originally a cargo ship on the sugar run to the West Indies.

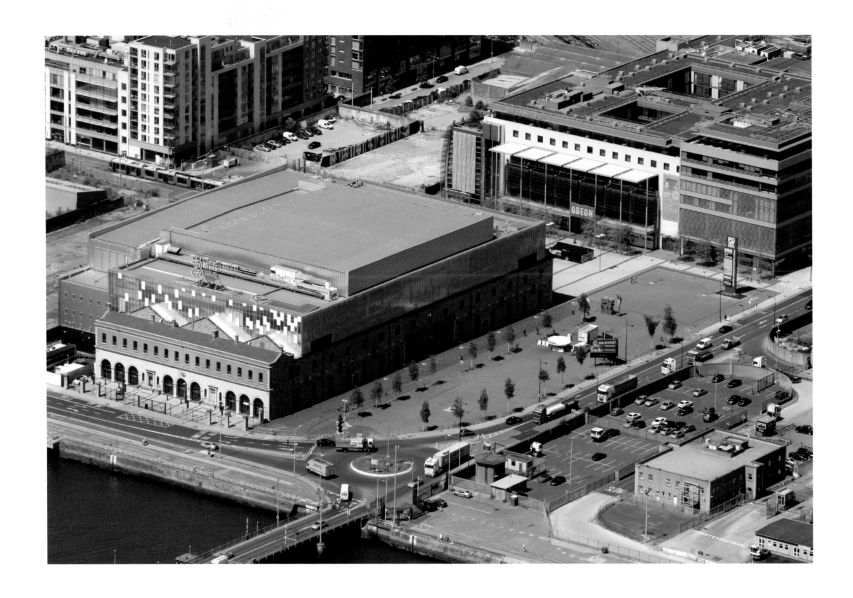

The 3 Arena (formerly The Point Depot) located at North Wall is a large entertainment venue which has hosted many top international acts. It is the largest indoor arena in Ireland.

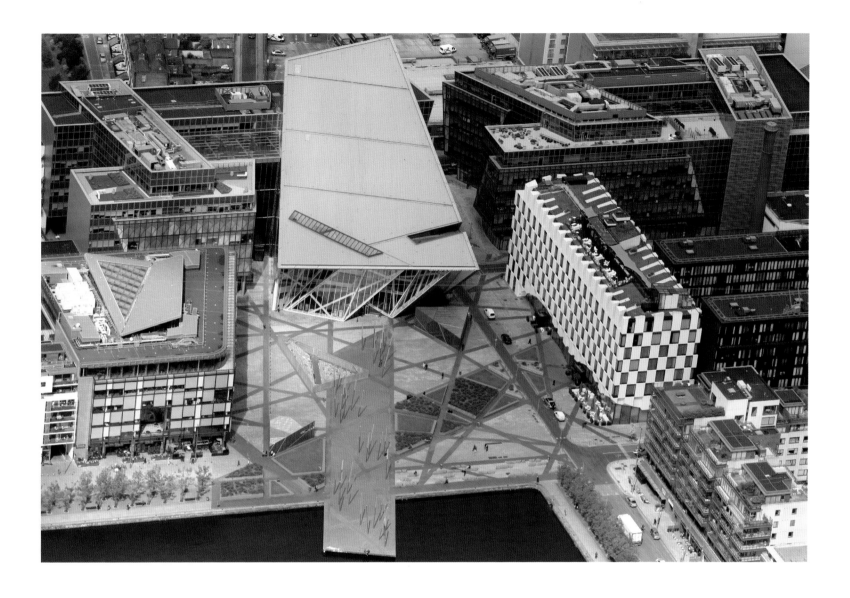

The Bord Gáis Energy Theatre, designed by world-renowned architect Daniel Libeskind. The venue hosts visiting ballet and opera companies, touring musicals and popular entertainment. The distinctive exterior of the Marker Hotel is to the right of the theatre in Grand Canal Square.

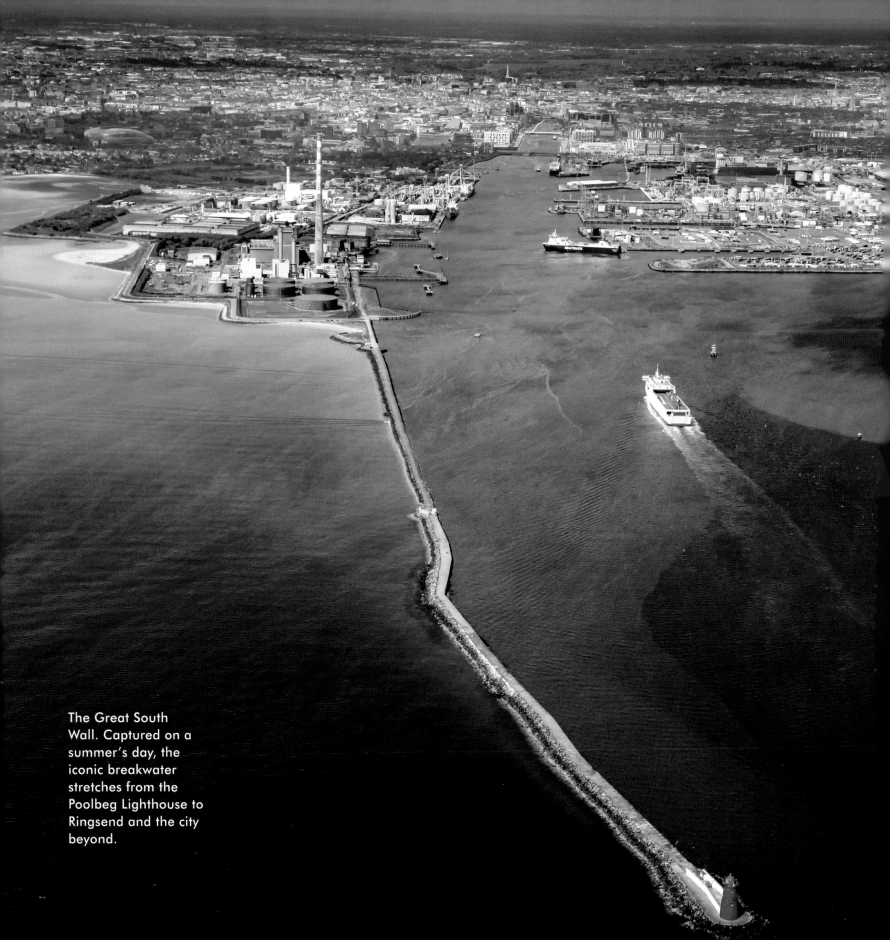

The Great South Wall. Captured on a summer's day, the iconic breakwater stretches from the Poolbeg Lighthouse to Ringsend and the city beyond.

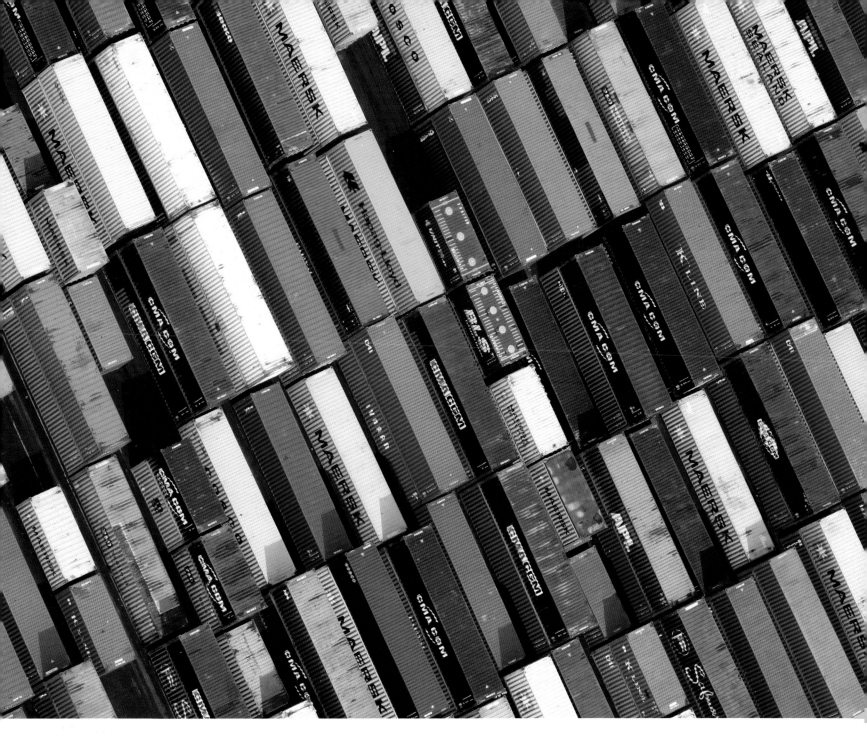

▲ Containers at Alexandra Quay. Dublin Port handles an ever increasing
volume of container traffic to and from Ireland and beyond.

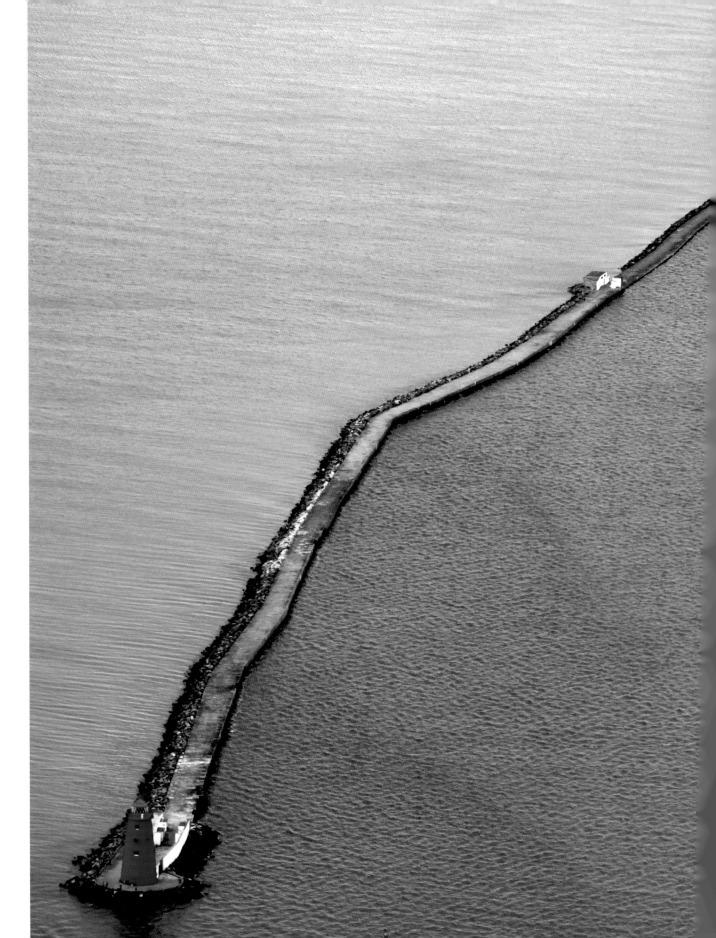

The Great South Wall (also called the South Bull Wall) extends all the way from Ringsend out to Poolbeg Lighthouse in Dublin Bay. Over 4 km in length, it is one of the longest sea walls in Europe.

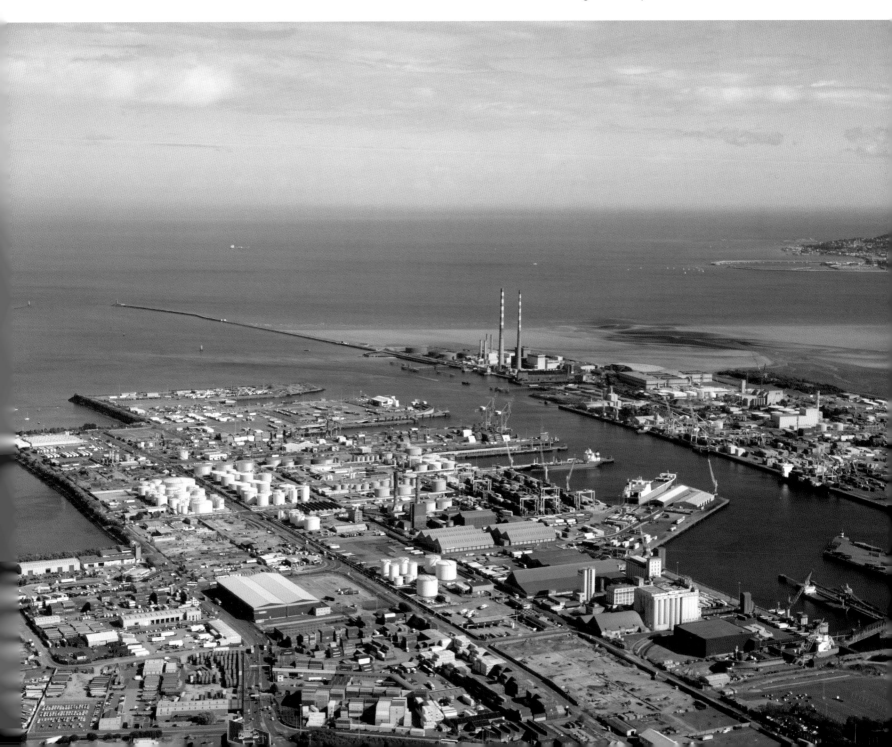

Dublin Port: the industrial heart of Dublin's docklands, looking east towards Ringsend and Dun Laoghaire beyond.

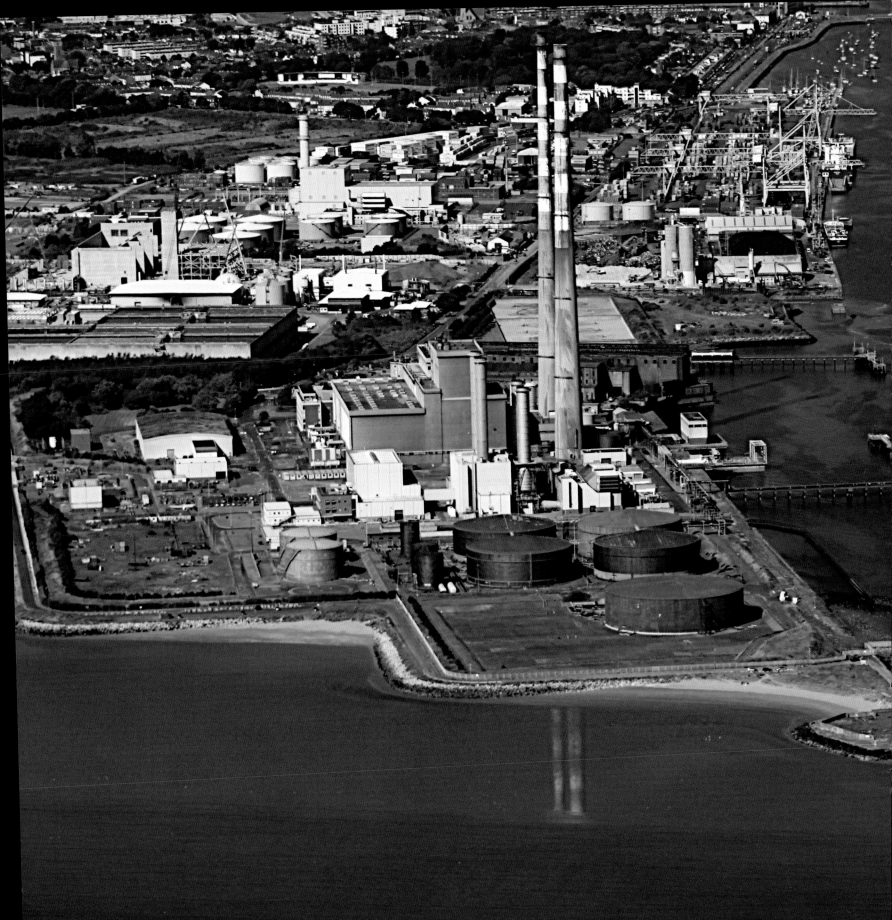

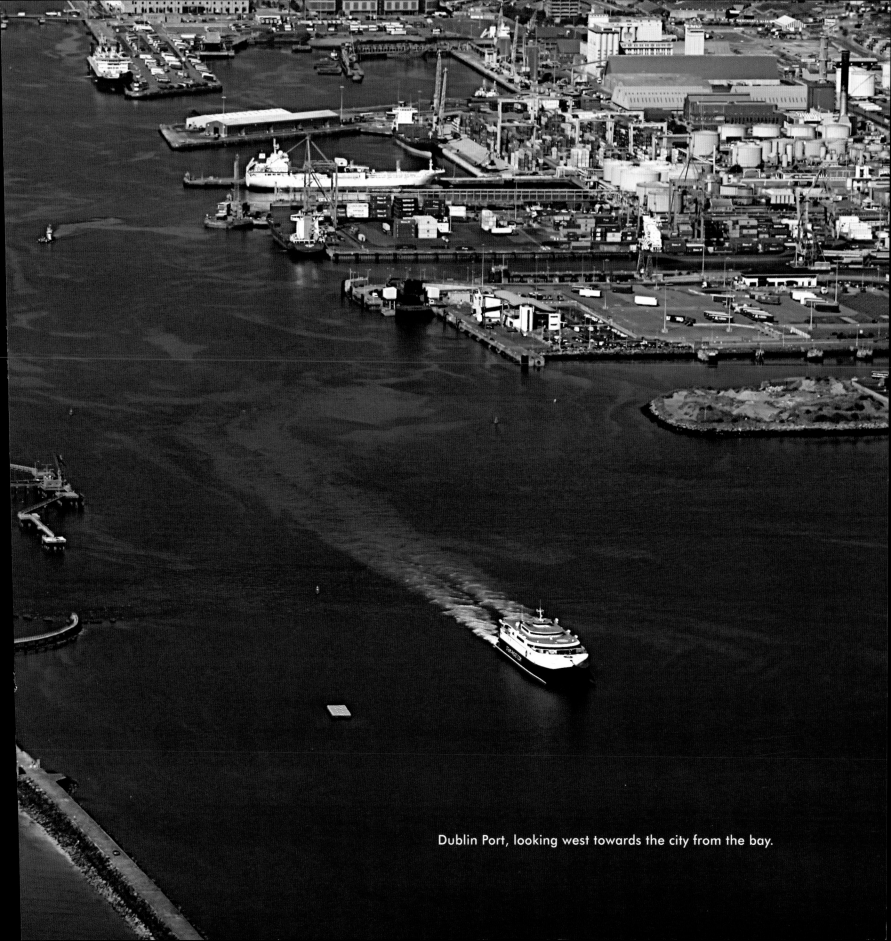

Dublin Port, looking west towards the city from the bay.

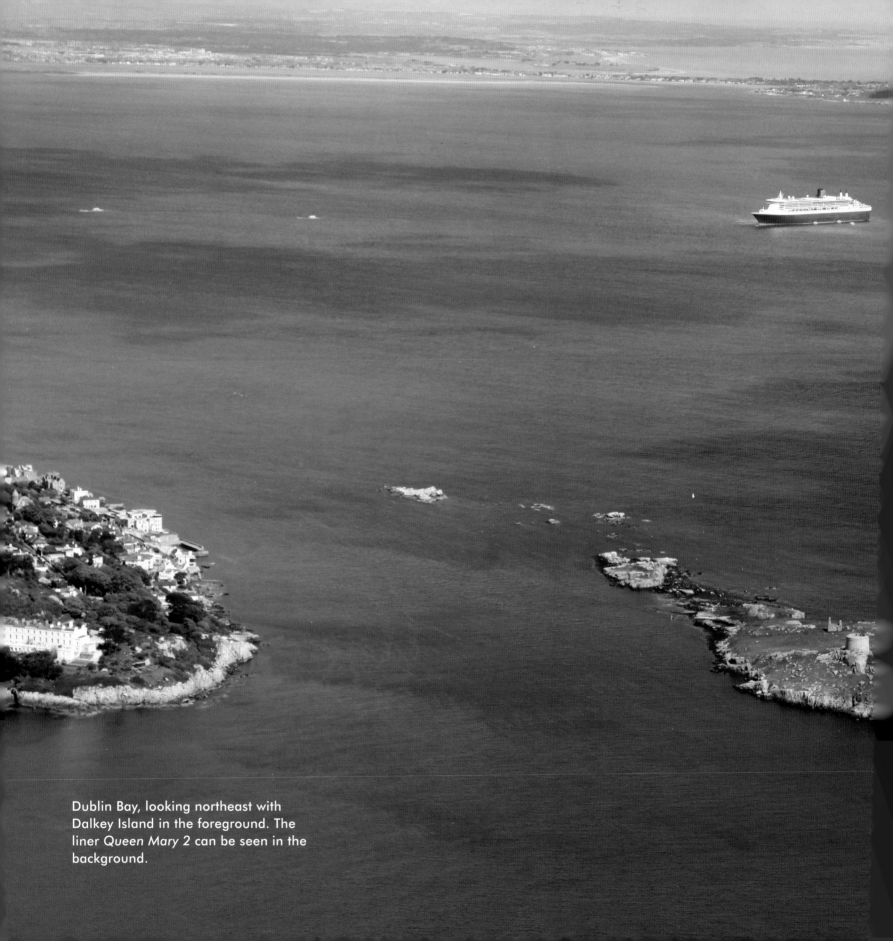

Dublin Bay, looking northeast with Dalkey Island in the foreground. The liner *Queen Mary 2* can be seen in the background.

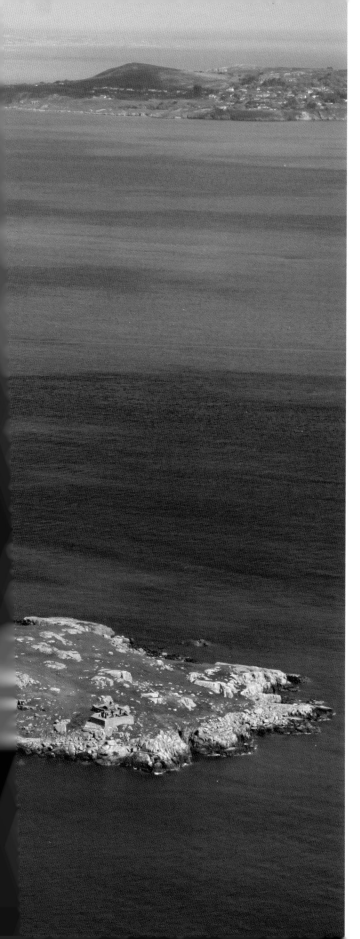

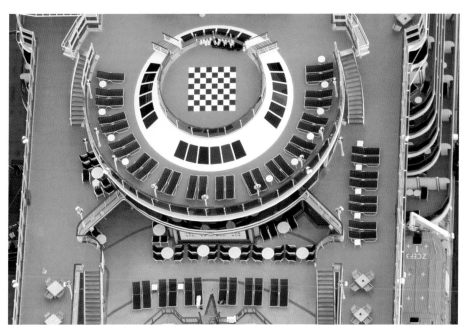

A close-up overhead view of the deck of another Cunard liner, the *Queen Victoria*.

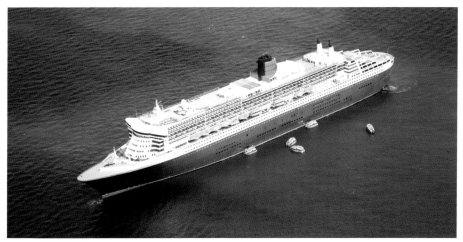

The ocean liner RMS *Queen Mary 2*, pictured here in Dublin Bay, is the flagship of the Cunard line and has made several visits to Dublin. The ship was launched in 2004 and has a capacity for 2,600 passengers plus a crew of over 1,000.

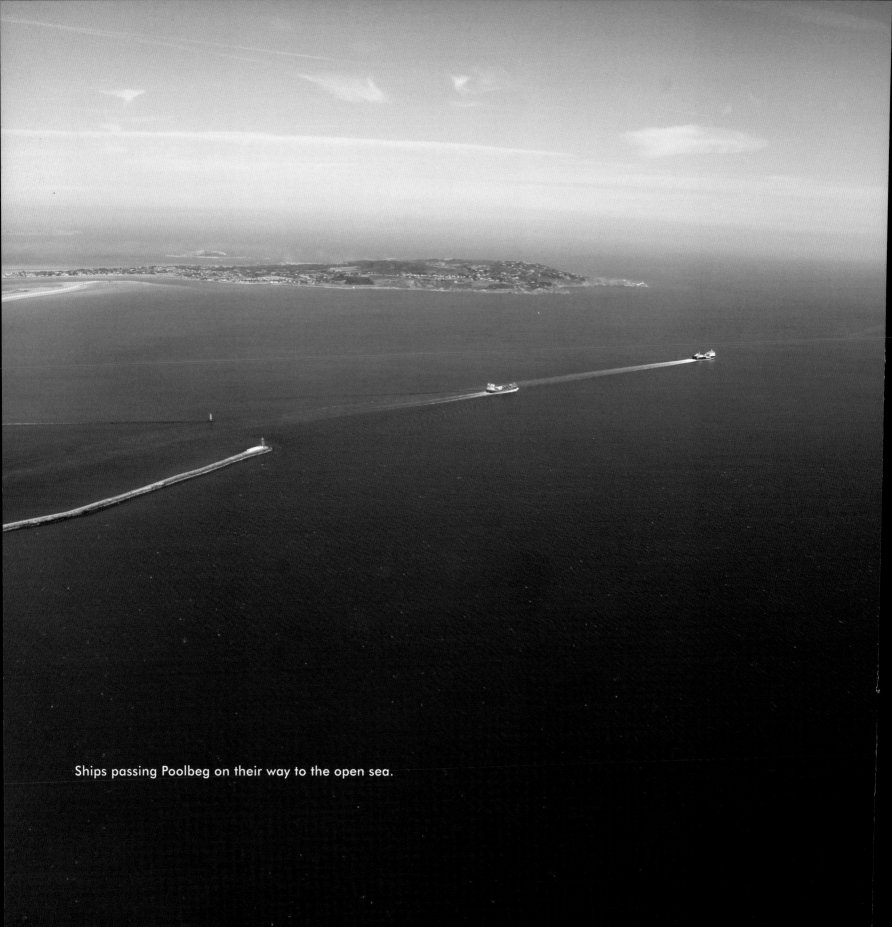

Ships passing Poolbeg on their way to the open sea.

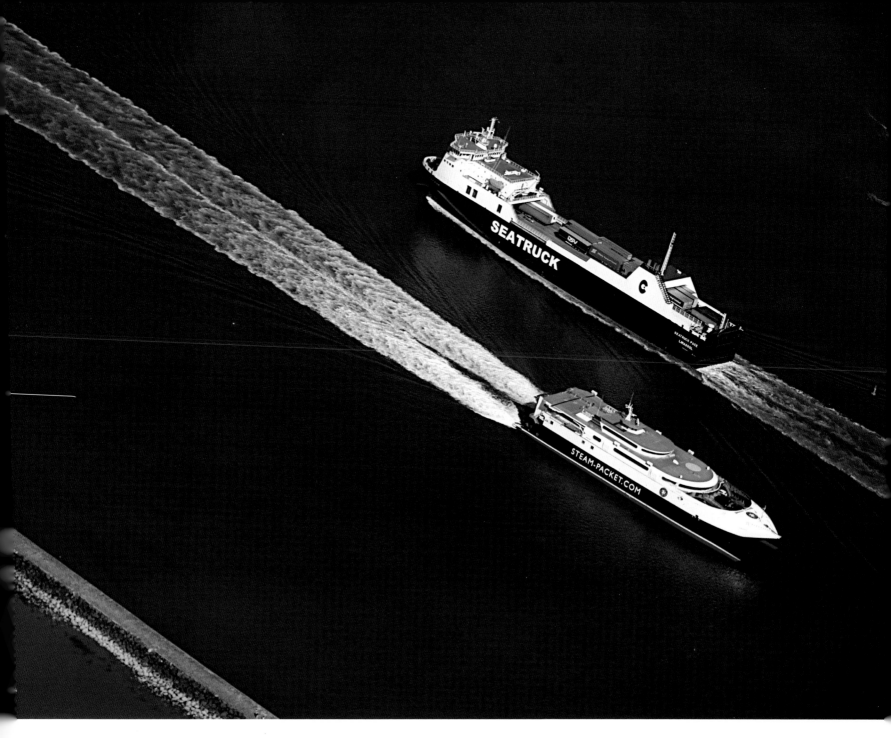

Dublin is a busy port with traffic departing and arriving on a constant basis. These two ferries pass each other in mid-channel by the Great South Wall.

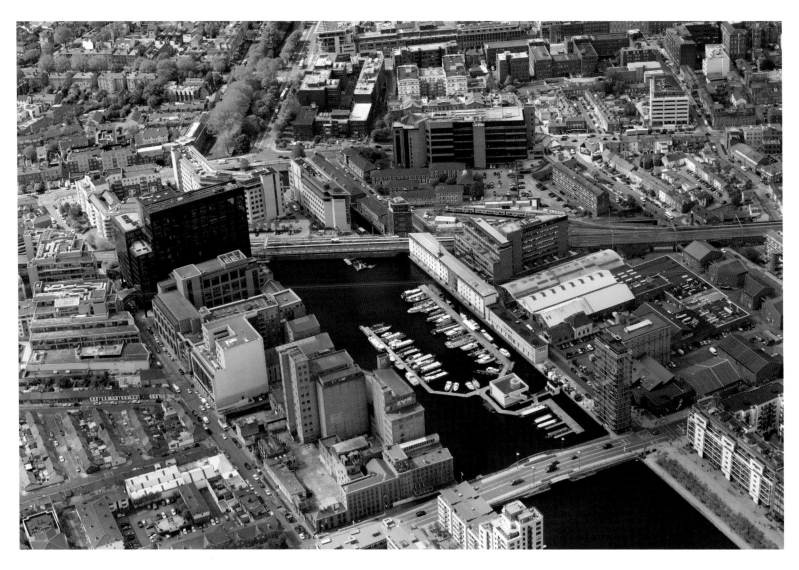

▲ Grand Canal Dock boasts an enclosed harbour and docking area close to the heart of the city.

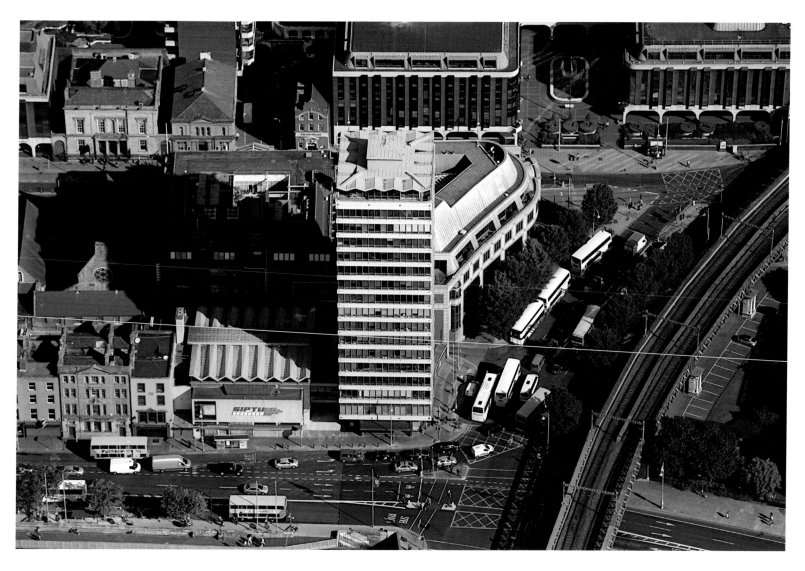

▲ Opened in 1965 and extending to sixteen storeys, Liberty
Hall is the headquarters of the SIPTU trade union.

Completed in 2002, George's Quay Plaza is a
complex of strikingly modern buildings, which
▼ house the headquarters of a major banking group.

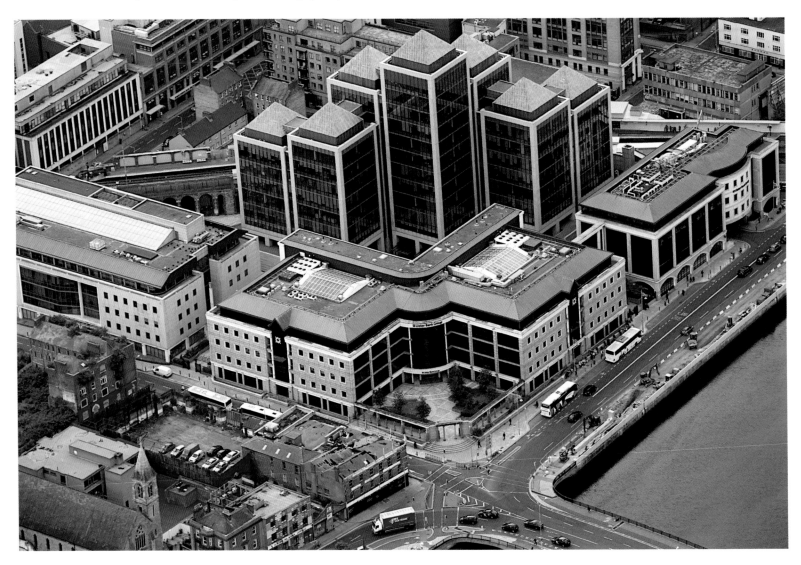

The DART crossing the Loopline Bridge, built in 1891, alongside Butt Bridge, heading north for Connolly Station.

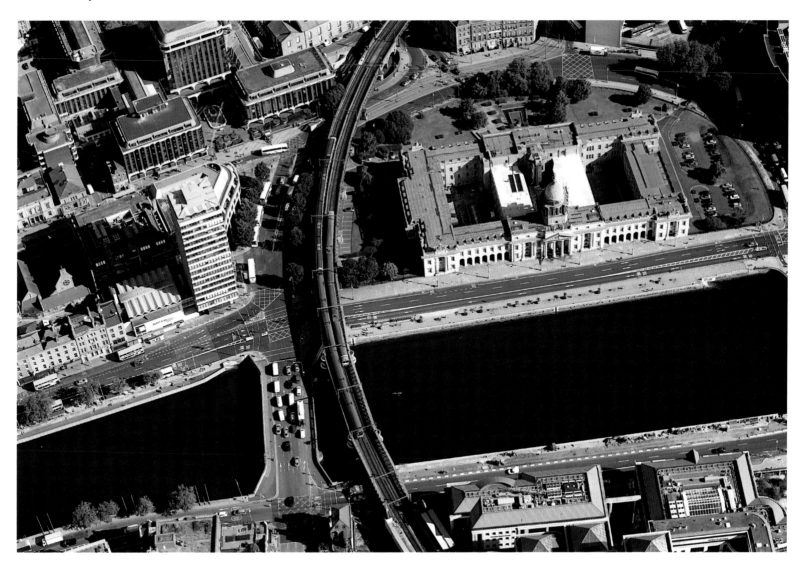

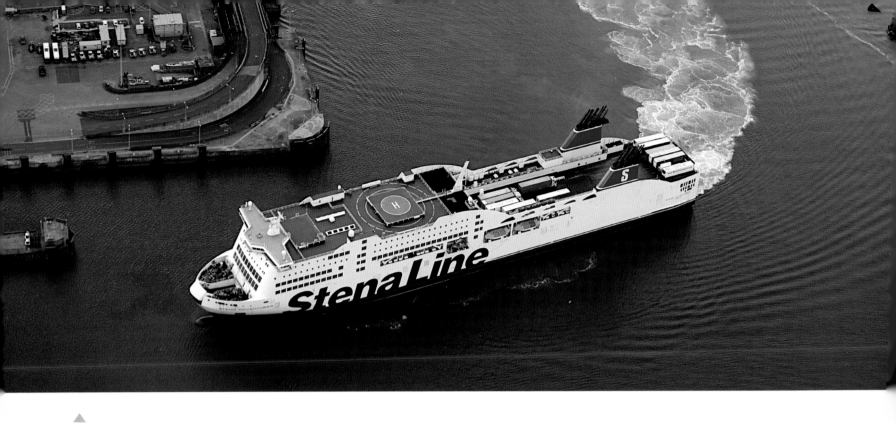

The *Stena Adventurer* ferry turns into its berth at Dublin Port. Stena Line operates a Dublin-to-Holyhead car ferry service.

Irish Ferries' *Ulysses*, seen here entering Dublin Port, services the Dublin-to-Holyhead route. With an overall length of 209 metres/686 feet, it is one of the largest car ferries in Europe and can carry over 1,500 vehicles and 2,000 passengers.

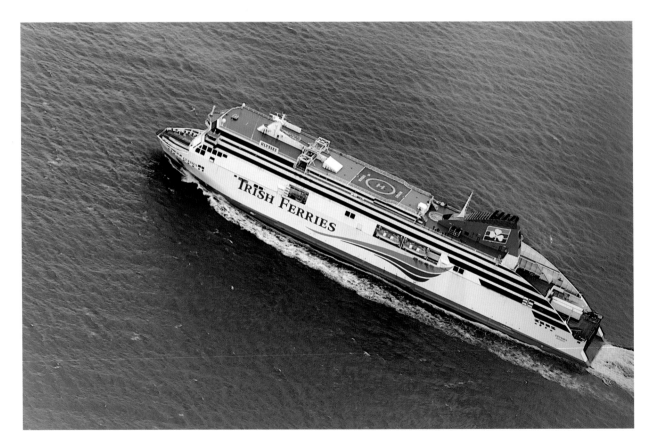

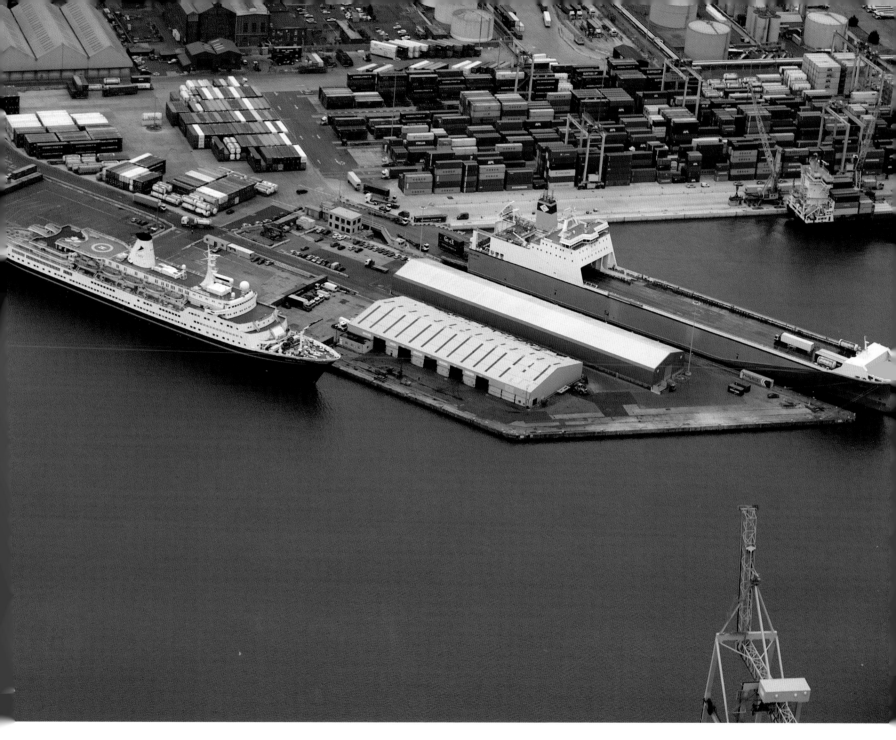

Berthed alongside each other at Dublin Port are the cruise liner *Marco Polo* and the roll-on/roll-off ferry *Palatine*.

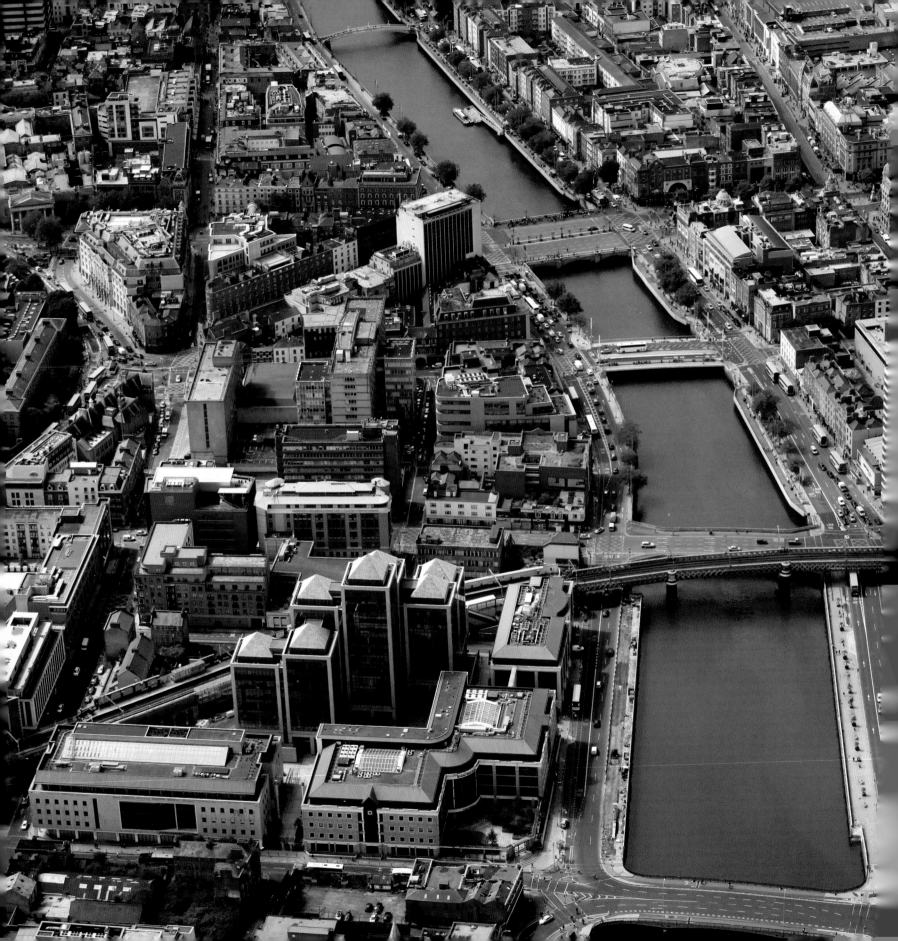

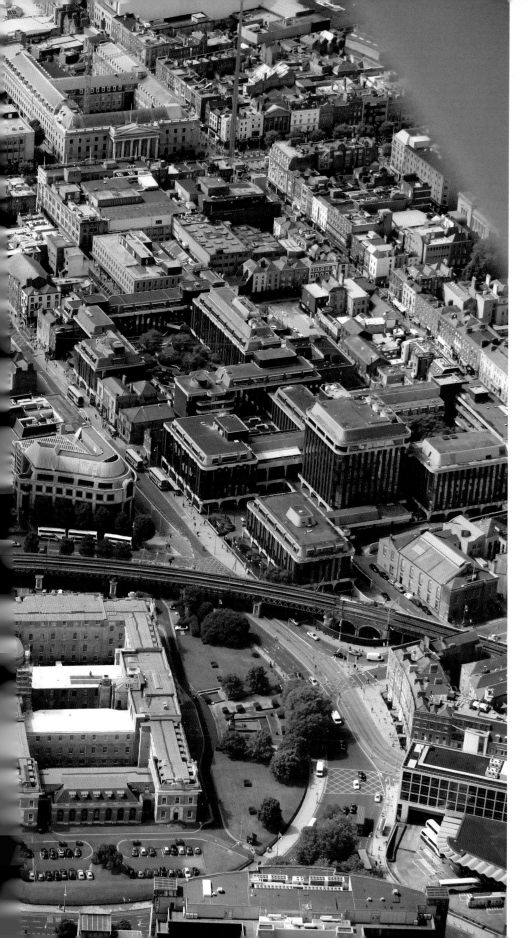

A westerly view of some of the many Liffey bridges. From foreground: Matt Talbot Bridge, Butt Bridge, Rosie Hackett Bridge, O'Connell Bridge and the Ha'penny Bridge.

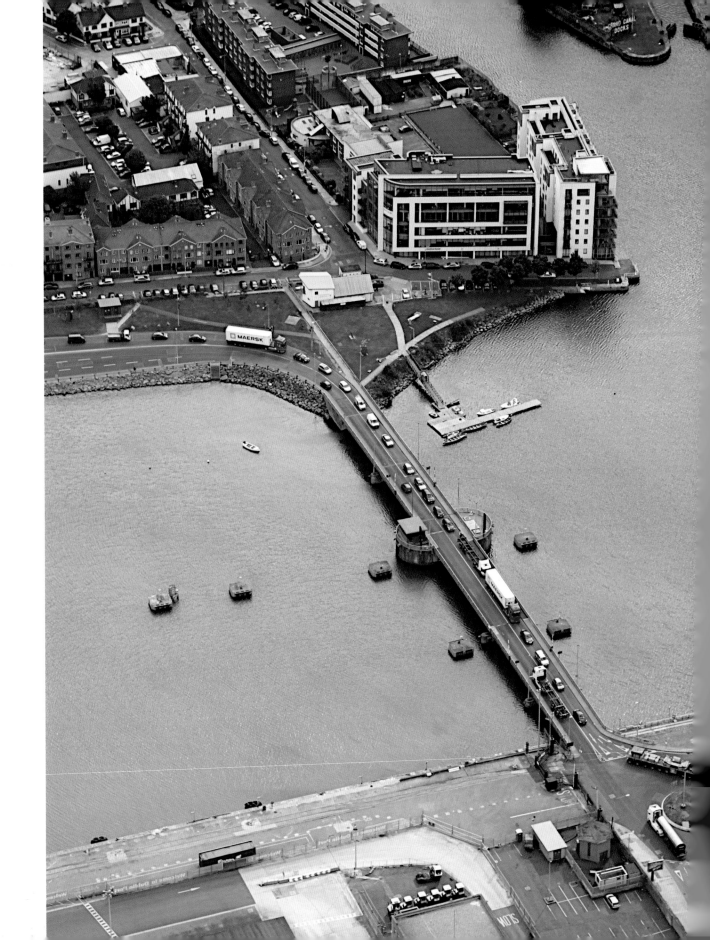

East Link Bridge. This bascule-type lifting bridge was opened in 1984, linking North Wall with Ringsend.

The Custom House, designed by James Gandon and completed in 1791, is without question the finest neoclassical building in Dublin. It houses the Department of the Environment, Community and Local Government. Busáras is in the top right of this image, and Butt Bridge is in the left foreground.

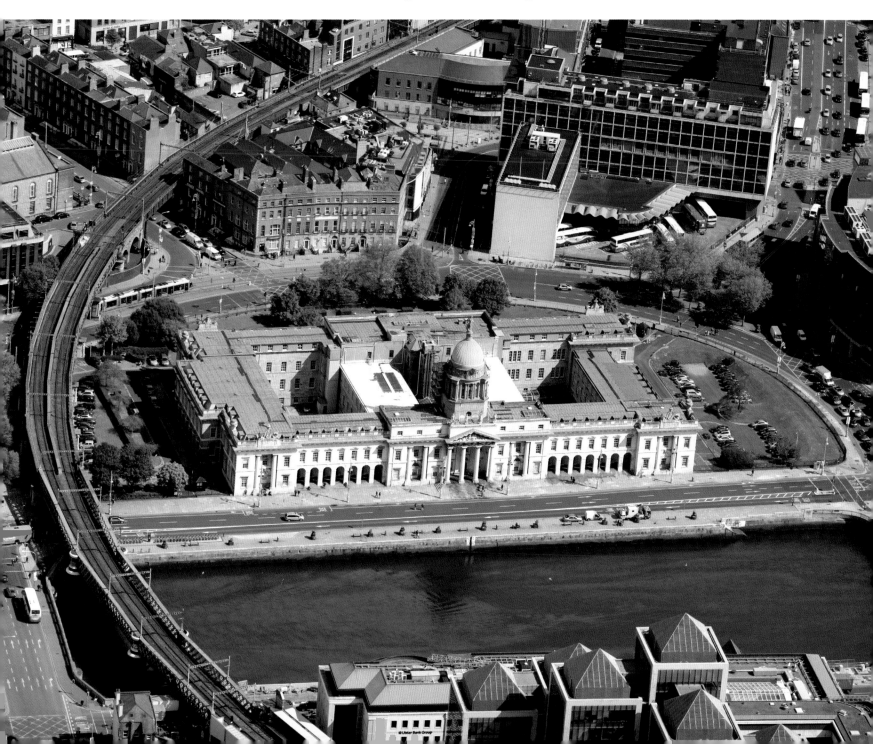

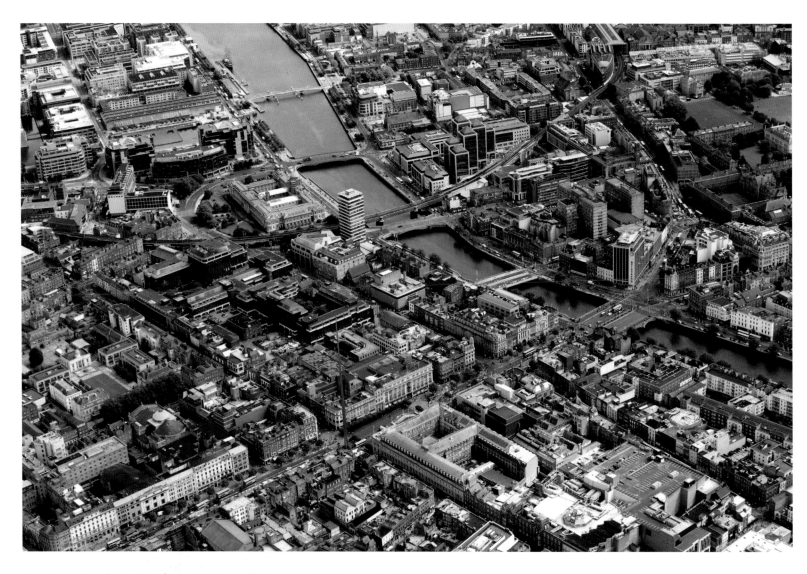

▲ A southerly aspect from O'Connell Street with Liberty Hall in the centre and the playing fields of Trinity College in the top right.

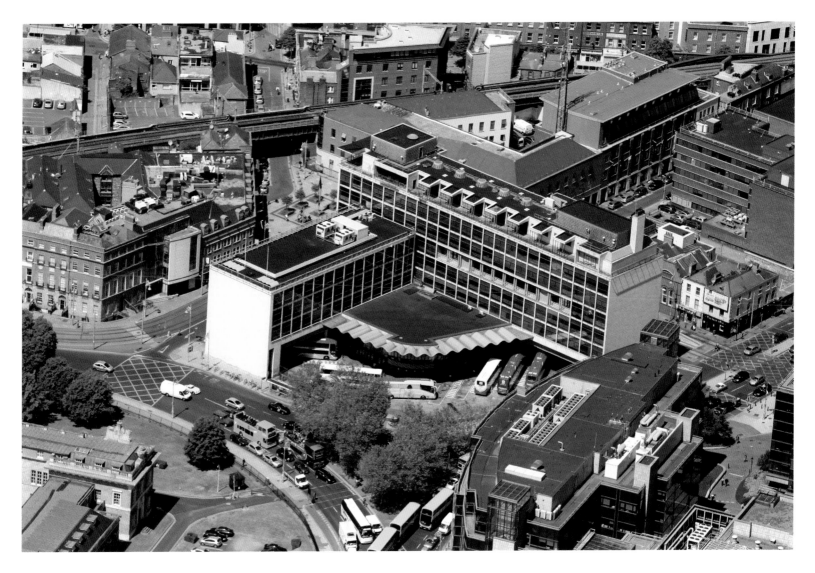

Busáras. Built between 1947 and 1953 and inspired by the work of Swiss-French architect Le Corbusier, this was the first major building in postwar Dublin to reflect a new modern style. It was designed by architect Michael Scott to house the bus terminus and offices.

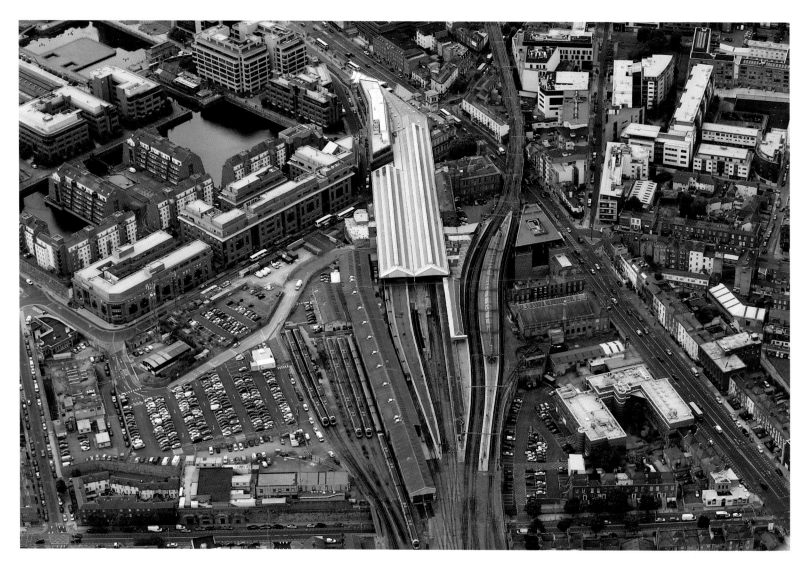

▲ Dublin Connolly is one of Ireland's main railway stations and is a
focal point in the Irish Rail network. It opened in 1944.

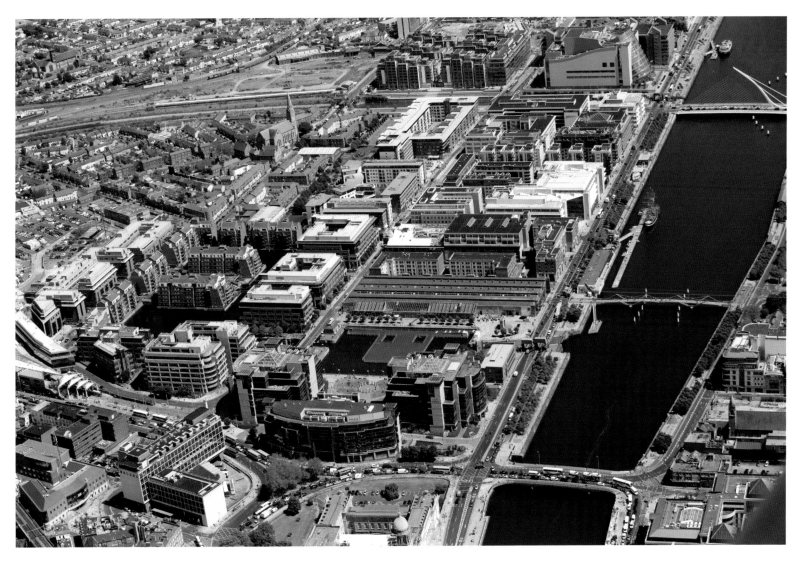

Located in the Custom House Docks area, the International Financial Services Centre (IFSC) was set up in 1987 and is regarded as one of the world's leading financial centres.

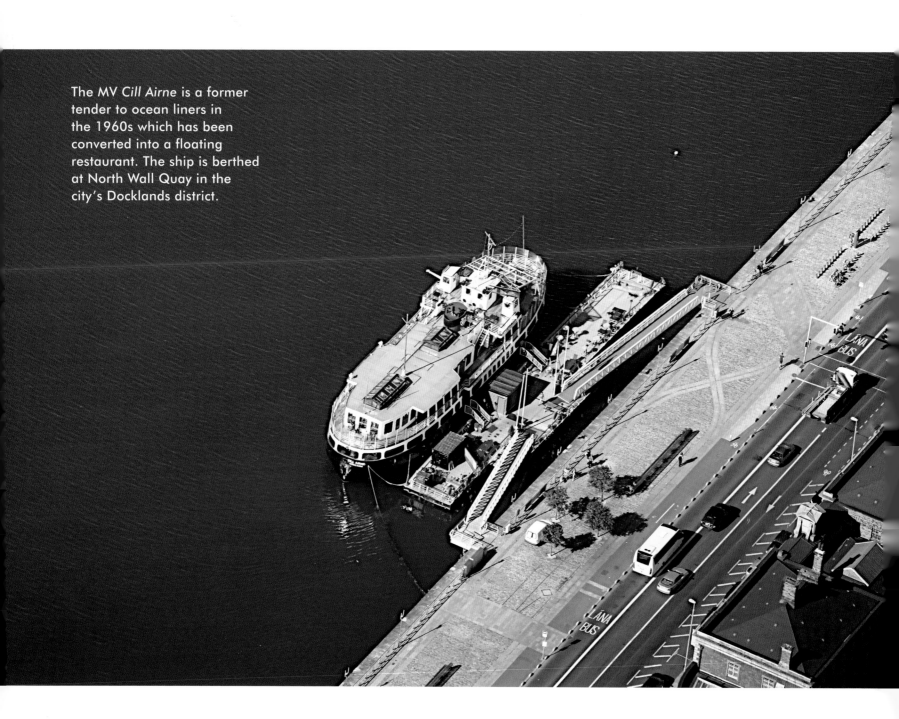

The MV *Cill Airne* is a former tender to ocean liners in the 1960s which has been converted into a floating restaurant. The ship is berthed at North Wall Quay in the city's Docklands district.

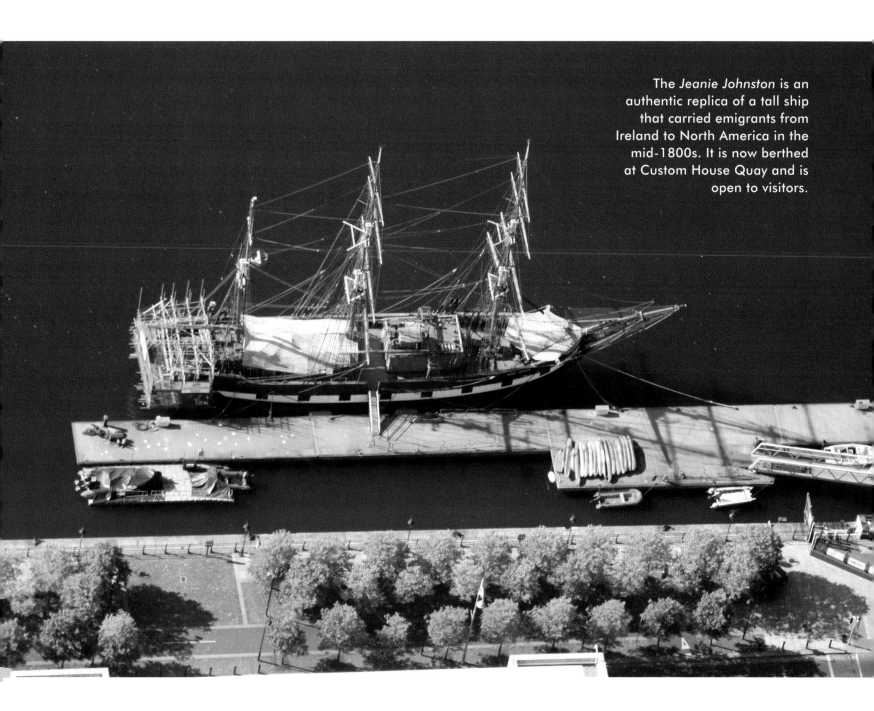

The *Jeanie Johnston* is an authentic replica of a tall ship that carried emigrants from Ireland to North America in the mid-1800s. It is now berthed at Custom House Quay and is open to visitors.

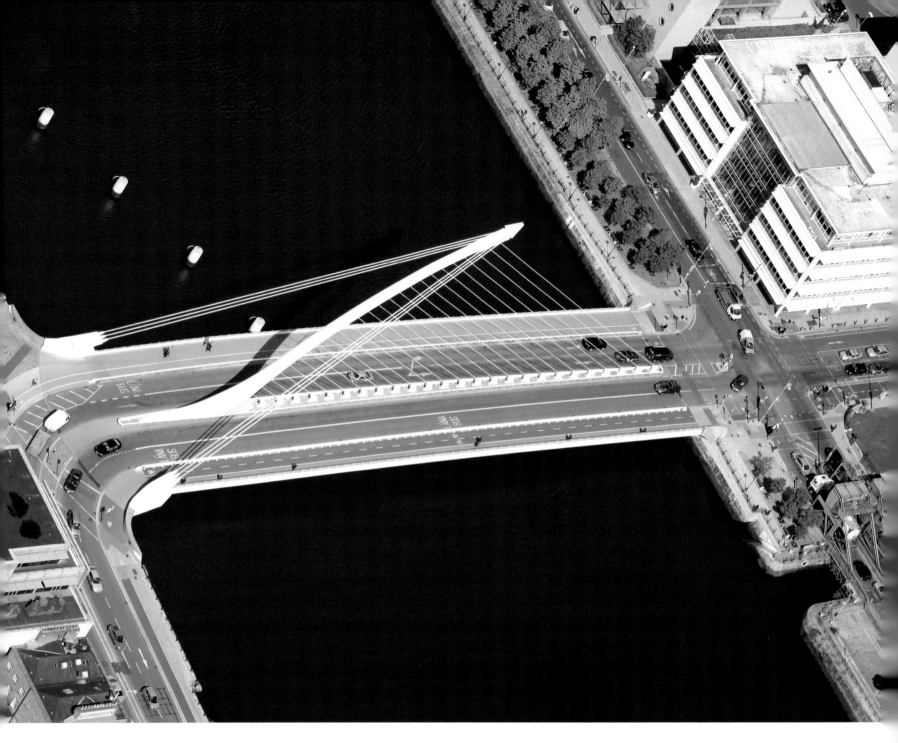

▲ Samuel Beckett Bridge. Opened in 2009 and designed by Santiago Calatrava with an Irish harp theme, this iconic Dublin bridge spans the River Liffey from Guild Street to Sir John Rogerson's Quay.

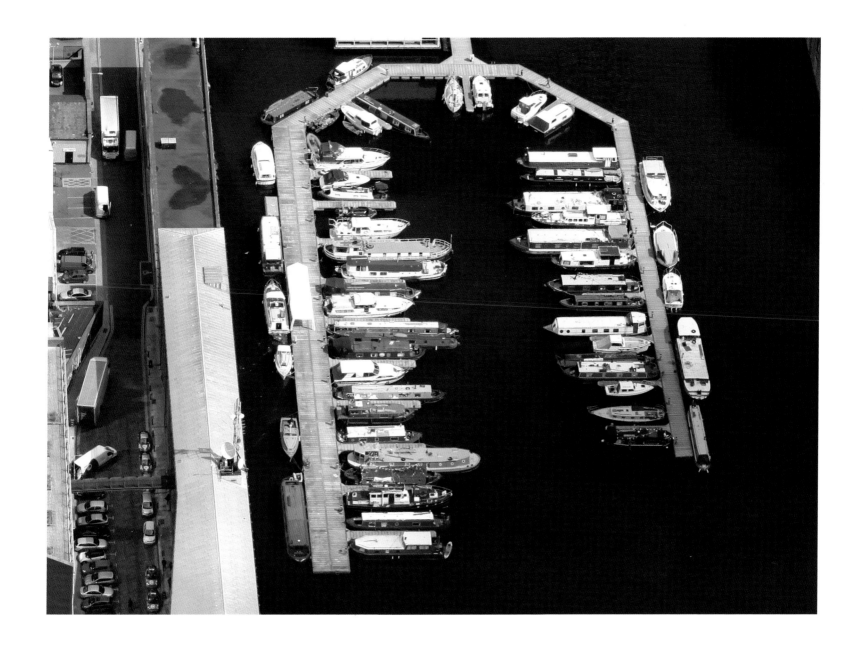

Motor cruisers, barges, houseboats and motor launches berthed at Grand Canal Dock. These craft are all regular users of our inland waterways system.

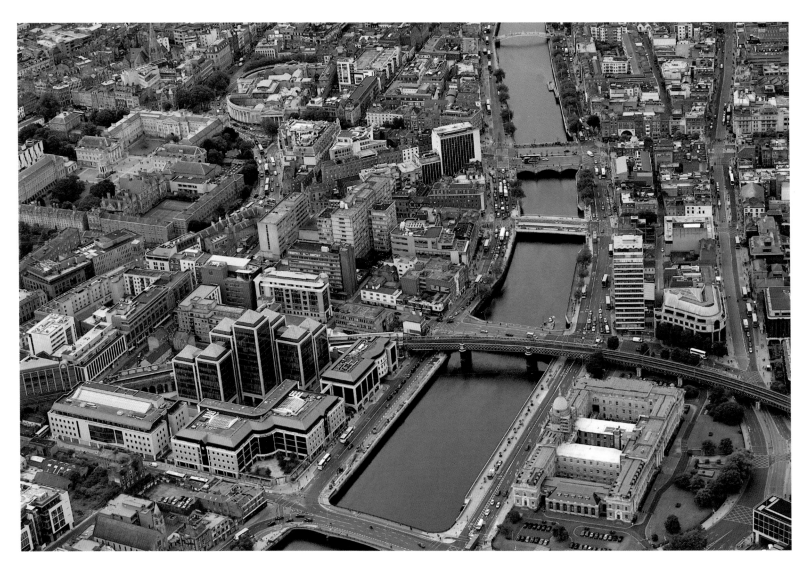

▲ Looking west along the Liffey, the bridges (from foreground) are:
Talbot Memorial Bridge, the Loopline and Butt Bridges, Rosie Hackett
Bridge, O'Connell Bridge and the Ha'penny Bridge.

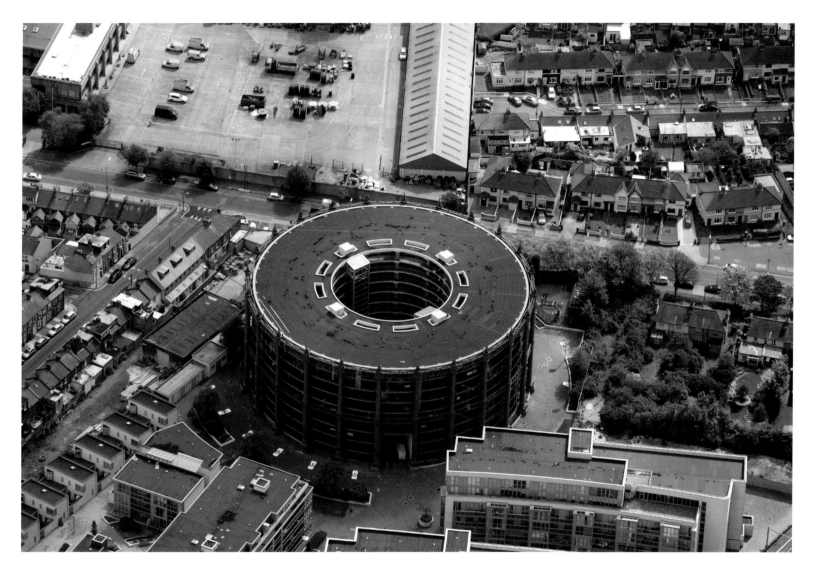

The Gasometer is a former gas storage facility built in 1934 for the Dublin Gas Company. It was redeveloped in recent years and retains its original facade.

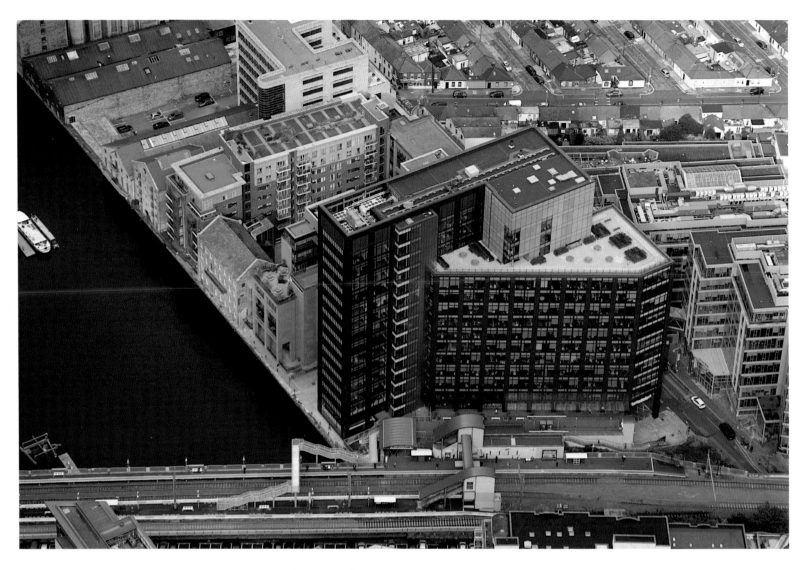

▲ Google European Headquarters. This striking building in the heart of a regenerated docklands is home to the US technology giant.

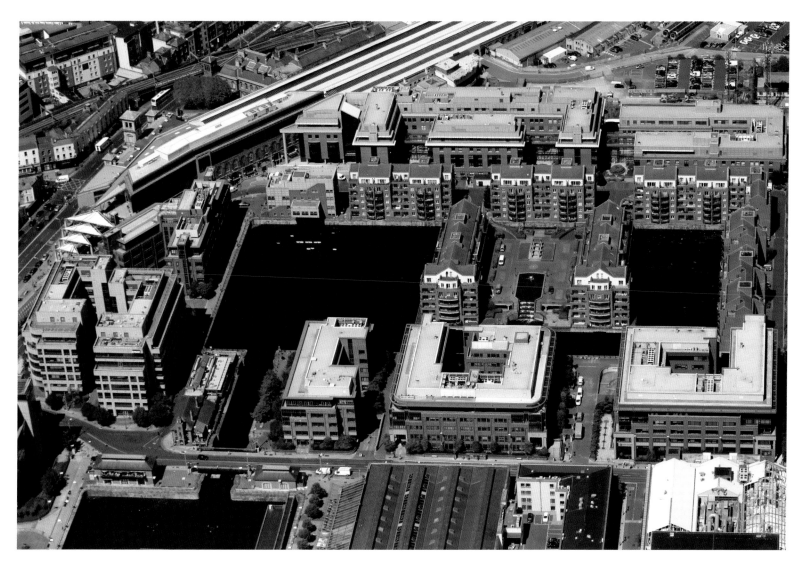

▲ George's Dock at the heart of the International Financial Services
Centre (IFSC).

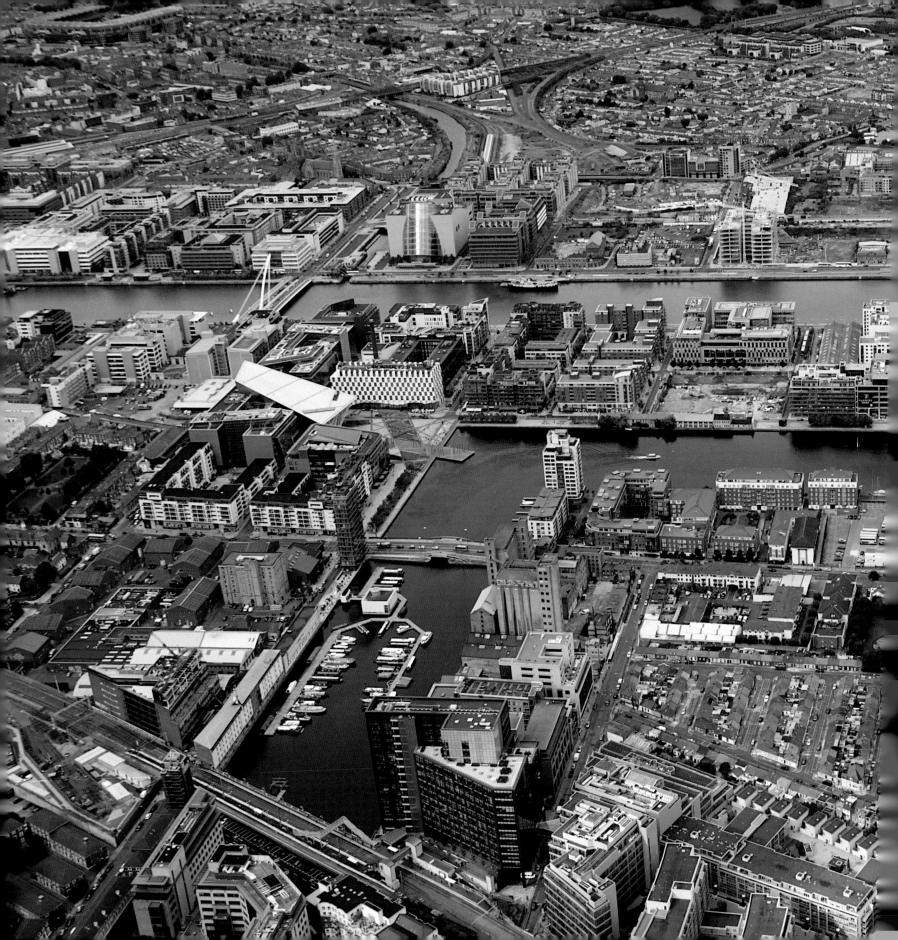

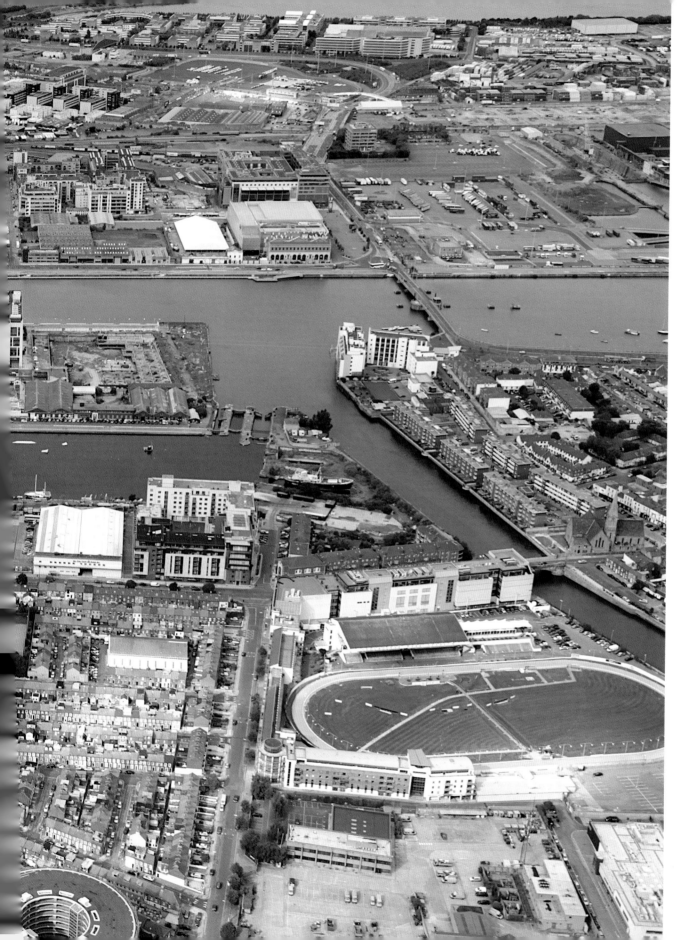

A panoramic view of
Grand Canal Dock
and Quay looking
north with the
Gasometer building
and Shelbourne Park
Greyhound Stadium
in the foreground.

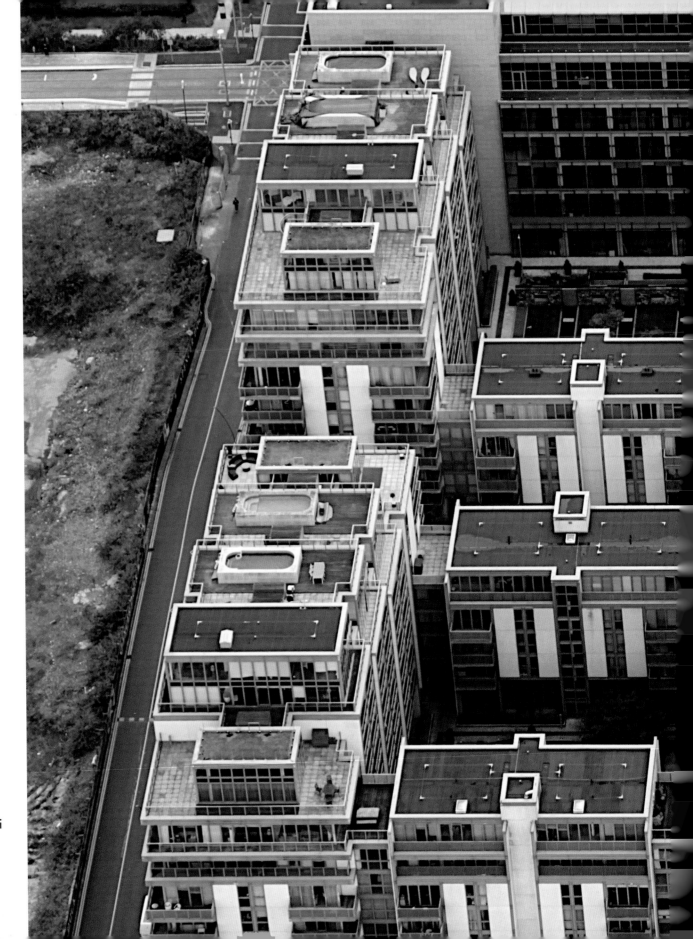

These top-floor apartments near North Wall have a superb view over the Docklands and the added benefit of mini swimming pools.

114

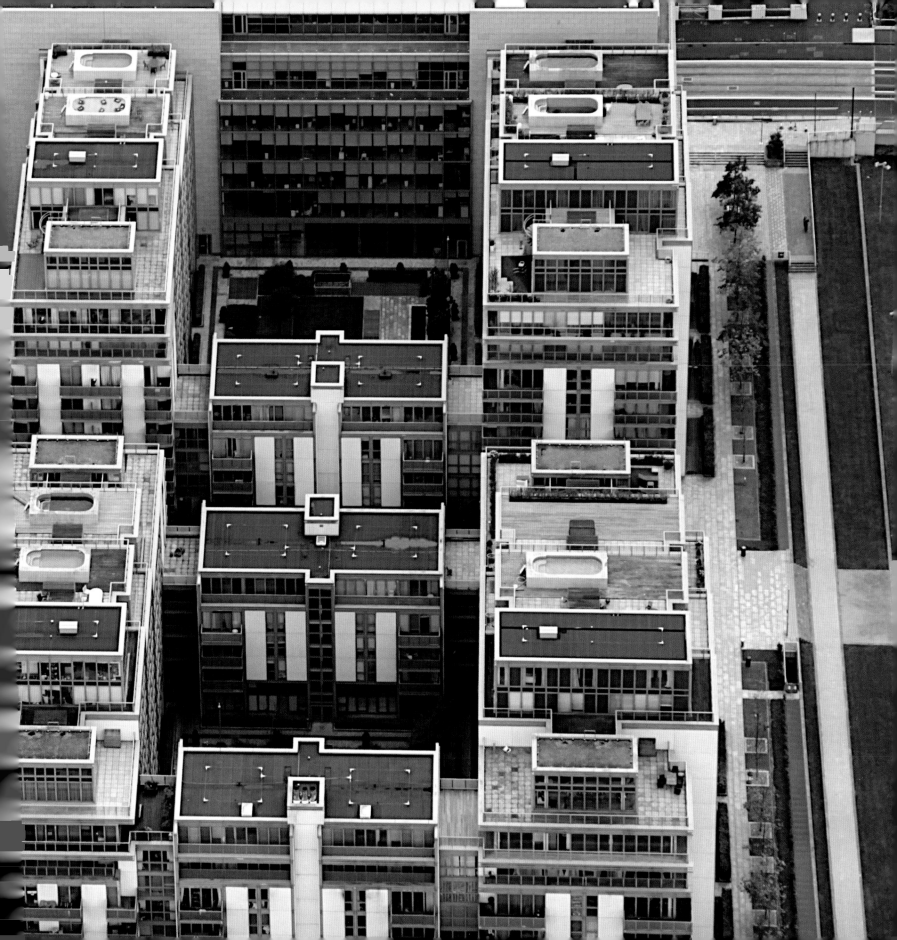

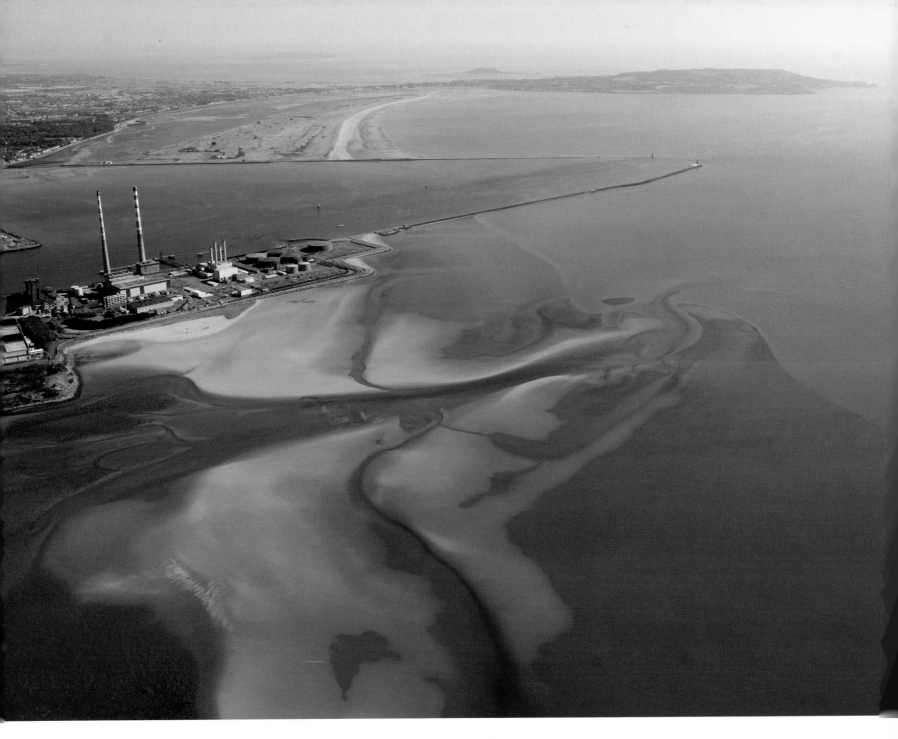

Captured at low tide, this view from Sandymount shows the Poolbeg
Power Station with Bull Island and Howth in the distance.

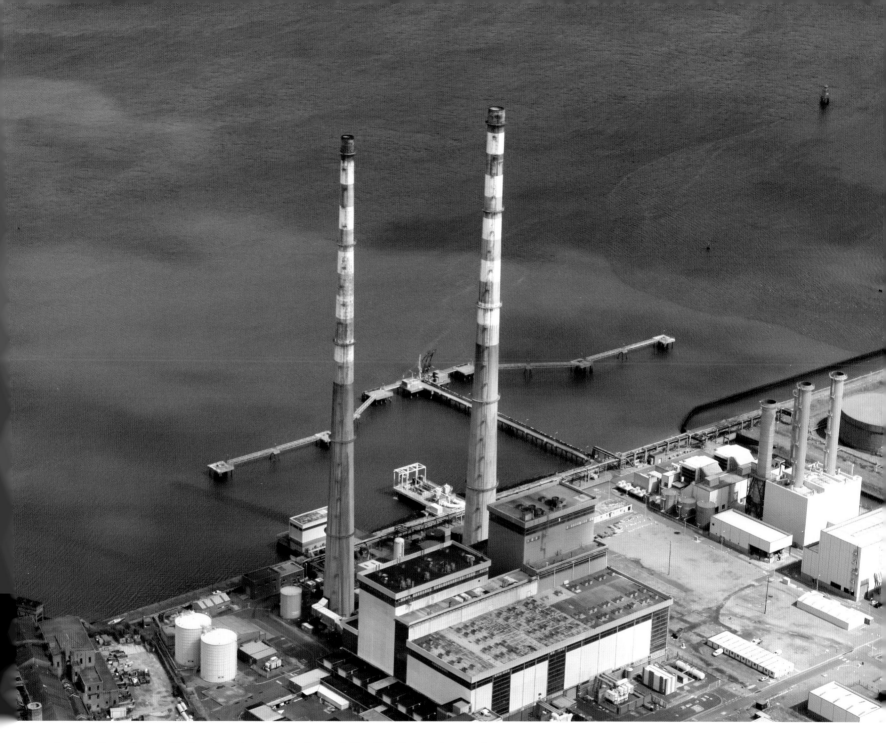

Poolbeg Power Station has been a feature of the Dublin landscape for decades. Its iconic twin chimneystacks, extending to a height of over 200 metres/680 feet, are visible for miles.

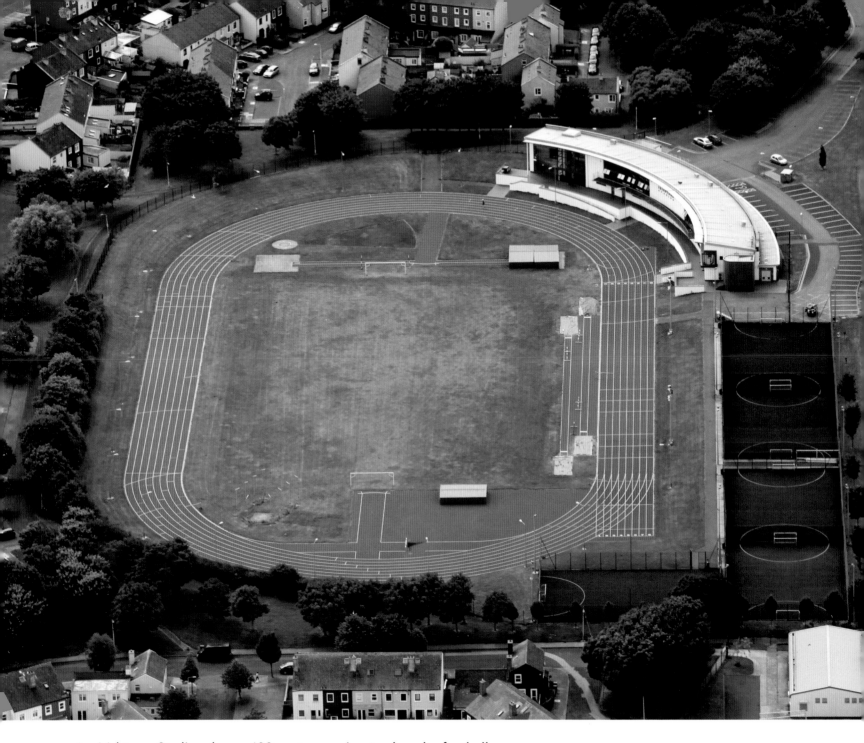

Irishtown Stadium has a 400-metre running track and a football pitch. It attracts athletics and soccer enthusiasts from all over Dublin and plays hosts to many sports events and tournaments.

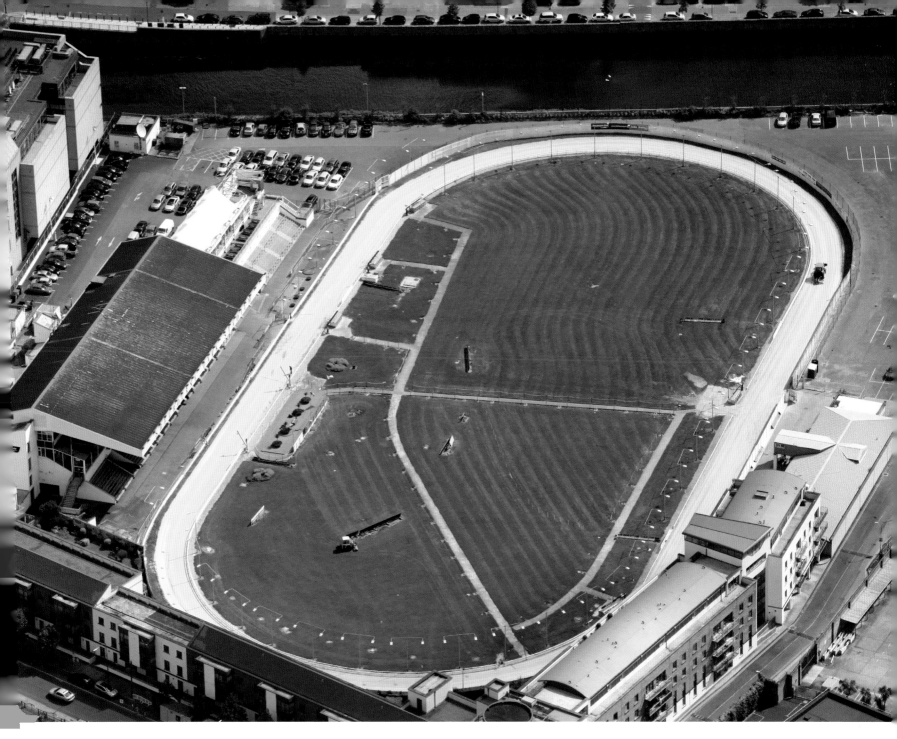

Shelbourne Park in the inner city at Ringsend is a modern greyhound track where race meetings are held on a regular basis.

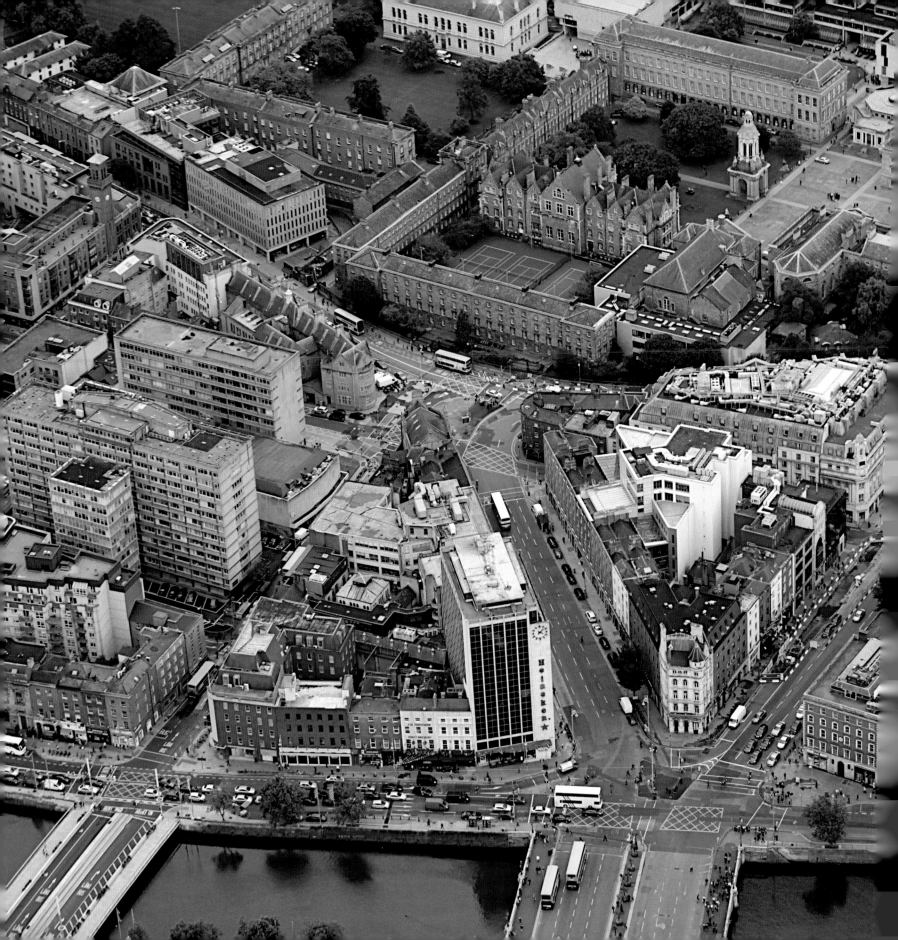

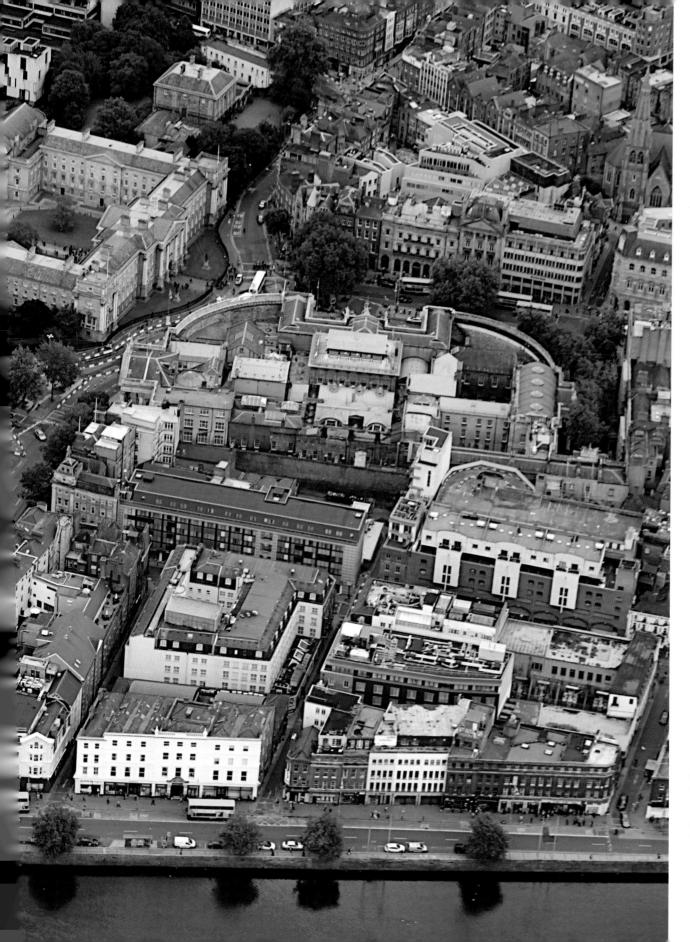

A view from
O'Connell Bridge
looking south towards
College Green and
Trinity College.

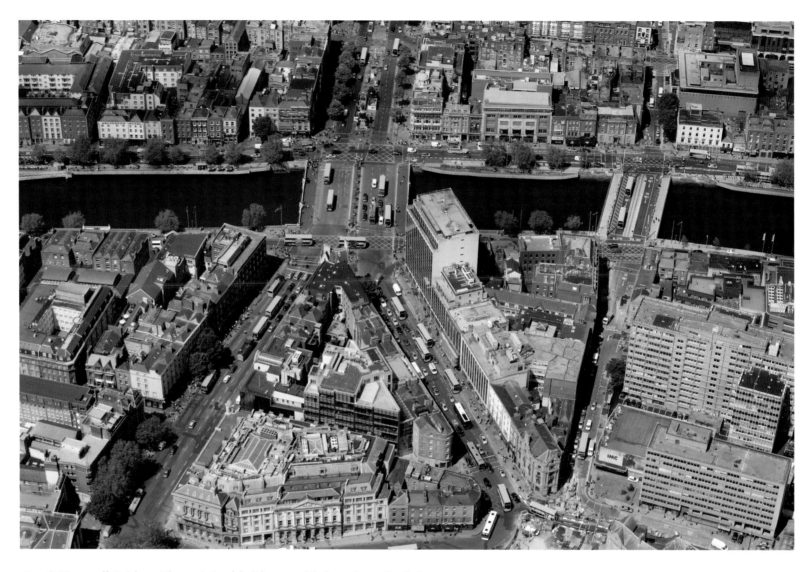

O'Connell Bridge. The original bridge at this location, Carlisle Bridge, was designed by architect James Gandon. It was widened in 1882 and renamed in honour of Daniel O'Connell. It is unique in Europe for being the only traffic bridge that is wider than it is long.

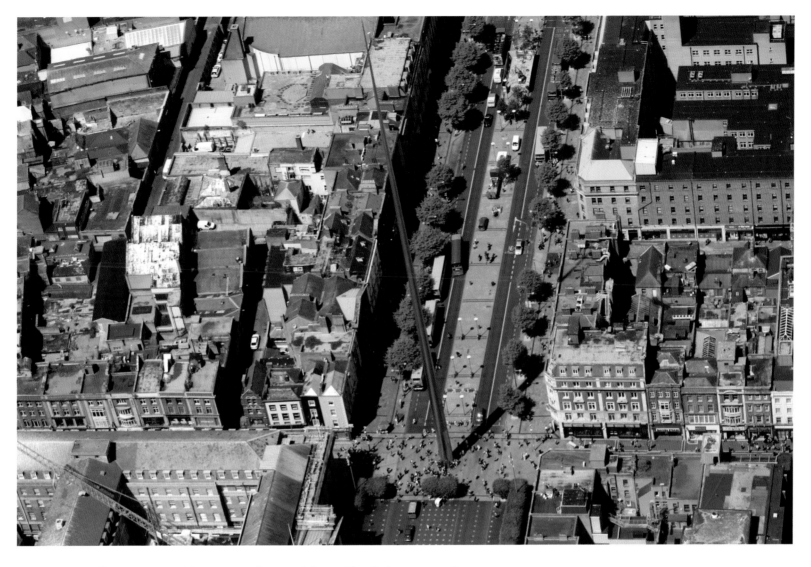

O'Connell Street is Dublin's main thoroughfare. The Spire, erected in 2002, is 121 metres/398 feet tall, making it by far the tallest structure in the city centre.

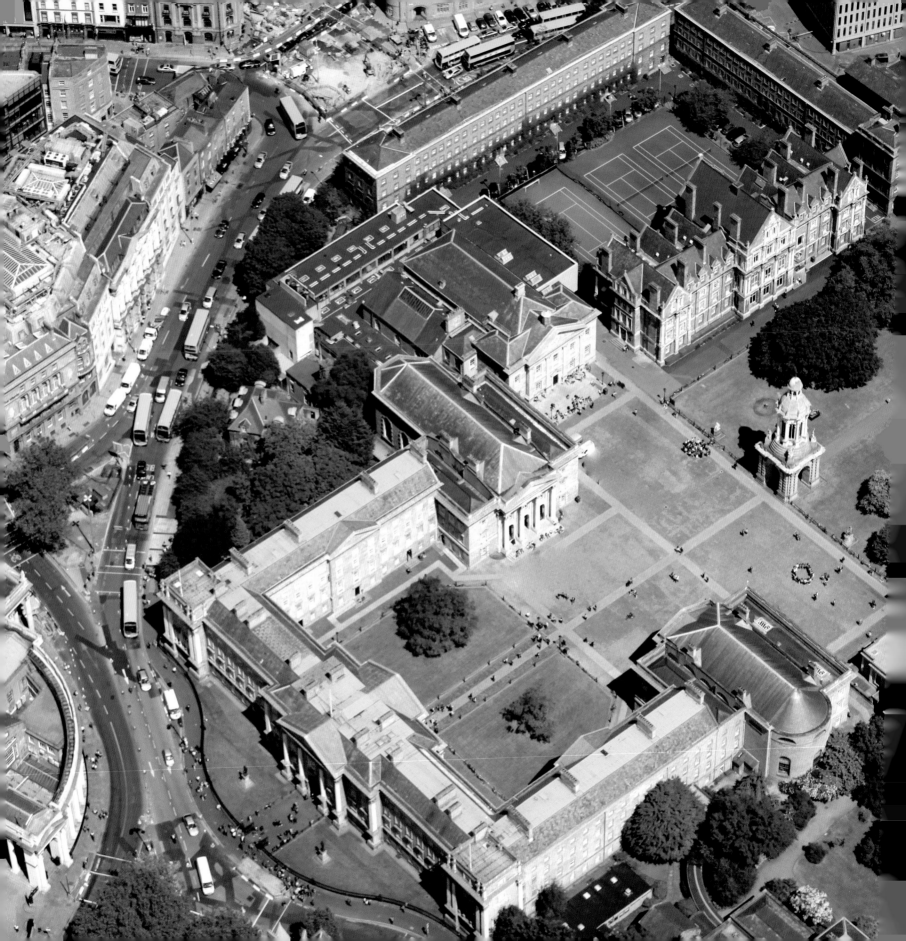

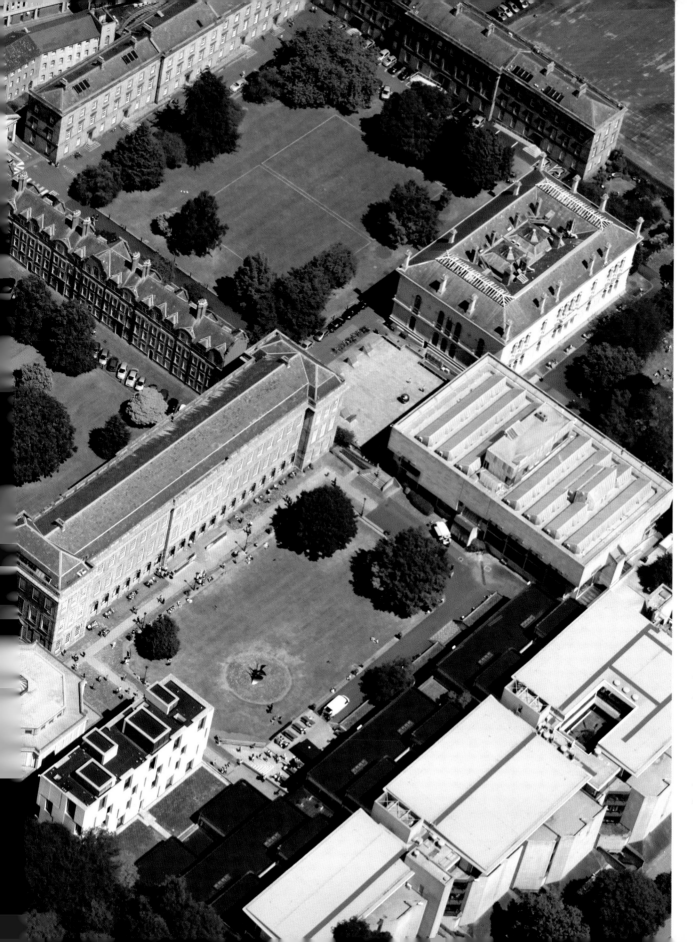

Trinity College, founded in 1592, is Ireland's oldest university and is ranked top in the country. It is hard to imagine today that, when originally built, it was outside Dublin's city walls.

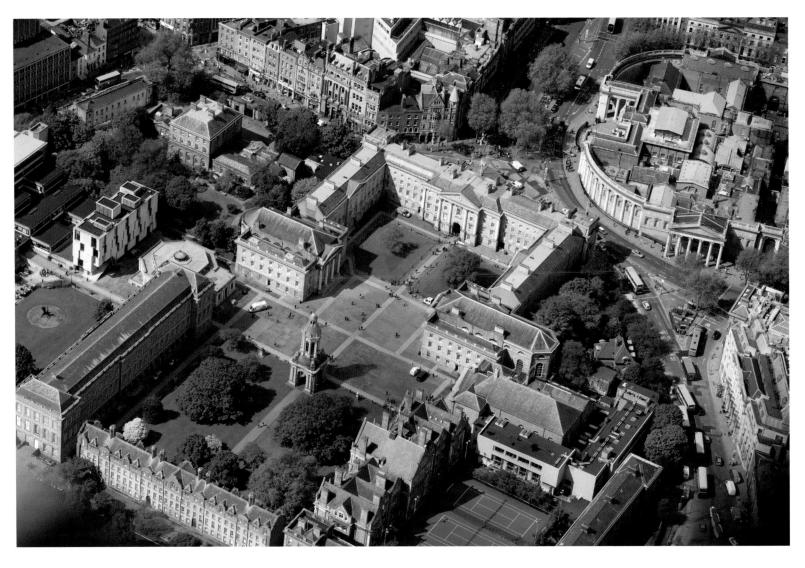

▲ This view of Trinity College shows (from left foreground) the Rubrics, to the left of which is the Old Library where the Book of Kells is housed, Library Square and Campanile, Front Square and Regent House facing the Bank of Ireland on College Green.

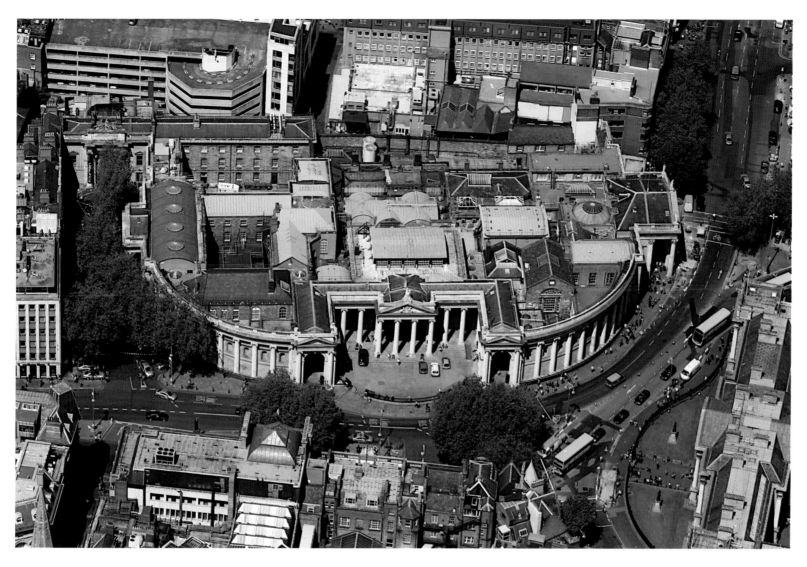

Bank of Ireland, College Green. The first purpose-built parliament house in Europe, it was built to the design of architect Edward Lovett Pearce and completed in 1739, with modifications made by James Gandon between 1785 and 1789.

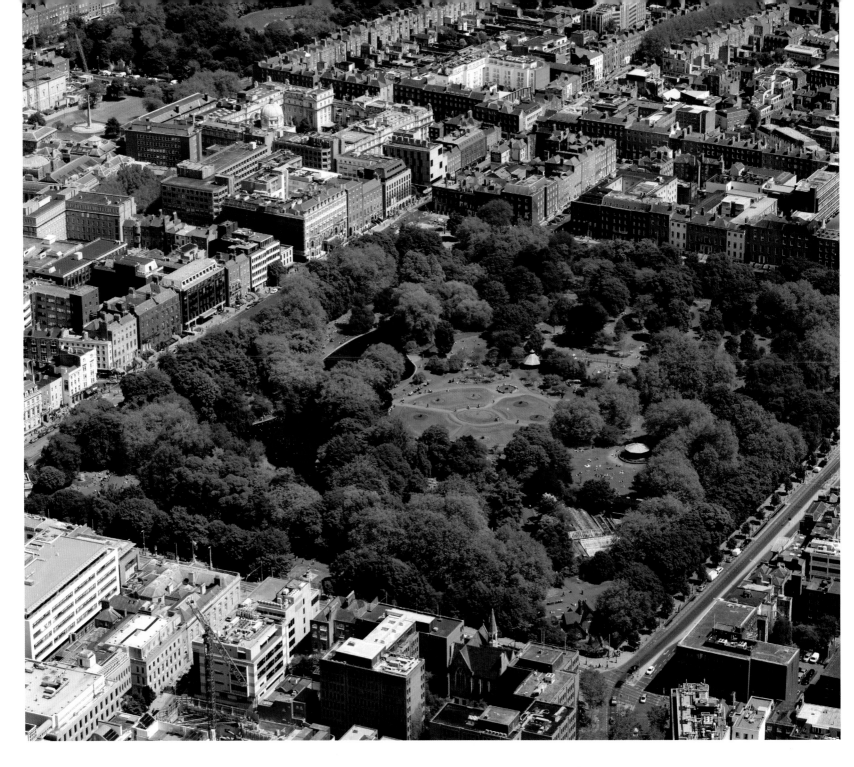

St Stephen's Green is Ireland's best-known public park. It was opened for the citizens of Dublin by Lord Ardilaun in 1880 and continues to be maintained in the original Victorian layout.

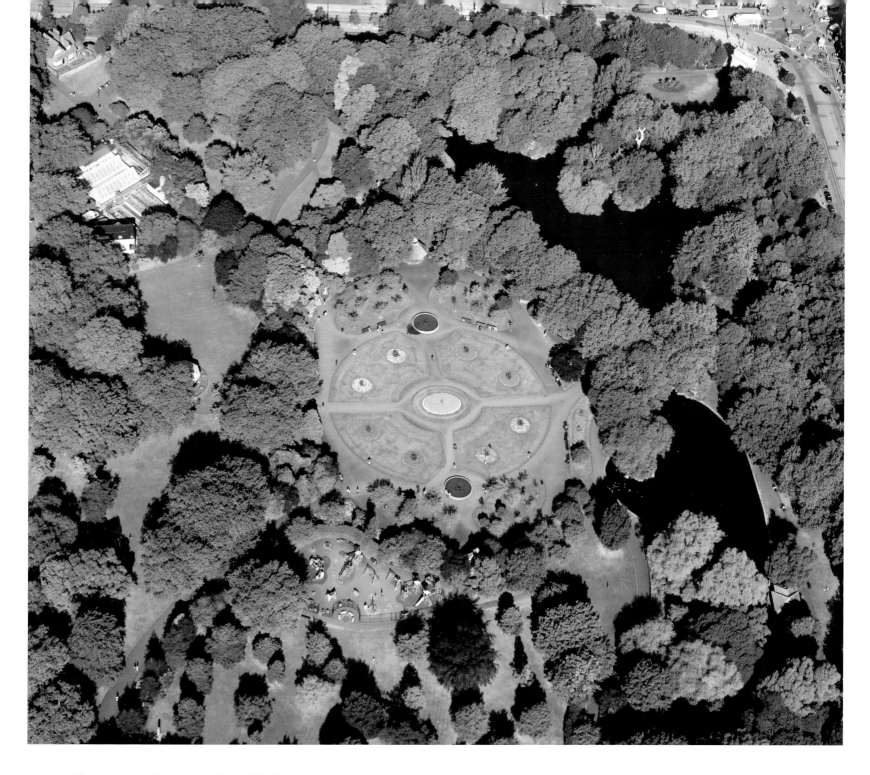

This overhead perspective of St Stephen's Green shows it in all its colourful glory with trees surrounding an ornate garden and playground.

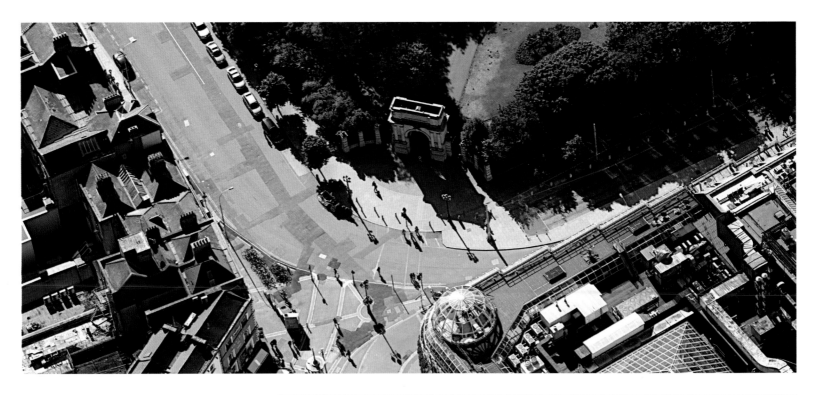

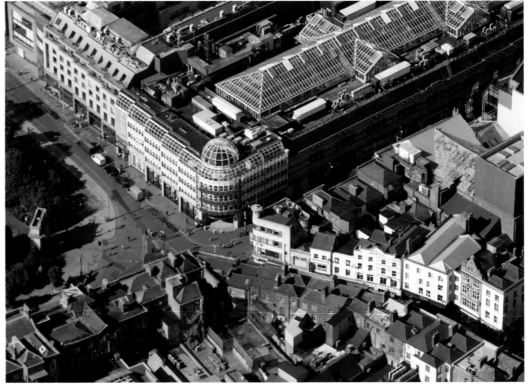

Fusiliers' Arch on St Stephen's Green commemorates the soldiers of the Royal Dublin Fusiliers who lost their lives in the Boer War.

St Stephen's Green Shopping Centre opened in 1988 and faces onto St Stephen's Green. It was imaginatively designed by architect James Toomey with a facade reminiscent of Victorian glasshouses.

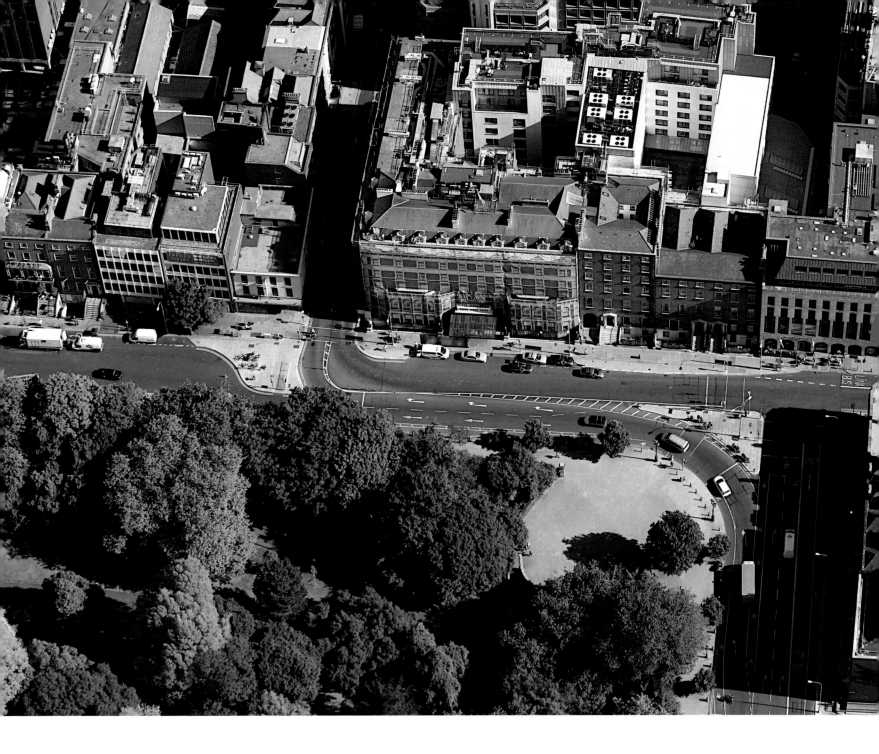

▲ The north-eastern corner of St Stephen's
Green shows the landmark Shelbourne
Hotel in the centre.

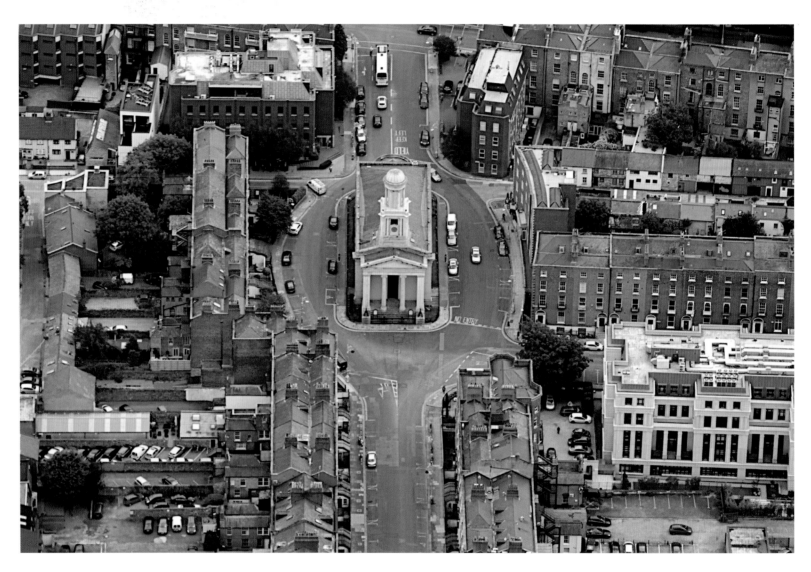

▲ St Stephen's Church on Upper Mount Street is known as the Pepper Canister. It is one in a series of Georgian churches built by the Church of Ireland in the early 1800s and is regarded as a 'gem' of Dublin.

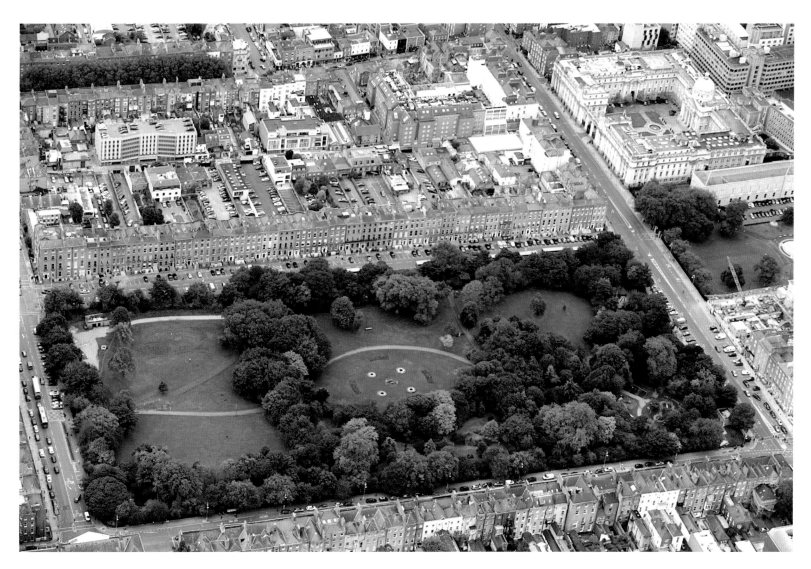

Merrion Square in the heart of Dublin city is an elegant tree-lined square surrounded by Georgian houses that date from 1792. It is now a public park.

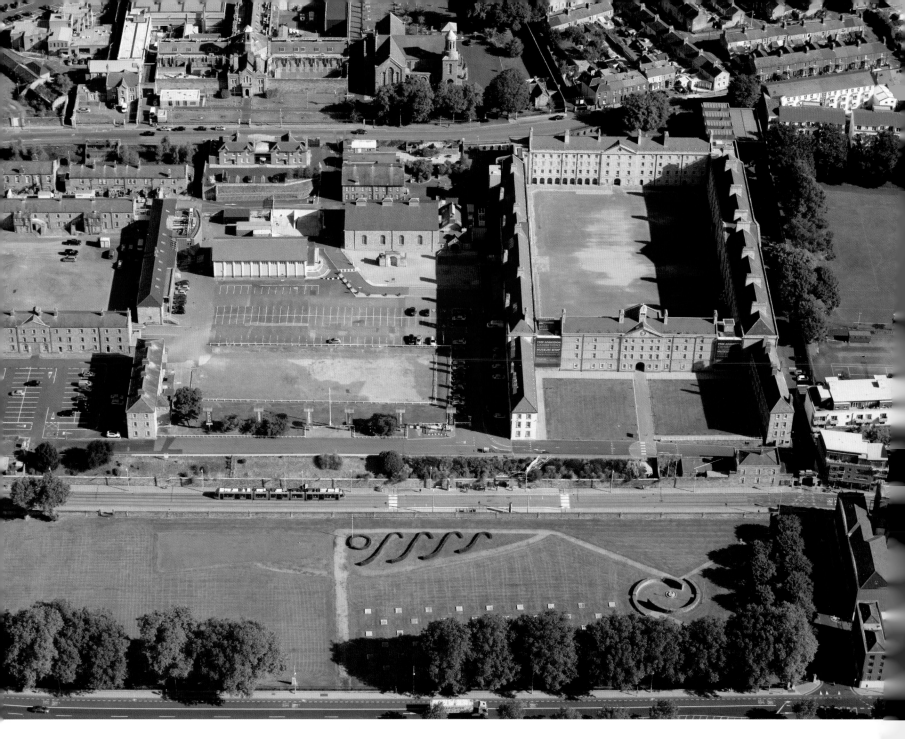

▲ The National Museum of Ireland is located in the former Collins Barracks
in the Arbour Hill area. It features exhibitions exploring Irish decorative
arts and history and attracts many visitors each year.

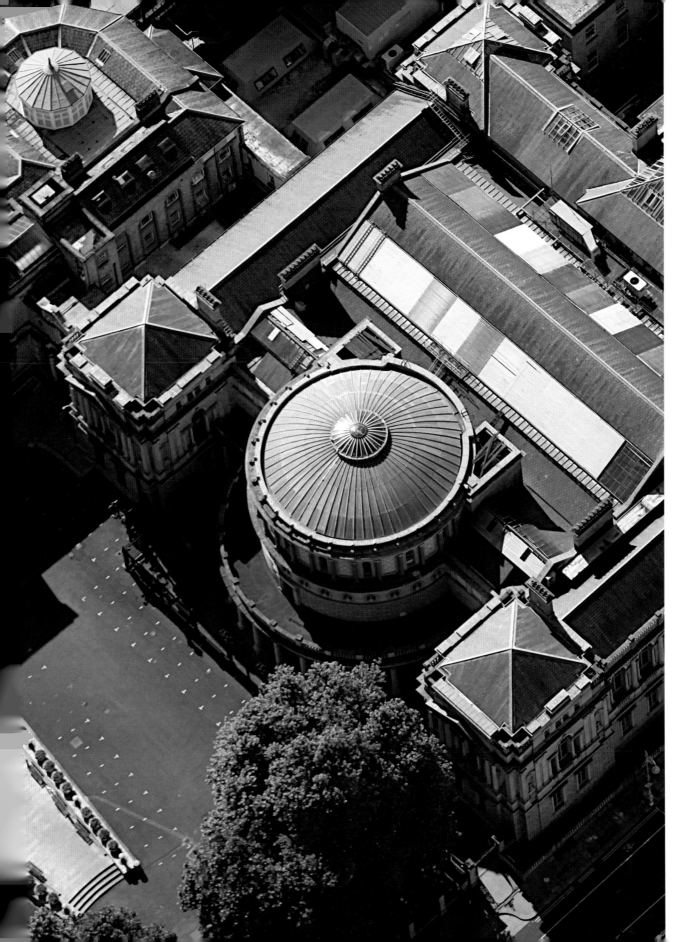

The National Library of Ireland was established in 1877 and is located in Kildare Street alongside Leinster House.

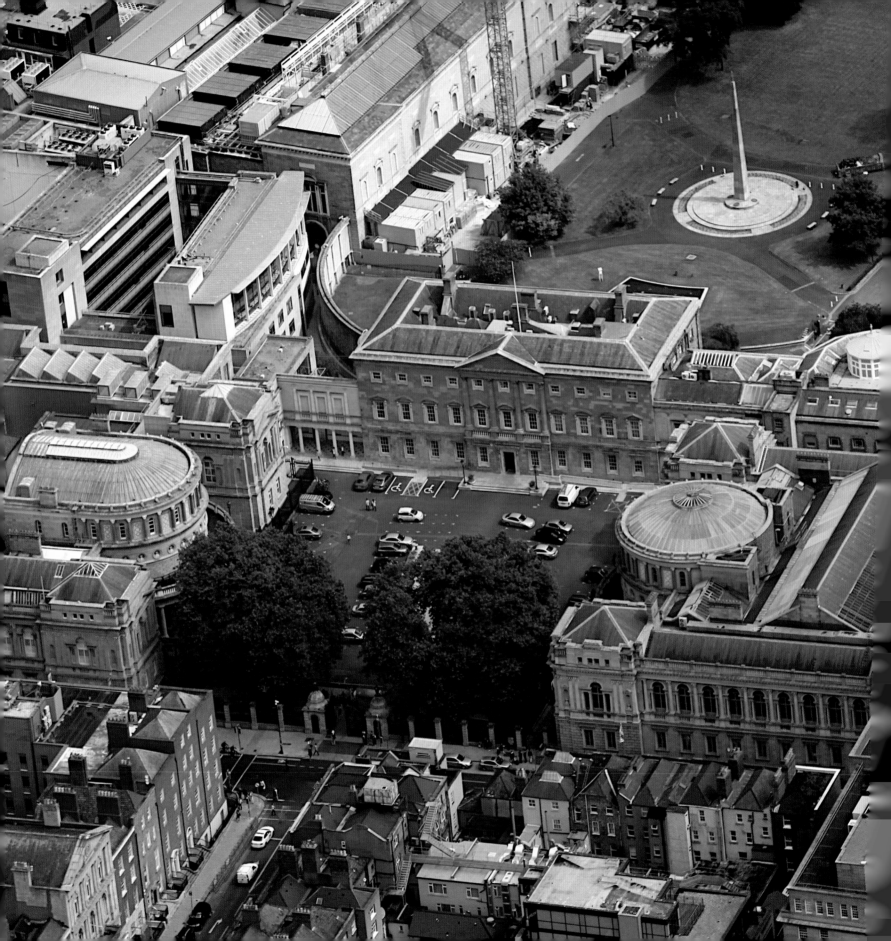

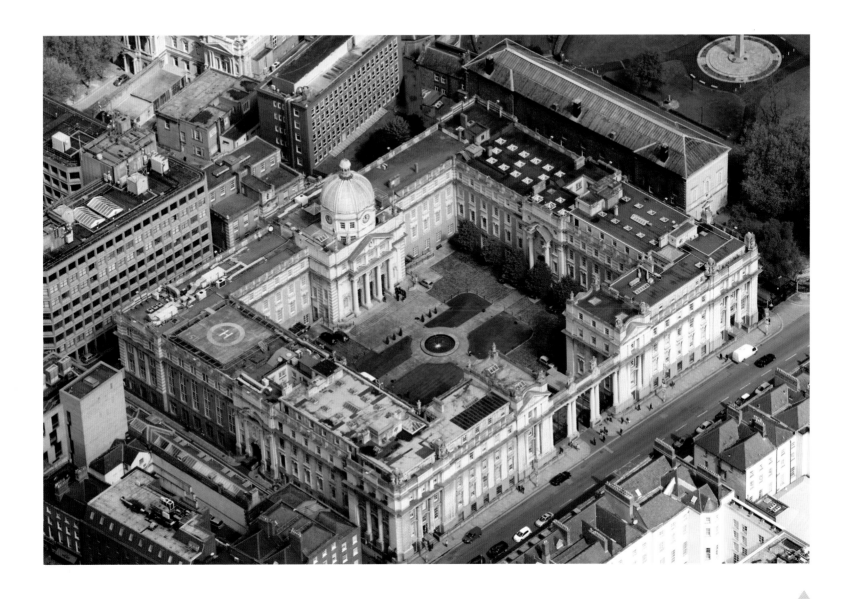

Leinster House in Kildare Street houses Dáil Éireann, the national parliament of Ireland. Designed by architect Richard Cassells and completed in 1748, it was originally known as Kildare House.

Government Buildings. Designed by Sir Aston Webb and Sir Thomas Manly Deane in the Edwardian Grand Manner and faced in Portland stone, the building was formerly the Royal College of Science. It was converted to government offices in 1991.

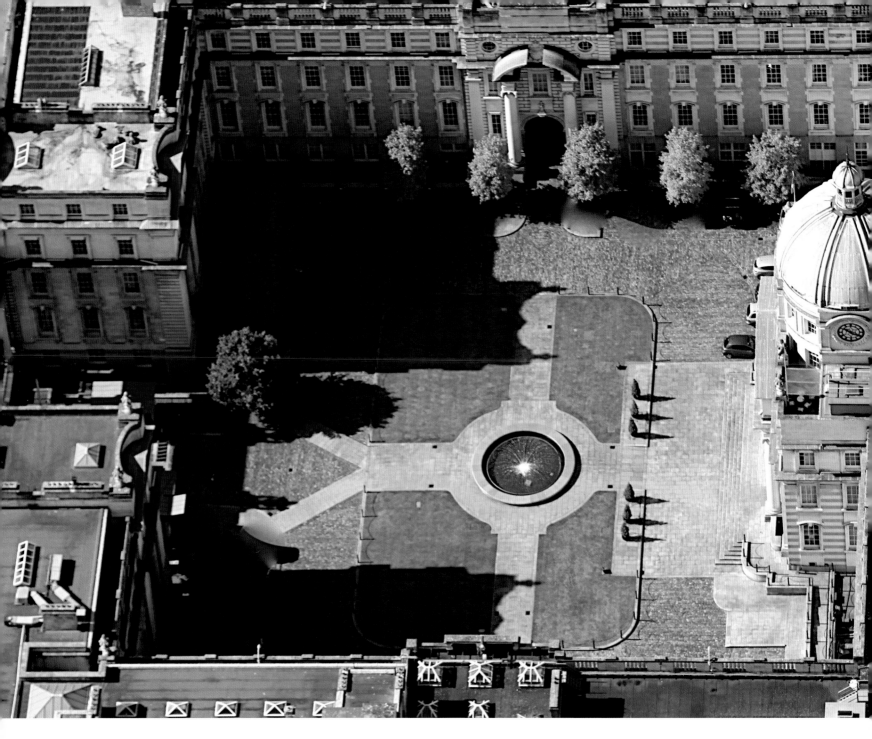

A closer look at the inner courtyard of Government Buildings.

National Concert Hall, Earlsfort Terrace. Built in 1865, it became the headquarters of University College Dublin in 1908. In 1981, the former examination hall was converted to the main auditorium of the National Concert Hall, seating 1,200.

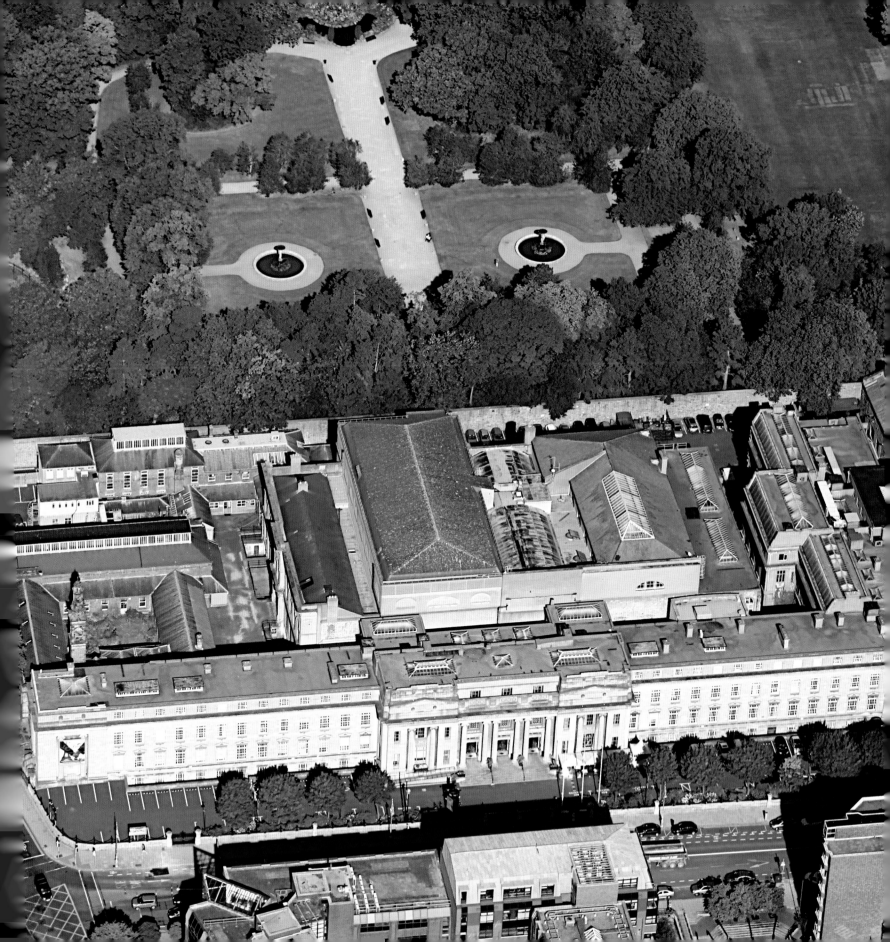

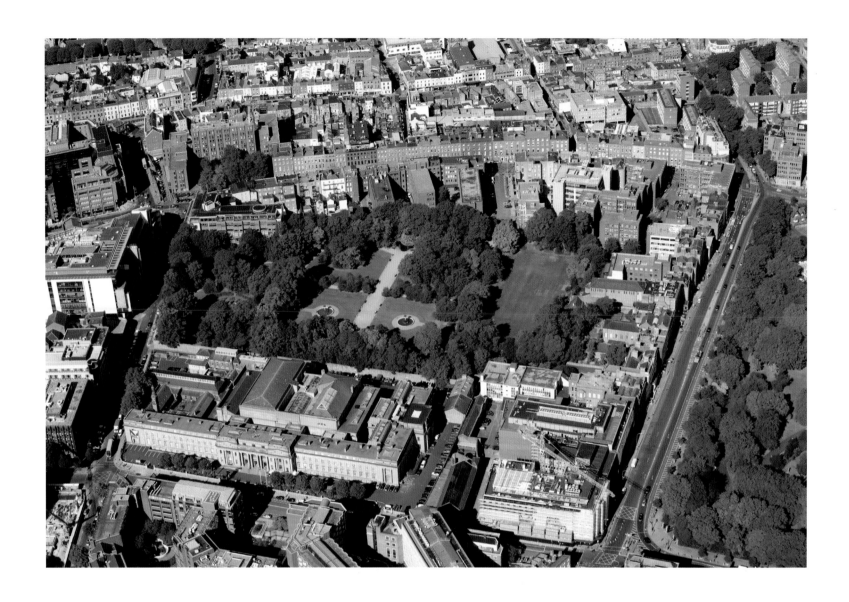

Designed by landscape architect Ninian Niven in 1865, the
Iveagh Gardens are considered to be amongst the city's finest.
The gardens are popular with visitors and natives alike.

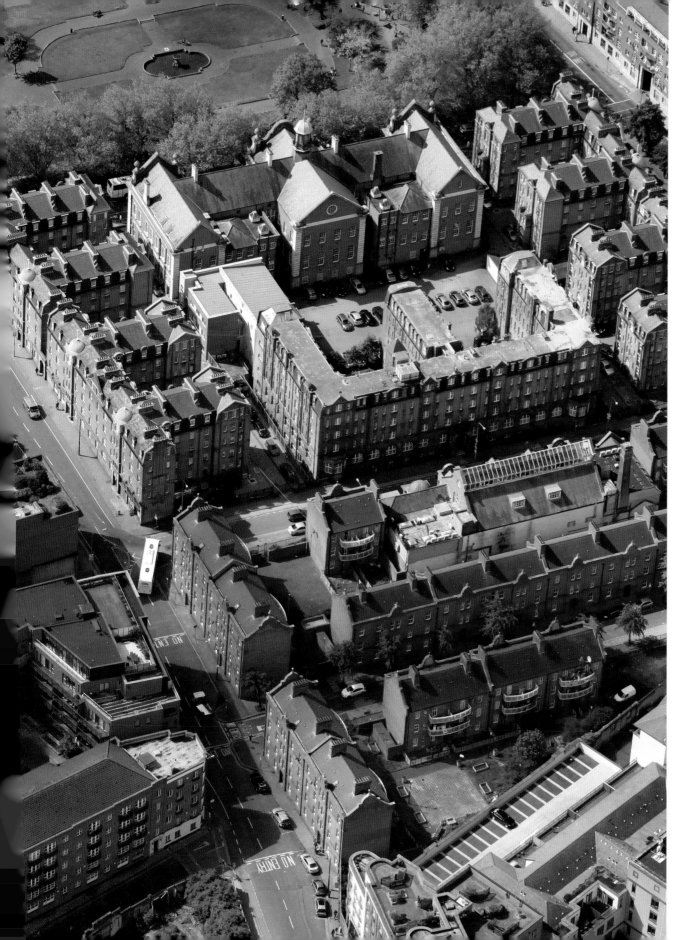

The Iveagh Trust
buildings were
constructed in
1901 by Sir Edward
Guinness and are to
this day administered
by the Trust. They are
located close to St
Patrick's Cathedral.

141

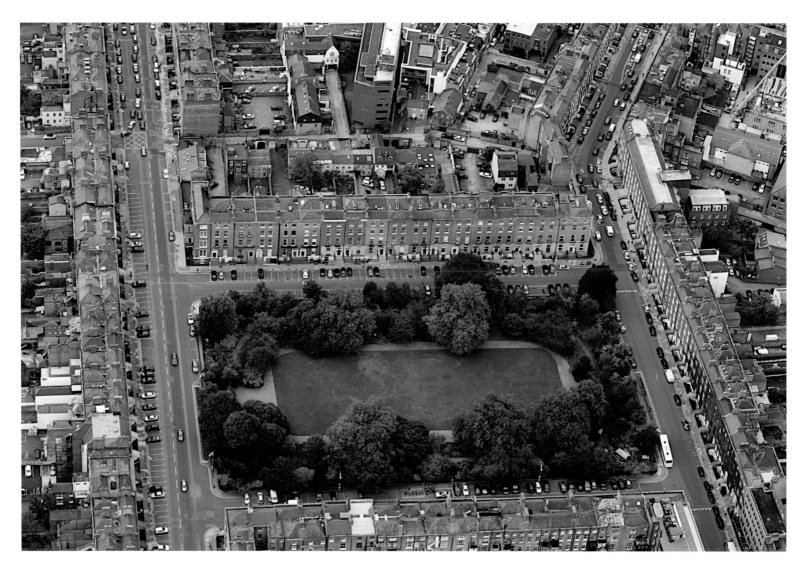

Fitzwilliam Square with its elegant houses was one of the last Georgian squares to be laid out in Dublin. It was developed in the early nineteenth century and is privately owned.

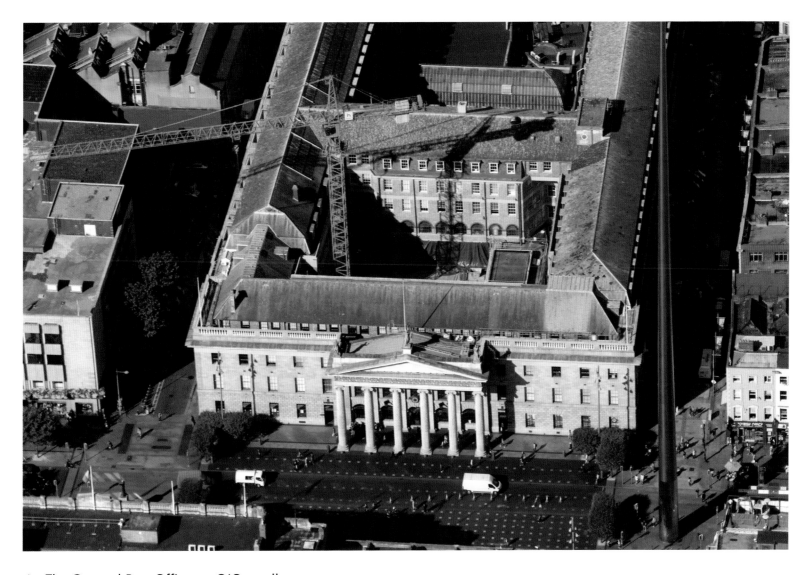

The General Post Office on O'Connell Street is indelibly linked with the 1916 Rising and the events that culminated in the emergence of an independent Irish state. The foundation stone was laid on 12 August 1814.

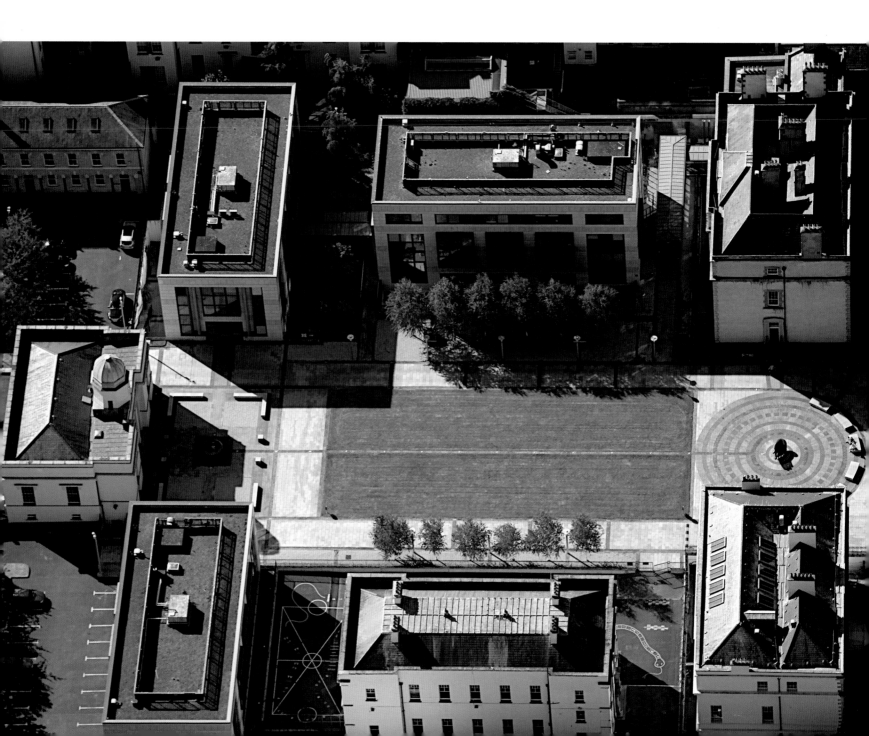

The Department of Education and
Skills on Marlborough Street.

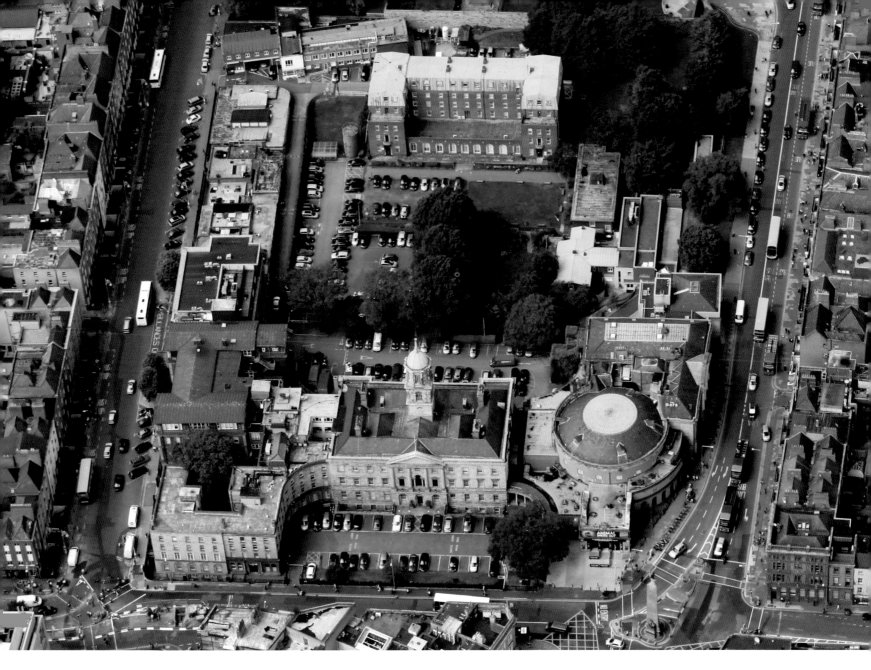

Founded in 1748, the Rotunda was the first maternity hospital in Ireland and for a time was the world's largest hospital devoted to maternity care. The building was designed by architect Richard Cassels, who also designed Leinster House.

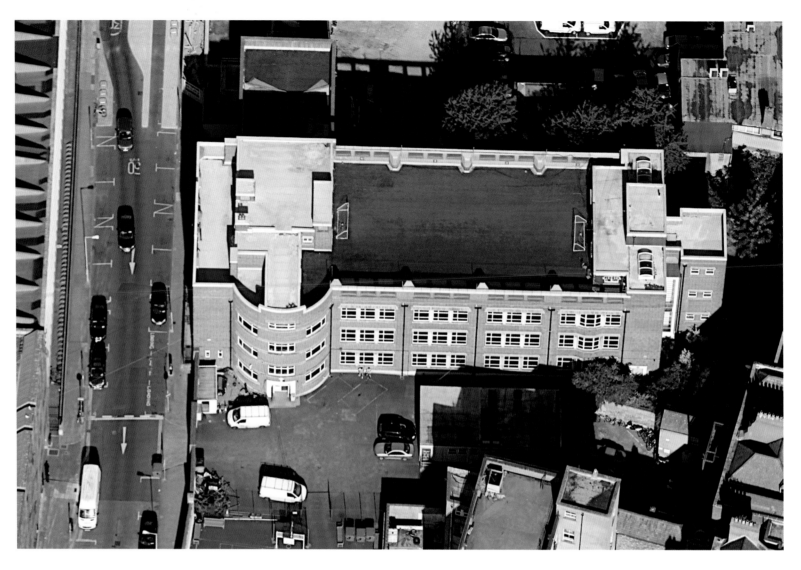

▲ Mount Carmel Secondary School in Bolton Street have made good use of their roof by installing a hockey pitch.

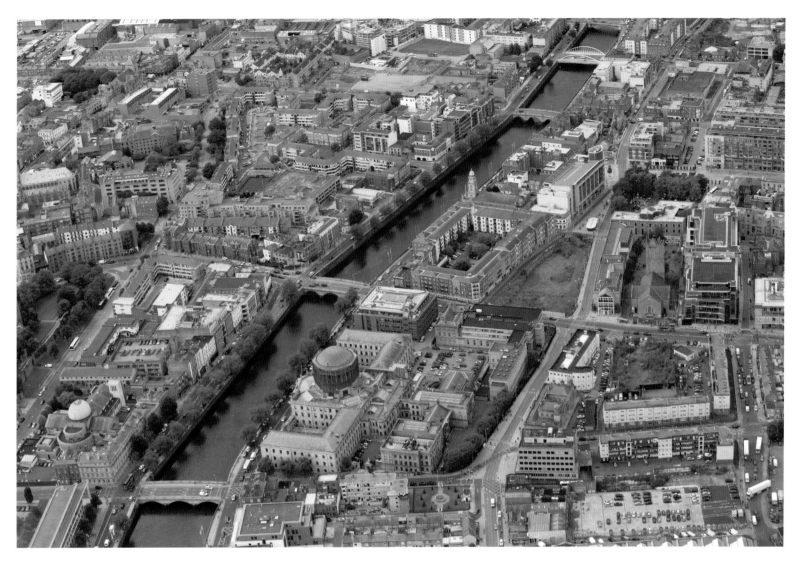

Looking southwest over the Liffey: the Four Courts is on the right of the river, with the green dome of the Church of St Adam's and St Eve's on the left. The Liffey bridges are (from foreground): O'Donovan Rossa Bridge, Father Mathew Bridge, Mellows Bridge, James Joyce Bridge and Rory O'More Bridge.

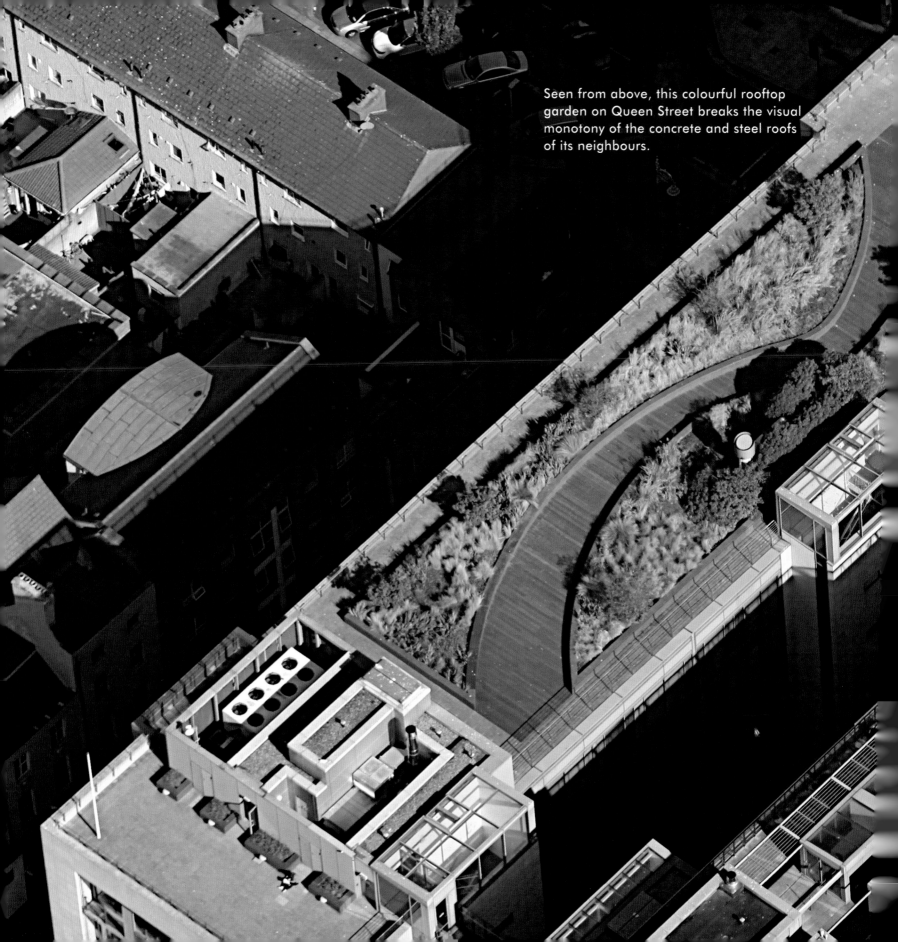

Seen from above, this colourful rooftop garden on Queen Street breaks the visual monotony of the concrete and steel roofs of its neighbours.

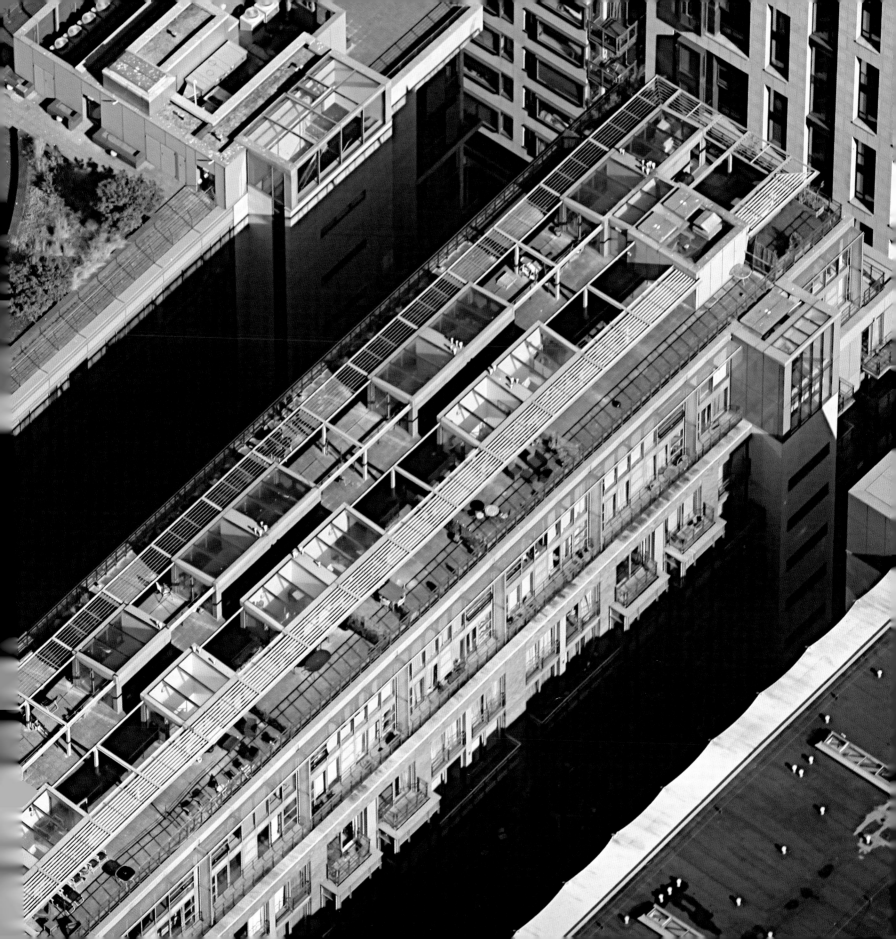

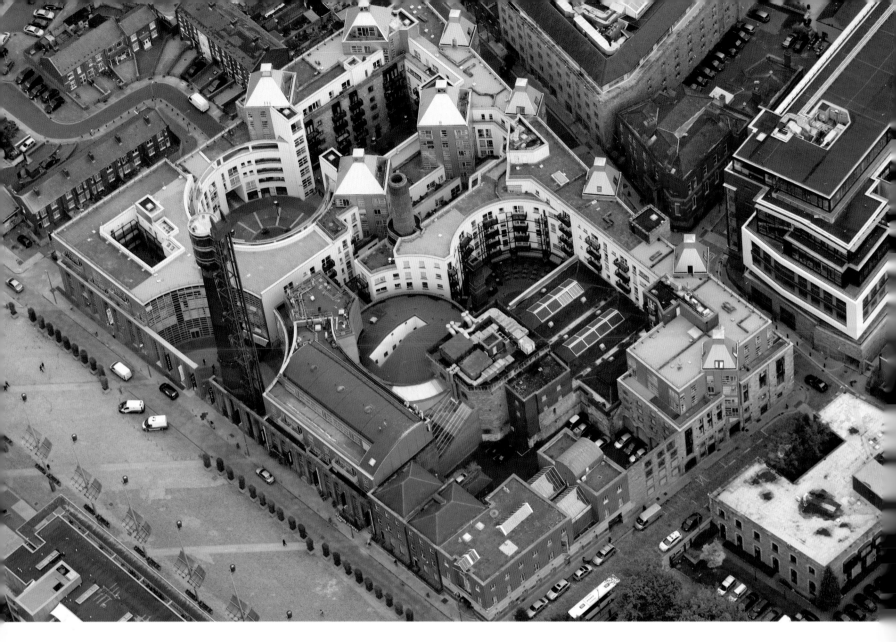

▲ The Old Jameson Distillery in Smithfield is one of the city's top visitor attractions and is set in the grounds of John Jameson's original distillery, founded in 1780.

In the heart of the city and close to the Four Courts, this brightly coloured playground stands out from its grey surroundings.

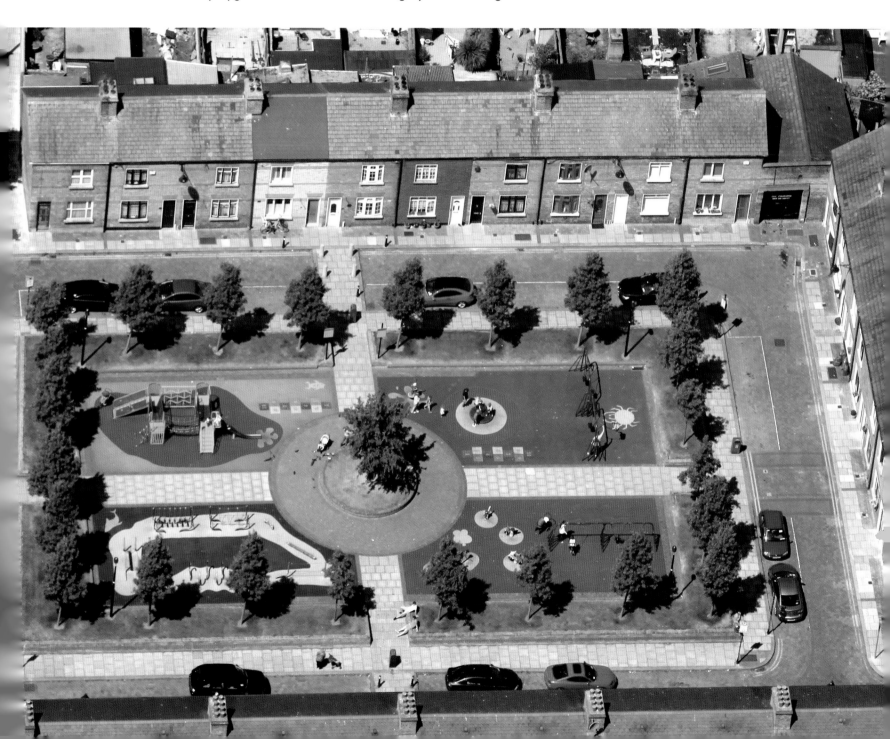

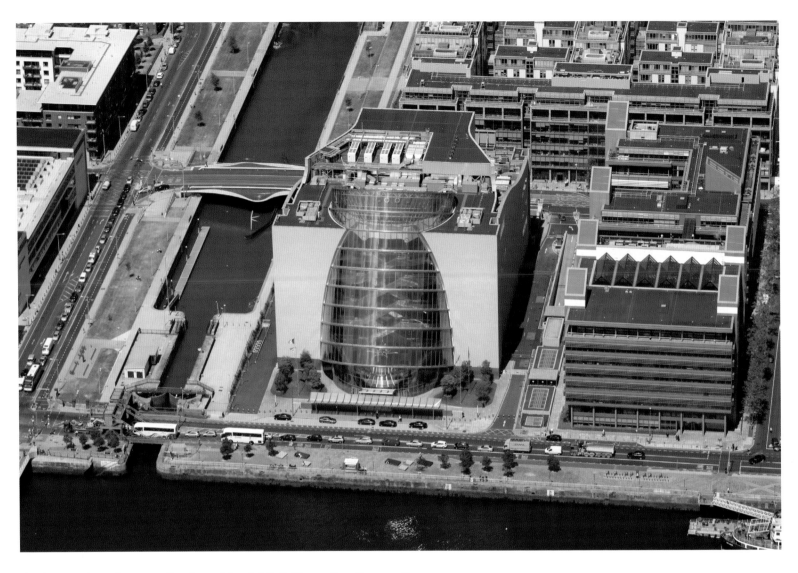

Located on Spencer Dock on North Wall Quay, the Convention Centre Dublin is a state-of-the-art conference and event venue. It was designed by American-Irish architect Kevin Roche and can hold up to 8,000 people.

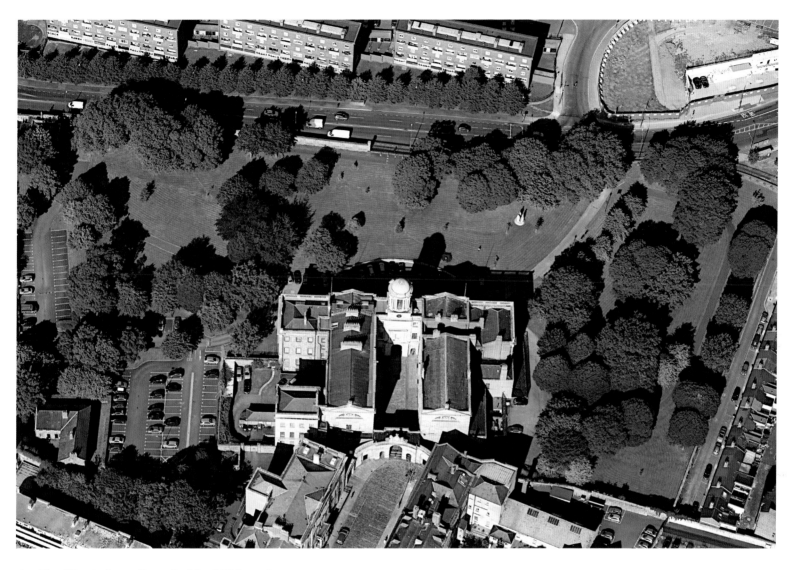

The King's Inns. Founded in 1591 and
designed by James Gandon, the King's Inns
is Ireland's oldest School of Law.

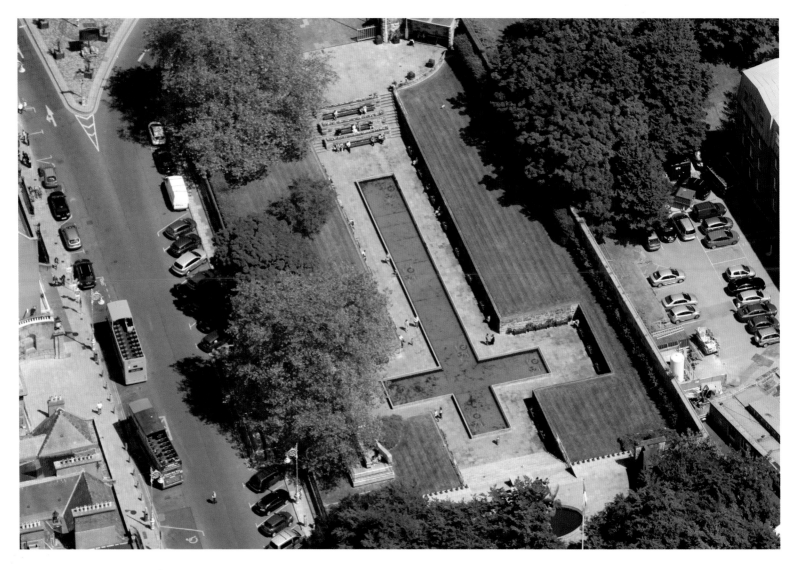

The Garden of Remembrance, at the
northern end of Parnell Square, was
opened on the fiftieth anniversary of the
Easter Rising of 1916 and is a memorial
to all those who gave their lives for Irish
freedom.

Croppies' Acre, the memorial park ▶
honouring the fallen of the 1798 Rebellion,
is part of the National Museum at nearby
Collins Barracks.

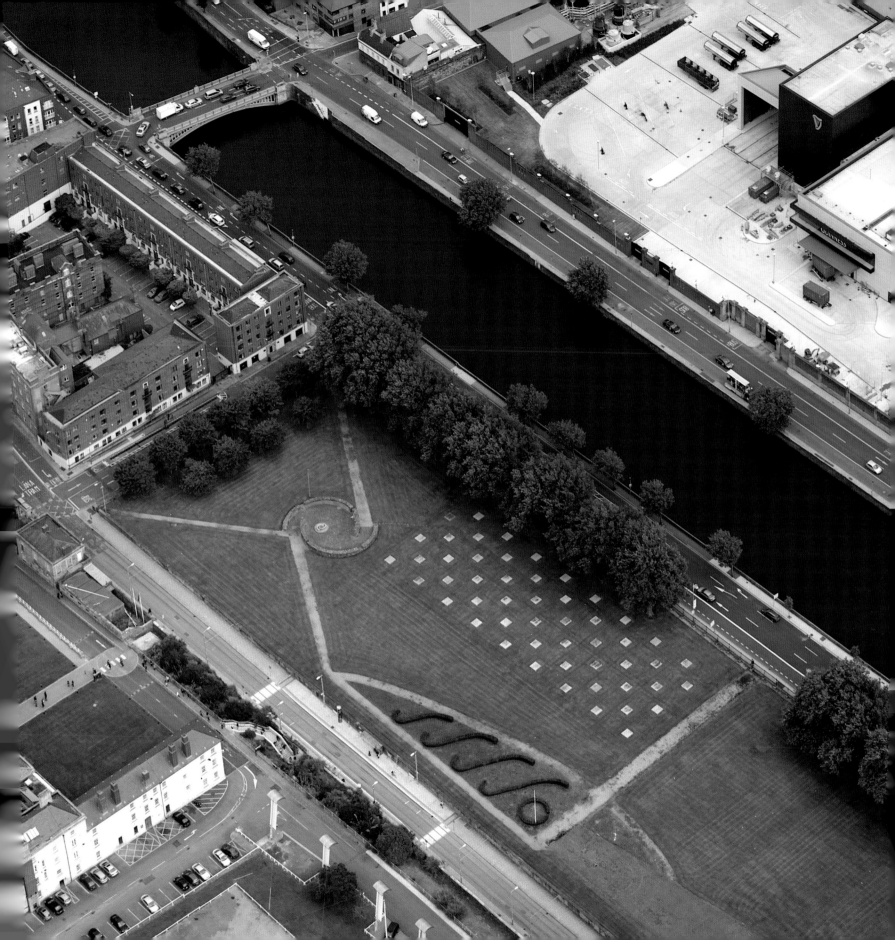

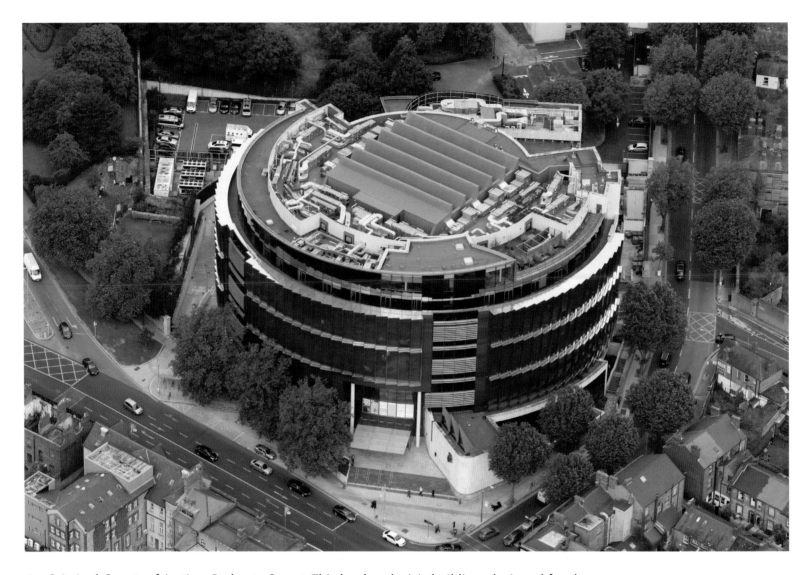

▲ Criminal Courts of Justice, Parkgate Street. This landmark civic building, designed for the administration of criminal justice, has over 400 rooms, including twenty-two courtrooms, and was completed in 2010.

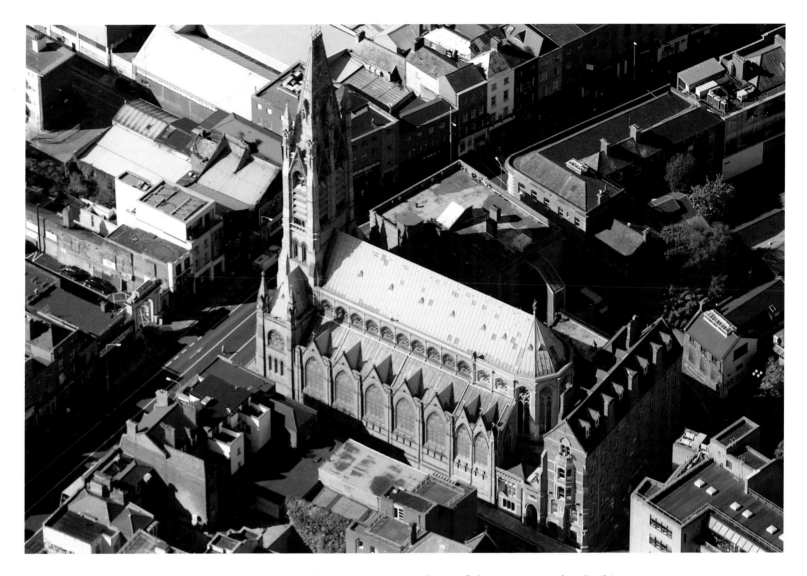

The Church of St Augustine and St John on Thomas Street is a beautiful structure in the Gothic Revival style. The spire is an imposing 68 metres/223 feet high. The church opened in 1874 on the site of St John's Hospital and is served by the Augustinian Order.

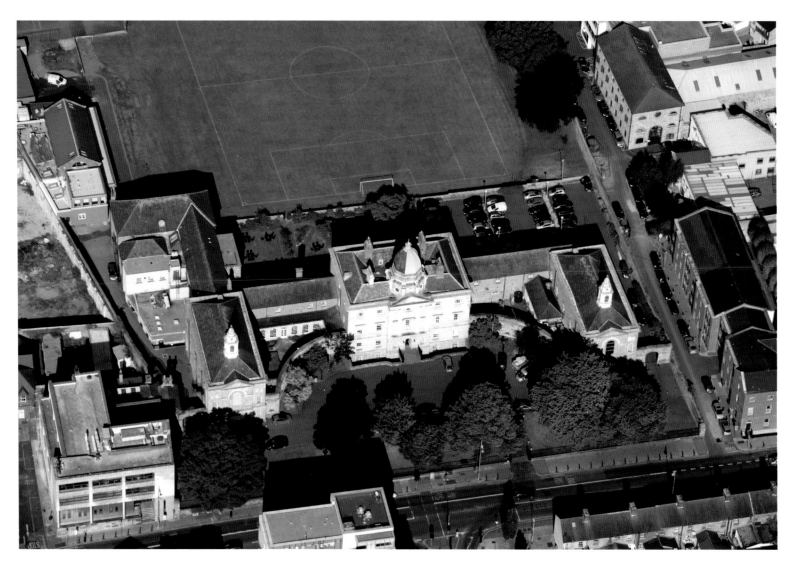

▲ No. 7 Blackhall Place. Home since 1978 to the Law Society of Ireland, the building was originally the King's Hospital or Blue Coat School until 1968. The Law Society acquired the building in 1971.

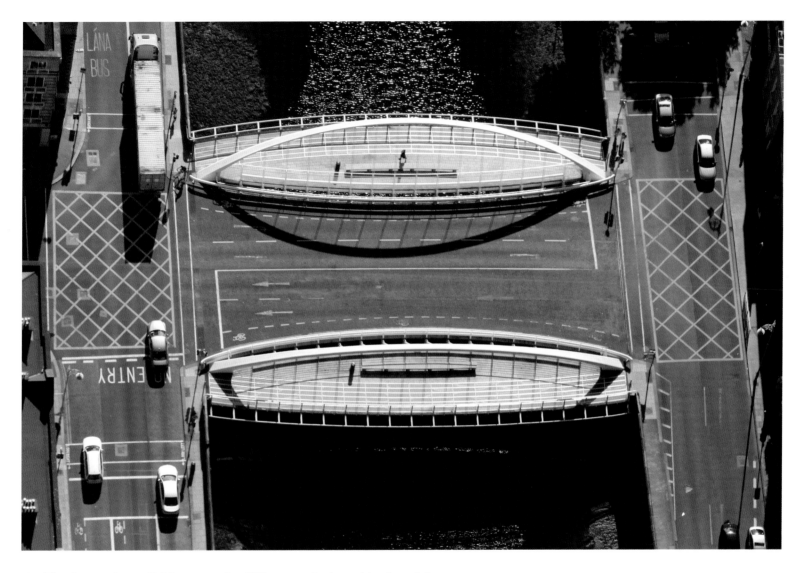

The James Joyce Bridge over the Liffey was designed by Spanish architect/engineer Santiago Calatrava, linking Ellis Quay to Usher's Island with a span of over 40 metres. It was opened in 2003.

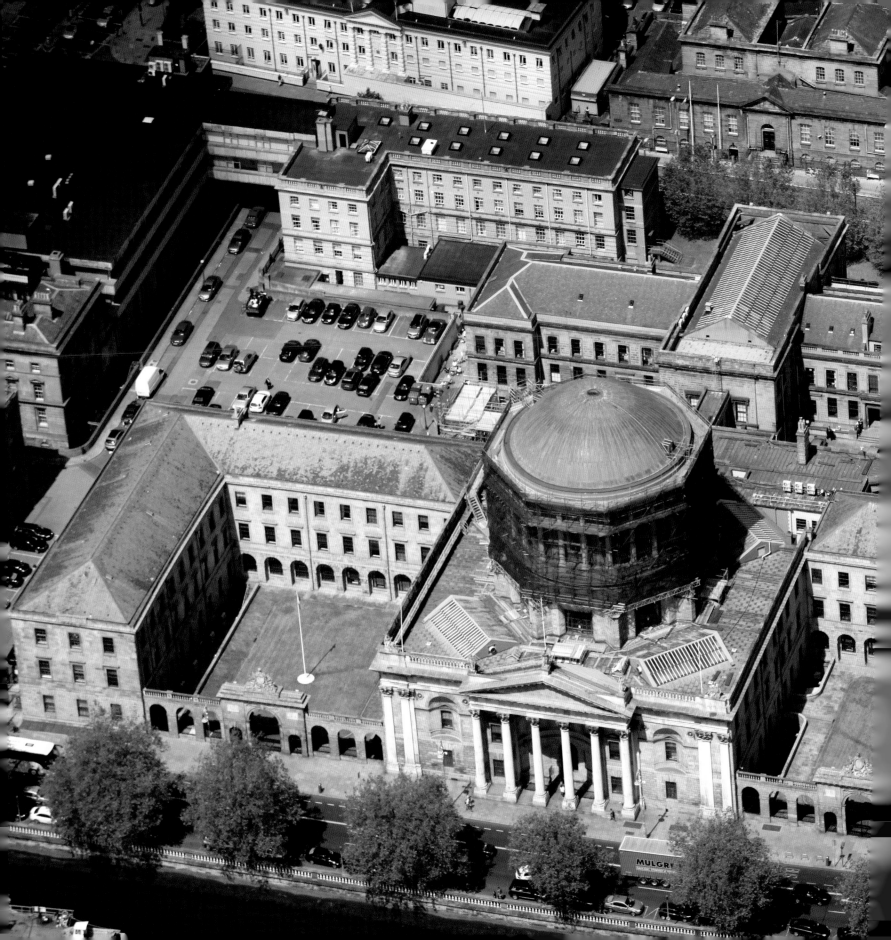

The Four Courts on Inns Quay, with its large drum-style dome, is visible all along the River Liffey. It was designed by James Gandon and is Ireland's main court building.

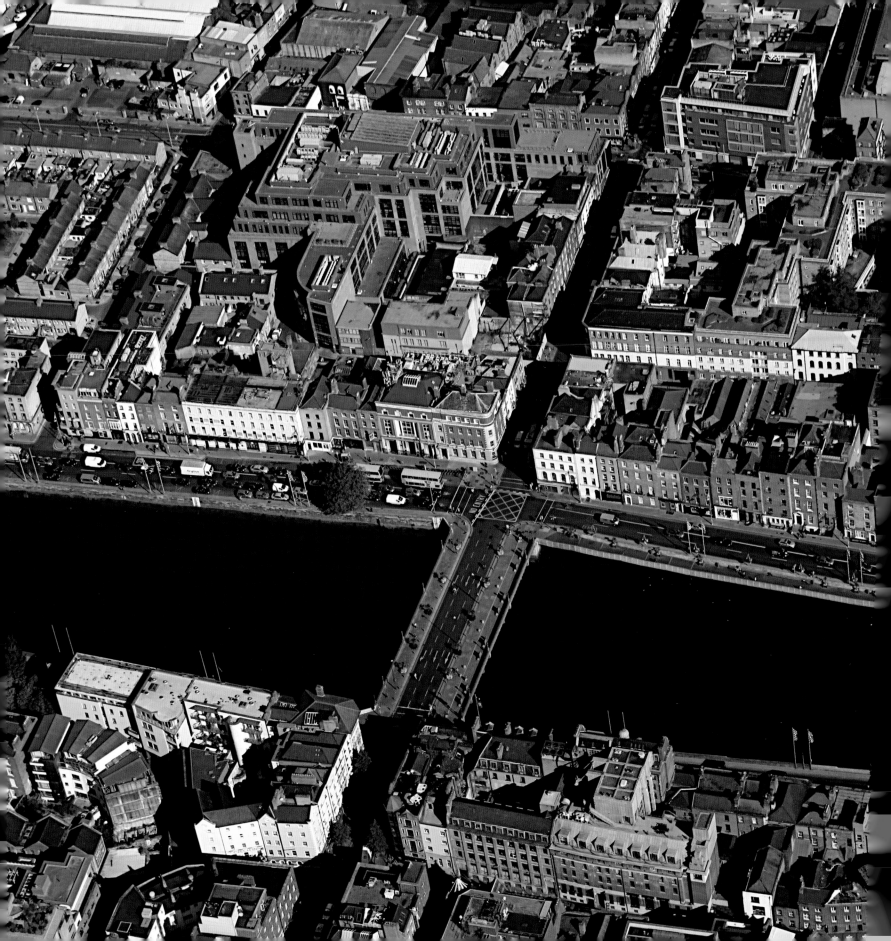

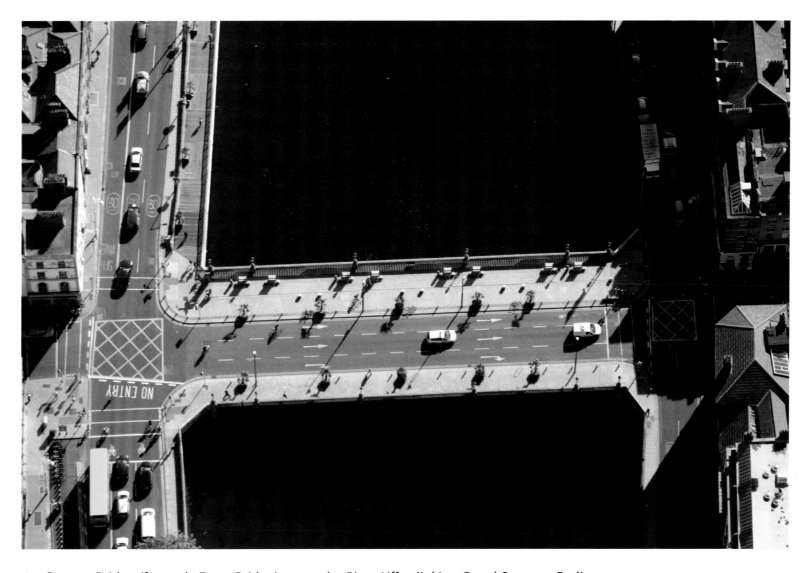

Grattan Bridge (formerly Essex Bridge) spans the River Liffey linking Capel Street to Parliament Street and the south quays. It is named after Henry Grattan MP (1746–1820).

Grattan Bridge looking north towards Ellis Quay.

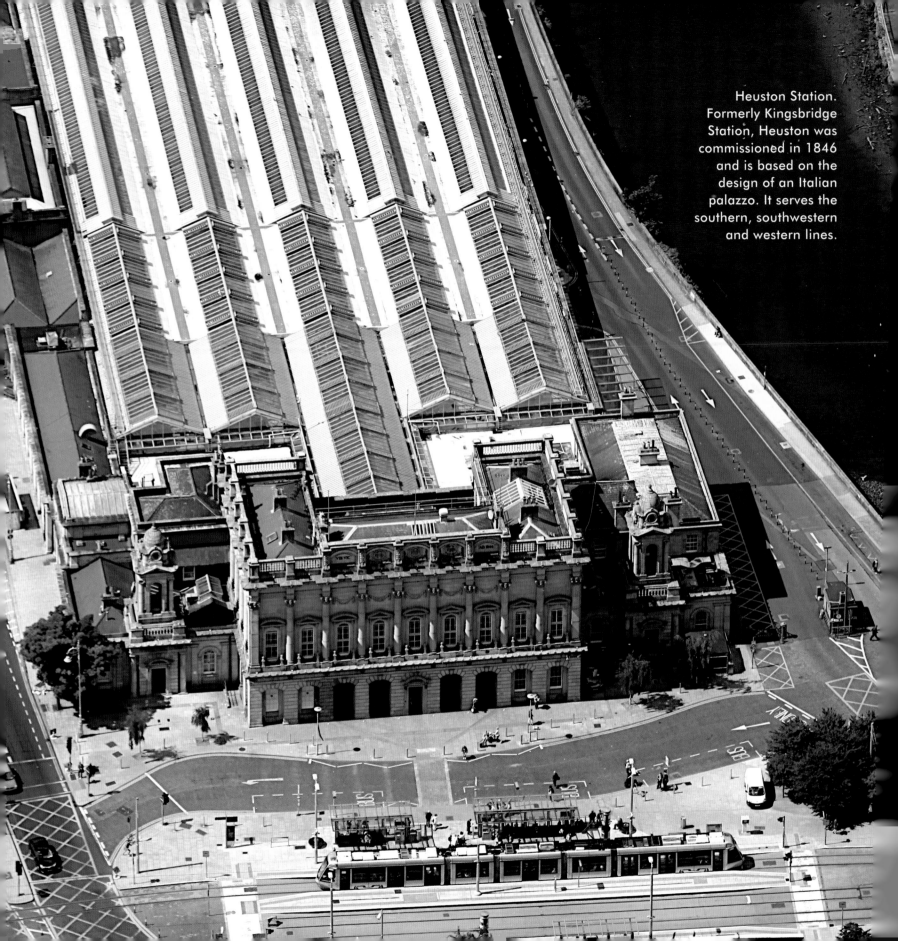

Heuston Station. Formerly Kingsbridge Station, Heuston was commissioned in 1846 and is based on the design of an Italian palazzo. It serves the southern, southwestern and western lines.

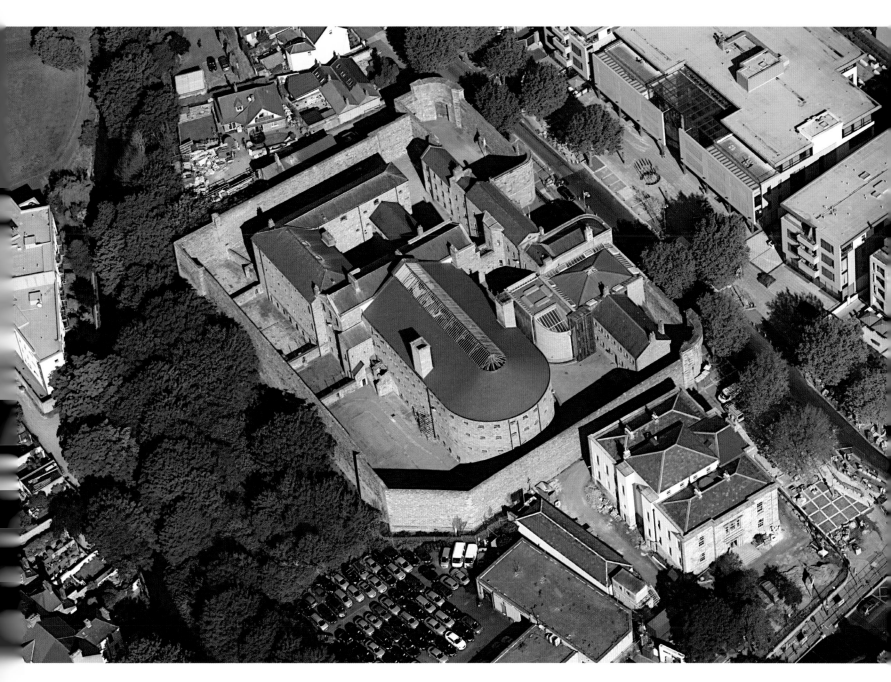

▲ Kilmainham Gaol is inextricably linked with Ireland's emergence as a modern nation. It is now a visitor centre incorporating a major exhibition detailing the prison's penal and political history.

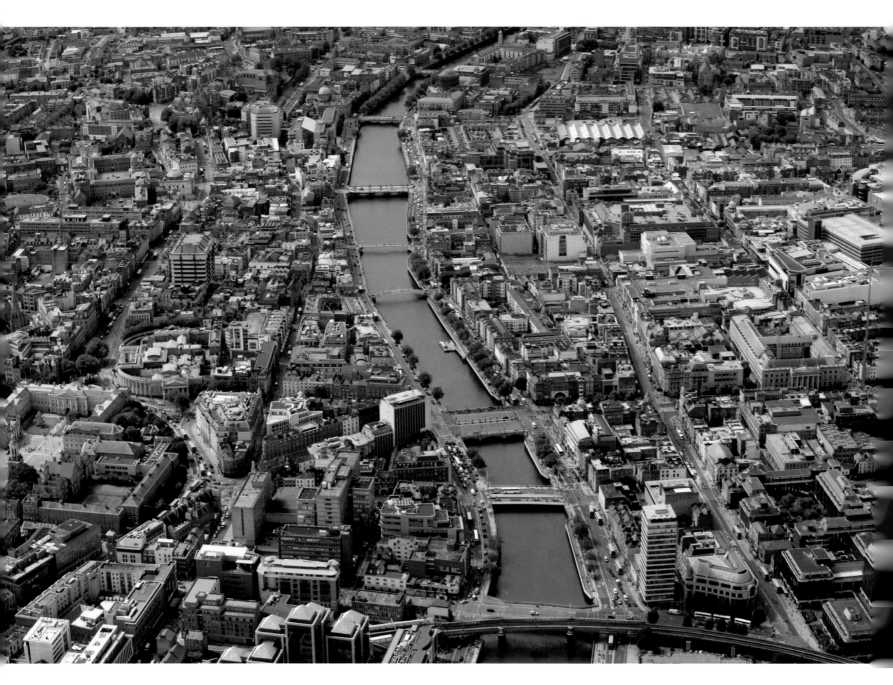

▲ Dublin is a city of many bridges and this perspective looking west along the Liffey shows (from foreground): the Loopline Bridge and Butt Bridge, Rosie Hackett Bridge, O'Connell Bridge, Ha'penny Bridge, Millennium Bridge, Grattan Bridge, O'Donovan Rossa Bridge and Fr Mathew Bridge.

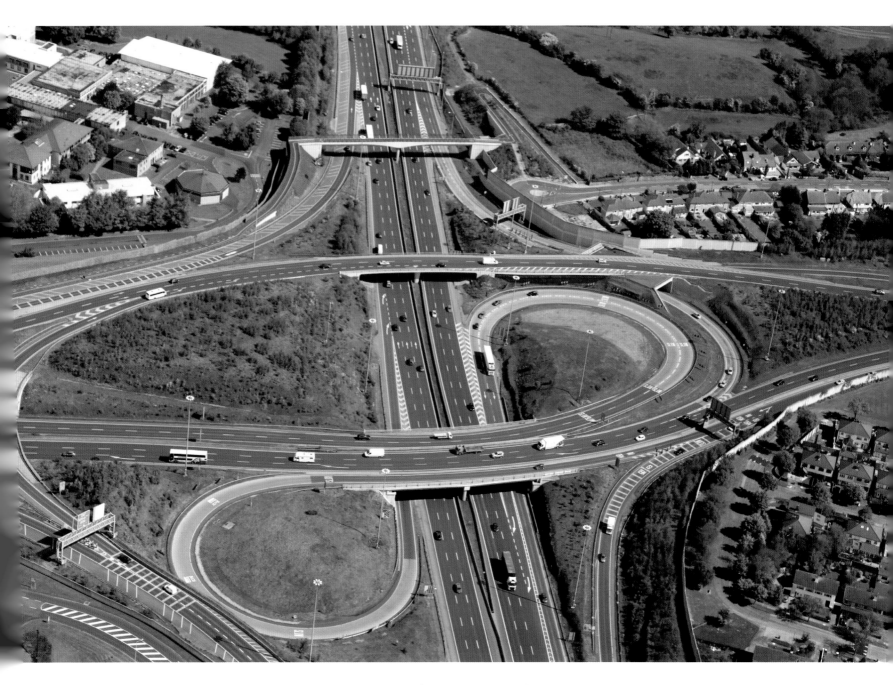

Palmerstown Roundabout weaves an intricate pattern of interlinking roads, with the M50 cutting through the centre.

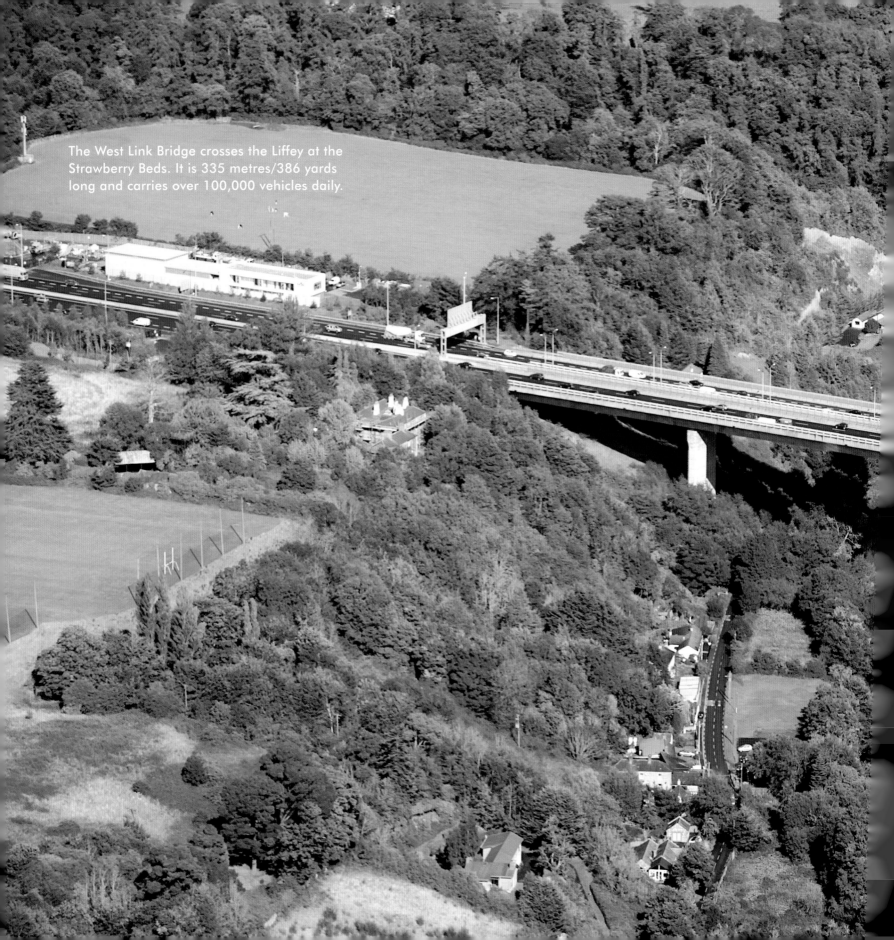

The West Link Bridge crosses the Liffey at the Strawberry Beds. It is 335 metres/386 yards long and carries over 100,000 vehicles daily.

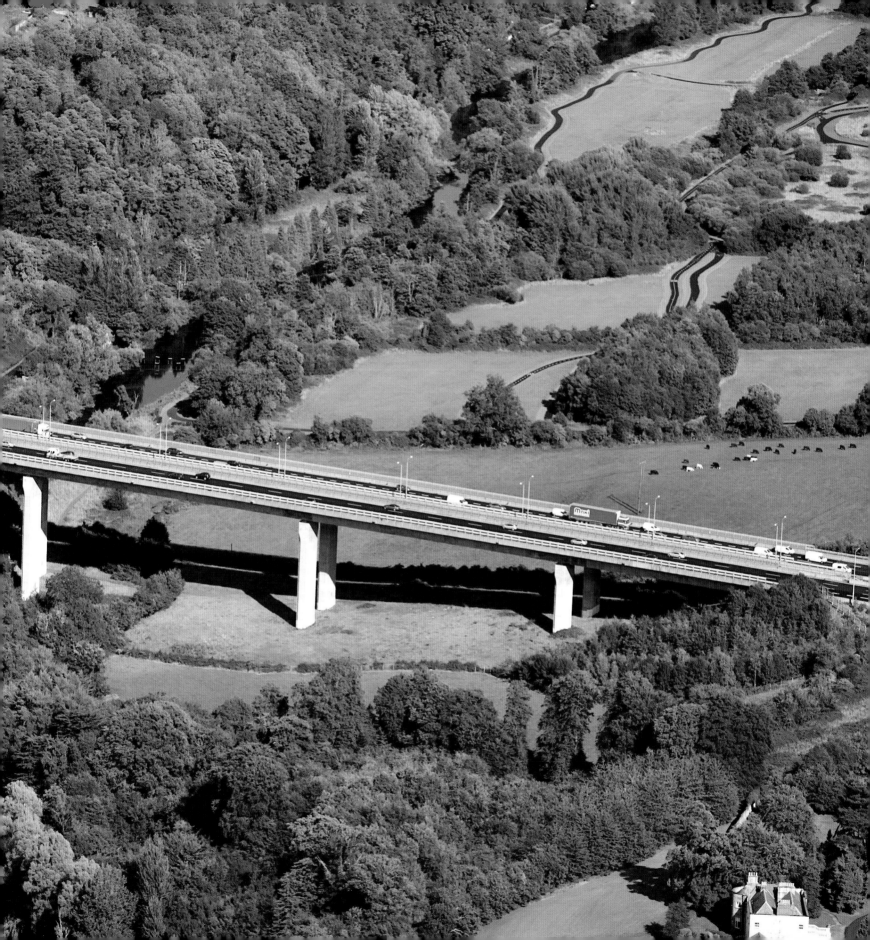

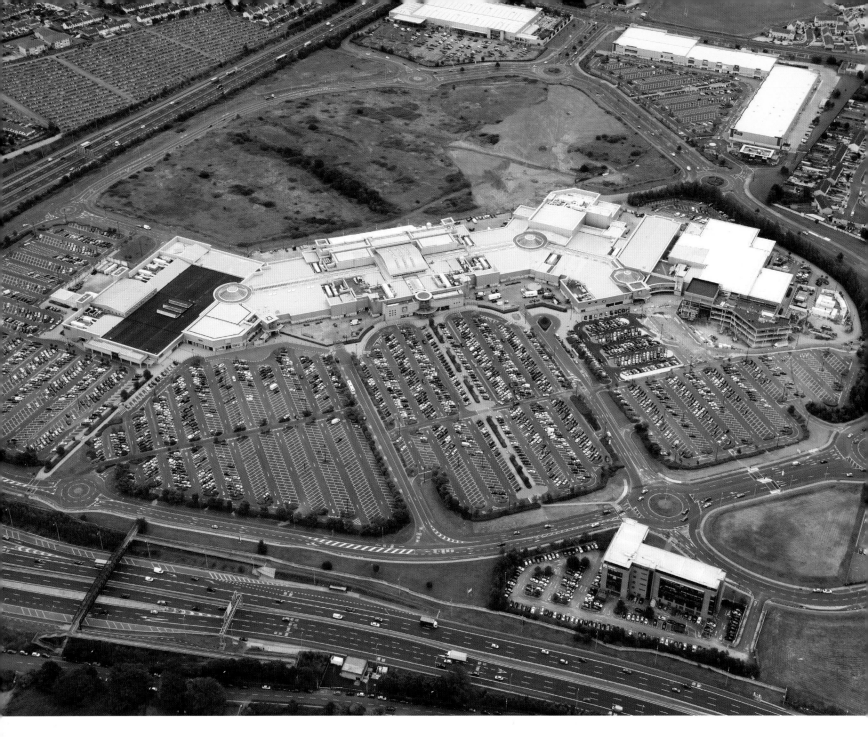

▲ Located off the M50 near Lucan, Liffey Valley Shopping Centre was opened in 1998. It is Dublin's second largest shopping centre.

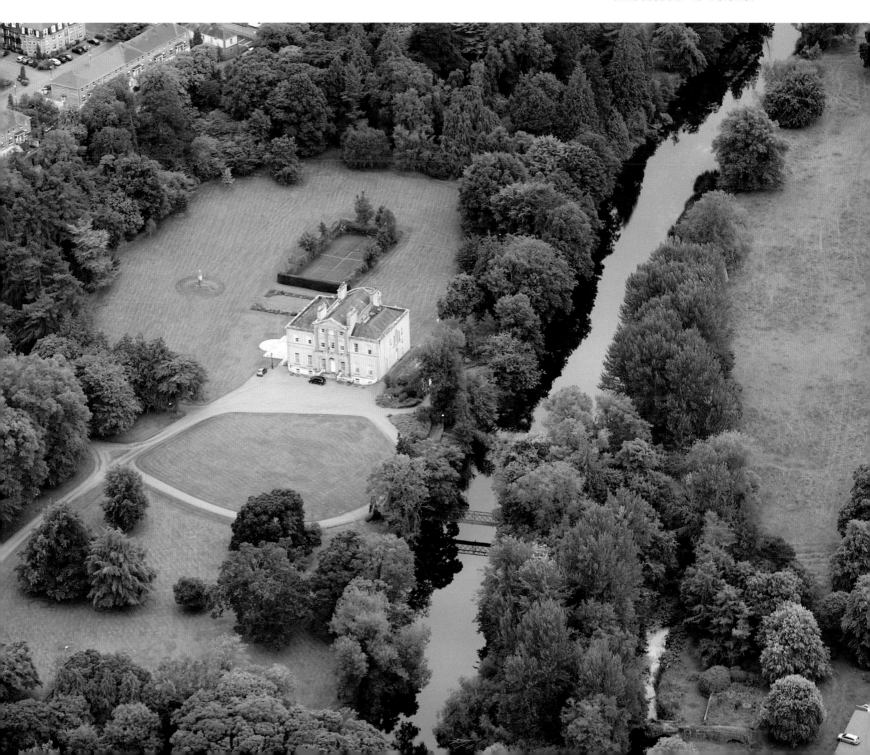

Lucan House dates from 1772 and is situated in Lucan village. It is the official residence of the Italian ambassador to Ireland.

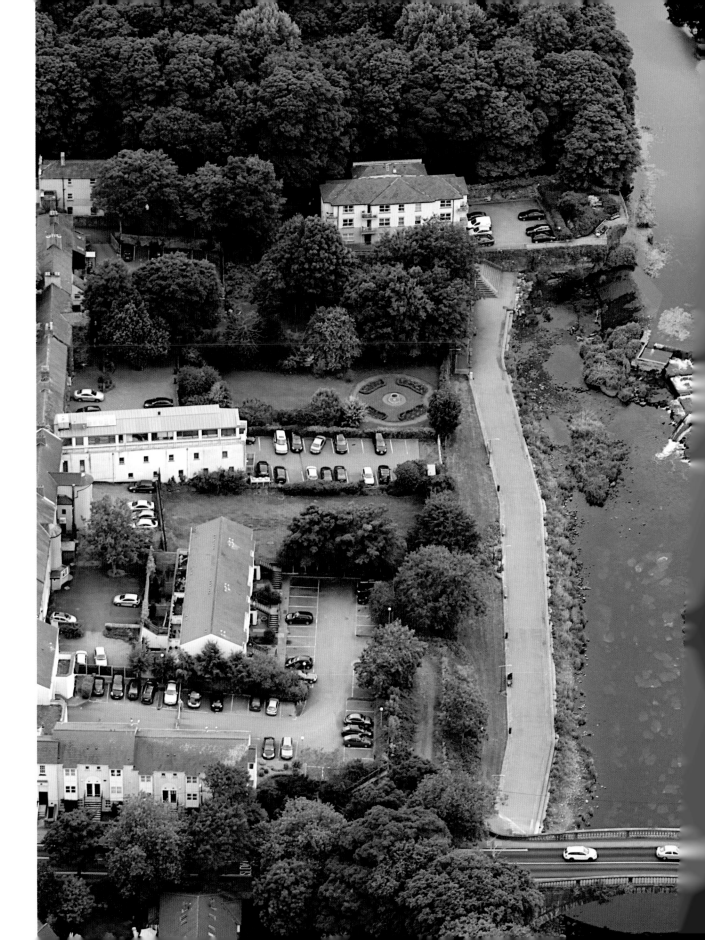

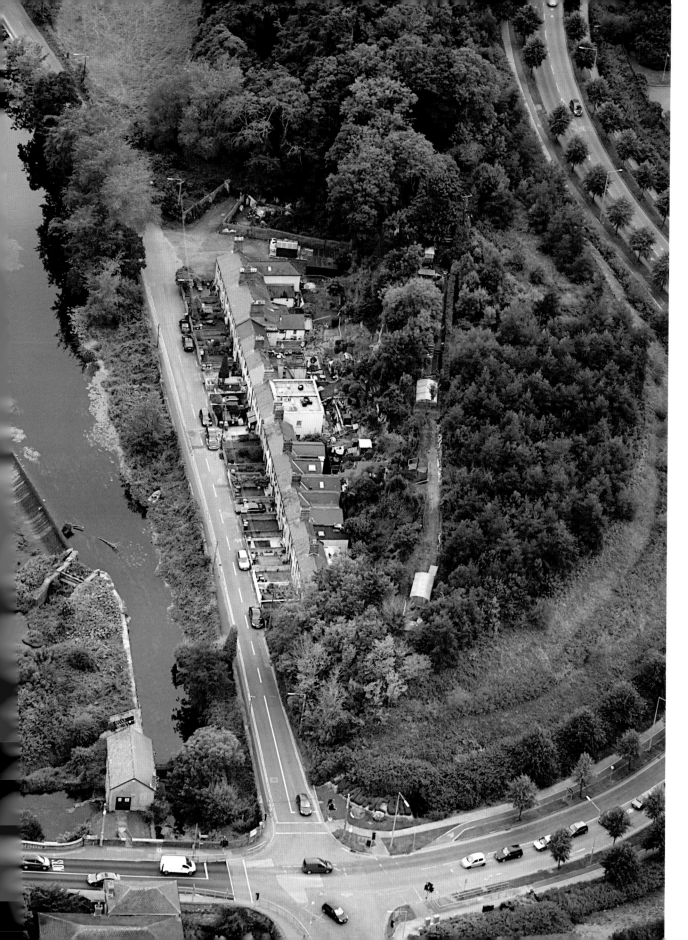

The County Dublin town of Lucan has a picturesque weir and a road bridge which spans the River Liffey.

▲ A lone tree in a field near Lucan in west County Dublin.

Luttrelstown Castle, near Clonsilla, dates from medieval times and ▷
was designed in the Gothic style. Later development of the castle was
undertaken in 1940–1950 by a member of the Guinness family.

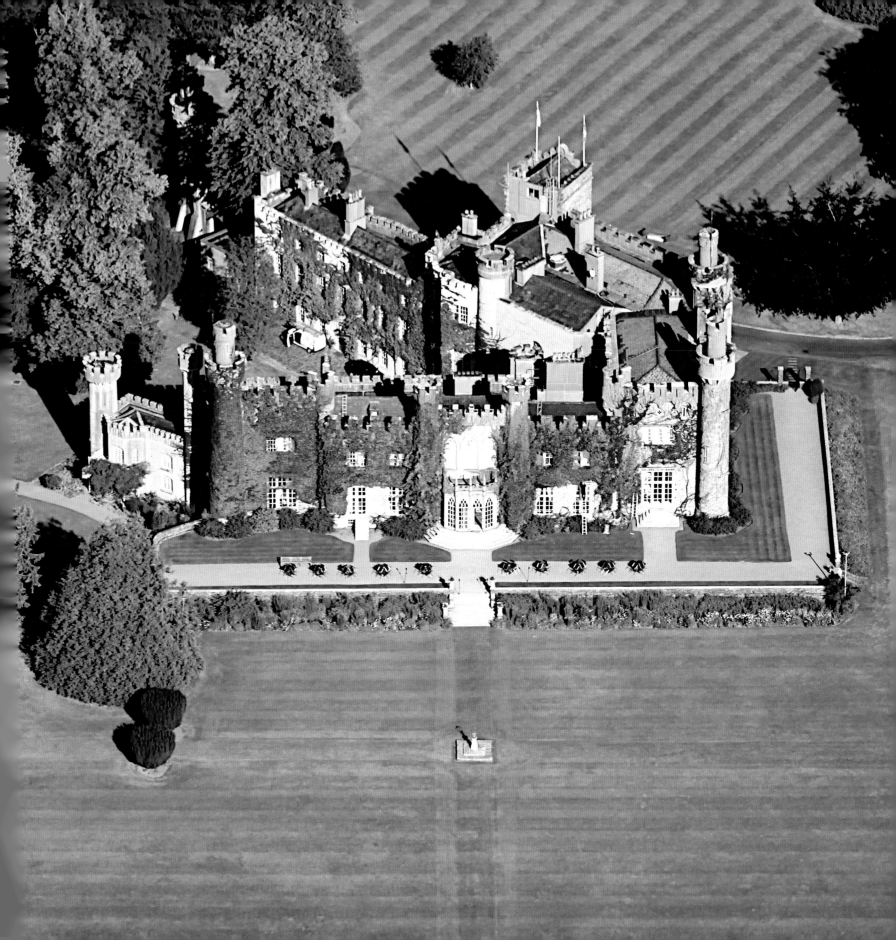

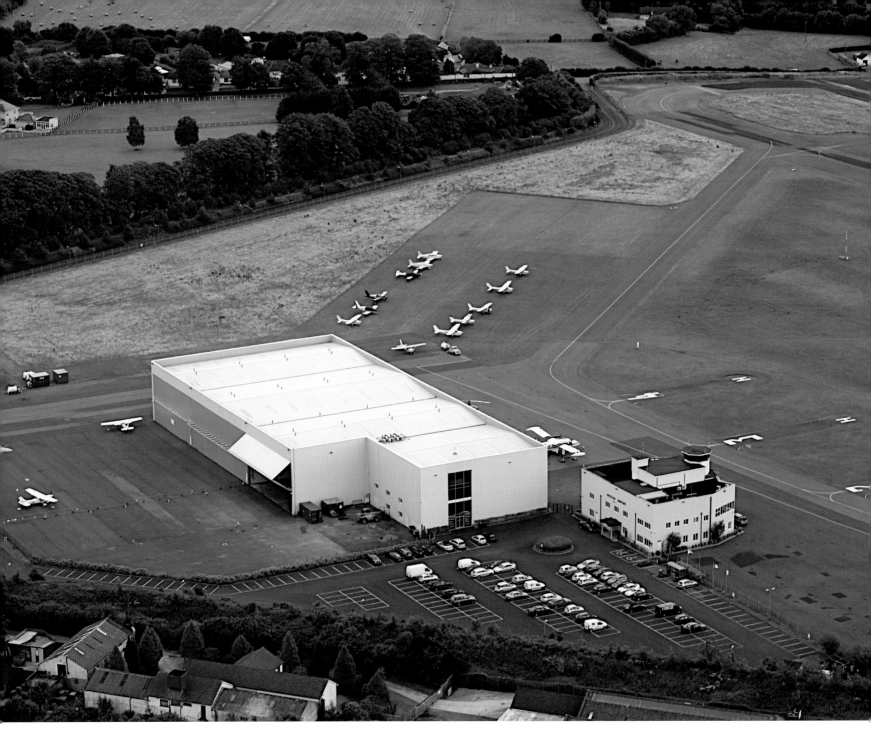

▲ Located near Celbridge, Weston Airport has its origins as an aerodrome founded in the 1930s. It was upgraded in the 1980s when a 3,000-foot/900-metre tarmac runway was laid. A number of flight schools, including National Flight Centre, are based here.

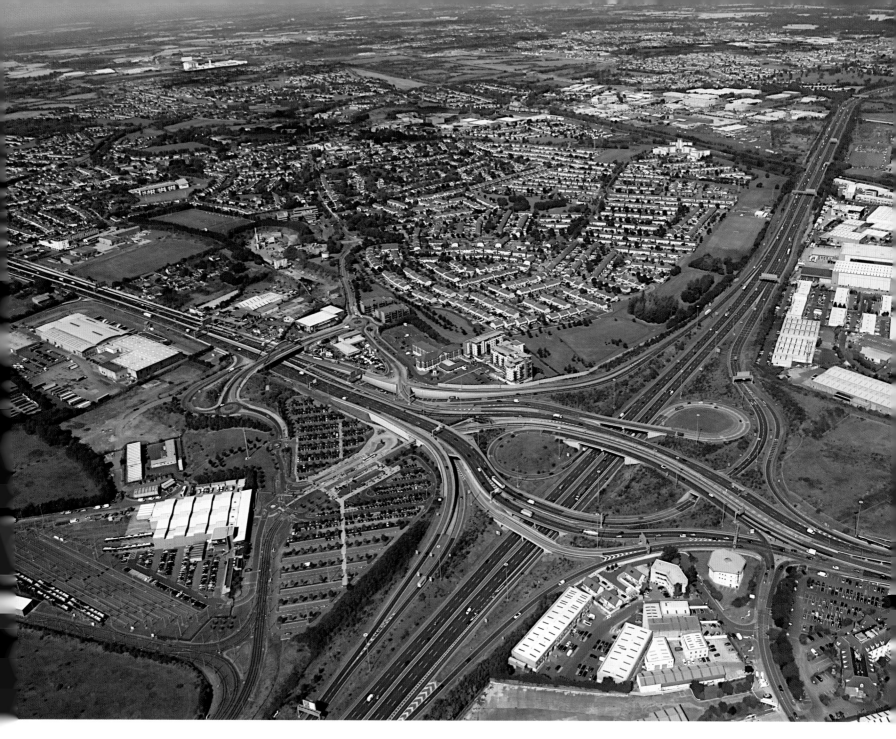

This high-level perspective of the Red Cow Interchange shows the intricate pattern of roads leading onto and off the M50. This junction is the busiest in Ireland and carries large volumes of traffic daily.

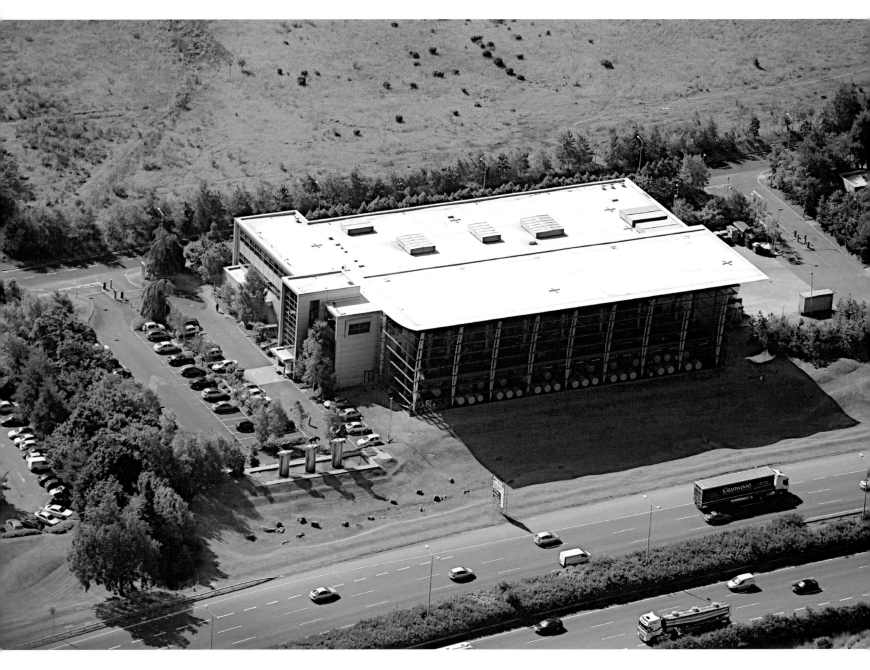

This landmark building with its glass facade and ultra-modern design is the headquarters of Independent News and Media and is located on the N7, south of Dublin city.

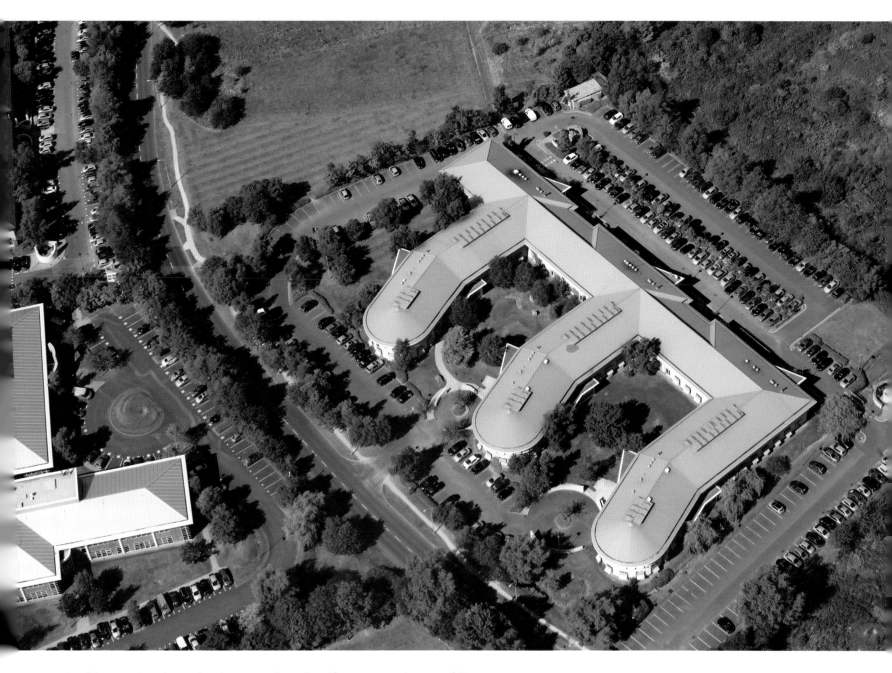

Citywest is a large business park and golf resort northwest of Saggart in County Dublin. Begun in 1990, it is home to some of Ireland's top companies, as well as Citywest Hotel, one of the country's largest hotels with 1,700 rooms.

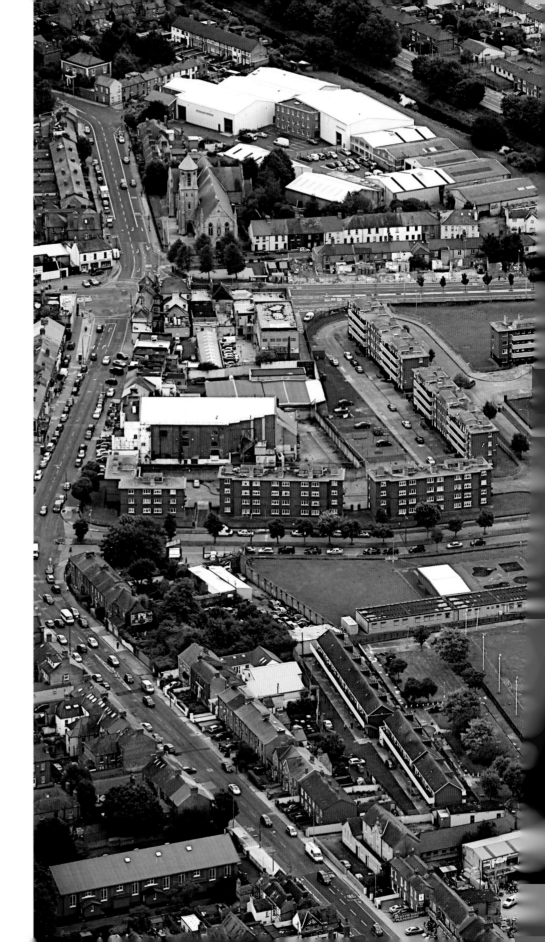

Dolphin's Barn. The Dolphin House complex along the banks of the Grand Canal comprises over 400 flats and was constructed in the 1950s.

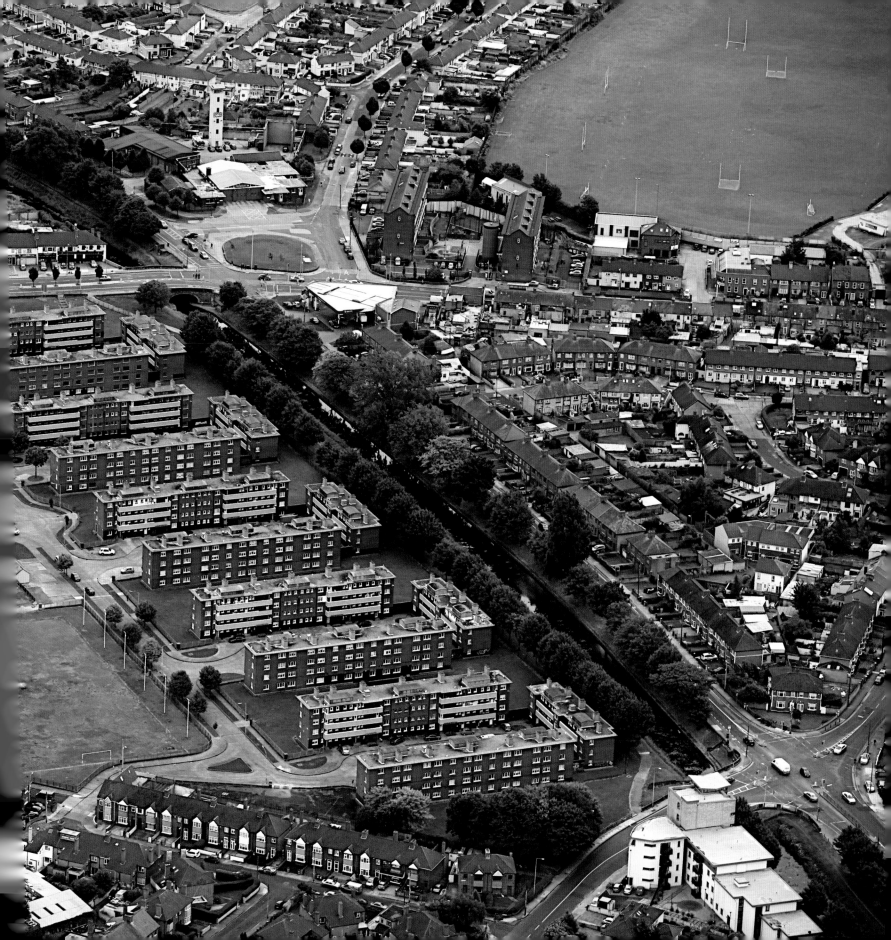

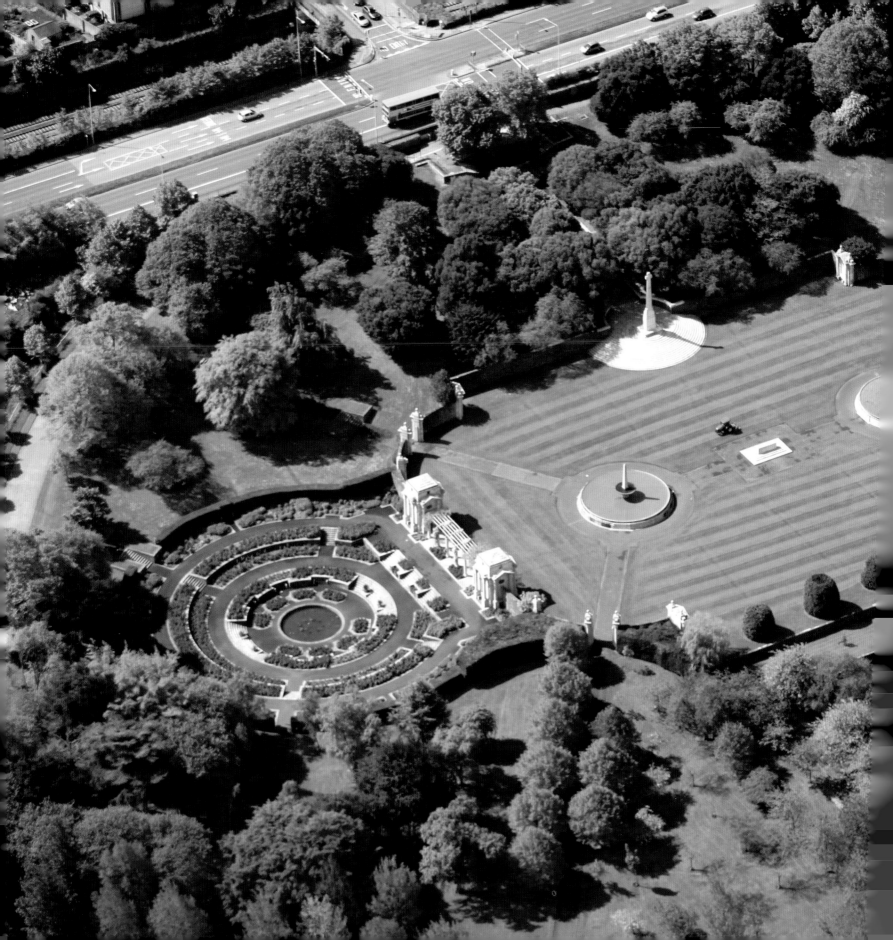

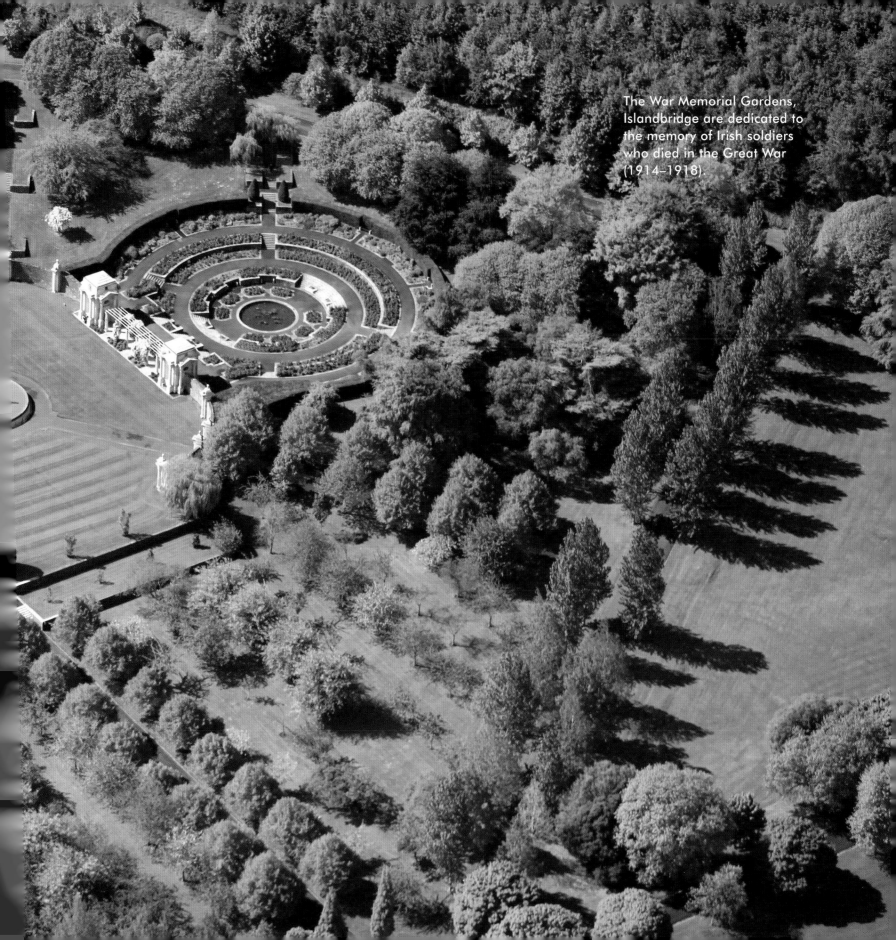

The War Memorial Gardens, Islandbridge are dedicated to the memory of Irish soldiers who died in the Great War (1914–1918).

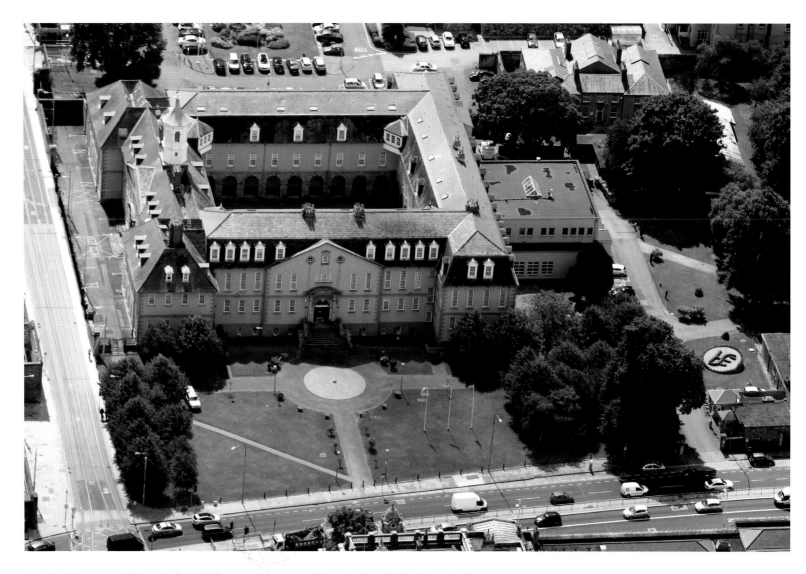

▲ Dr Steevens' Hospital. Building commenced in 1719 and the hospital opened in 1733. The design was by Thomas Burgh, Surveyor General, who claimed no fee for his work. It is now the headquarters of the Eastern Health Board.

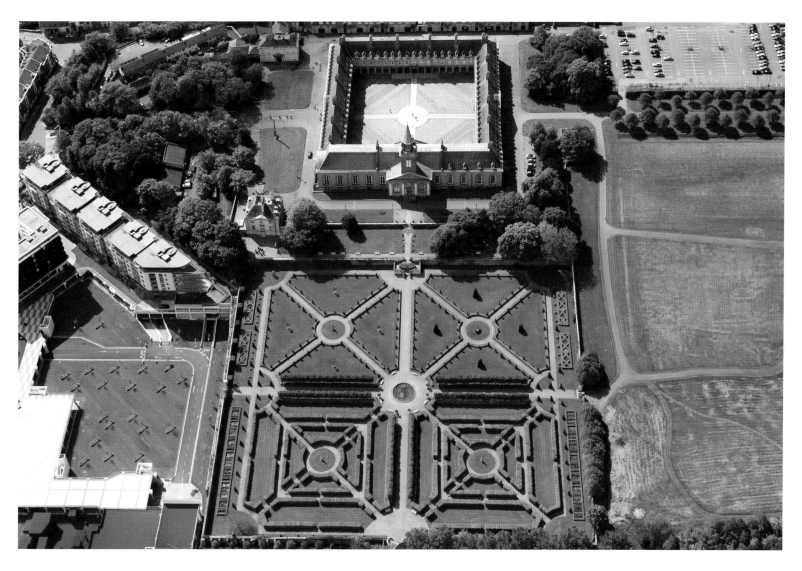

The Royal Hospital Kilmainham is considered to be one of the finest seventeenth-century Irish buildings and houses the Irish Museum of Modern Art. It is also a popular concert venue.

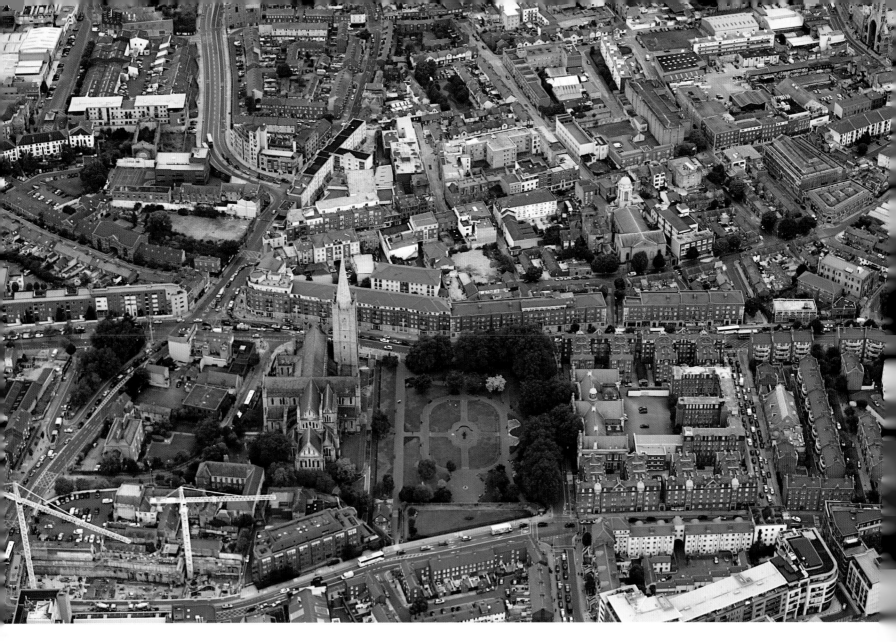

▲ This view shows St Patrick's Cathedral and gardens with
the distinctive red-brick Iveagh Buildings to the right.

St Patrick's Cathedral dates from 1220 and is the national cathedral of the Church of Ireland. Jonathan Swift,
author of *Gulliver's Travels,* was Dean of the Cathedral from 1713 to 1745. ▷

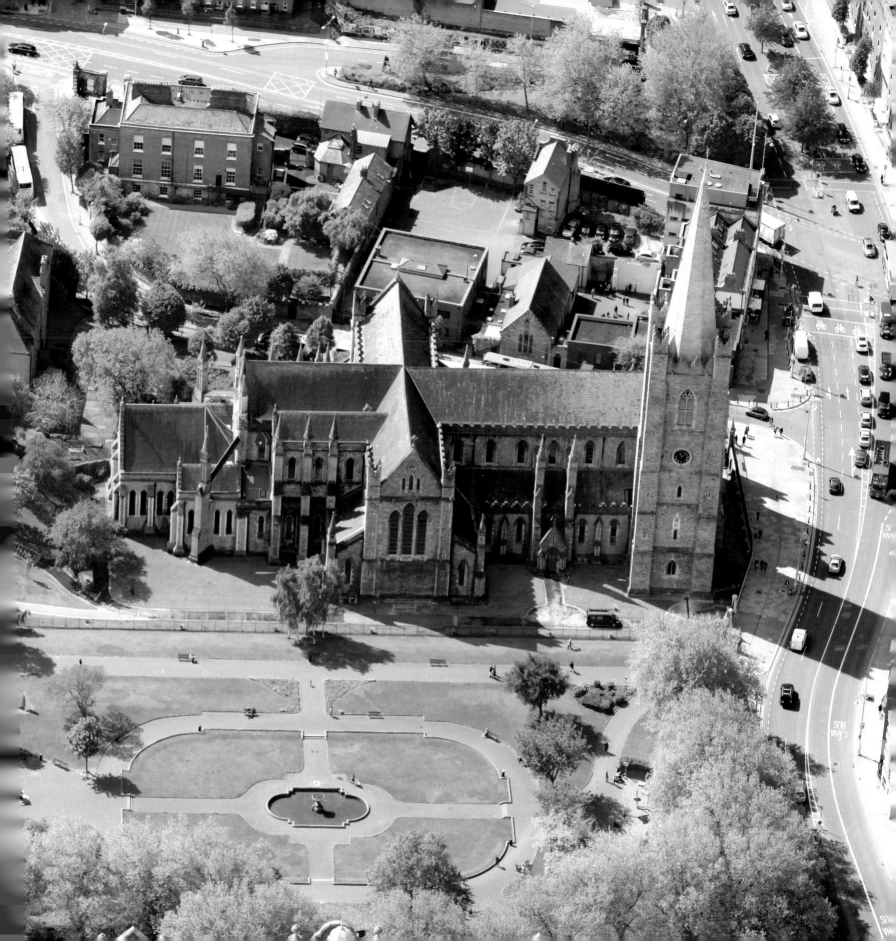

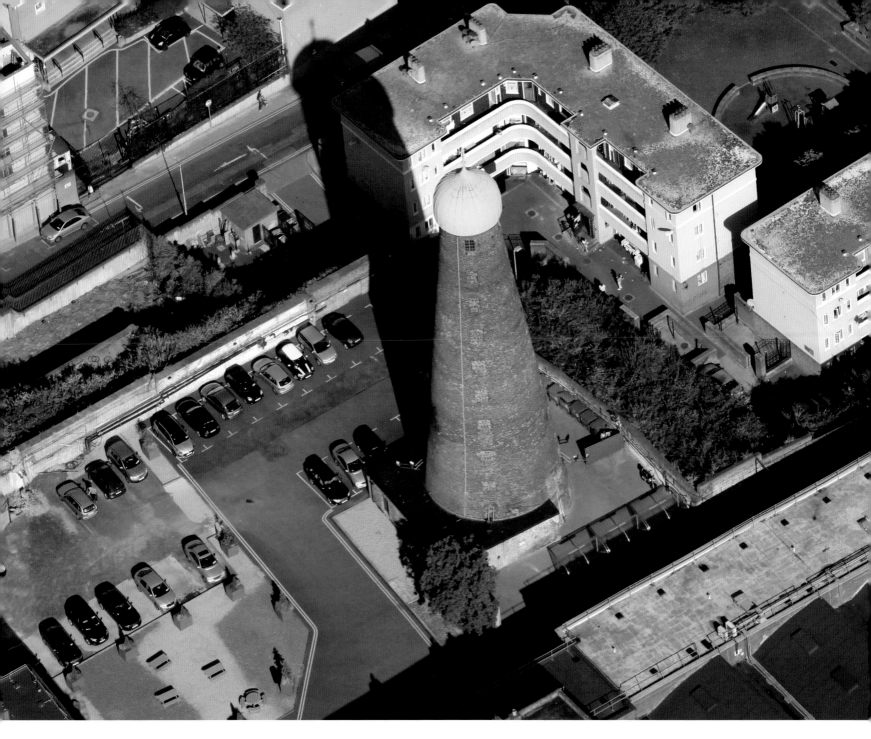

A former windmill, St Patrick's Tower had its beginnings in 1757 and was used to power a small distillery. It was acquired by the Guinness family in 1949.

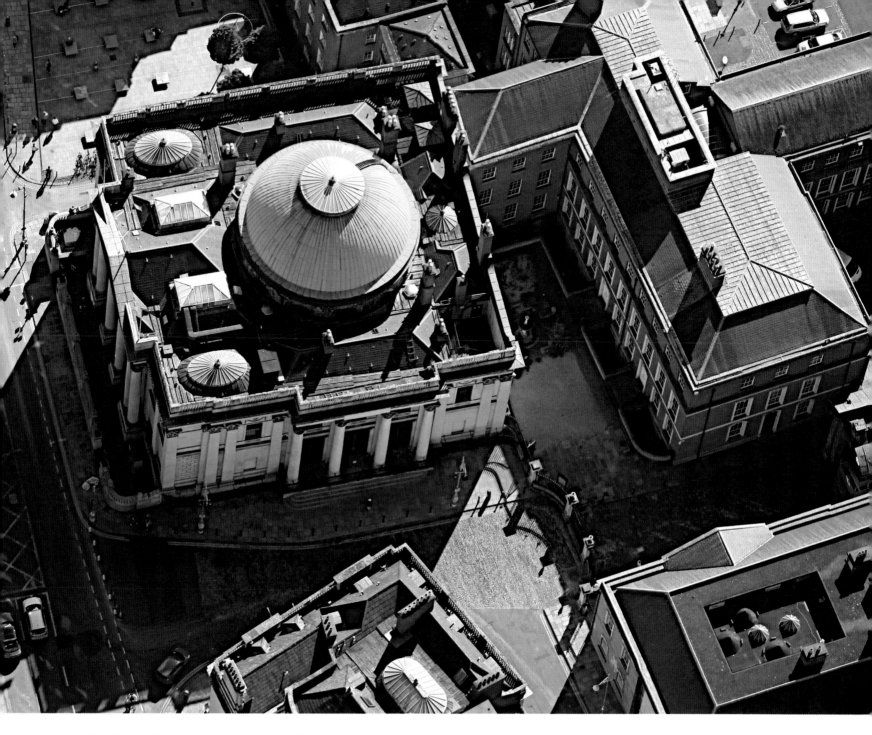

Dublin City Hall was the former Royal Exchange and first major neoclassical building in Ireland. Its prominent hilltop site dominates the vista from Capel Street across Essex Bridge and through Parliament Street.

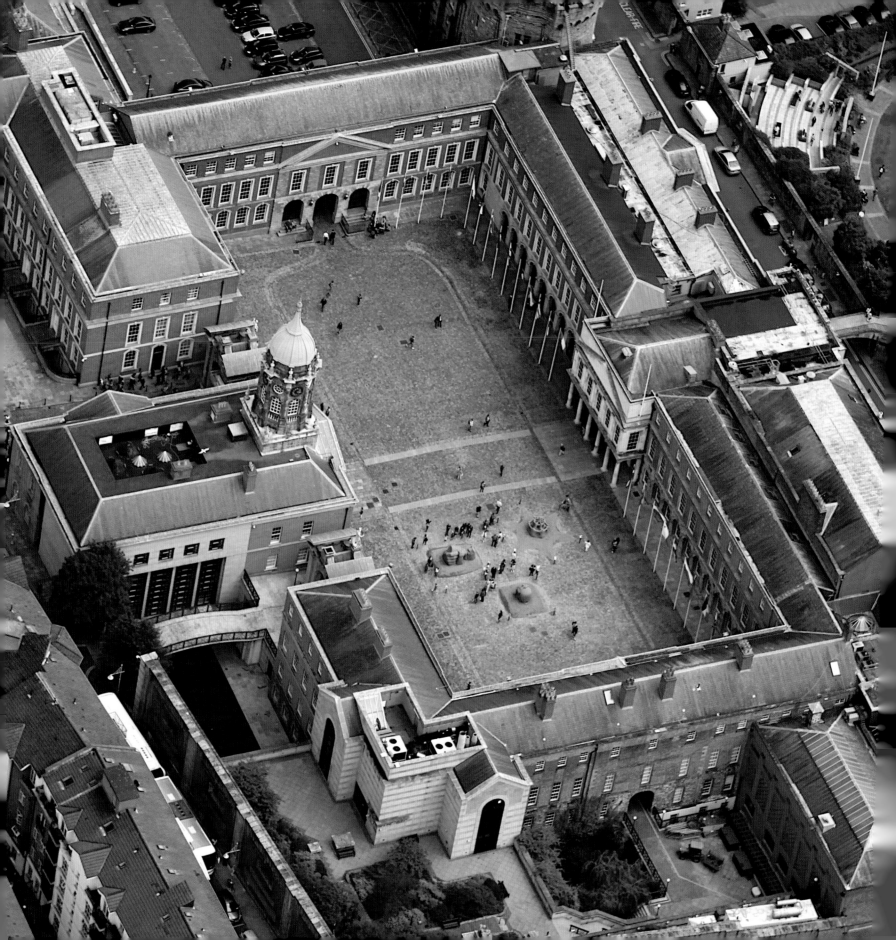

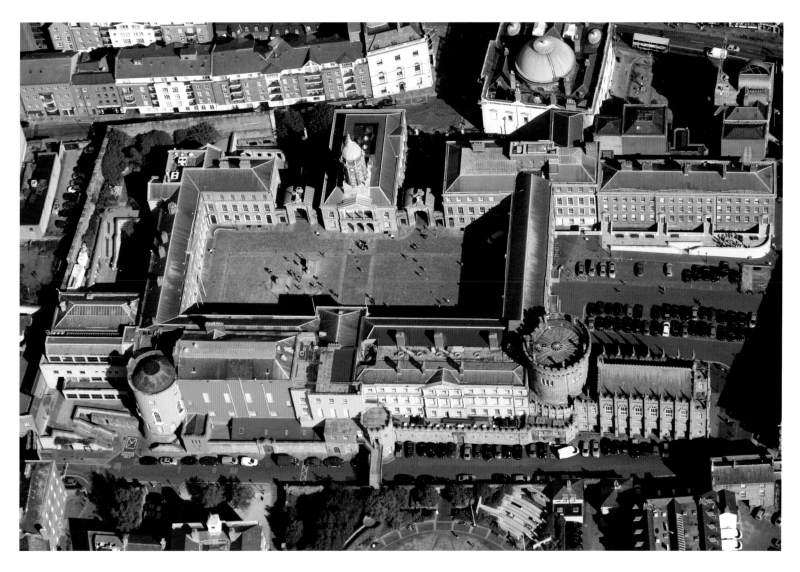

Dublin Castle, originally the seat of the British administration in Ireland, was built in the thirteenth century as a military fortress and is now used for important State functions and presidential inaugurations. Dublin Castle also boasts a state-of-the-art international conference centre. (Left): An exhibition of sand sculptures can be seen in the courtyard.

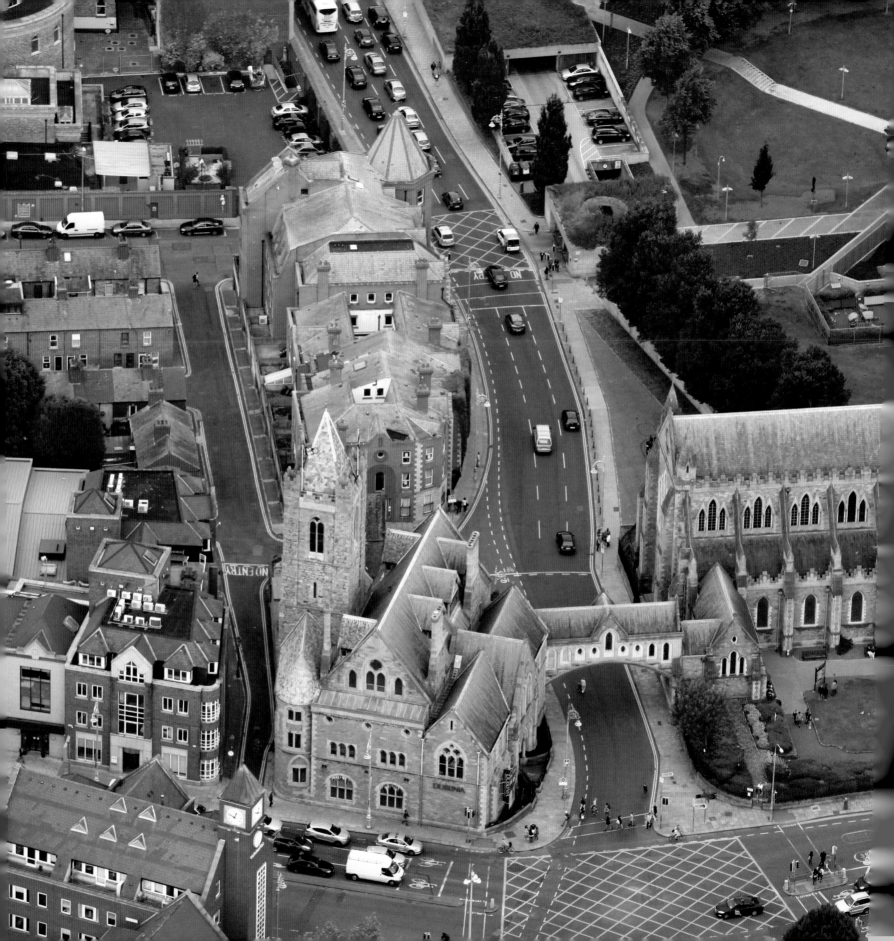

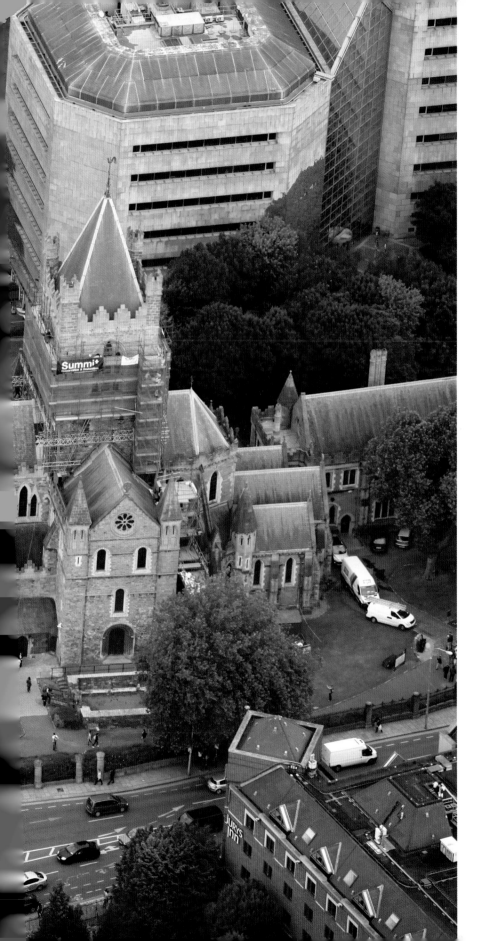

A fine example of Gothic architecture, Christchurch Cathedral is in the heart of medieval Dublin on the site of a wooden church built in 1038 by the Danish king Sitric. The cathedral was started by Strongbow in 1172 after his conquest of Dublin. Strongbow's remains are interred in a tomb in the south aisle of the nave.

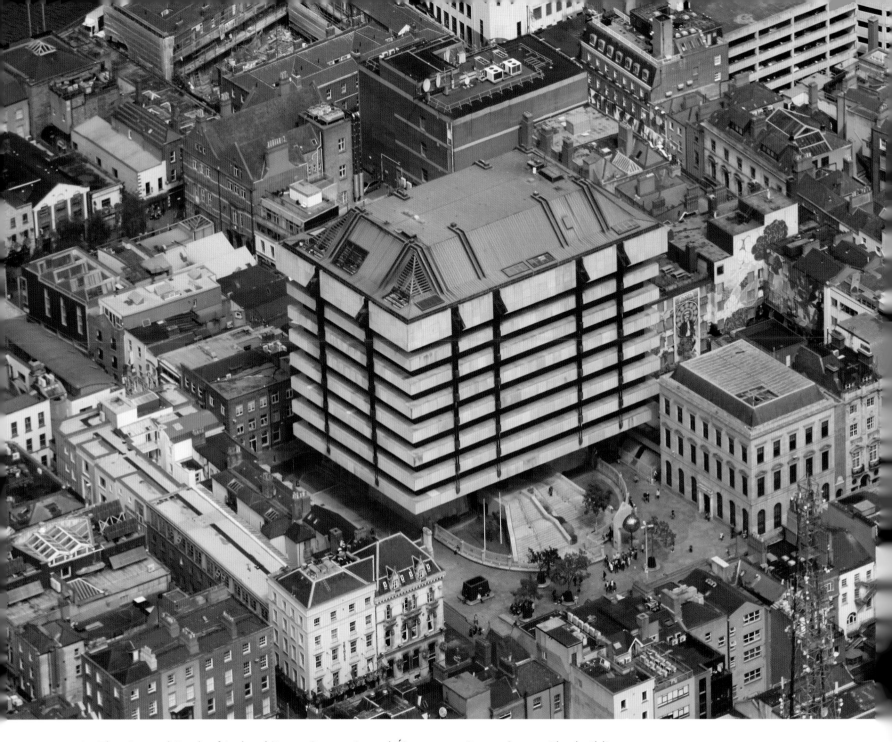

The Central Bank of Ireland/Banc Ceannais na hÉireann on Dame Street. The building was designed in 1980 by renowned architect Sam Stephenson.

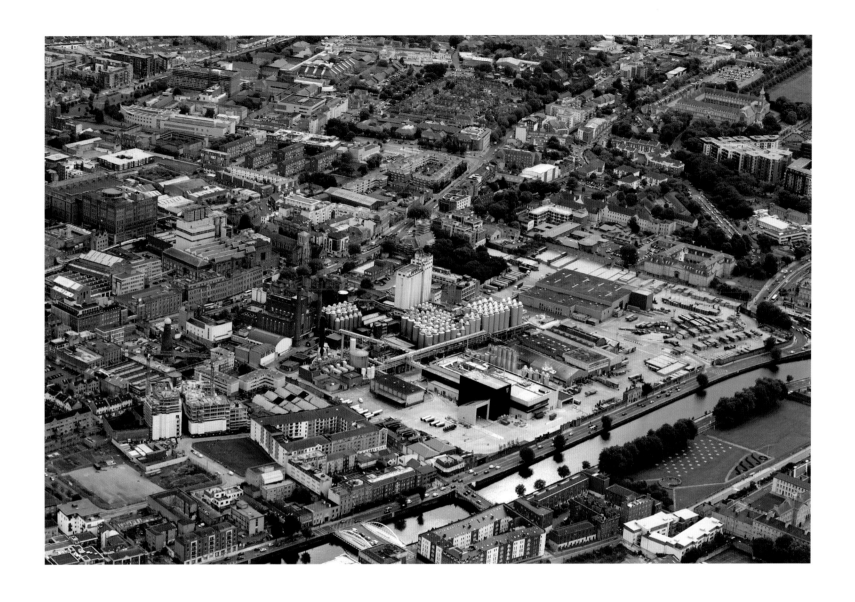

▲ Guinness Brewery, St James's Gate. There has been a brewery on this
site on the south bank of the River Liffey since 1759.

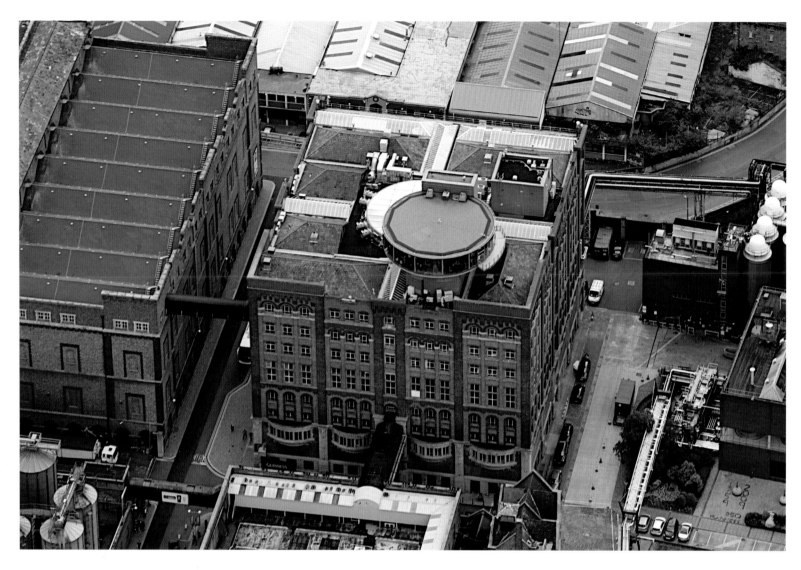

The Guinness Storehouse in the heart of St James's Gate Brewery is one of Europe's top visitor attractions and tells the story of Ireland's famous stout and one of the world's most renowned breweries.

The Gravity Bar, on the rooftop of the Guinness Storehouse, affords spectacular views over the city.

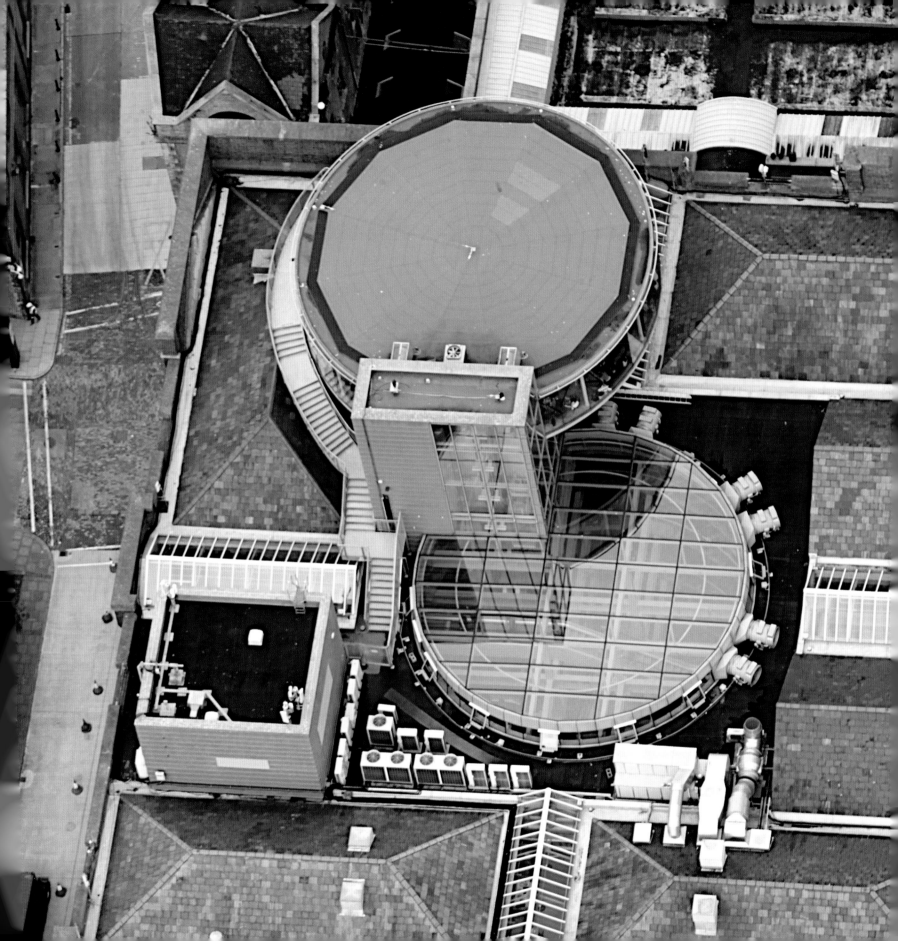

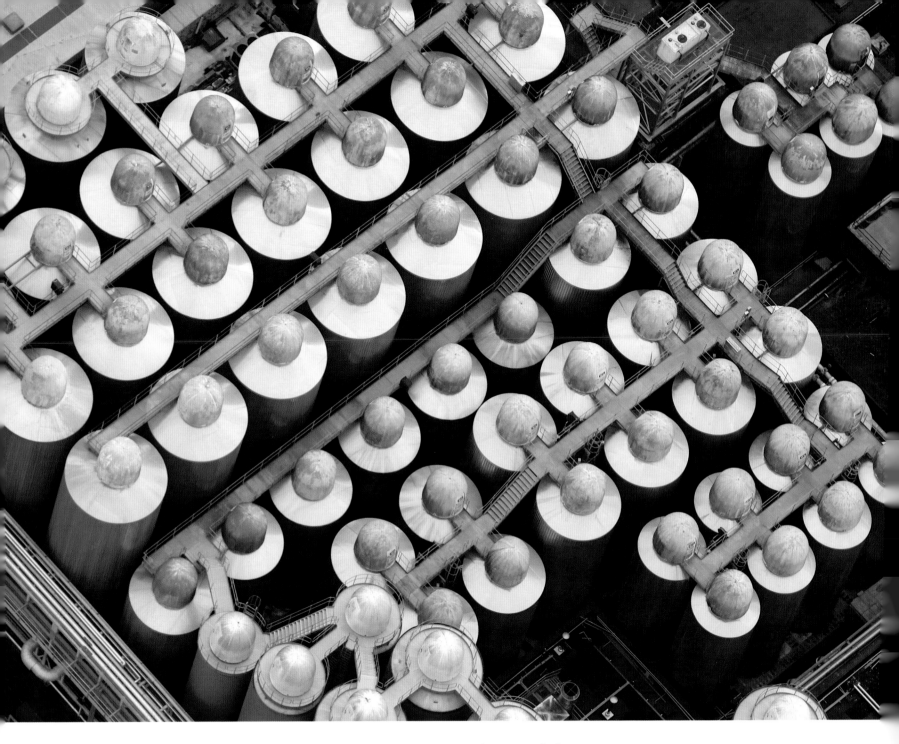

▲ From above, these storage tanks at St James's Gate Brewery take on a whole new appearance, reminiscent of a scene from a *Star Wars* film.

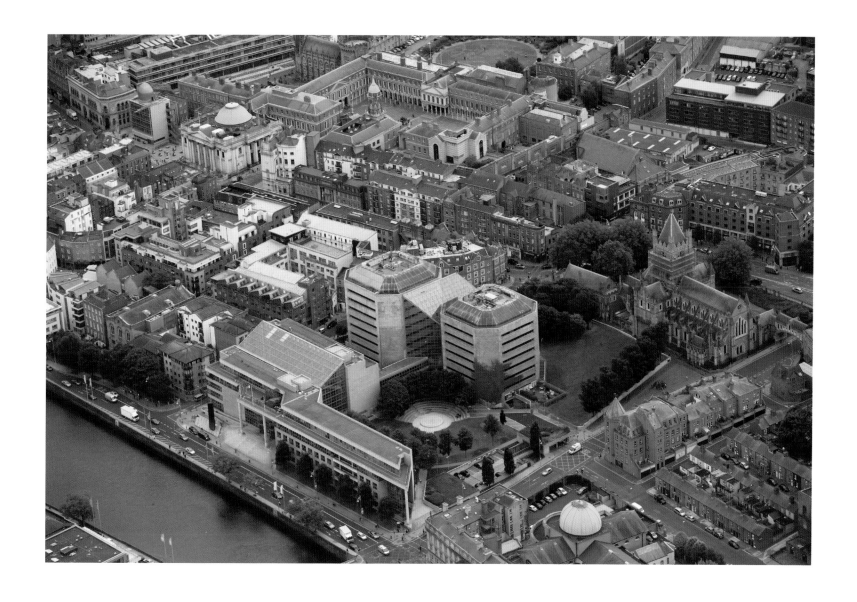

▲ Civic Offices, Wood Quay (foreground), with Dublin
Castle and City Hall (centre background).

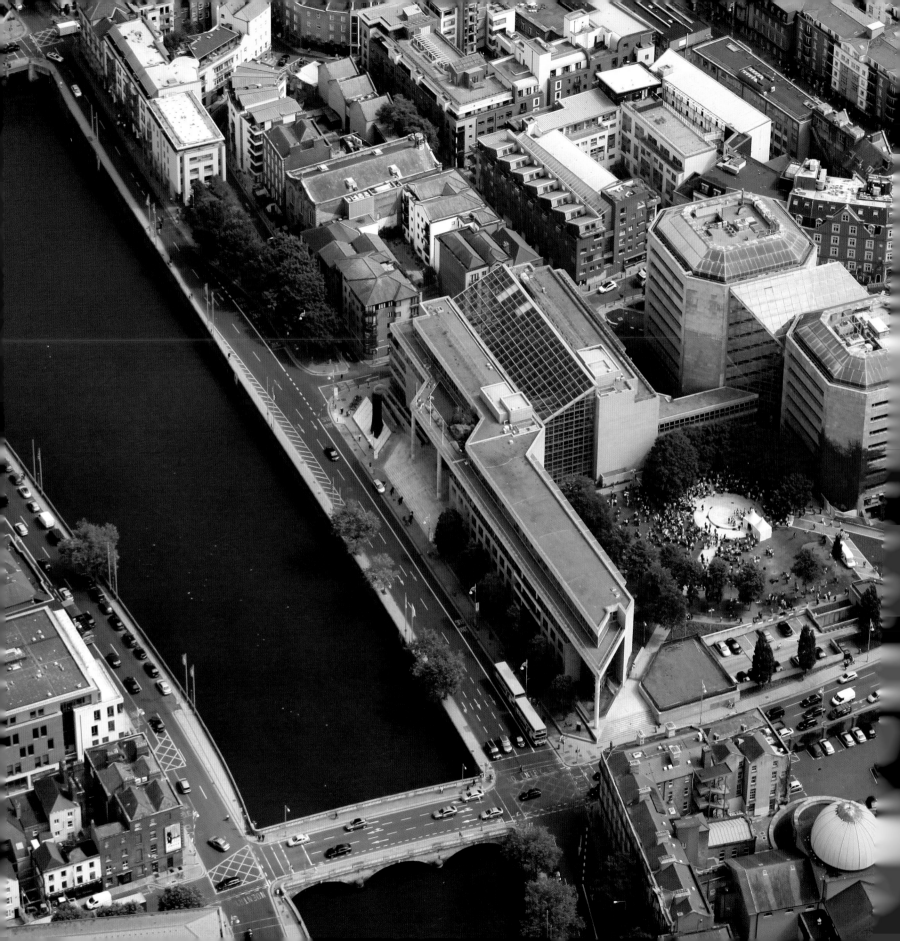

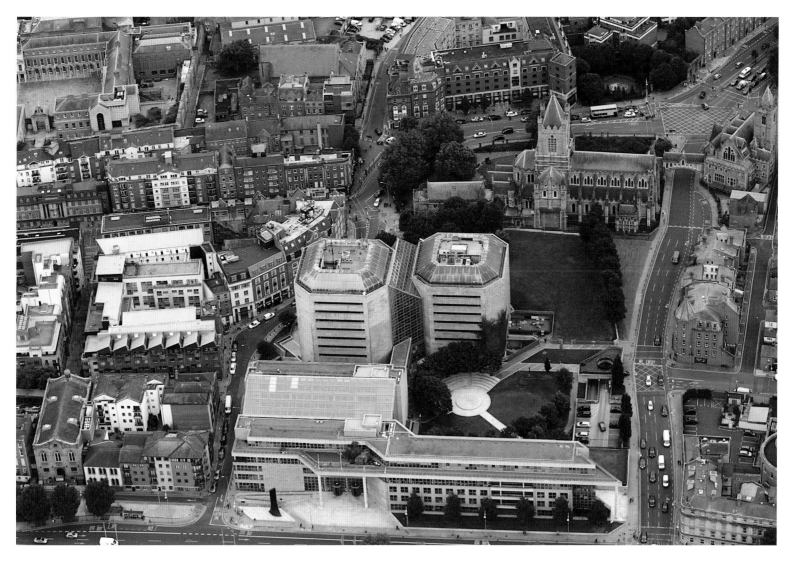

▲ Wood Quay stands on the banks of the Liffey and was the site of a Viking settlement. The Civic Offices of Dublin City Council are located here.

◀ An overhead view of the Civic Offices at Wood Quay.

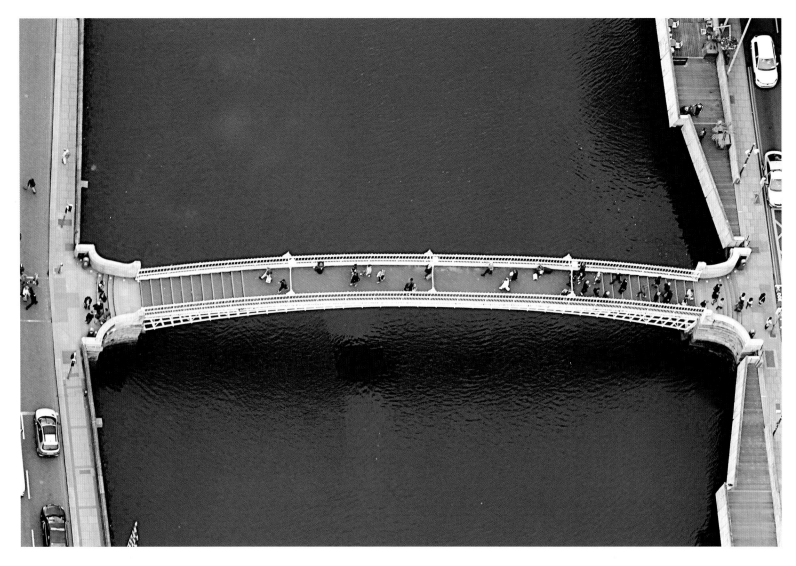

▲ The Ha'penny Bridge was opened in 1816 and Dubliners paid a toll in ha'pennies for the convenience of using it. Today, the bridge is regarded as a jewel of the city.

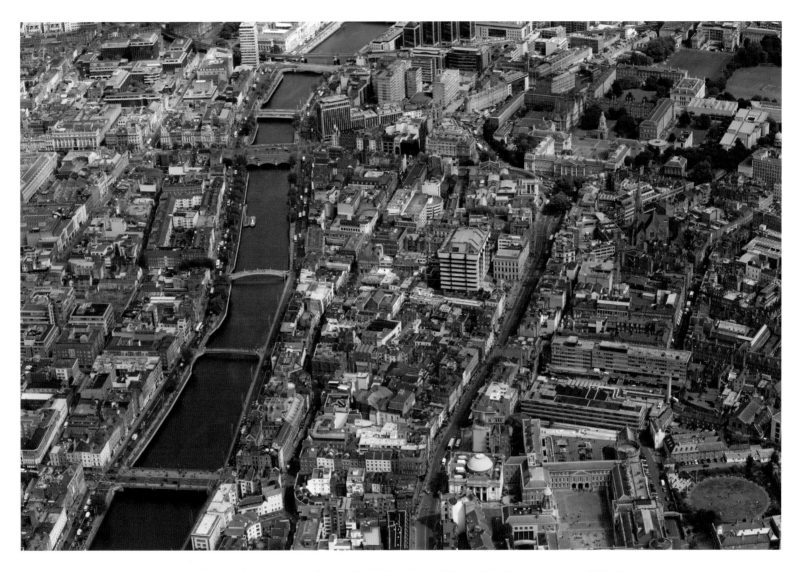

▲ The Temple Bar District is located on the south bank of the River Liffey. With its narrow, cobbled streets and colourful shops, it is a major tourist attraction. In years gone by, skilled craftsmen and artists lived and worked in this area.

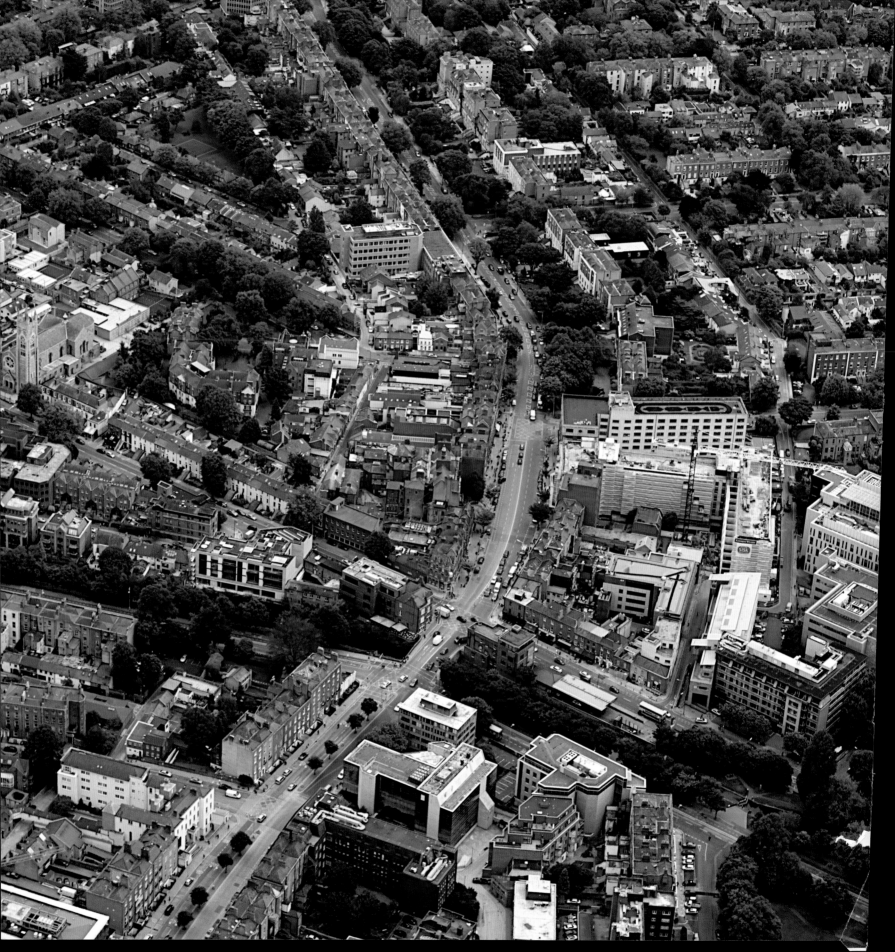

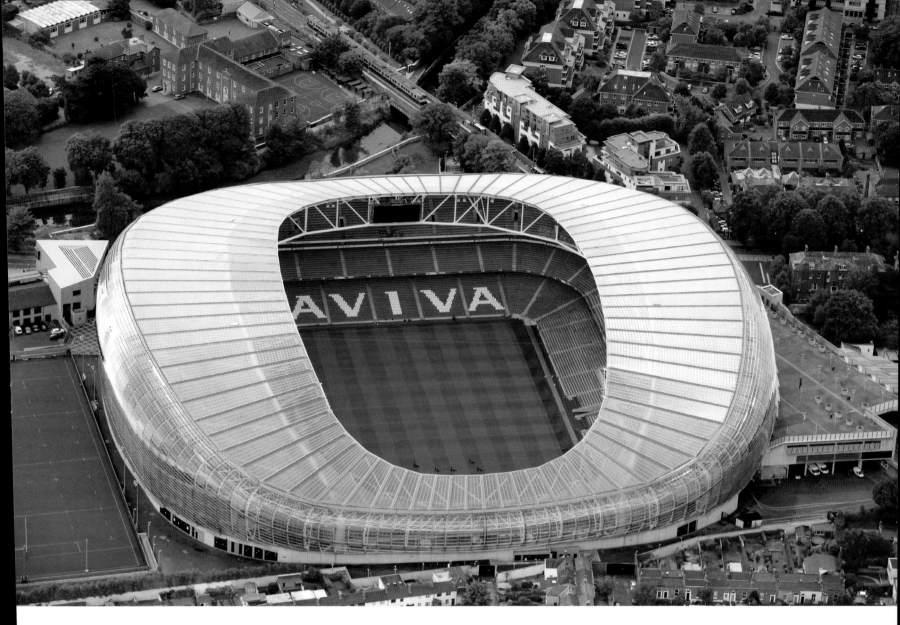

▲ Aviva Stadium (formerly Lansdowne Road – spiritual home of Irish rugby since 1872). The first international match played here was on 11 March 1878 when Ireland played England. The redeveloped stadium opened in May of 2010 and has a capacity of over 50,000 for sporting fixtures or concerts.

◀ Baggot Street Bridge spans the Grand Canal at the junction of Baggot Street with Pembroke Road.

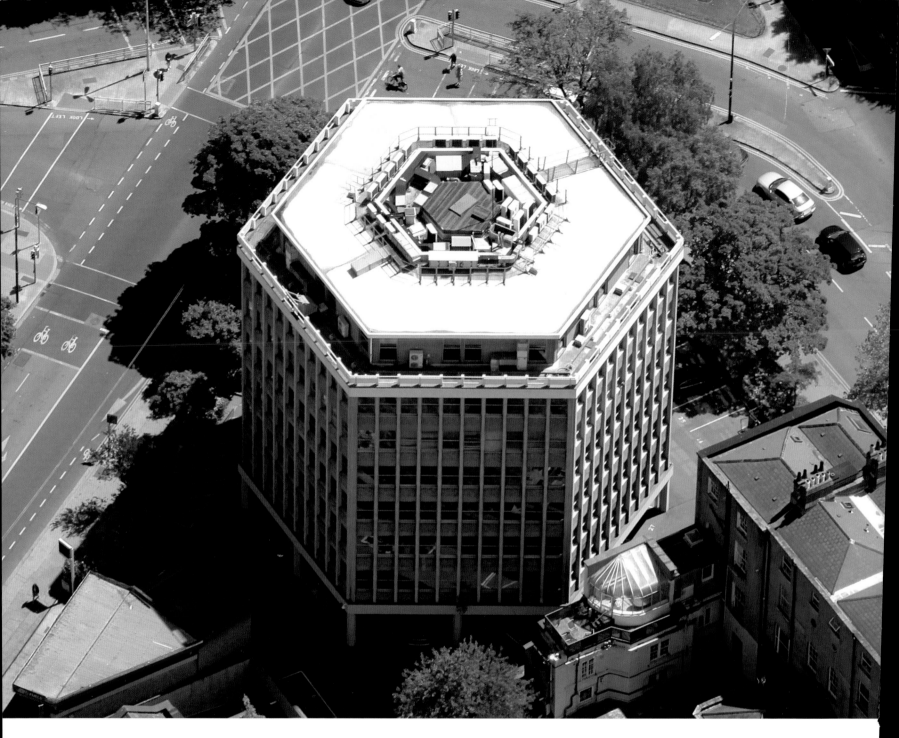

▲ Carrisbrook House, on Northumberland Road. This modern edifice
is built on the site of the original Carrisbrook House, which played a
major role in the 1916 Rising.

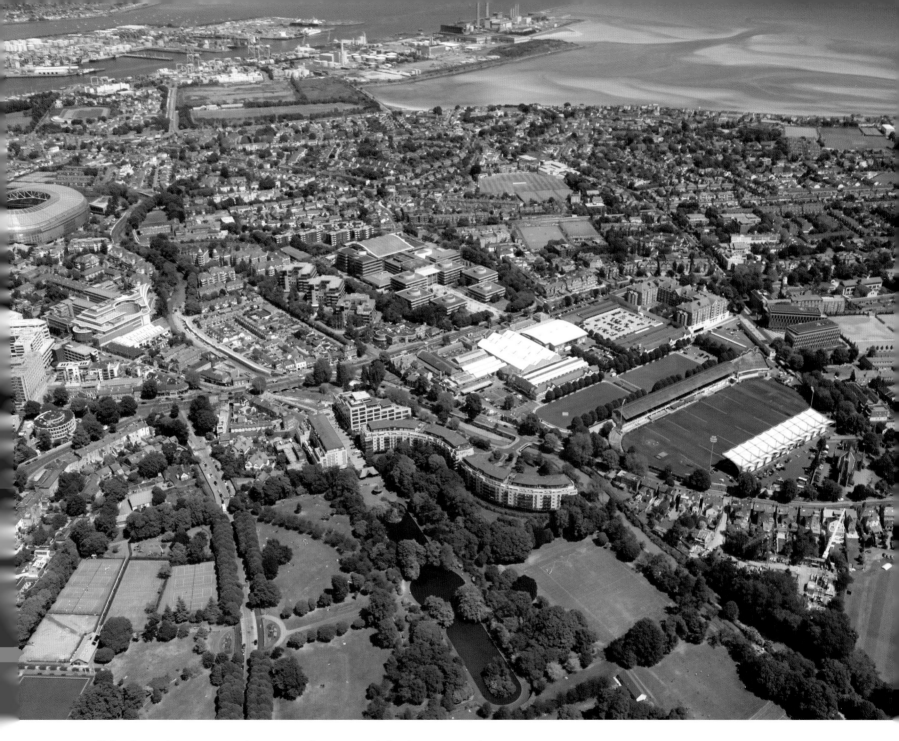

Ballsbridge. The Aviva Stadium is to the west, while the eastwards
view overlooks Elm Park Golf Club towards Ringsend.

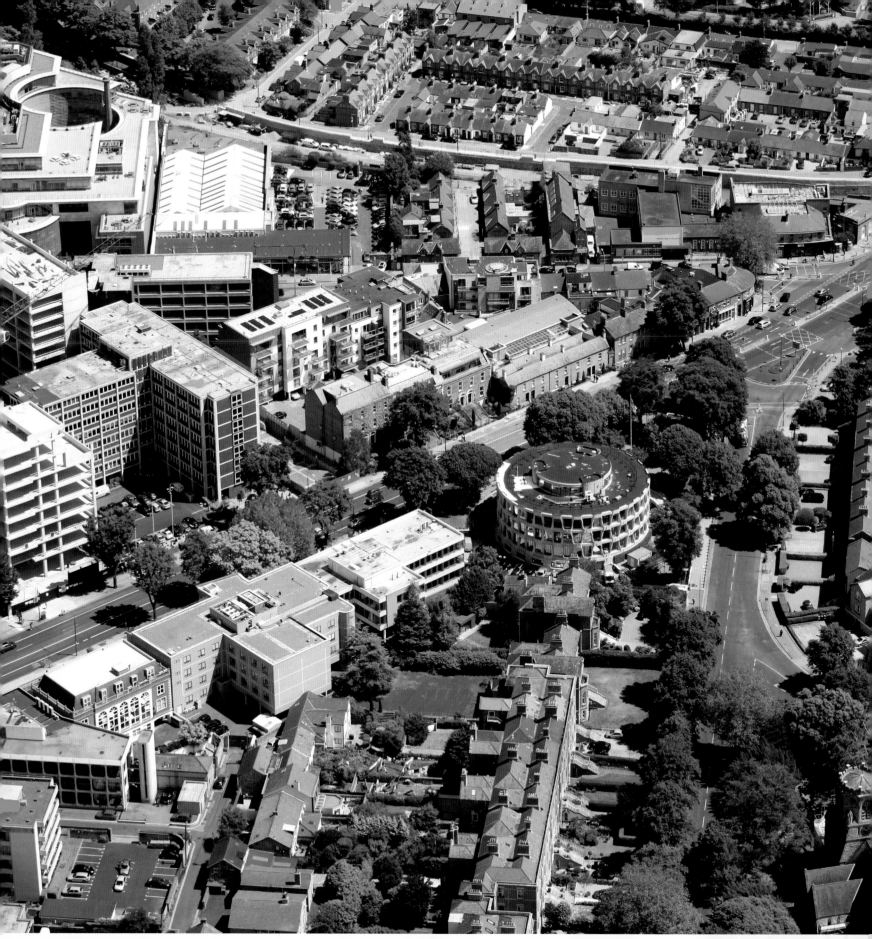

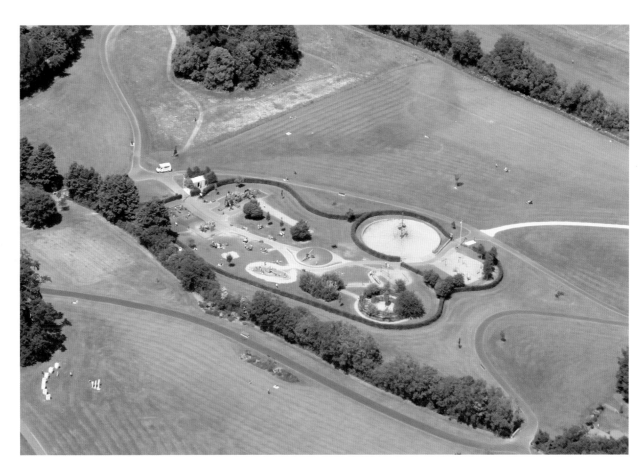

Dublin has many playgrounds and the one pictured here in the grounds of Herbert Park is extremely popular.

Ballsbridge. St Bartholomew's Church, Clyde Road (right foreground) was consecrated in 1867 when this was open countryside. The United States Embassy (centre) opened in 1964. The building was designed by a who took his inspiration from Celtic mythology.

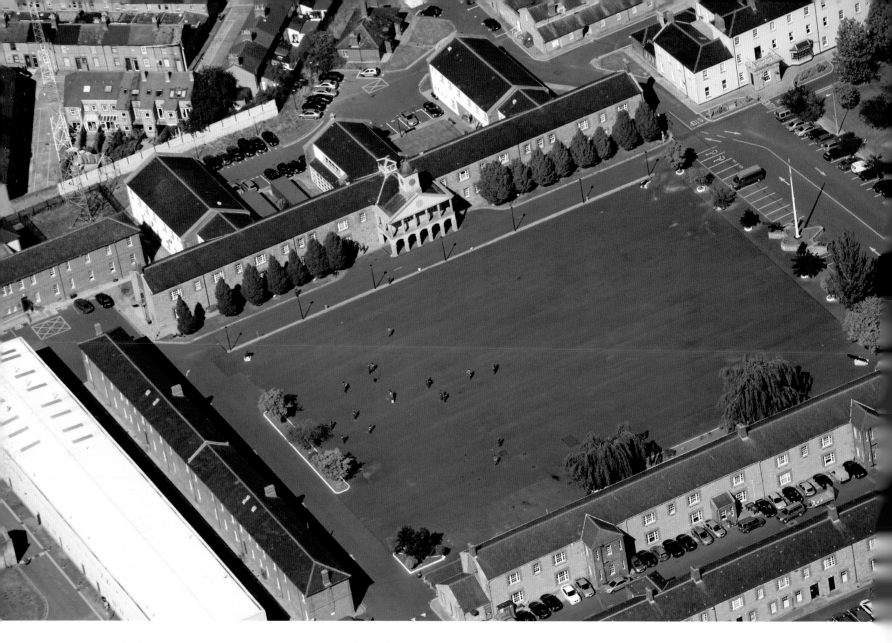

▲ Located in Rathmines, Portobello Barracks (also known as Cathal Brugha Barracks) is an Irish Defence Forces barracks and also houses the military archives of the Department of Defence. It was constructed as a cavalry base in the early 1800s.

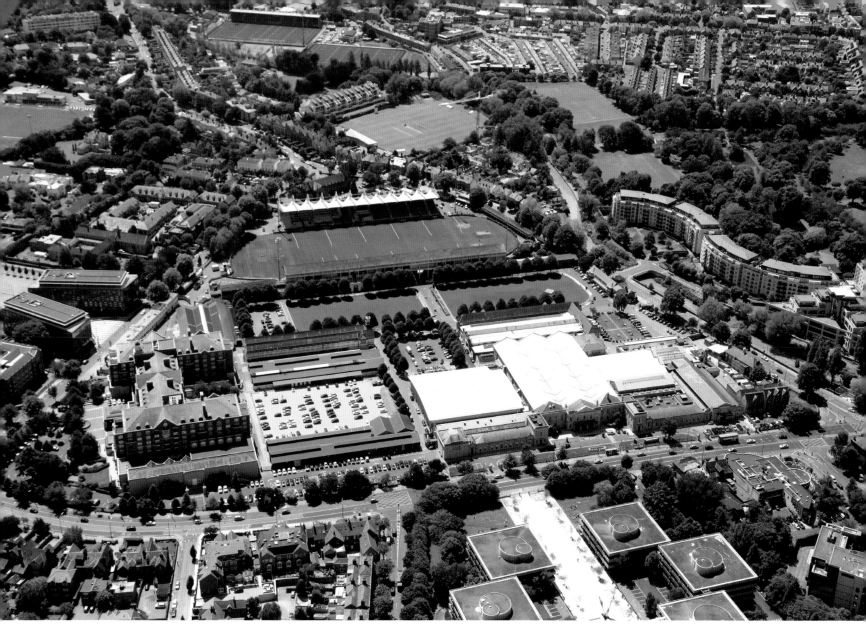

The RDS is a conference and exhibition
centre in Ballsbridge owned by the Royal
Dublin Society.

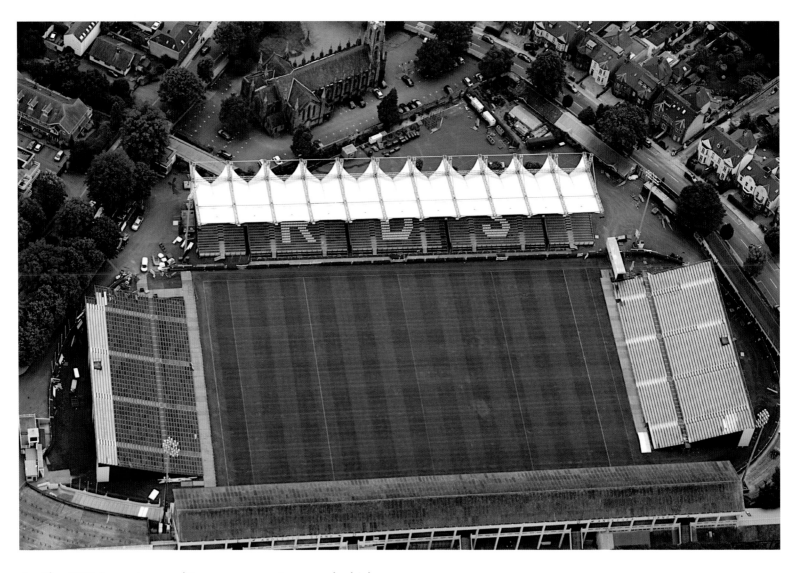

The RDS Arena is a multi-purpose sports ground which was developed to host equestrian events, mainly the annual Dublin Horse Show. The arena has also hosted concerts, rugby and soccer events. The arena is home to the Leinster rugby team.

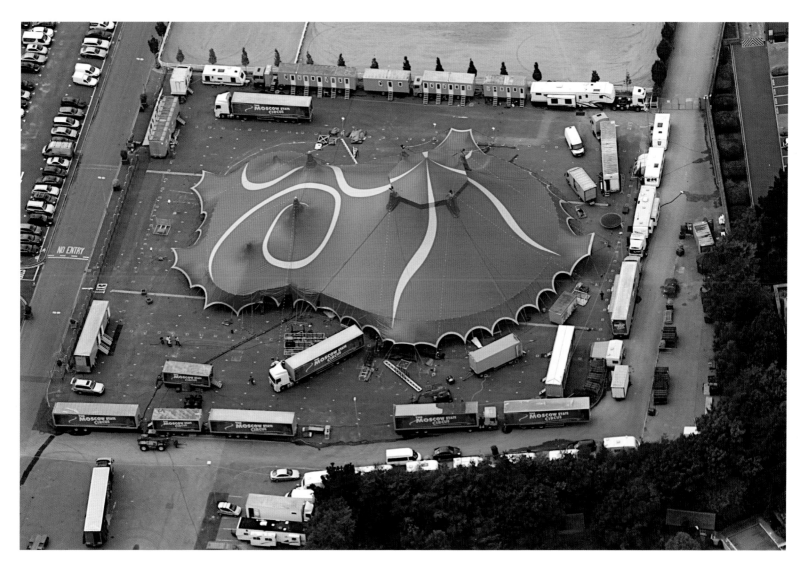

The Moscow State Circus prepares for a series of performances in the RDS. The distinctive colour and shape of its 'big top' is easily spotted from above.

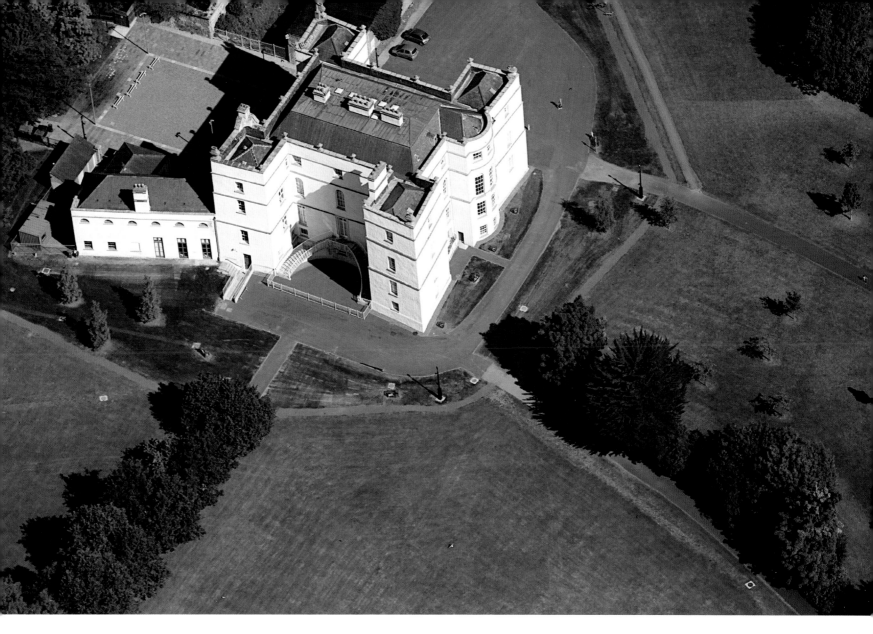

▲ Rathfarnham Castle dates back to the Elizabethan period. The castle, with its four flanker towers, is an excellent example of a fortified house in Ireland.

◄ Built in 1725, Rathfarnham House was renamed Loreto Abbey in 1822 after a girls' school was established there. It closed in 1999 after 247 years as a centre of education.

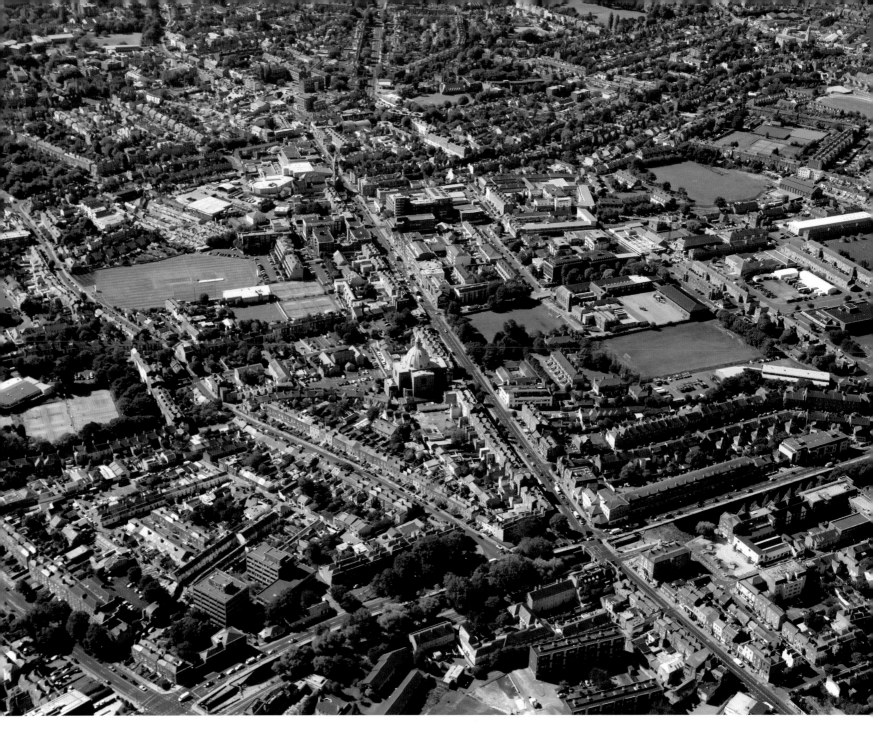

▲ Rathmines is located about 3 km from Dublin's city centre and begins
at the south side of the Grand Canal, stretching along the Rathmines
Road to Rathgar in the south.

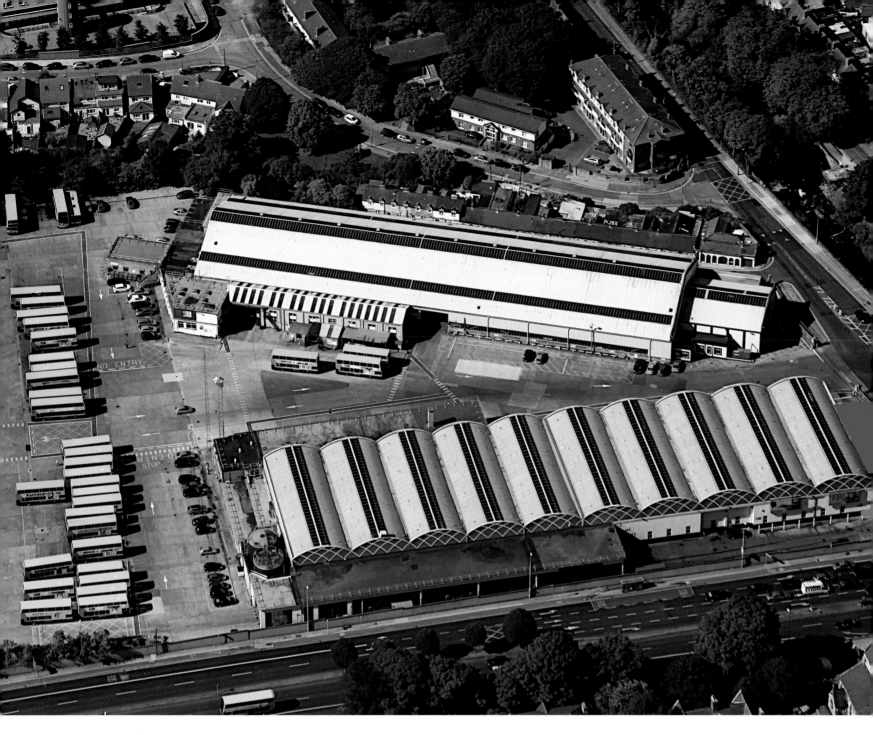

Donnybrook Bus Garage. Designed by Michael Scott and completed in 1952, the edifice was considered radical for its time in what was then a rural setting.

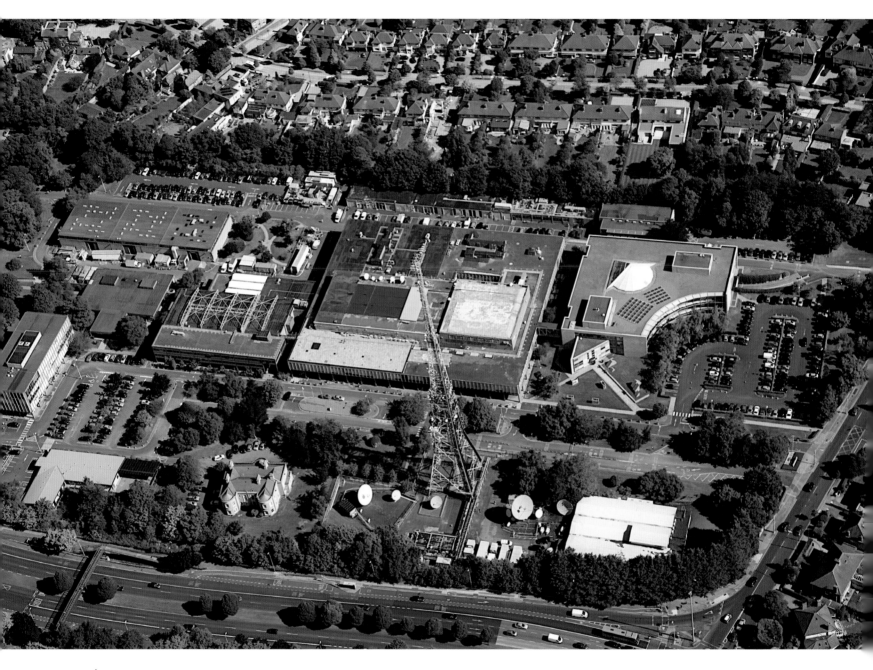

▲ RTÉ, Ireland's national public-service broadcaster, is based in this large complex in Donnybrook. Its most distinctive feature is the broadcast mast which, at 110 metres/360 feet in height, dominates the skyline.

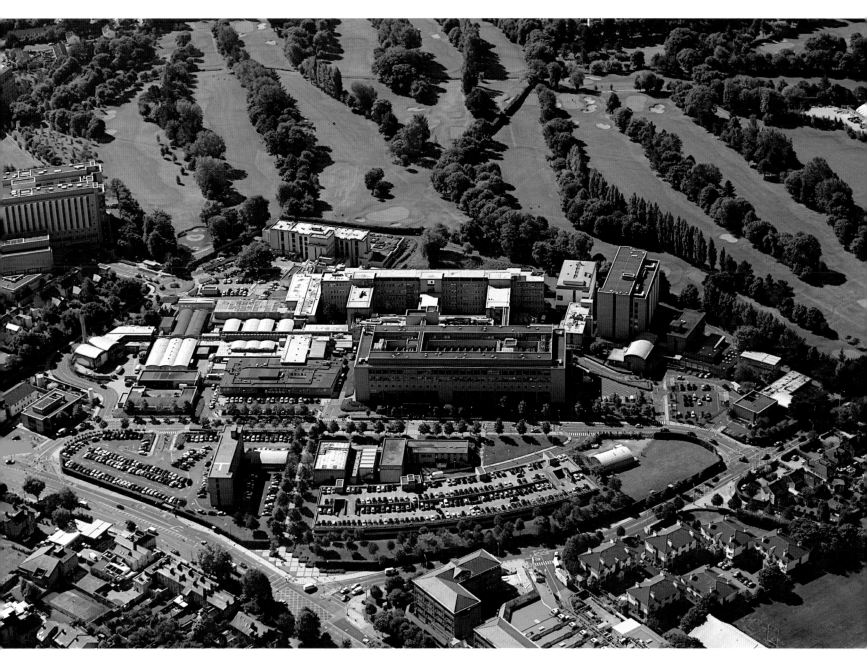

Located south of the city in Elm Park, St Vincent's is a teaching hospital affiliated to University College Dublin. The hospital moved to its present location in 1970.

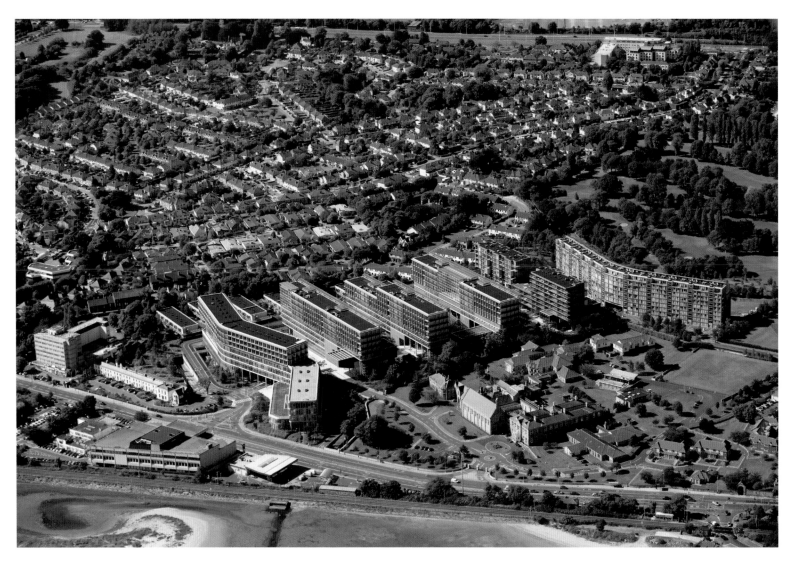

This modern development of offices and apartments on Merrion Road backs onto Elm Park Golf Club, with St Vincent's Private Hospital in the upper right-hand corner.

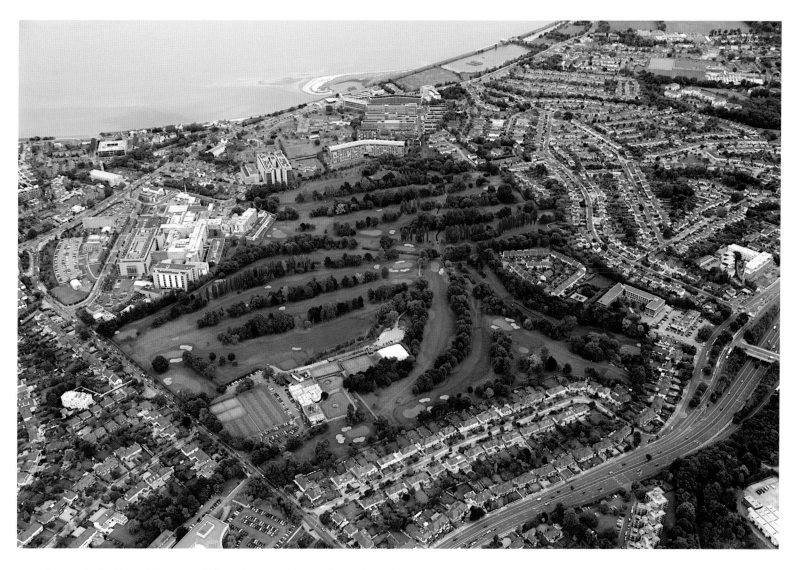

Elm Park Golf and Sports Club, where golf was first played in 1925.
Tennis courts were added several years later.

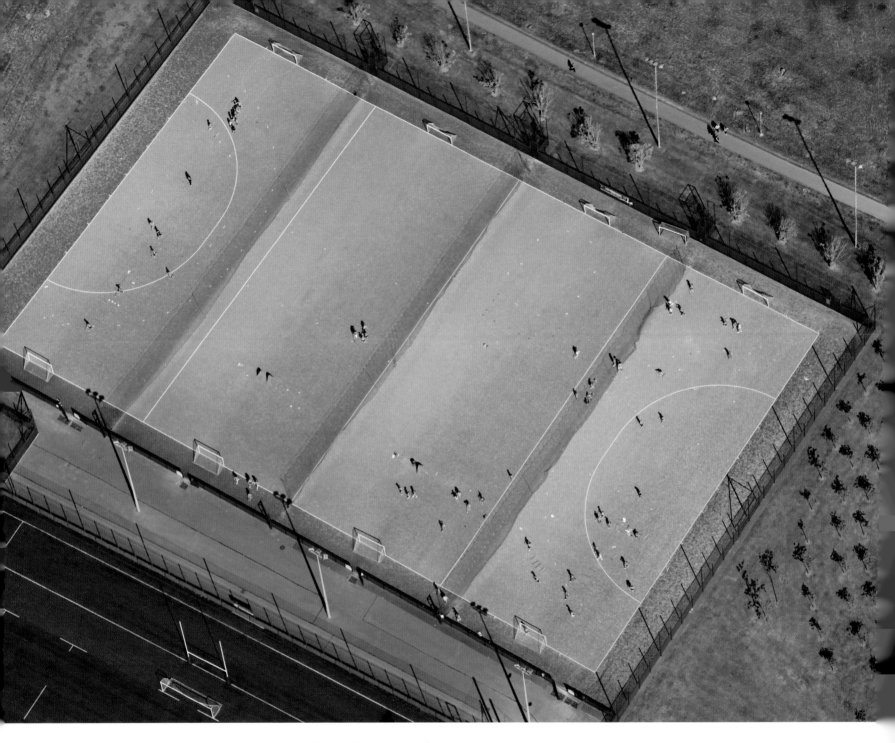

▲ Seen from a height, the players on the hockey
pitches at University College Dublin are
reduced to mere dots on a green canvas.

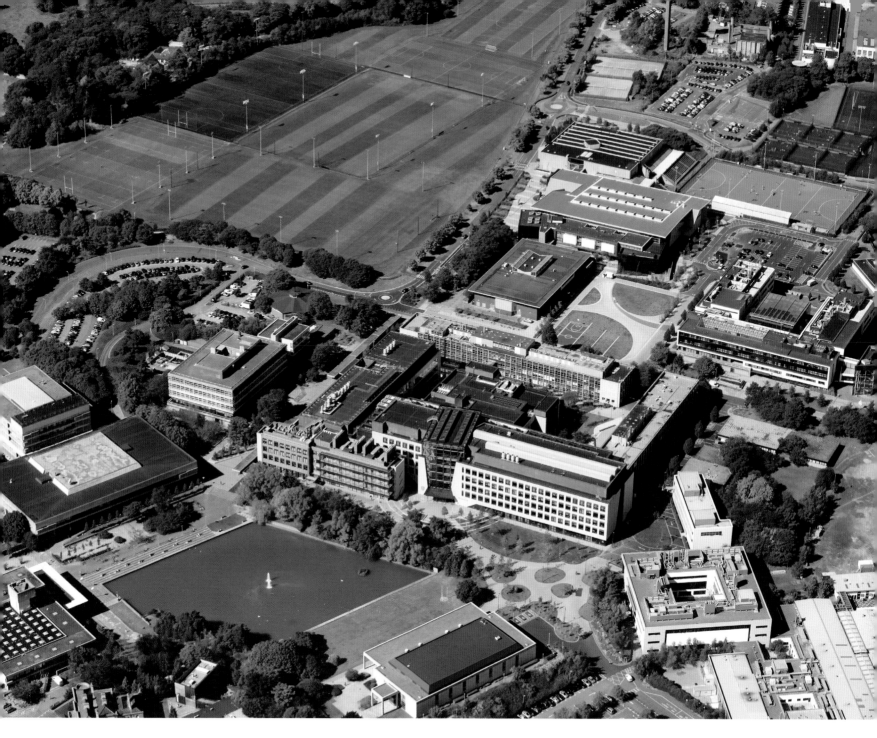

University College Dublin is Ireland's largest university, with over 30,000 students. The campus at Belfield extends to over 130 hectares. The university traces its origins back to 1834.

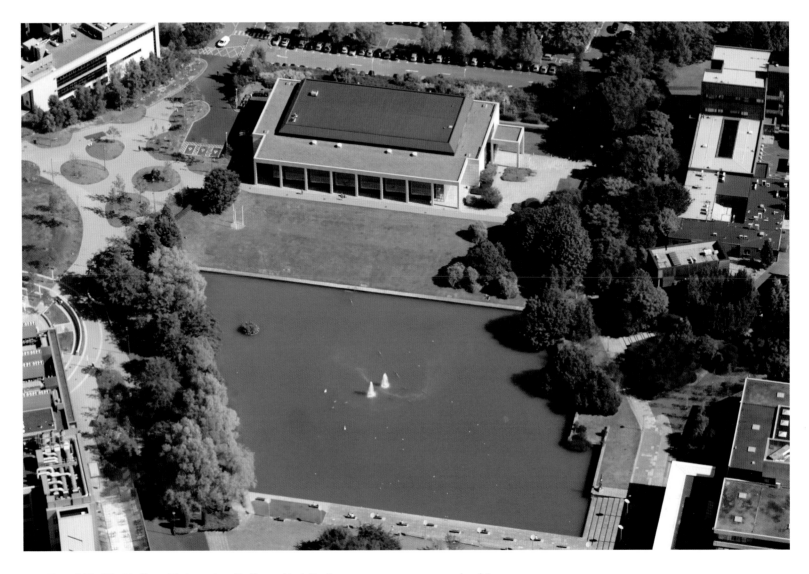

The O'Reilly Hall at University College Dublin is a conservatory overlooking the campus lake, used for receptions and as an assembly area.

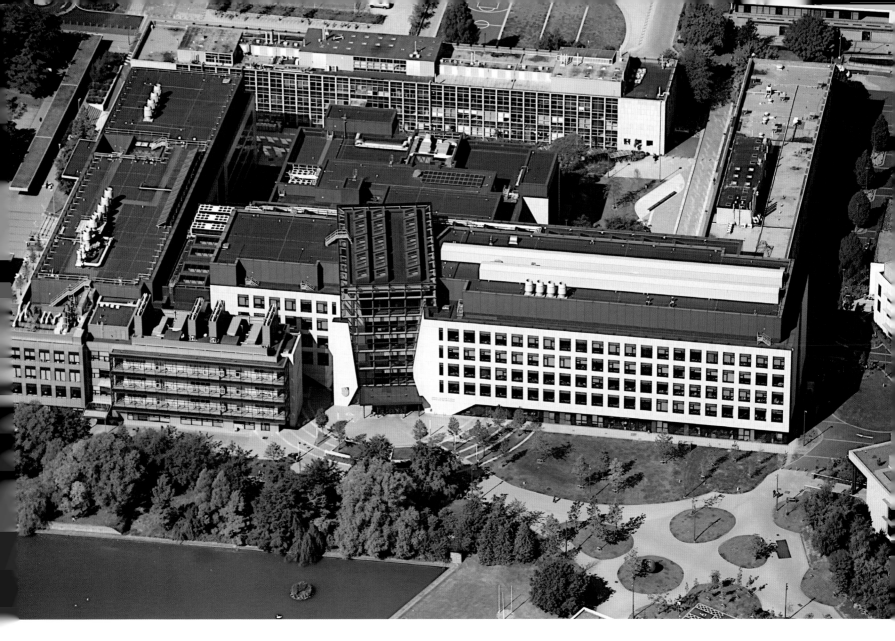

▲ The UCD O'Brien Centre for Science is a world-class research and teaching facility at University College Dublin.

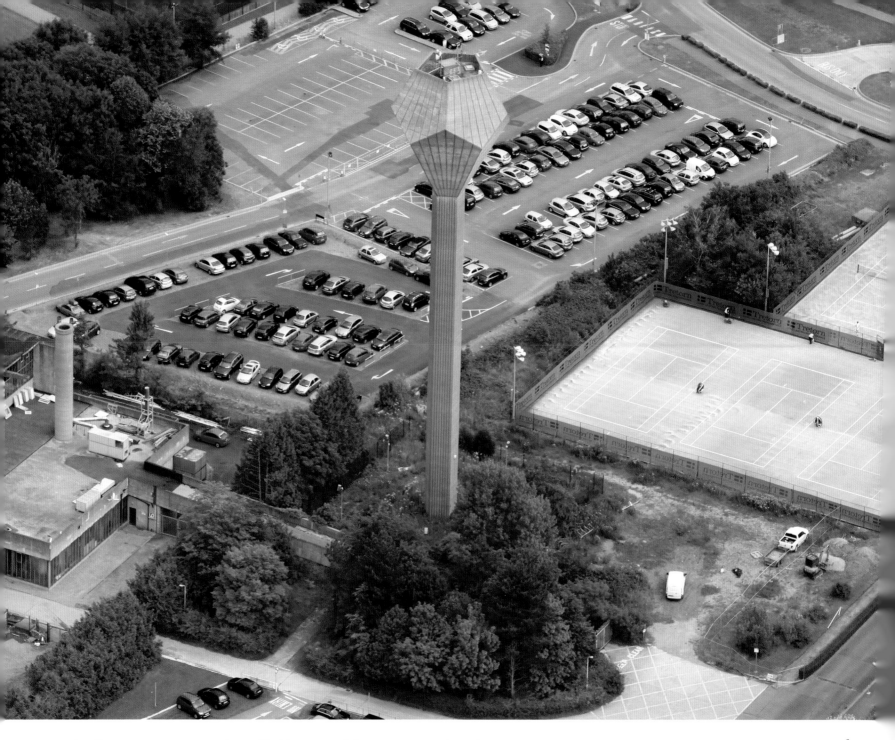

▲ The water tower at UCD Belfield is one of the university's best-known landmarks. This futuristic structure stands at close to 60 metres/200 feet and was built in 1972.

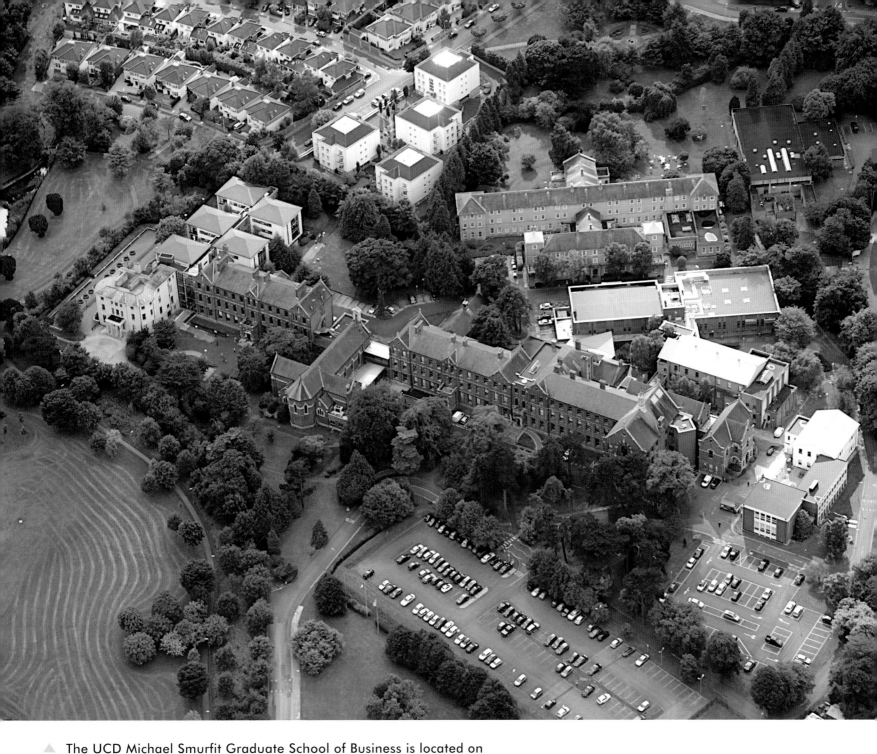

The UCD Michael Smurfit Graduate School of Business is located on the site of the former Carysfort Teacher Training College in Carysfort Avenue.

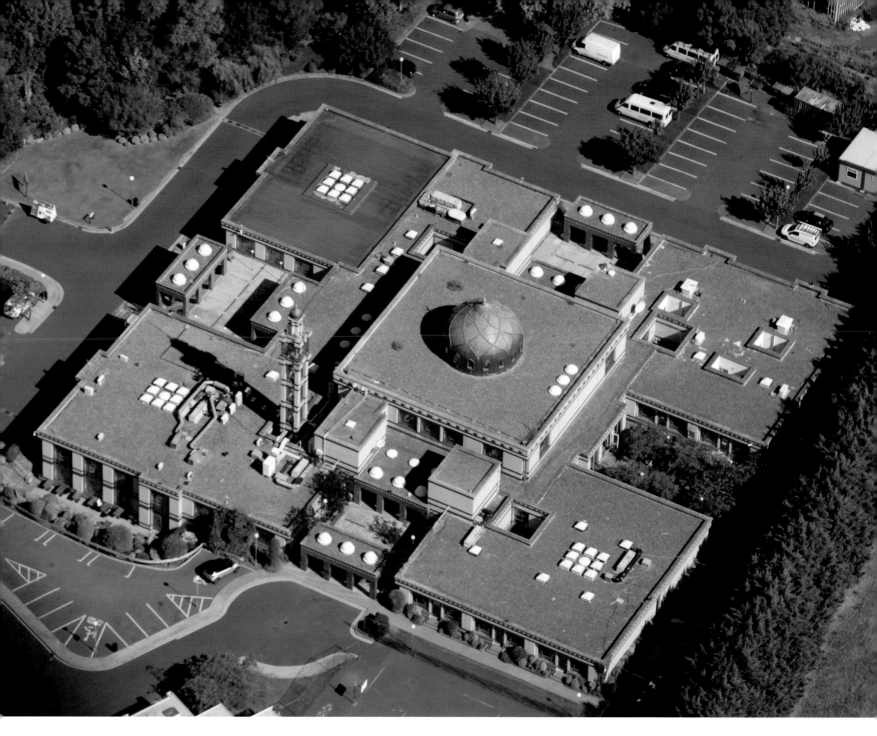

▲ The Islamic Cultural Centre of Ireland in
Clonskeagh, which was opened in 1996, houses a
mosque, school, library and meeting rooms.

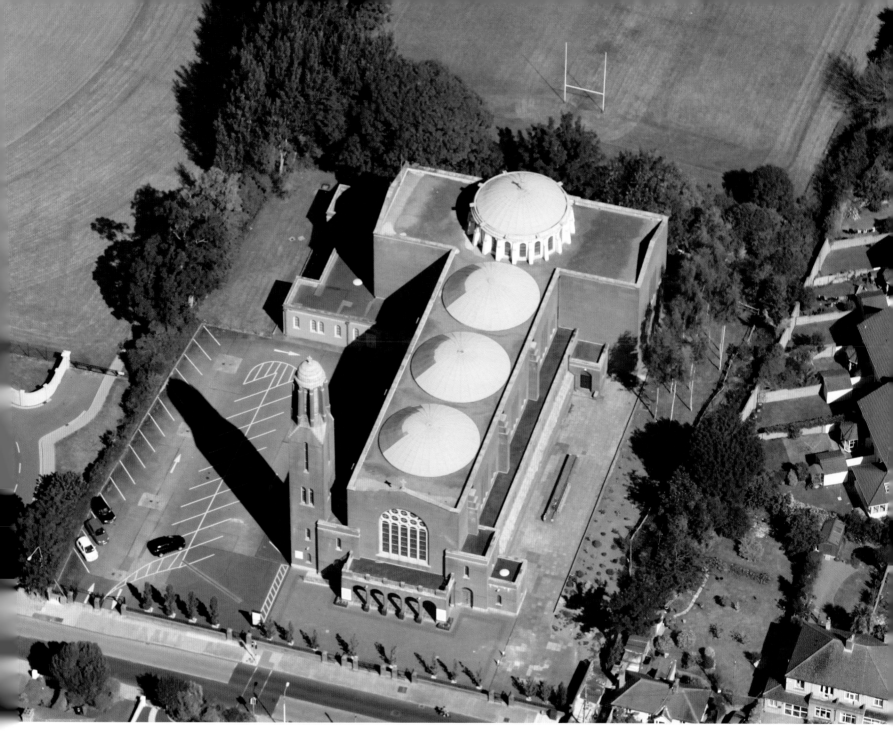

The Miraculous Medal Church in Clonskeagh is a large red-brick-faced church with four distinctive copper domes on its roof.

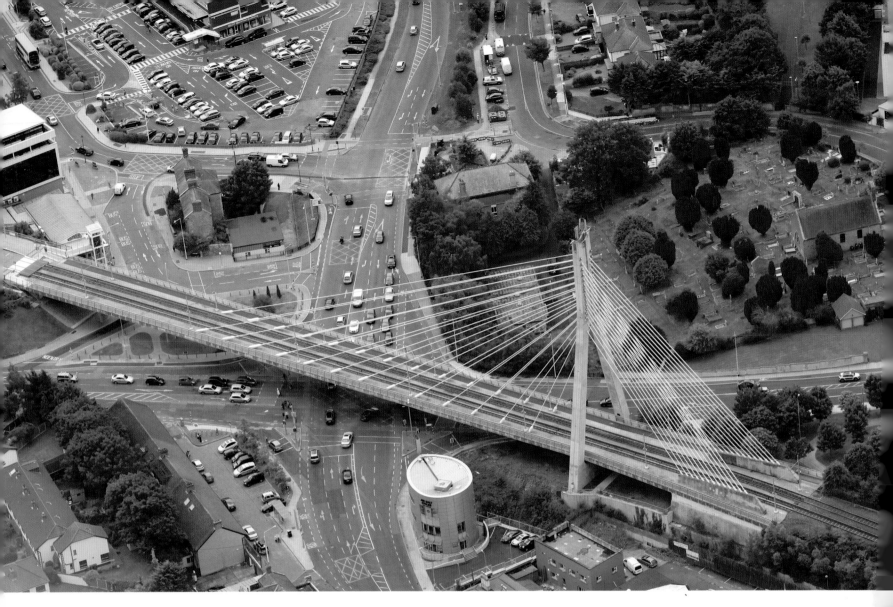

The William Dargan Bridge at Dundrum has a span of over 100 metres and serves the Luas, Dublin's light-rail tram system. It is a cable-stayed bridge of distinctive design.

Dundrum Town Centre which opened in 2005 is Ireland's largest shopping centre.

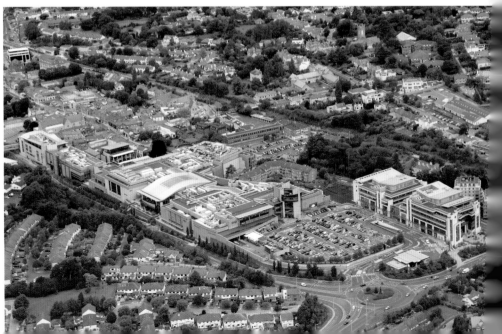

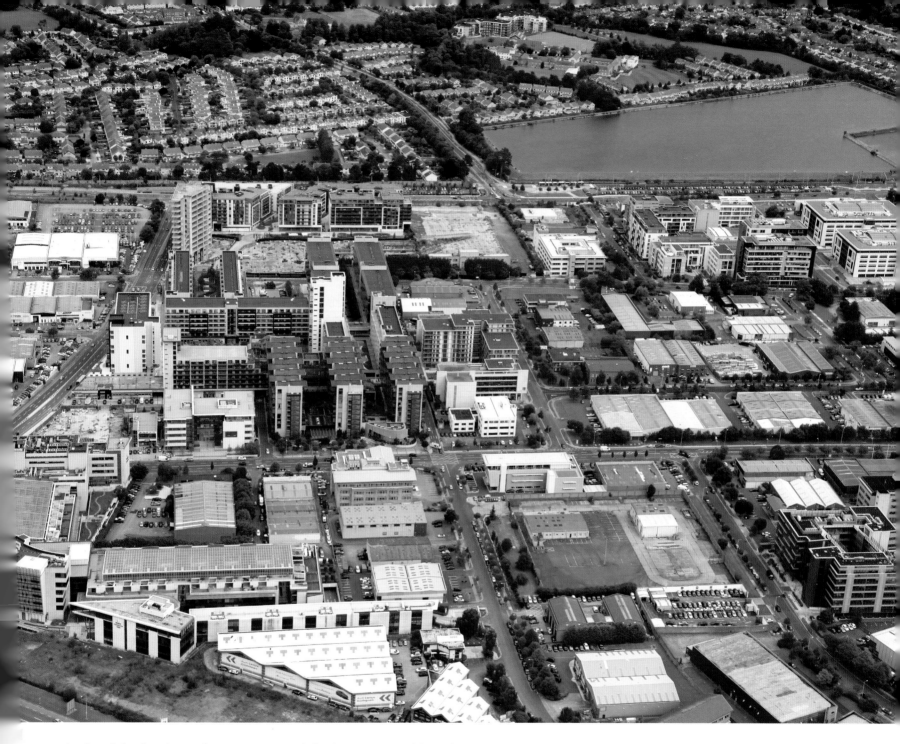

▲ Sandyford Industrial Estate is one of the largest in Dublin. The Beacon Hospital and the headquarters of Microsoft Ireland, among others, are located here.

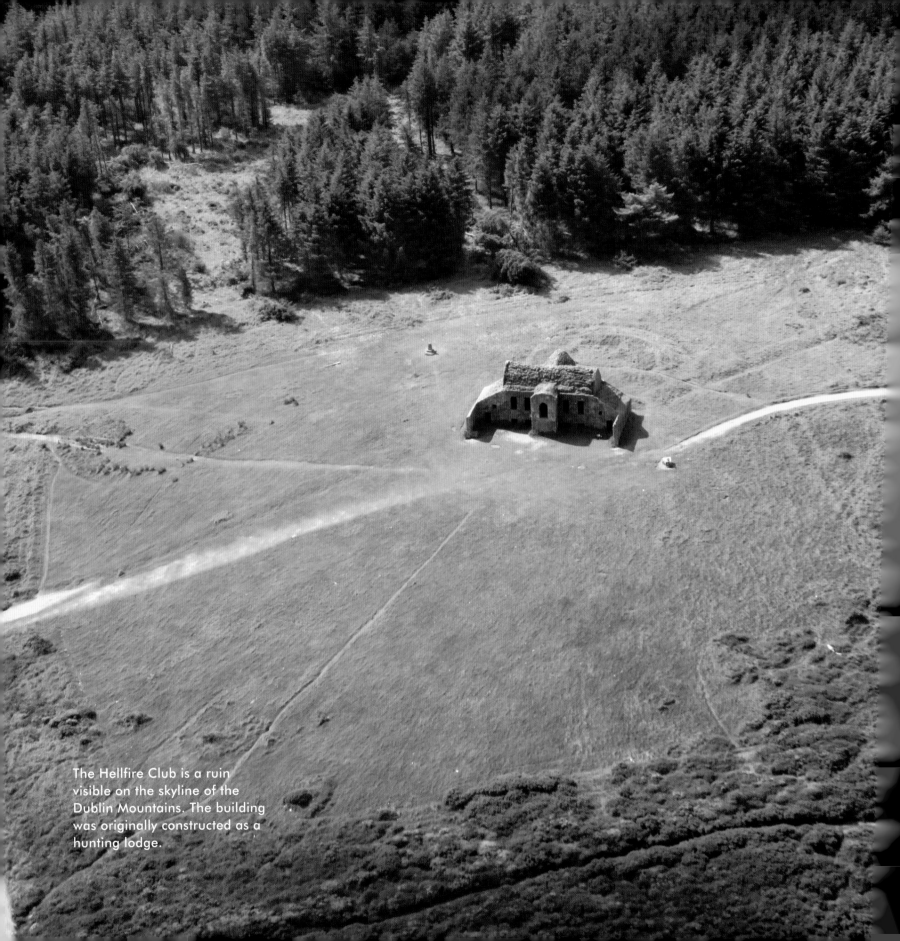

The Hellfire Club is a ruin
visible on the skyline of the
Dublin Mountains. The building
was originally constructed as a
hunting lodge.

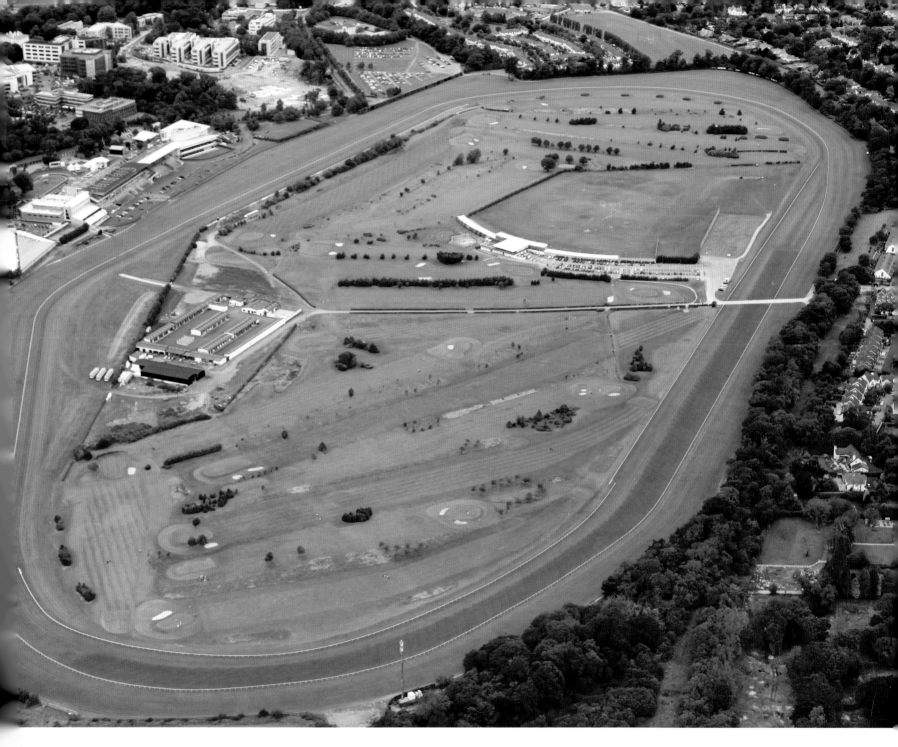

Leopardstown Racecourse. Modelled on Sandown Park Racecourse in Britain and completed in 1888, Leopardstown hosts both National Hunt and flat races, with an oval track of 1 mile and 6 furlongs.

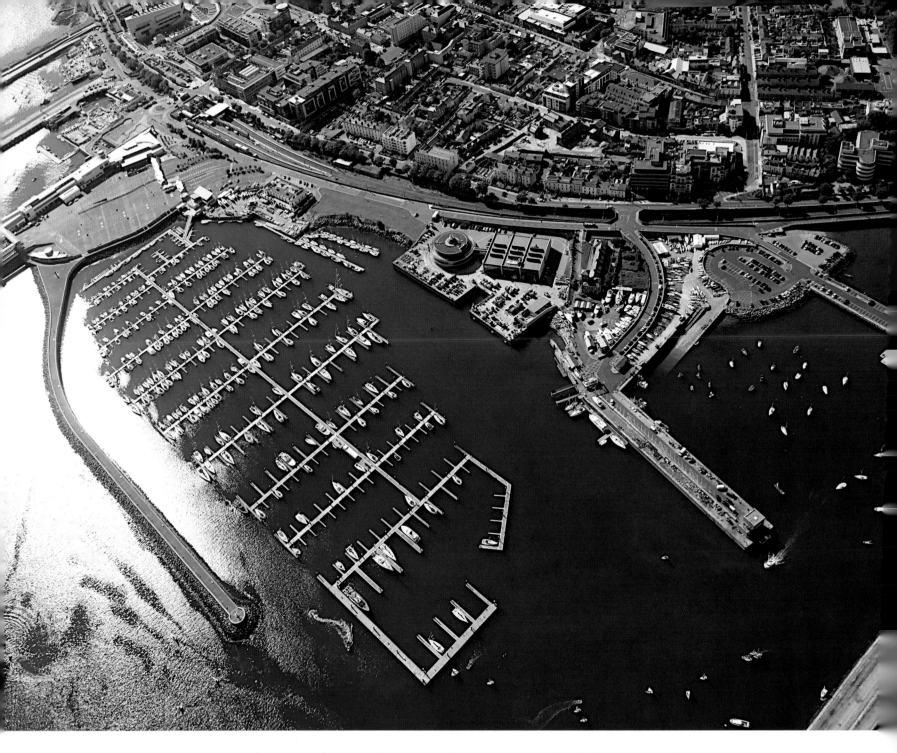

▲ A high-level perspective of Dun Laoghaire Harbour, with the Royal Irish Yacht Club marina and the Commissioners of Irish Lights headquarters at the centre.

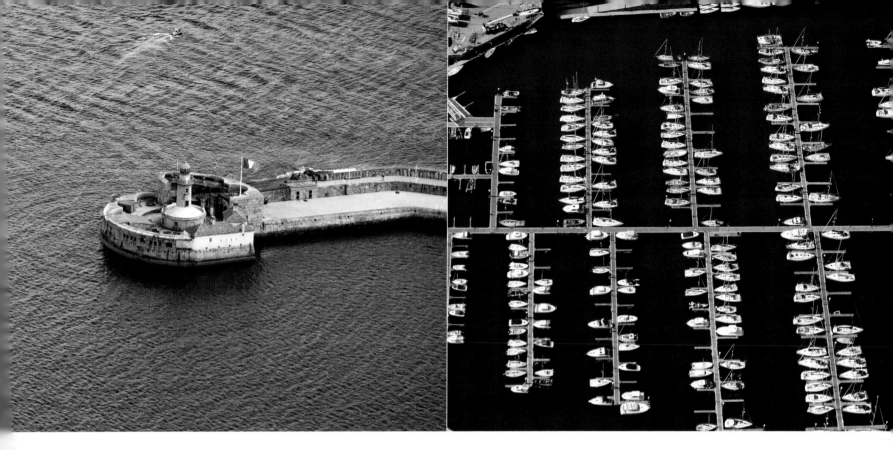

▲ The East Pier, Dun Laoghaire.

▲ Rows of berthed yachts form a geometric pattern from above.

◁ The headquarters of the Commissioners of Irish Lights on Harbour Road, Dun Laoghaire.

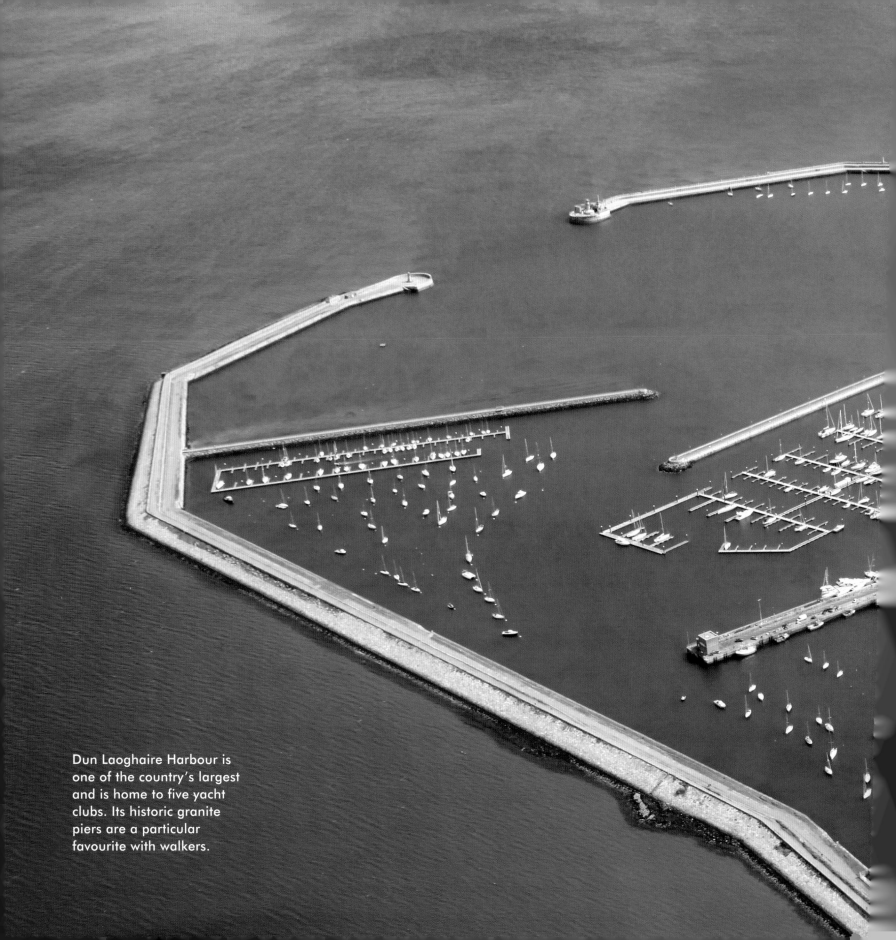

Dun Laoghaire Harbour is
one of the country's largest
and is home to five yacht
clubs. Its historic granite
piers are a particular
favourite with walkers.

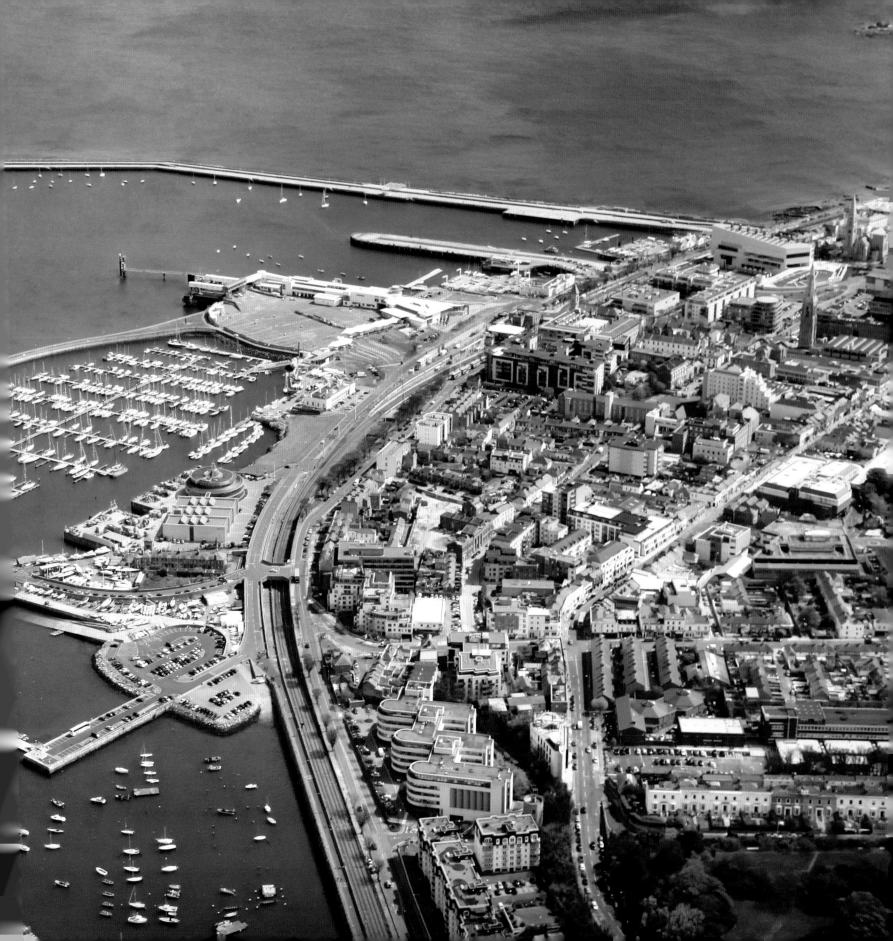

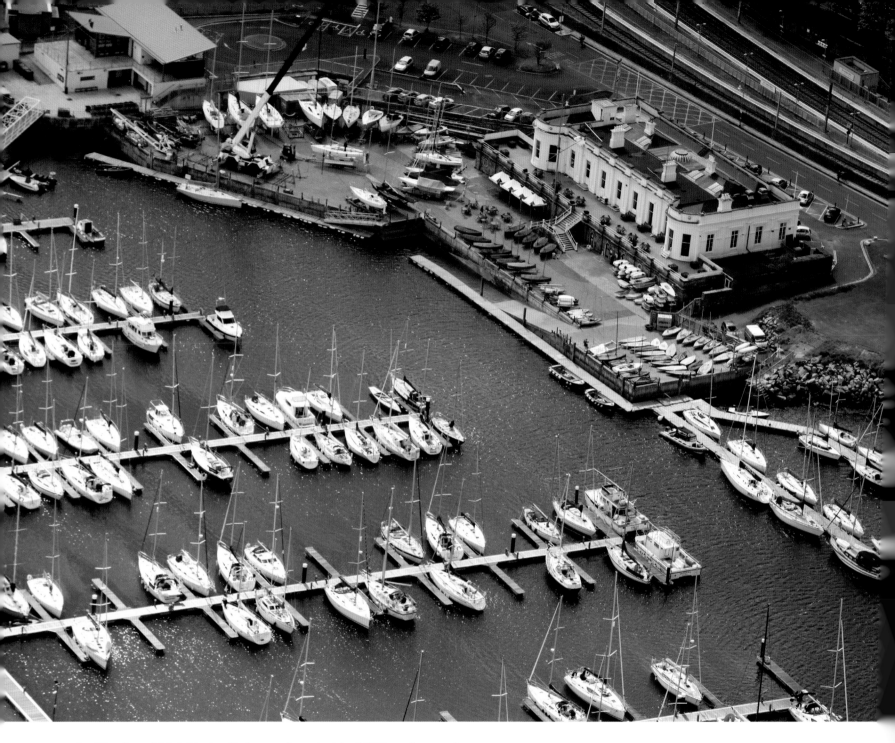

▲ The Royal Irish Yacht Club was founded in 1831 and occupies an elegant clubhouse on the waterfront at Dun Laoghaire. In recent times a large marina was built to accommodate the ever-increasing numbers of yachts.

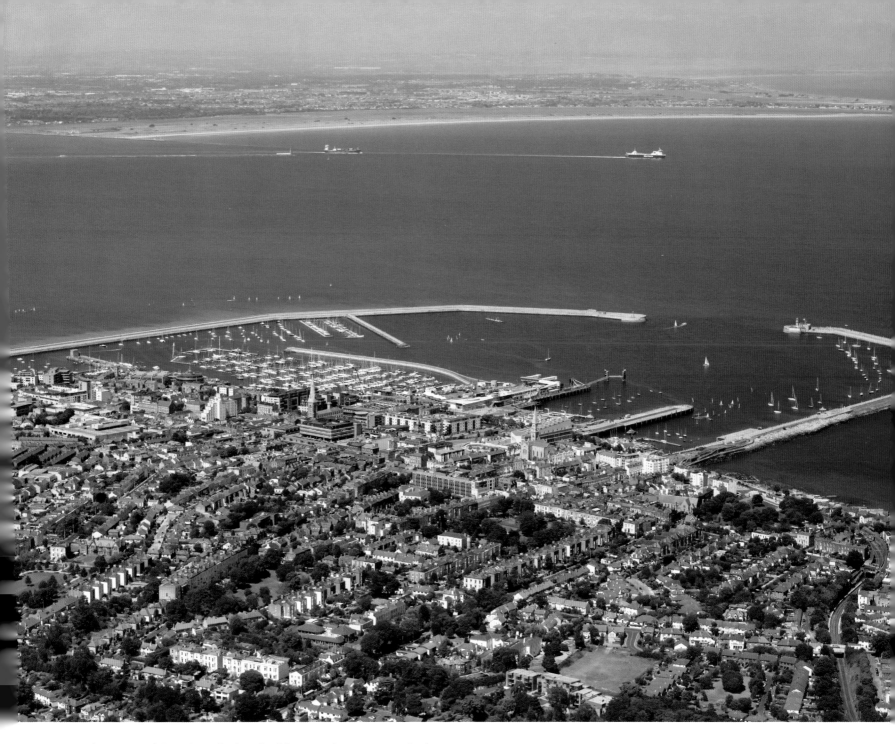

The town of Dun Laoghaire, looking northeast towards the harbour and Bull Island beyond.

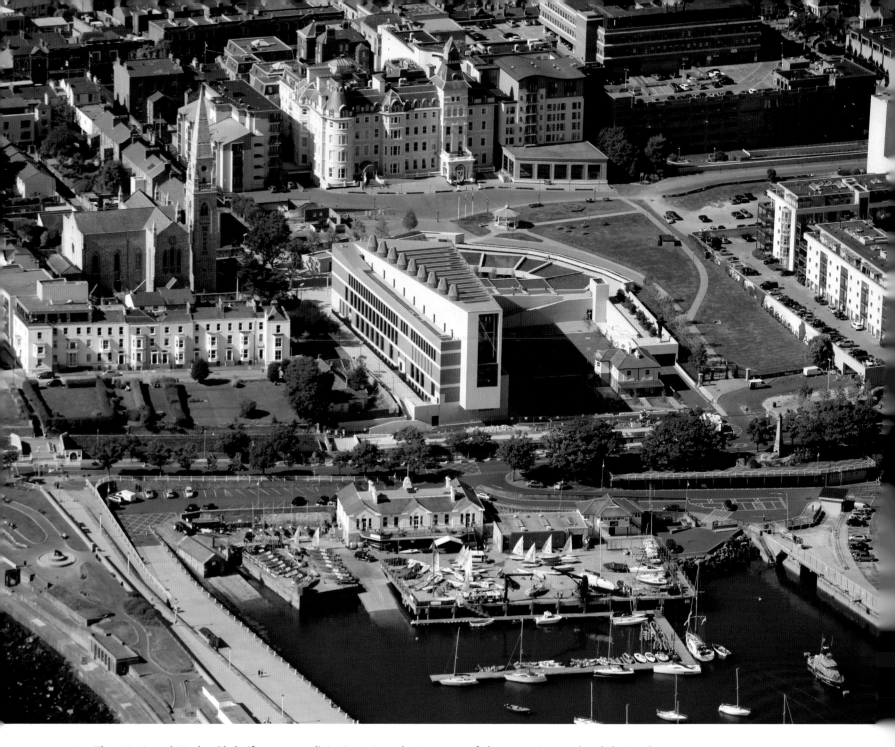

▲ The National Yacht Club (foreground) in Dun Laoghaire, one of the premier yacht clubs in the country, and the latest addition to the seafront, the Lexicon Library (centre). This imposing four-storey building houses a library, performance space and a municipal gallery.

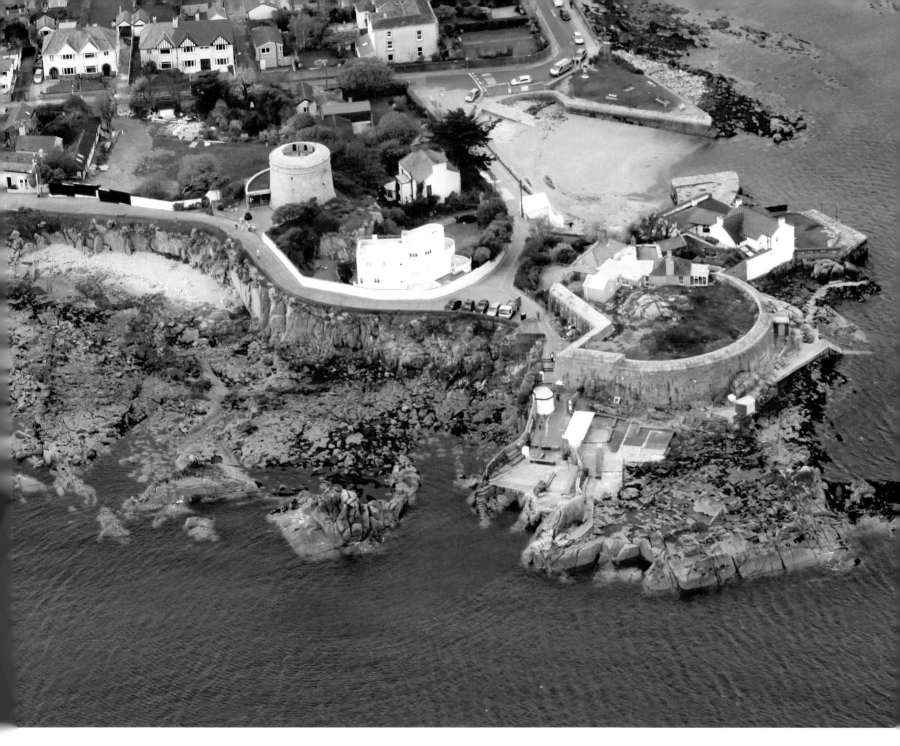

▲ The Forty Foot is a rocky plateau jutting out into the sea between Sandycove and Bullock Harbours in South Dublin. With its clean, deep waters, it has been a favourite swimming place of Dubliners for over 250 years.

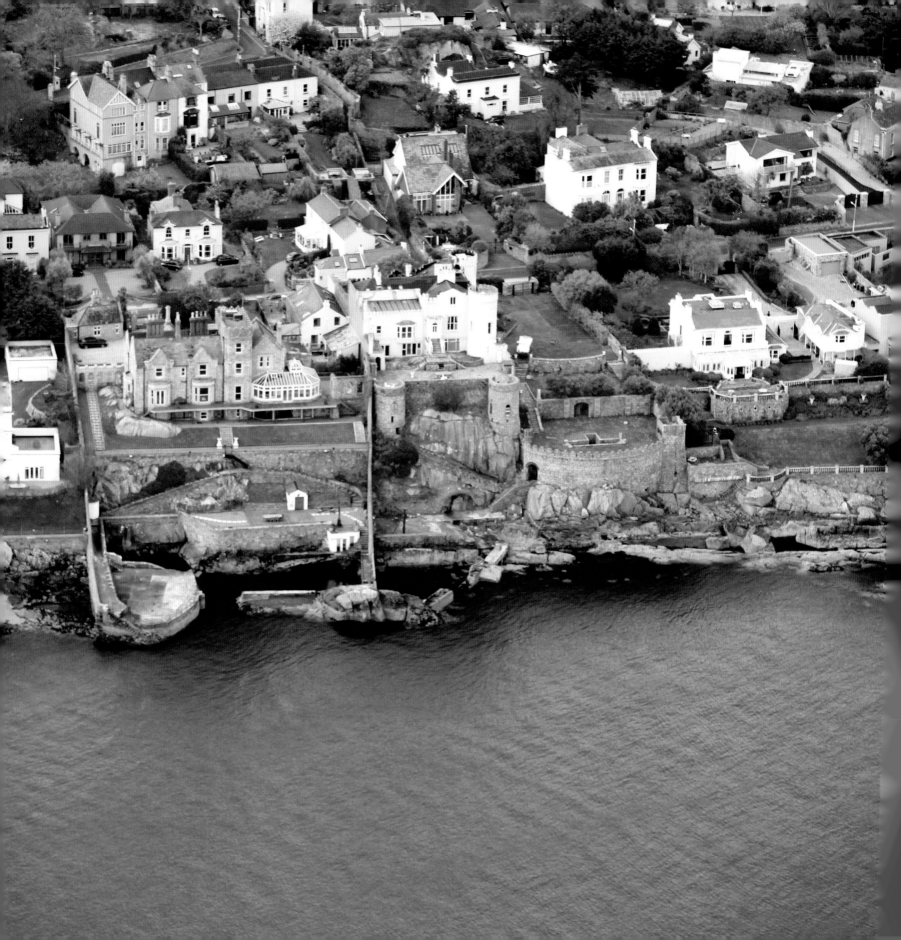

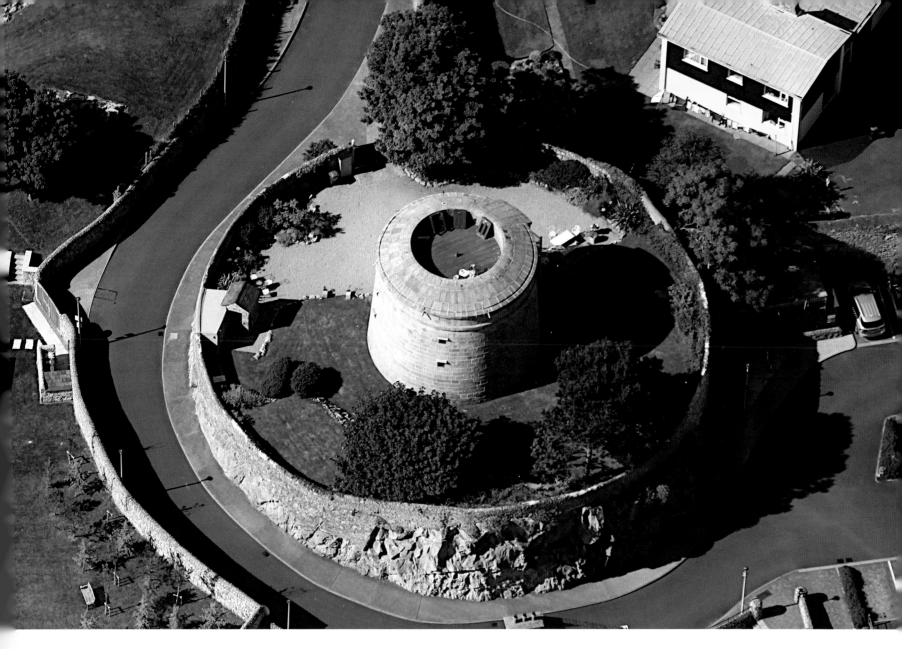

▲ Bartra Martello Tower, a magnificent Napoleonic-era defence tower built in 1804 on Harbour Road in Dalkey, now maintained as a private residence.

◀ Elegant homes of varying designs adorn the clifftops at Dalkey.

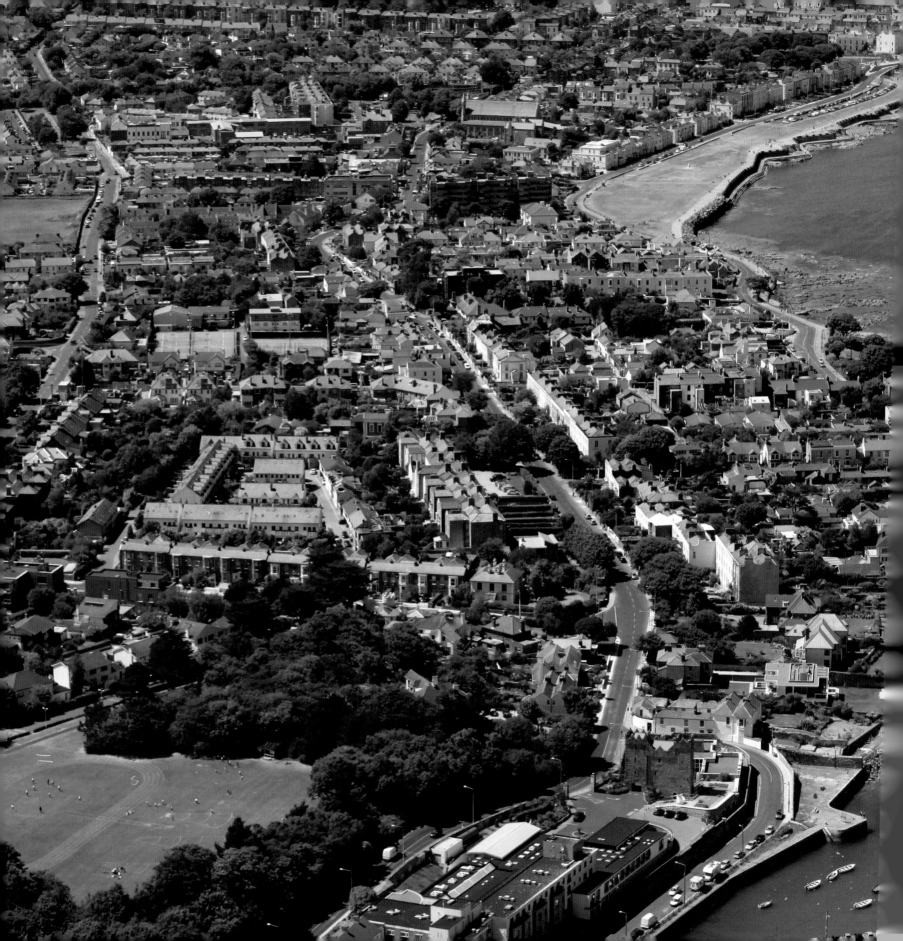

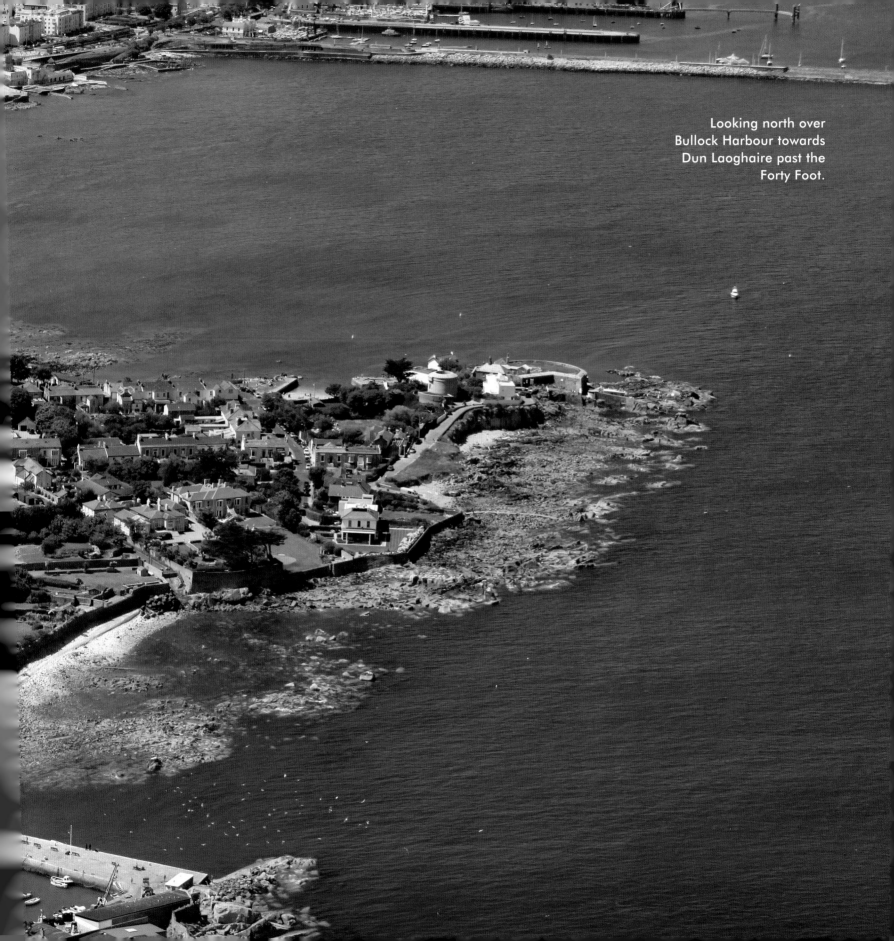

Looking north over Bullock Harbour towards Dun Laoghaire past the Forty Foot.

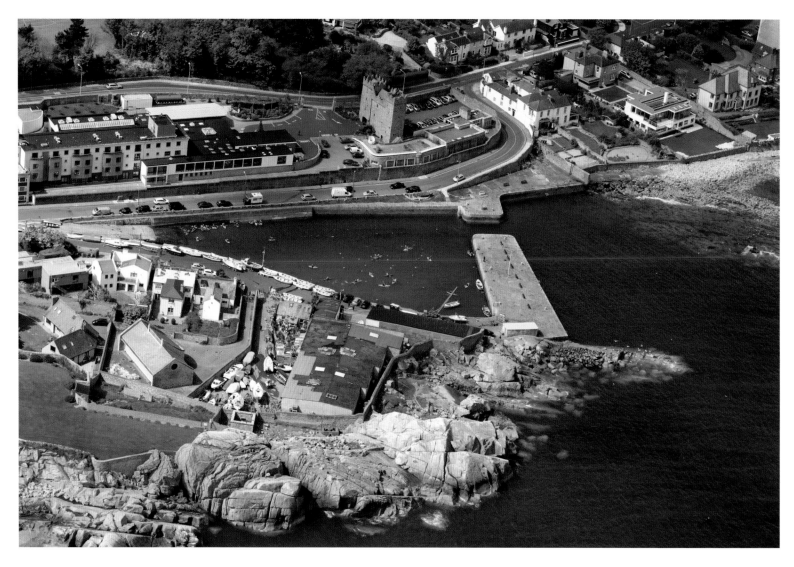

▲ Bullock Harbour (Blue Haven) was built using local granite from Dalkey Hill by the monks of St Mary's Abbey in nearby Dublin.

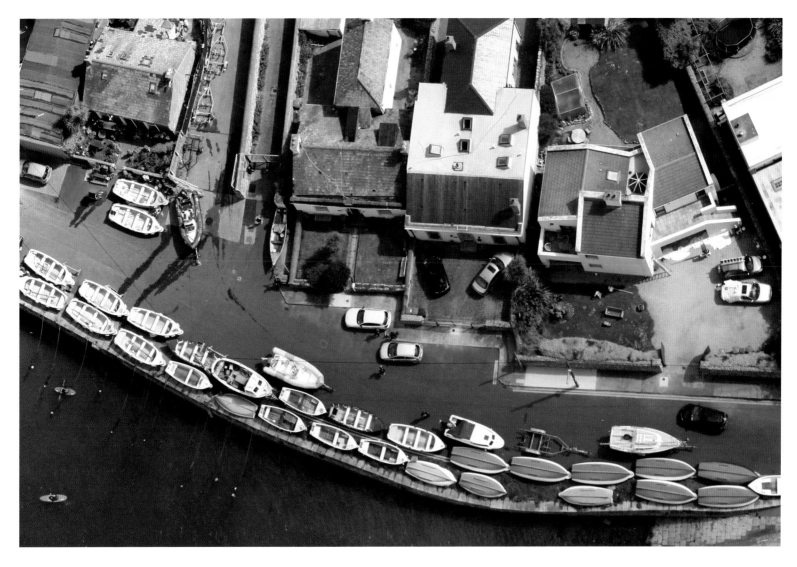

▲ Boats at Bullock Harbour. Angling is popular on the east coast and these boats are available for hire to enthusiasts.

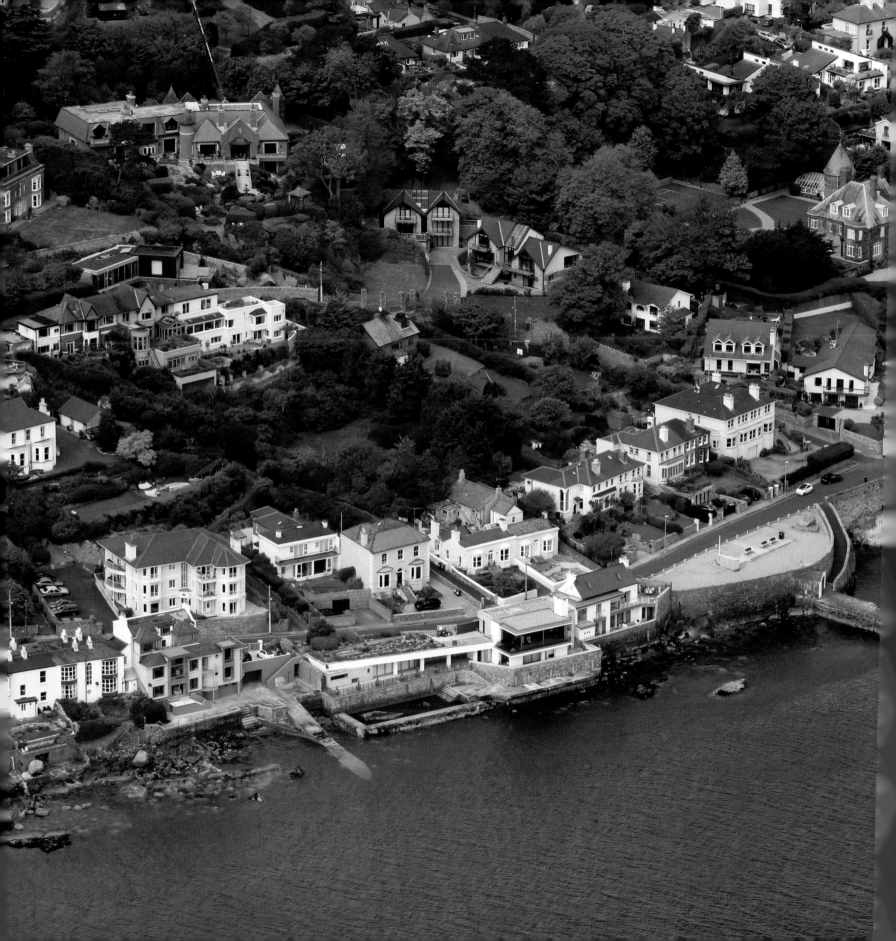

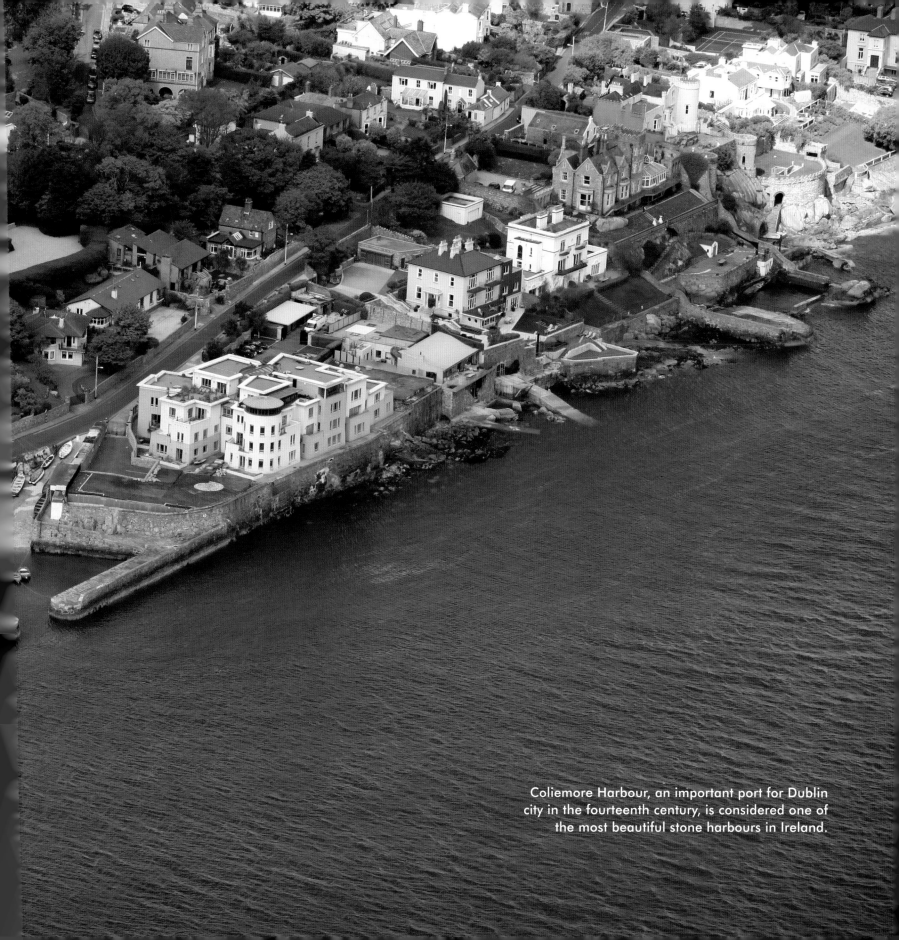

Coliemore Harbour, an important port for Dublin city in the fourteenth century, is considered one of the most beautiful stone harbours in Ireland.

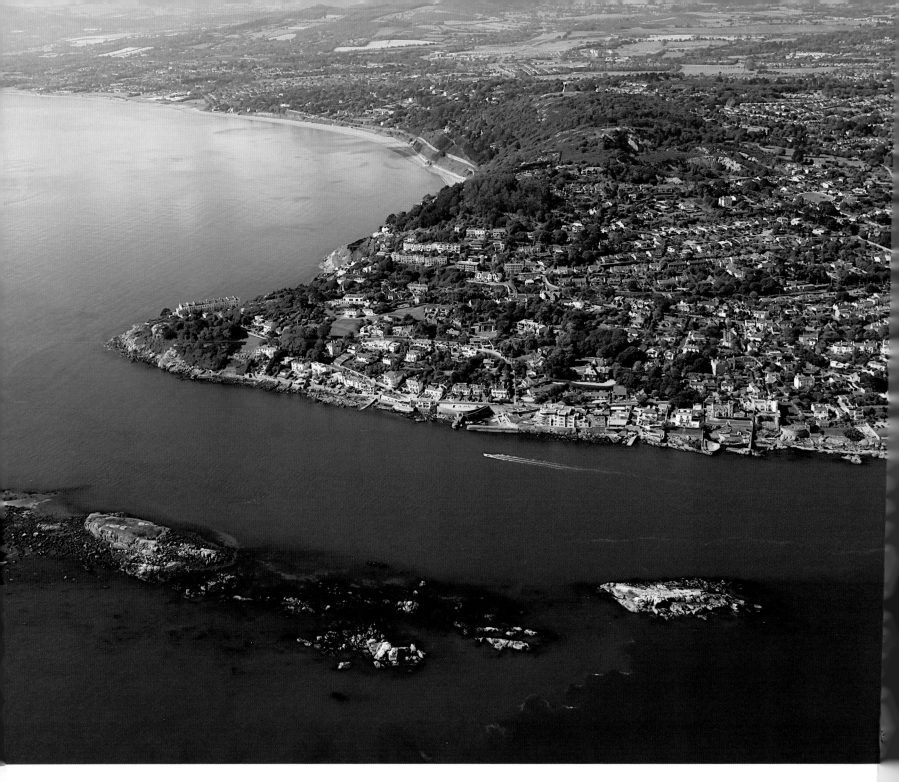

▲ This view of Dalkey looks southwest towards Bray with part of Dalkey Island visible in the foreground.

The Muglins are a group of rocks lying northeast ▶ of Dalkey Island and are a hazard to mariners. The conical stone beacon was built on the rocks in 1880 and the light was added some years later.

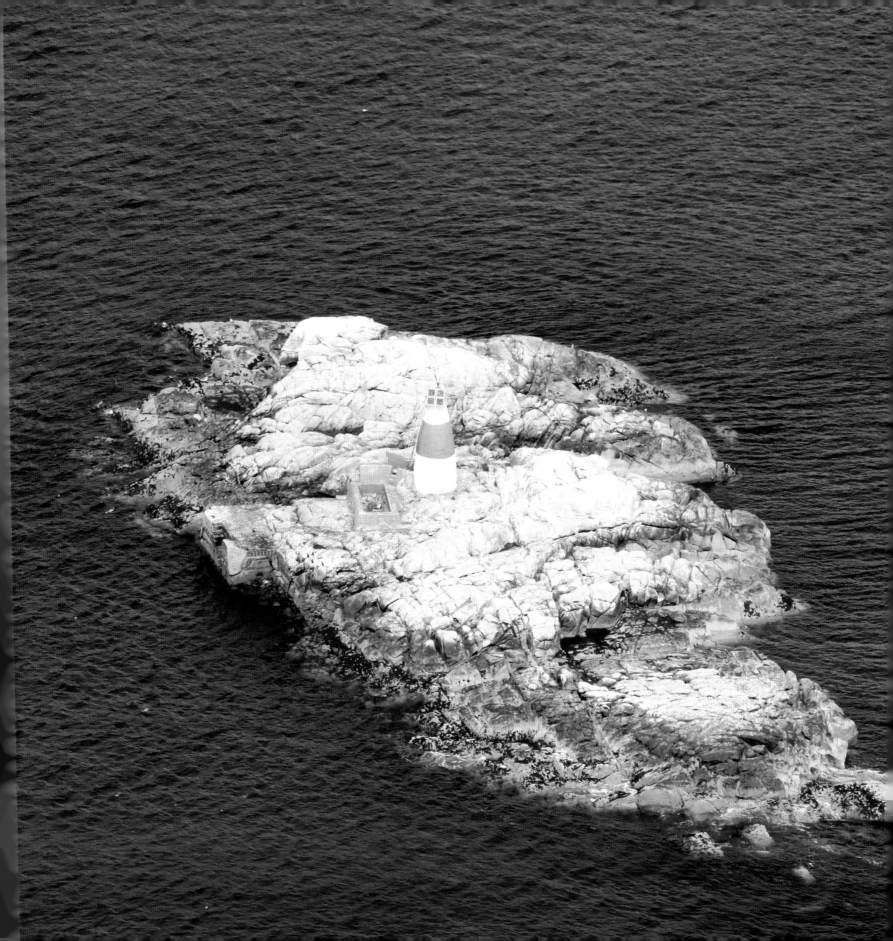

Named after Sorrento on the Bay of Naples and situated at the easternmost end of Dalkey, this terrace of eight period houses has superb views over Killiney Bay to the Wicklow mountains in the distance.

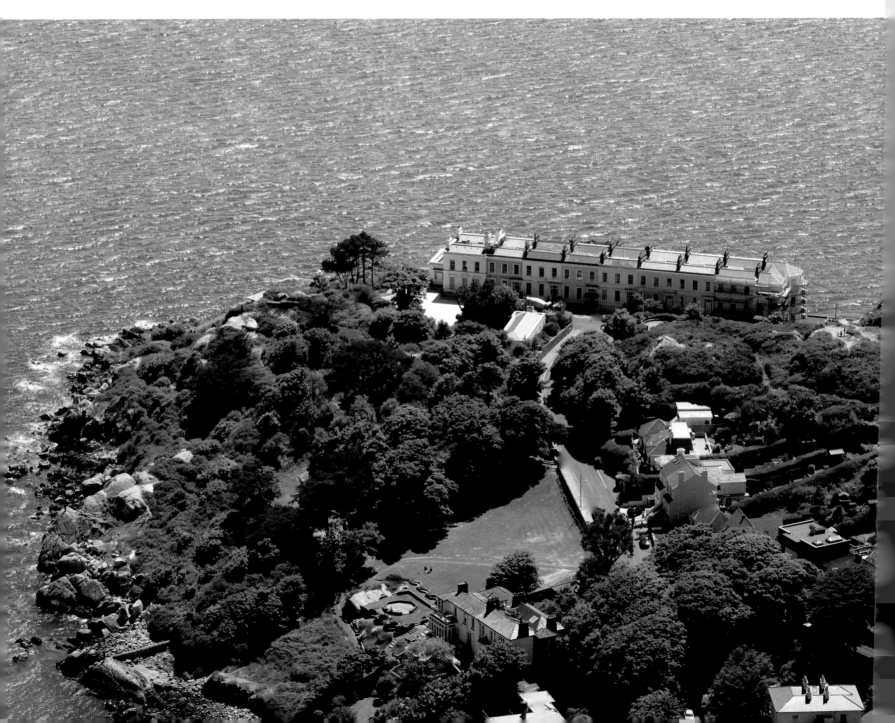

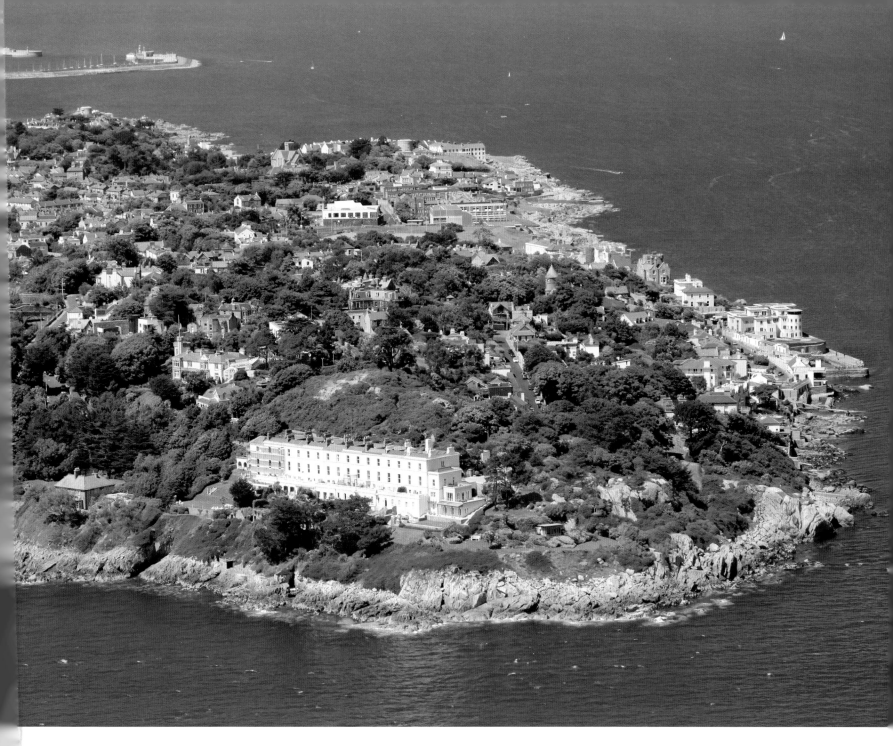

▲ Dalkey (*Deilginis* in Irish, meaning 'thorn island') is a heritage town and popular with visiting tourists.

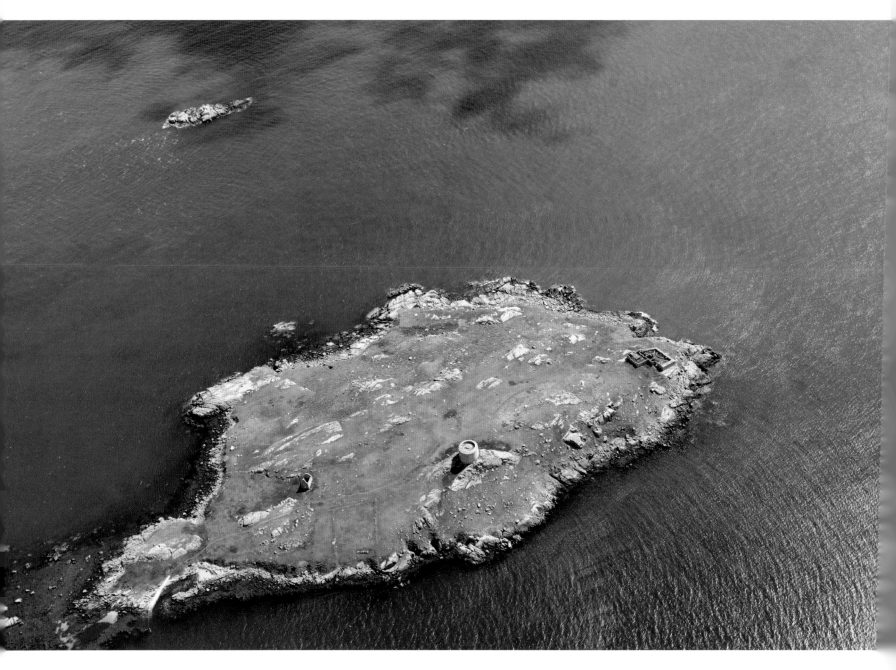

▲ Dalkey Island. Located just offshore from
Dalkey town, this small uninhabited island
was once used as a Viking base. Ruins
remain of a church linked to a fourteenth-
century saint, Begnet.

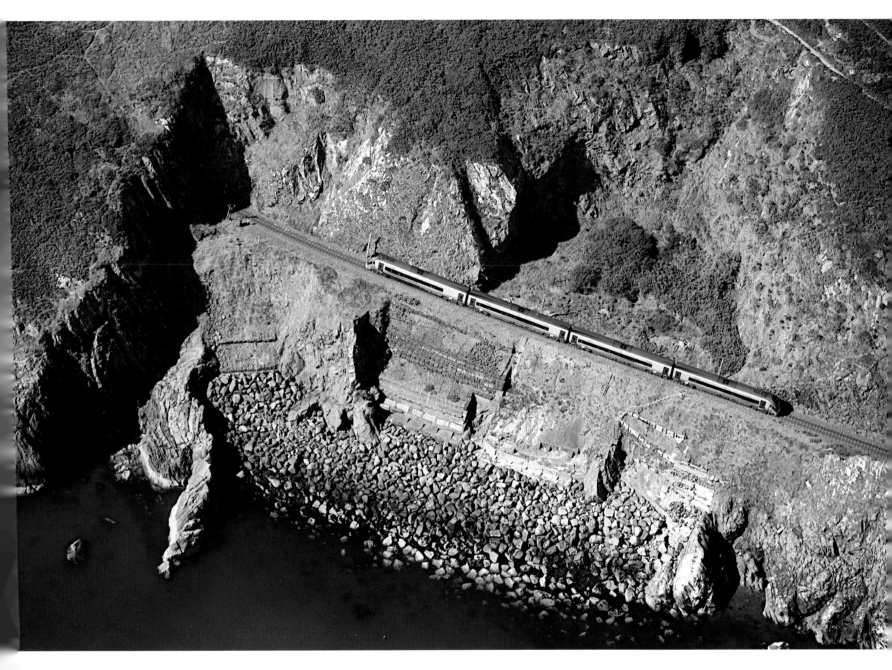

An Irish Rail train on the southerly route of one of the most scenic sections of the entire rail network.

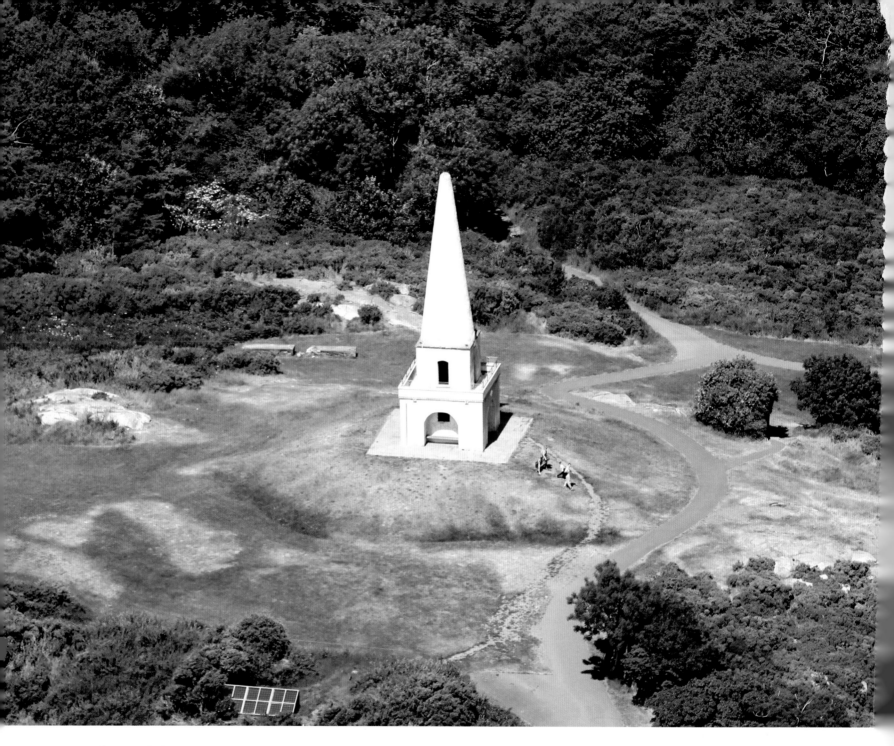

▲ The Obelisk on Killiney Hill is 170 metres/560 feet above sea level. It was erected in 1742.